THE REPEATING IMAGE

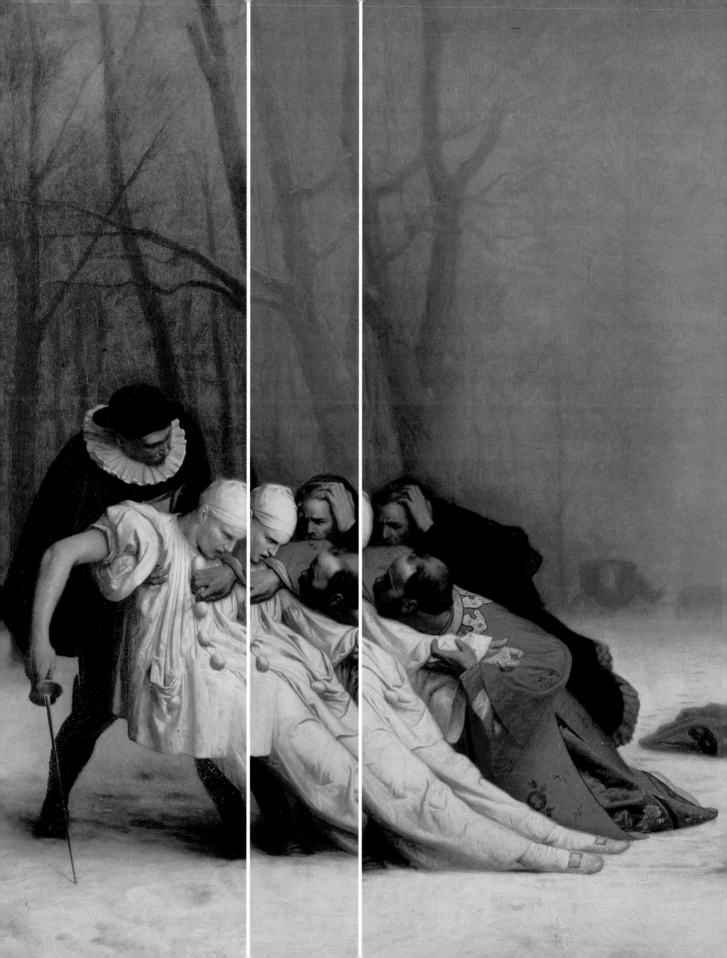

THE REPEATING IMAGE: MULTIPLES IN FRENCH PAINTING FROM DAVID TO MATISSE

THE REPEATING IMAGE: MULTIPLES IN FRENCH PAINTING FROM DAVID TO MATISSE

Edited by Eik Kahng

With contributions by

Stephen Bann

Simon Kelly

Richard Shiff

Charles Stuckey

Jeffrey Weiss

The Walters Art Museum

Baltimore

Distributed by

Yale University Press

New Haven and London

This publication accompanies the exhibition *Déjà Vu? Revealing Repetition in French Masterpieces,* organized by the Walters Art Museum, Baltimore, in association with the Phoenix Art Museum.

Exhibition dates:
7 October 2007–1 January 2008
The Walters Art Museum, Baltimore, Maryland

20 January–4 May 2008
Phoenix Art Museum, Phoenix, Arizona

Library of Congress Cataloging-in-Publication Data
The repeating image : multiples in French painting from David
 to Matisse / edited by Eik Kahng ; with contributions by
 Stephen Bann . . . [et al.].
 p. cm.
 Catalog of an exhibition entitled "Déjà Vu? Revealing
Repetition in French Masterpieces," at the Walters Art
Museum, Oct. 7, 2007–Jan. 1, 2008 and at the Phoenix
Art Museum, Jan. 20–May 4, 2008.
 Includes index.
 ISBN 978-0-300-12669-3 (cloth)
 ISBN 978-0-911886-68-9 (pbk.)
 1. Painting, French—19th century—Exhibitions.
2. Painting, French—20th century—Exhibitions.
3. Repetition (Aesthetics)—Exhibitions. I. Kahng, Eik.
II. Bann, Stephen. III. Walters Art Museum (Baltimore,
Md.). IV. Phoenix Art Museum.
ND547.R38 2007
759.4—dc22 2007015023

The Walters Art Museum
600 North Charles Street
Baltimore, Maryland 21201
www.thewalters.org

Hardcover edition distributed by
Yale University Press
302 Temple Street
P.O. Box 209040
New Haven, Connecticut 06520-9040
www.yalebooks.com

Dimensions are given in centimeters; height precedes width.

The Walters Art Museum, Baltimore
Manager of Curatorial Publications: Charles Dibble

Designed by Jeff Wincapaw
Proofread by Sharon Rose Vonasch
Typeset in ScalaPro and Berthold Akzidenz Grotesk by
Marissa Meyer
Color separations by iocolor, Seattle
Produced by Marquand Books, Inc., Seattle
 www.marquand.com
Printed on 157 gsm Gold East matte art
Printed and bound in China by C&C Offset Printing Co., Ltd.

Contents

Over the years, the Walters Art Museum has earned a reputation as
that rare mid-size museum, willing to throw its institutional weight
behind ambitious exhibitions committed to the advancement of
academic scholarship. From *Pandora's Box: The Roles of Women in
Ancient Greece* (1995) to *Masters of Light: Dutch Painters in Utrecht
During the Golden Age* (1997) to *The Book of Kings: Art, War, and
the Morgan Library's Medieval Picture Bible* (2002), the Walters has
sought to originate shows that have both a clear scholarly value
and popular appeal. However, in a fiscal climate in which most art
museums are increasingly pressured to keep the turnstile spinning,
this ideal has become more and more difficult to uphold. When
organizing curator Eik Kahng first proposed an exhibition on the
theme of repetition in French painting I immediately recognized
its potential as a show that might attract both our traditional mem-
bership and entice new audiences. At once an exhibition born of
the latest in cutting-edge scholarship, new conservation research,
and ambitious educational programming, it is just the type of show
the Walters aspires to produce in this latest phase of its evolution.
Déja Vu? Revealing Repetition in French Masterpieces capitalizes on the
intellectual rigor of the museum's unusually deep pool of curatorial
and conservation talent, while encouraging innovations in installa-
tion design and in interpretive tools. It also tackles issues of art and
its interpretation that are of deep consequence in art historical and
museological terms.

The merits of this exhibition project, like the theme it treats,
are multiple. First, the exhibition explores a seminal issue of early
modernism—repetition in painting—in an attempt to articulate
the multivalent significance of this ubiquitous attribute of visual
culture of the last two centuries, which, as Dr. Kahng argues, cannot
be merely incidental. Second, the show explores this broad theme
through a selection of painters, both familiar and not-so-familiar,

thereby complicating received wisdom about such popular favorites as Claude Monet or Paul Cézanne, while refocusing attention on neglected academic painters such as Paul Delaroche. Third, the project has adhered to a principle of collaboration rarely maintained throughout the genesis of an exhibition and its accompanying catalogue. The team assembled by Dr. Kahng, which included conservators, academic art historians, and curators, enjoyed a two-day brainstorming session, generously funded and hosted by the Sterling and Francine Clark Institute in the summer of 2005. The themes of this book, like the exhibition, reflect the rich conversational flavor of the ongoing dialogue between team members, initiated at the Clark and continued throughout the project's development. In addition, Dr. Kahng was privileged to enjoy the resources offered by a two-month fellowship in the early summer of 2006 at the Center for Advanced Study of the Visual Arts at the National Gallery, Washington, where she was afforded time to read and further reflect in preparation for her essay. As a wide-ranging overview of the complex theme of repetition in painting, the essays collected here promise to retain their relevance for students of the nineteenth and twentieth centuries, as well as those who seek an historically informed point of view on the persistence of repetition in contemporary art.

As always, a project of this scope and ambition could not have happened without the contributions of each and every member of the Walters' dedicated staff. We wish to acknowledge for their instrumental roles: development director Toni Condon; chief registrar Joan Elisabeth Reid; former traveling exhibitions manager Betsy Gordon; traveling exhibitions manager Annie Lundsten; former exhibition designer Paula Millet; associate exhibition designer Danielle Jones; educators Amanda Kodeck and Kathy Nussbaum; head of paintings conservation Eric Gordon; senior paintings conservator Karen French; assistant paintings conservator Gillian Cook; senior books and paper conservator Elissa O'Loughlin; visiting conservation researcher Brian Baade; and head of photography Susan Tobin. Walters manager of curatorial publications Charles Dibble produced this handsome volume with the collaboration of designer Jeff Wincapaw of Marquand Books. Our thanks as well to Ed Marquand for his originality, expertise, and enthusiasm.

Dr. Kahng enjoyed the particular collaboration of Susan Ross and Gülru Çakmak, who held the position of Bates fellow at the Walters for 2003–2004 and 2006–2007, respectively. On Dr. Kahng's behalf, we also acknowledge the generous contributions of her colleagues, Stephen Bann, Claire Barry, Thomas Crow, Michael Fried, Marc Gotlieb, Ann Hoenigswald, Michael Ann Holly, Simon Kelly, Richard Kendall, Mark Ledbury, Thomas Loughman, Keith Moxey, Peter Parshall, Richard Shiff, Charles Stuckey, and Jeffrey Weiss. She would also like to thank Joan Freedman, director of the Media Center of the Johns Hopkins University. Her staff and students produced some of

the innovative interactive components distinguishing the exhibition installation. Our thanks, as well, to Michel Draguet, director of the Musées royaux de Belgique and its chief curator, Frederik Leen, for their cooperation in the production of the Marat video project.

For their invaluable support of the exhibition and the publication, we would also like to thank: Alexander Babin, Philip Brookman, Alain Daguerre de Hureaux, Patrick Deron, Charlotte Eyerman, Jay Fisher, David Franklin, Aprile Gallant, James Ganz, Gloria Groom, Sarah Hall, Axel Hémery, Kelly Holbert, Colta Ives, Sophie Jugie, Isabelle Julia, Ian Kennedy, Michelle Komie, Susan Higman Larsen, Sylvain Lavaissière, Terry Lignelli, David Liot, Louise Lippincott, Georges Matisse, Mary Morton, Alexandra Murphy, Lynne Federle Orr, Peter Parshall, Nicholas Penny, Joachim Pissarro, Rebecca Rabinow, Richard Rand, Pierre-Lin Renié, Christopher Riopelle, Joseph Rishel, Betsy Rosasco, Katy Rothkopf, Marie-Catherine Sahut, Xavier Salmon, Polly Sartori, Scott Schaefer, George Shackelford, Cheryl Snay, Gary Tinterow, Andrew Walker, John Weber, Jeffrey Weiss, Jean Woodward, John Zarobell, and Henry Zimet.

In closing, I would like to thank our partner and exclusive southwestern venue for this traveling exhibition, the Phoenix Art Museum. My colleague, James Ballinger, and Dr. Kahng's counterpart, Thomas Loughman, have remained steadfast supporters of this challenging project from its earliest incarnation. They shared my conviction in the merits of this groundbreaking show and we hope this book will be enduring proof of their wisdom.

Gary Vikan
Director
The Walters Art Museum

Lenders to the Exhibition

Austin, Blanton Museum of Art, The University of Texas at Austin
Baltimore, The Baltimore Museum of Art
Baltimore, The Walters Art Museum
Bordeaux, Musée Goupil
Boston, Museum of Fine Arts, Boston
Cardiff, Amgueddfa Cymru–National Museum Wales
Chicago, The Art Institute of Chicago
Dijon, Musée des Beaux-Arts de Dijon
Kansas City, The Nelson-Atkins Museum of Art
London, The National Gallery
Los Angeles, The J. Paul Getty Museum
New York, French & Company LLC
New York, The Metropolitan Museum of Art
Northampton, Massachusetts, Smith College Museum of Art
Ottawa, National Gallery of Canada
Paris, Musée du Louvre
Philadelphia Museum of Art
Pittsburgh, Carnegie Museum of Art
Pittsburgh, The Frick Art & Historical Center
Portland, Oregon, Portland Art Museum
Princeton, Princeton University Art Museum
Private collections
Reims, Musée des Beaux-Arts de la ville de Reims
Saint Louis Art Museum
Saint Petersburg, Russia, The State Hermitage Museum
San Francisco, Fine Arts Museums of San Francisco
Toulouse, Musée des Augustins
Versailles, Musée national des châteaux de Versailles et de Trianon
Washington, The Corcoran Gallery of Art
Washington, National Gallery of Art
Williamstown, Massachusetts, Sterling and Francine Clark Art Institute

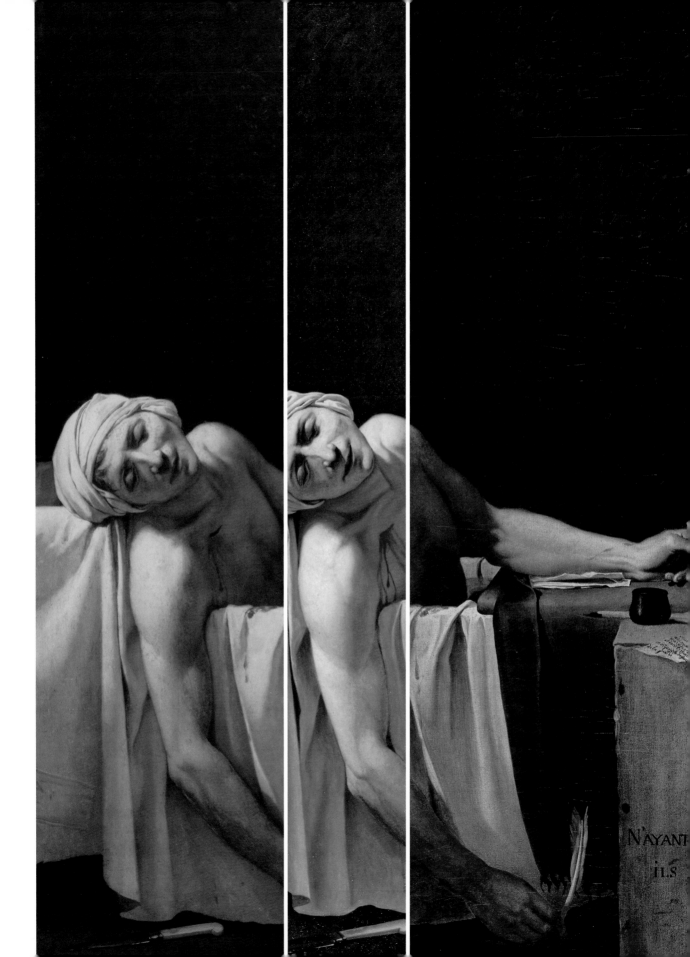

Eik Kahng

Repetition and Art History

In his classic text published in 1962, George Kubler attempted to describe what he grandly referred to as "The Shape of Time." In one of the few expansive discussions of the topic, Kubler posited repetition as a fundamental mechanism by which to measure the uneven rhythms of history. In reprint, the book retains its modish cover in bright yellow and red, decorated with schematic illustrations of a series of fragments of ancient pottery faces from what is now Mexico, arranged in fairly regular rows (fig. 1). The purpose of Kubler's ambitious essay was to counter what he saw as an overreliance on the vagaries of the history of style.[1] In Kubler's opinion, the concept of period "style" introduced a type of art history that suffered from an uncomfortably wide margin of subjective error.[2] Using his own long experience as a historian of non-Western antiquity, Kubler sought to resurrect the merits of form as a legitimate and more "objective" means of finding the shape of time, which, as he argued, is made visible only through reiteration and rupture: a material syncopation or prolonged rubato still graspable in "The History of Things" (a phrase that he used to qualify the title of his book). For Kubler, repetition is the art historian's primary means of investigation. It is what persists as a tangible history of things, if only in fragmentary form, even when the civilization that produced that history may have left no other trace. An archaeologist accustomed to resurrecting cultures long extinct, Kubler takes a very long, backward-looking view of art history, but his willingness to meditate on the methodological implications for the historian of the repetitiveness of things provides a succinct entrance into the subject this essay is meant to introduce.

At this distance of some forty-five years, one of the more endearing aspects of Kubler's essay is his probing use of metaphors by which to delineate the proper domain and method of the art historian. There is the electro-dynamic imagery of the repeated "signal" the pulse of

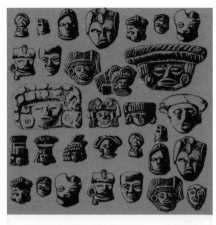

which may dim over time or may even be interrupted, only to be resumed centuries after its initial generation. Kubler warned against the limitations of the biological metaphors that had so often colored art-historical generalizations of stylistic evolution, but he liked the descriptive efficacy of the word "mutant," as a means of further nuancing the mathematically infused concept of a "prime object" (for example, the Parthenon marbles). Successful prime objects give rise to "replica masses." To further qualify the types of replica masses, Kubler called upon a metaphor of motion:

Replication obeys two contrasting kinds of motion. They can be described as motions towards and away from quality. Augmented quality is likely when the maker of a replica enriches upon his model by adding to its excellences, as when a talented pupil improves upon his mediocre teacher's exercises. . . . Diminished quality becomes apparent when the maker reduces the excellence of the replica, either because of economic pressures or because of his inability to comprehend the full scope or import of the model. . . . When a mass-produced article

Fig. 1. Cover of George Kubler, *The Shape of Time: Remarks on the History of Things* (New Haven and London: Yale University Press, 1962)

of good design begins to have a wider market and more intense competition, the manufacturers simplify its design to get the price down until the product is reduced to the fewest possible parts in a construction no more durable than necessary.[3]

Summarized here, then, are types of repetition in the visual arts, especially the "fine arts," that one readily recognizes. An obvious example of a prime object might be the no-longer-extant Athena Parthenos carved by Phidias.[4] The many renditions in less precious materials inspired by the original ivory and gold statue would be considered part of the "replica mass" to which the prime object gave rise. A straightforward version of quality degrading through repetition might be, as Kubler says, the consequence of economic necessity (that is, shortchanging quality in the interests of profit) or, in our context of Western painting, the inferior product of a workshop, which can never quite approach the perfection of the master's original. This is manifestly true of the multiple studio copies, which vary widely in quality, of Jacques-Louis David's (1748–1825) stupefying martyr portrait, *Marat at His Last Breath,* discussed at the end of this essay.

What is not covered in Kubler's lucid description of repetition is the instance when it is the most conceptually elusive; the type of repetition that might be schematically illustrated by a flat, horizontal line, neither ascending or descending.[5] Significantly, this is the kind of repetition practiced in the painted series of Claude Monet (1840–1926), as well as in modern industrial production and, more frighteningly, in the domain of genetic engineering. In other words, it is the kind of repetition that has come to dominate contemporary everyday experience, just as it has the art world of the last century and a half. One wonders if Monet himself recognized that photographic illustration, whether in the form of the catalogue raisonné or in a wall calendar, would allow for his series'

reconstitution, no matter how much time and space might separate their members.

To posit repetition in painting as a topic may seem to be historically tenuous, since the reasons for it are usually presumed to be self-evident. For example, artists repeat themselves when attempting to work out or perfect an initial idea. The several versions of Jean-Auguste-Dominique Ingres's (1780–1867) *Oedipus and the Sphinx* are a case in point, although it remains unclear what function the smaller version now in the collection of the National Gallery, London, might have served.[6] Thus, preparatory drawings, sketches, and the like are routinely used as clues by art historians to guide our understanding of an artist's intentions. Artists also repeat themselves for purely practical reasons. An important commissioned portrait of a religious official, for example, exists in multiple studio replicas, whether autograph or not. When we move into the modern era, however, the transparency of repetition in painting quickly becomes murky. Even today the ubiquity of repetition as a mode of decoration, a condition of technological production and consumption, an advertising tactic, not to mention a storied habit of minimalism and its aftermath, makes it nearly impossible to see at a comfortable historical distance.

To gird the breadth of the topic, I have chosen to focus on one medium: painting. This decision was not arbitrary. A consideration of painting in early modernism immediately raises some of the trenchant issues attached to the concept of repetition in the visual arts. The period from the rendering of the ur-*Marat at His Last Breath* and its studio copies, to Henri Matisse's (1869–1954) meticulous recording of compositional changes in his paintings—roughly 1800 through 1940—includes the invention of photography and its perfection as a reproductive medium, as well as its emergence as an art form in its own right. It includes the invention and ascendancy of film and the consequent sea change in habits of making and viewing that

the moving image has imposed. The nineteenth and twentieth centuries also saw the establishment of the modern conditions for the production, diffusion, and consumption of the fine arts. Gallery culture, the catalogue raisonné, and a mass-market cultivation of an ever-growing demand for images are all in place by the middle of the nineteenth century. The consequent expansion and diversification of the audience for the fine arts continues today. The early modern period, then, offers a perfect environment in which to profile this radical shift in the significance of repetition in painting and to speculate on its implications.

To be sure, this is not the first attempt to explore the question of repetition in painting,[7] but the question has more often been discussed from the point of view of making and meaning in the Western tradition, specifically with respect to the changing status of copying in the history of painting. There is no question that copying (a term whose modern-day potential for pejorative connotation instantly vanishes when returned to the context of academic emulation)[8] was the lifeblood of the Western tradition, at least since the Renaissance. There is also general agreement that the status of copying undergoes a crippling fall from grace in early modernism. Emulation as a positive and nurturing aspect of the academic tradition is displaced by a modern anxiety over issues of authenticity and its closely related cousin, originality.[9] The spatial metaphor implicit in the Platonic definition of the mimetic copy as increasingly distant from its original essence abruptly loses its footing in this context. In what follows, I differentiate between the old aesthetic framework of the original (and by implication, its copy) from what might be described as an aesthetics of repetition. In so doing, I hope to illuminate the expressive necessity of repetition as a fully naturalized symptom of modernity; one that is as much rooted in the philosophical bind of secular skepticism, as it is in the reproductive technologies of late capitalism.

I have chosen to use the word "repetition" because of its relative neutrality within the broader discipline of art history. There are a host of terms commonly used by art historians to describe the recognizable reappearance of an iconological formula (to use Erwin Panofsky's terminology) or schemata (to use Ernest Gombrich's) in the history of Western art. The verbs used from these methodological standpoints are active and distinctly positive in connotation: to cite, to allude, to refer, to recollect, to emulate. The presumption here is that the artist has intentionally mobilized a repeating form that he hopes the viewer/critic/historian will recognize, as it is intertwined with the broader meaning of his work of art. No absolute identity is possible between the source or referent (an earlier work of art) and the new embodiment of it. Such repetitions are, thus, variations and not exact repetitions. But in this scenario, the artist invites his viewers—indeed, re-petitions them to attend to the decision to repeat or to recapitulate an earlier form.

However, there is also a sense in which the repetition of a visual form can be deeply negative in connotation. Plagiarism is the most obvious instance, as it implies a willful deceit in its repetition of a prior visual formation, which has been "stolen" or deceptively presented as "original" to the artist. Recently, the charge of plagiarism has been increasingly complicated by the defense of an unwitting duplication of another's material, especially in the realm of prose, whether fictional or nonfictional. In an era of "sampling," plagiarism has flourished in an increasingly litigious society, especially one that can claim the proverbial "onslaught of information" as the culprit. There is, as well, the version of visual repetition most commonly encountered in post-structuralist critiques of visual culture in hegemonic society, in which visual forms are "appropriated" (as in the colonial sense of wrongful assumption of property).

Last, there is the macrocosmic version of repetition, as observed from a great distance of time and space, which is the type showcased by Kubler. This kind of notable repetition is also implied by a social-historical approach to visual culture, in which society's perspective takes on the locationless yet pervasive character of an "Age" or an "Era," or in Marxist terms, an ideology.

While repetition may appear to be too neutral a term to refer to all of these versions of visual recapitulation in Western painting, its noncommittal status also highlights, by contrast, the value-laden quality of these other synonyms used to describe repeating forms in painting. Indeed, when it comes to the specific history of painting in early nineteenth-century France, the term *répétition*, as explored by Stephen Bann,[10] contained within it a certain neutrality. It did not necessarily signify a subsequent version of lesser quality than the original, but simply the existence of an additional version or versions that may or may not exceed or vary from the first.

Repetition Retro: Series in the 1960s

Kubler was not alone in his preoccupation with repetition. In the late 1960s, repetition in the guise of the related topic of series, cropped up everywhere. Serial art, as explained with deadpan conviction by artist Mel Bochner (b. 1940), was where it was at. His essay "Serial Art, Systems, Solipsism," reprinted as part of Gregory Battcock's critical anthology of minimalism, first appeared in *Arts Magazine* in 1967. Bochner was among a group of artists, including Sol LeWitt (1928–2007), Dan Flavin (1933–1996), and Carl Andre (b. 1935), who were featured in *American Sculpture of the Sixties,* an exhibition at the Los Angeles County Museum that year. Even his manner of writing, reflecting the solipsism that was his subject, was repetitive. Taking the familiar tactic of emphasizing the thingness of things ("the thing itself"), Bochner defined serial art as one in which "the succession of terms (divisions) within a single work is

based on a numerical or otherwise predetermined derivation from one or more of the preceding terms in that piece." He began his discussion by quoting Edmund Husserl ("Go to the things themselves") and David Hume ("No object implies the existence of any other") and ended his brief pronouncement with the assertion of the "autonomous and indifferent" nature of things.

Just one year later, curator John Coplans's traveling exhibition *Serial Imagery* opened at the Pasadena Art Museum (fig. 2). Coplans's selection of artists and objects breached the boundaries set up by Bochner's listing.[11] The thirteen artists represented in *Serial Imagery*, beginning with Monet and ending with Andy Warhol (1928–1987), constituted a kind of canonical genealogy that traced the persistence of the serial mode, largely in painting. Bochner's list had been composed mostly of sculptors; Coplans's included not only Monet's familiar *Wheatstacks* and *Rouen*

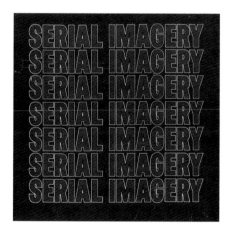

Fig. 2. Cover of John Coplans, *Serial Imagery* (Pasadena Art Museum, 1968)

Cathedrals, but also Piet Mondrian's (1872–1944) less familiar landscapes as well as his better-known gridded *Compositions*. Mondrian's abstraction provided a convenient segue to Josef Albers's (1888–1976) series, including the seemingly endless *Homage to the Square*. Expatriate Marcel Duchamp's (1887–1968) *Three Standard Stoppages* provided the conceptual ancestry

for the younger serialists. The migration of the art world's center of gravity to America was completed through the rapid unfolding of the rest of the family tree with Morris Louis (1912–1962), Ellsworth Kelly (b. 1923), Kenneth Noland (b. 1924), Warhol, and Frank Stella (b. 1936). The only sculptor included was the American Larry Bell (b. 1939), whose work in light and glass had a distinctly pictorial character. The story narrated by Coplans in the accompanying exhibition catalogue was careful to distinguish the authentically serial from what Coplans called the merely "modular," by which he meant "such sculptors as Donald Judd" (1928–1994). Coplans asserted, "This is incorrect. Judd, for example, replicates parts by having identical units manufactured; they are then positioned to form one sculpture, one unit. Judd's images have a modular structure, and his range of similar sculptures relate more to sculptors' traditional use of editions than to true Serial forms."[12] If Bochner and Coplans parted company in their qualifications of what constituted true series, they shared the tactic of employing the language of rhetoric, logic, and mathematics in their attempts to define series. Words such as "syntax" and "structure" (Coplans) or "system" and "method" (Bochner) reflect a preoccupation with conceptual processes rather than working medium or end product as the definition of true seriality. The more art-historically minded Coplans even attempted a few concluding paragraphs that speculated upon the peculiar "Americanness" of the ascendancy of series in the most ambitious art:

There are sufficient indications in the emergence of Serial Imagery over the past decade in the United States that the rhythms attendant upon the Serial style ritually celebrate, if only obliquely or subliminally, overtones of American life. In various ways Serial Imagery reveals local color that identifies the ambience of its origin. Serial Imagery is particularly fitted to reflect its contemporary environment, because of the open and unplanned nature of its

internal dialogue, its highly systematic yet flexible process of production, its high degree of specialization, and its narrow, deep focus upon a single issue. Its redundancy is a positive act that continuously affirms the power and continuity of the creative process. Taken together, the approaches of the artists mentioned above in no small measure evoke the underlying control-systems central to an advanced, "free enterprise, technological society."[13]

The optimism of this reading is remarkable in itself. But what I want to attend to more specifically is Coplans's effort to interpret seriality as an apt reflection of the late 1960s and as a natural consequence of the "overtones of American life." Serial imagery somehow mirrored a "technological society" whose "rhythms attendant upon the Serial style ritually celebrate."

Likewise, David Lee's Bochner-like explanation of an exhibition in which he was included at Finch College Museum of Art, New York, in December 1967 made the same intuitive connection between a scientistic context (Lee, echoing Kubler, talks of the "electric era") and, as the show was titled, *Art in Series*. Lee, a painter, was featured alongside sculptors Judd, Andre, and Eva Hesse (1936–1970), as well as Warhol, Kelly, and Jasper Johns (b. 1930), among others. As Lee commented, the artists who practice series cut across the usual distinctions of medium and style, with the common denominator being that "the organization is essentially serial and the content involves repetition."[14]

Despite a shared compulsion to define series, no consensus as to the correct definition emerged. The Finch College show, following Bochner's assertions, deemed the multiples of Monet and Willem de Kooning (1904–1997) to be variations and not true series, while Coplans's show argued for a direct line of descent from Monet's *Wheatstacks* to Warhol's *Soup Cans*. But it seemed clear that the repetitiveness of series pointed to something fundamental at stake—something that

lay at the heart of the Americanness of American art.

In this discursive climate, is it merely coincidental that Michael Fried's essay "Manet's Sources" should have appeared in the March 1969 issue of *Artforum*, two years after the *American Sculpture of the Sixties* show and less than a year after *Serial Imagery*? Remarkably, this long text on a nineteenth-century French painter by the precocious young scholar and critic even appeared as a special issue of *Artforum*, an unlikely venue given the periodical's overt emphasis on contemporary art. On the face of it, Fried's stated objective (to correct the art-historical exaggeration of formalism alone as the constitutive element of Édouard Manet's (1832–1883) modernism through an exhaustive resurrection of the artist's use of the art of the past) would seem to have no relation to the topic at hand. And yet, there is something naggingly parallel in Fried's assessment of Manet's critics and their apparent blindness to the artist's overt citation of a whole host of canonical old masters and Fried's own stalwart rejection of the literalist sculpture with which series were so frequently tied in the 1960s. A brief quote captures the vehemence of his criticism of so-called minimalist or ABC art. Fried insisted on the inherent theatricality of the literalist sensibility in his analysis of the positions held by Tony Smith (1912–1980) and Robert Morris (b. 1931). As he summed it up, "the imperative that modernist painting defeat or suspend its objecthood is at bottom the imperative that it *defeat* or *suspend theatre*. And *this* means that there is a war going on between theatre and modernist painting, between the theatrical and the pictorial—a war that, despite the literalists' explicit rejection of modernist painting and sculpture, is not basically a matter of program and ideology but of experience, conviction, sensibility."[15]

Among his critics, only Théophile Thoré recognized how Manet provided a compelling response to the question of what constituted

the Frenchness of the French School. Similarly, only Fried sounded the alarm by arguing vehemently against literalist artists such as Judd. By endorsing his "Three American Painters"[16]—Jules Olitski (b. 1922), Noland, and Stella—whose approach to series he rooted firmly in the modernist dialectic that had dominated the greatest art of the previous two centuries, Fried clearly opted for the painterly trajectory of series explored by Coplans in his show three years later (with the notable exception of Warhol) and not the "one-after-the-other" route of the minimalists. As Fried explained with his usual conviction:

The most important of these questions can be formulated roughly as follows: Which painters, ancient and modern, are authentically French and which are not? More generally, in what does the essence or natural genius of French painting consist? Does in fact a body of painting exist in which that essence or genius is completely realized? Has painting in France ever been truly national, or has it always fallen short of that ideal, however the ideal itself is understood?

These questions are not wholly separable from one another. The judgment that certain painters but not others constitute the authentic French school implies a particular view of the nature of French painting, and probably of Frenchness as such, just as any characterization of the essence of French art implies a particular canon of painters and paintings. As a result contemporary discussions of these issues may strike the modern reader as at least somewhat circular or arbitrary. Moreover, the questions themselves are far from rigorously historical by modern standards. The fact remains, however, that almost every important French scholar of the French painting of the past addressed himself to them, not only at the time but for decades after: one might say that the discipline of art history arose in France largely in response to them.[17]

If one were to substitute "Americanness" for "Frenchness" in this paragraph, a resembling

critical crisis could be said to have emerged in the 1960s. In a sense, Americanness and "true" series constituted the recurrent, if only vaguely intuited pressure point in the art world of the 1960s, just as—at least according to Fried's account—Frenchness and the authentic French school constituted the leitmotiv for Manet and his critics in the 1860s. Repetition, whether with respect to form, subject matter, or even, ambitious claims about the ontological status of the art object itself, is the key to correct critical interpretation in this scenario. But the right recognition of such repetitiveness (such effective re-petitioning of the problematics of the most important art of the past with its implied canon projection extending into the late twentieth century) and its historical motivations continues to be debated.

Repetition as Resistance

Coplans's show and essay of the same name, "Serial Imagery," received modest critical attention in the local press. In a piece written for the 29 September 1968 issue of the *Los Angeles Times*, art critic William Wilson had this to say about the show:

Any adult will walk into the gallery severely conditioned to react negatively to repetition. He comes from a world that teaches him to value change, climax, aggression, victory, progress and goals, a world that teaches that repetition is the same as boredom. . . . Some people find a crisis existence very stimulating. Other people dig a contemplative, ruminative life. The first is represented by the kind of art that works up to "Masterpieces," the second by the present exhibition. If I have reason to praise "Serial Imagery," it is on account of its affirmation of the second, currently unfashionable mode of calm life. If I have reason to criticize "Serial Imagery" it is because Coplans's essay seems to take the position that there is something wrong with the "Masterpiece" mode.

Wilson then goes on to say somewhat peevishly, "It seems to me obvious that Noland

has the right to paint masterpieces if he chooses. The validity of the serial mode does not exclude the validity of its opposite. I don't know why the human mind is so drearily invidious."[18]

Whether or not he realized it, Wilson had put his finger on the heart of the matter. If there was something unsettling about Coplans's show, it must have been in part because of its visual undoing of the very idea of the singular masterpiece. Wilson mentioned some of the negative response to the show expressed by both those in the know and the lay public, who were "bored, angry or indignant" over *Serial Imagery*. Alfred Frankenstein, another critic, commented on feeling "uneasy" about this serial "trend," which was amply in evidence at the Venice Biennale that same year.[19]

It was in the following year, 1969, that Walter Benjamin's famous essay "The Work of Art in the Age of Mechanical Reproduction" appeared in translation in the selection of essays published under the title *Illuminations*.[20] Interestingly, Benjamin's discussion of art and its aura, with the presumption of its decay through the undermining effects of mechanical reproduction (the mechanical variety of repetition in its most pernicious form), seems to echo Frankenstein's anxiety. As Stephen Bann has amply demonstrated, Benjamin's oft-cited commentary on the demise of aura has little bearing on the history of static media such as painting. Bann's nuanced historical account of the highly generative interaction between painting and its reproductive relatives in nineteenth-century France, whether in the form of prints or of photographs, exposes the limitations of Benjamin's concept when it comes to painting (as opposed to film), which is in itself a frequent deformation of Benjamin's original text.[21] As twentieth-century art has clearly proven, reproductive technologies have not made much of a dent in the putative authority of the singular masterpiece. Bann has even argued for the greater empowerment of the

art object through its diffusion in reproductive form.[22] Indeed, it might be argued that the greater the art object's susceptibility to replication, the greater its currency. Certainly, the profit earned through the reproductive progeny of a given art object, whether in the form of limited-edition casts, prints, or photographs, has become a desideratum for many aspiring artists. Auguste Rodin's (1840–1917) factory-inspired approach was a precedent for the likes of Henry Moore (1898–1986), just as the Henry Moore Foundation has provided a precedent for the so-called studios of such artists as Louise Bourgeois (b. 1911). The currency relevant here is not Kubler's electrodynamic signal, but the equally intangible one of money. In this scenario, Benjamin's supposition is entirely turned on its head. The art object burnishes all its progeny with the gold dust of its aura, causing its own aura to burn all the more brightly.

This is not to suggest, however, that the market alone suffices as an explanation for the prevalence of repetition in modern art, nor for the evident ascendancy of the serial mode in the 1960s. Progressive art's simultaneous embrace of and recoil from the onslaught of commodification is a complicated tale indeed, and one that I will not attempt to summarize here.[23] As John Klein has suggested, painting in series cannot be entirely extricated from the conditions of gallery culture that nurtured it in the first place.[24] Even Monet cannot have been immune to the encouragement of his voracious art dealer, Paul Durand-Ruel, who surely recognized the genius of Monet's series from a purely marketing point of view. As Klein points out, painting in series quickly became the preferred mode of production for younger artists such as André Derain (1880–1954), who was encouraged to do so by his dealer, Ambroise Vollard. But if the "auratic status" of the "embodiment of personality in a series"[25] accounted for the demand for Monet's series paintings, as Klein suggests, it also, somewhat ironically,

provided the conceptual point of departure for its dismantling. Klein relates the juicy anecdote of the origin of Roy Lichtenstein's (1923–1997) riff on Monet's *Cathedrals*. It was in looking at the photographic reproductions of Monet's series while visiting John Coplans, who was in the middle of organizing the aforementioned exhibition, *Serial Imagery*, that Lichtenstein got the idea of producing his silk-screened series of "manufactured Monets." In so doing, Lichtenstein wielded repetition as resistance, critiquing the habits of consumption that ambitious art now had to keep at arm's length, even while mimicking its methods.

But repetition as resistance is also a phrase that takes us immediately in the direction of intimate individual experience, and not sweeping epochal generalizations, when it is allowed to regain its enduring resonance in the context of classical psychoanalysis. In this account, repetition is symptom but unconsciously so. It is not the savvy manipulations of the fully conscious artist as pragmatic self-promoter, but the recurrent eruption of neurosis—of repressed psychical material that can find no other outlet. The temptation to see art as neurosis has a long history. Suffice it to say that a reading of repetition in painting as obsessive compulsion all too easily takes on the flat-footed feel of a well-worn modernist cliché—one that does not adequately account for the ascendancy of repetition as a preferred artistic means of expression in the modern era.

What if one were to consider repetition not merely as a technique or conceptual process, but as a symbolic structure, akin to the way perspective, according to Erwin Panofsky, became the symbolic form of the Italian Renaissance? One would need to apply Panofsky's *circulus methodicus*, as he explained in a dense footnote of his canonical opus, *Studies in Iconology*, first published in 1939:

To control the interpretation of an individual work of art by a "history of style" which in turn can only be built up by interpreting individual works, may look like a vicious circle. It is, indeed, a circle, though not a vicious, but a methodical one. Whether we deal with historical or natural phenomena, the individual observation assumes the character of a "fact" only when it can be related to other, analogous observations in such a way that the whole series "makes sense." This "sense" is, therefore, fully capable of being applied as a control, to the interpretation of a new individual observation within the same range of phenomena. If, however, this new individual observation definitely refuses to be interpreted according to the "sense" of the series, and if an error proves to be impossible, the "sense" of the series will have to be re-formulated to include the new individual observation. This *circulus methodicus* applies, of course, not only to the relationship between the interpretation of *motifs* and the history of *style*, but also to the relationship between the interpretation of *images*, *stories* and *allegories* and the history of *types*, and to the relationship between the interpretation of *intrinsic meanings* and the history of *cultural symptoms* in general.[26]

If repetition is a cultural symptom of modernity, it follows that its emergence as the dominating feature of the art of our age ought to be retrospectively meaningful and not merely incidental. It is difficult not to suspect that the ascendancy of repetition is directly connected to philosophical nihilism in general as the normative worldview of a secularist Western hegemony; a godless worldview based on the impossibility of meaning unless defined relatively; the impossibility even, of repetition itself. As Gilles Deleuze commented in *Difference and Repetition*, which was also published in the late 1960s: "With respect to this power, repetition interiorizes and thereby reverses itself: as Péguy says, it is not Federation Day which commemorates or represents the fall of the Bastille, but the fall of the Bastille which celebrates and repeats in advance all the Federation Days; or Monet's first water lily which repeats all the others."[27]

20

It is not necessary to wander much farther into Deleuze's deliriously repetitive prose to glean a suspicion of its apposite relation to repetition, series, and what was at stake in contemporary art of the 1960s. It may be sufficient to simply rely on the helpful *explication de texte* supplied by Briankle Chang in an essay titled "Deleuze, Monet, and Being Repetitive":[28]

the claim that "Monet's first water lily . . . repeats all the others" also takes on a more precise meaning: it no longer suggests the eristic, counterintuitive proposition that an earlier act repeats later ones; far more radically, it states an architectural rule of timing: the so-called first impression, the first scene seen, the first stroke, in short the very constitution of firstness as such, is already a repeated occurrence. As the Lacanian-Deleuzian refrains suggest, an event always take place twice before it really happens, or, as I dare to rephrase it, an event must take place virtually before it occurs effectively. It is this twice-over of an event that consolidates the event's phenomenal integrity, and it is its virtual occurrence before the fact that restores to the event its truth as retroactive happening, the aftermath of a "somber precursor," that delivers what comes henceforth always in the form of déjà pas encore.[29]

Repetition in this sense is not a choice: in modernity, it has become a necessity for the activation of meaning and value. It provides the possibility of evaluation and thus, a means of validation, not in terms of distance from a prior original, but in terms of its very perception. Now we have returned to our starting point as my argument dovetails with that of Kubler. The shape of time can be seen through the repetition of the material artifact in both form and expression. In modernism, the art object's currency in terms of perceived hipness and monetary value is established by its susceptibility to repetition and its consequent repetitiveness.

This conclusion is nothing new in the realm of recent studies in twentieth-century art.

Briony Fer's 2004 account, for example, treats "the strategies of remaking art through repetition in the wake of the exhaustion of a modernist aesthetic."[30] While it is an open question as to how to demarcate the beginning and end of modernism proper, I contend that the cultural symptoms, in Panofsky's sense, of what I started out by describing as an aesthetics of repetition are already in full display by the middle of the nineteenth century.

It may seem odd that I should have expended my word allotment in this volume on the art history, art, and criticism of the 1960s, given the time frame of the art included in this exhibition. But the persistent recurrence of repetition as a leitmotiv in all three areas has needed decompounding, so that the historical foundation of my initial intuition—that is, repetition as symbolic form—might be uncovered. I have left the much more pleasurable task of actually treating the question of repetition and painting in the art of our artists to the essayists that follow. Their discussions, which range broadly from academic to avant-garde production, and from the long view of institutional practice to the close view of artistic process, exemplify the flexibility of interpretation and analysis enabled by the premise of repetition as symbolic form in the early modern era. I will allow myself only this brief, closing meditation on repetition and painting in the case of David and his students as a way of distinguishing its transitional status in the shift from a premodern aesthetic of the singular masterpiece to an aesthetics of repetition, which I have tasked the four copies of *The Death of Marat* to embody.

Apprenticeship always gives rise to images of death, on the edges of the space it creates and with the help of the heterogeneity it engenders.
—GILLES DELEUZE[31]

David's *Death of Marat* (fig. 3) or more precisely, *Marat at His Last Breath,* as translated

from the French title given by the artist to his masterpiece,[32] certainly qualifies as a prime object.[33] Its specter would inspire and compete with the most ambitious artists of the next several generations. Commissioned by the Convention as a potent form of visual propaganda, the painting purports to be a record of actuality, no matter how eloquently summarized by David's poetic license. The literature on this single painting[34] has continued to search out the many iconological and formal precedents embedded so suavely by the artist, and its fund of heretofore unrecognized precedents, disguised by its powerful realism, may still not be exhausted. At once a history painting, a portrait, a humble snapshot of the everyday, and literally a stilled life,[35] the painting is also an allegorical personification of virtuous self-sacrifice. Not surprisingly, David directed its replication through student copies, utilizing a process that differs little from portraiture replication in the service of monarchy or papacy. And yet, what does distinguish this otherwise typical case of a prime version and its replica mass is the conceit of the painting as testimony. In that David supposedly saw the deceased Marat, witnessed his cooling flesh as life departed, the painting's rhetoric contains within it a Judeo-Christian element of empirical verification. As conjured by David, Marat's body provides access to the transcendent message of Republican virtue through action, through self-sacrifice; it was in the witnessing of it that the viewer was/is induced to Republican fervor. In the stroke-by-stroke re-creation of *Marat at His Last Breath,* David's students, whether the gifted François Gérard (1770–1837) or the lesser talents, Gioacchino Giuseppe Serangeli (1768–1852) and Jérome Langlois (1779–1838), reenacted their master's very act of testimony (figs. 4–7). Thus, the painting's replication is itself imbued with the aura of its original creation—a quasi-religious merging of student, master, and martyr that is

achieved through the act of its painted re-creation. Repetition, even in the handmade capacity of the student copyist, reinscribes rather than diminishes the aura of the prime object, at least in the case of the two accomplished versions now preserved at Versailles (thought by some specialists to be largely by the hand of Gérard) and at the Musée du Louvre.

The brilliance of David's harnessing of the very structure of empathetic transmission through the portrait replica as testimonial is well captured by Laura Mulvey's perceptive analysis of the tension between movement and stillness in the early cinema. At the end of her essay, she notes of the Soviet filmmaker Dziga Vertov's 1929 film, *The Man with the Movie Camera:*

Among the many beautiful and interesting devices in this documentary record of filming everyday life in Moscow, one stands out in the context of this argument. The man with the movie camera is filming a white horse as it draws a carriage of new arrivals from the station to their hotel. The horse is moving briskly, at a canter. Suddenly, at a moment when the horse fills the frame and its movement is, in a sense, the subject of the image, the film comes to a halt. The horse seems to shift in time into the "there-and-then-ness" of the still photograph. This frozen image is more magical, it suddenly seems, than the illusion of movement itself. The spectators' look, one moment casually following the horse's movement, is, the next moment, arrested. The bustle of the city, its continuity and presence, falls away.[36]

David's recognition of the pretense of movement in any lifelike portrait, captured at the moment that its possibility is stolen by death, not unlike the "there-and-then-ness" of the still photograph, makes the same claim through the copyist/viewer's reenactment, repetition of vision as testimonial. In this sense, as Deleuze/Péguy commented of Monet's *Wheatstacks,* it is David's portrait that repeats all its replicas.

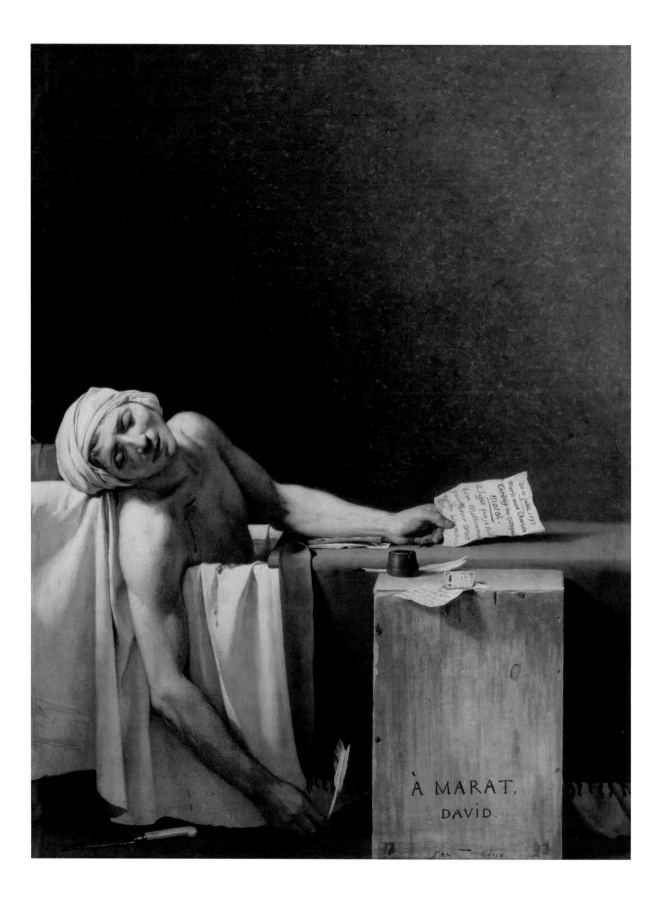

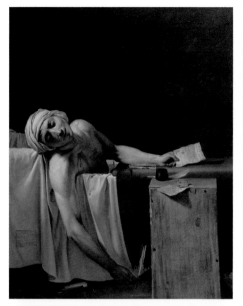

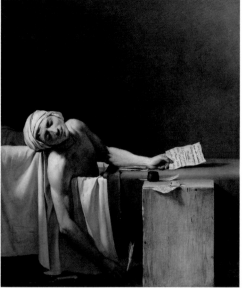

4, 5

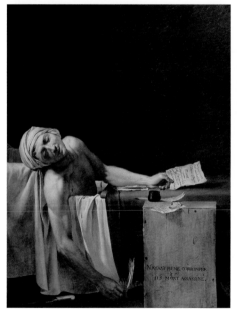

6, 7

Opposite:
Fig. 3. Jacques-Louis David, *The Death of Marat,* 1793. Oil on canvas, 165 × 128 cm. Brussels, Musée d'art ancien, Musées royaux des Beaux-Arts

Fig. 4. Studio of Jacques-Louis David, *The Death of Marat,* ca. 1793. Oil on canvas, 92 × 73 cm. Musée des Beaux-Arts de Dijon (2306)

Fig. 5. François Gérard or Jérome Langlois, after Jacques-Louis David, *The Death of Marat,* 1793–94. Oil on canvas, 157.5 × 136 cm. Musée national des châteaux de Versailles et de Trianon (MV 5608)

Fig. 6. Jacques-Louis David and Studio, *The Death of Marat,* ca. 1794. Oil on canvas. 111.3 × 85.6 cm. Musée des Beaux-Arts de la Ville de Reims; don Paul David, 1879 (879.8)

Fig. 7. Studio of Jacques-Louis David, *The Death of Marat,* 1793–94. Oil on canvas, 162.5 × 130 cm. Paris, Musée du Louvre; legs du Baron Jeanin, descendant de l'artiste, 1945 (RF 1945-2)

I would like to thank Michael Fried and Peter Parshall for their inspiration and encouragement during the evolution of this essay. I am grateful to Professor Fried for affording me the intellectual stimulation of teaching a graduate seminar on this topic at the Johns Hopkins University, during which these ideas were further honed through discussion with Gülru Çakmak, Jamie Magruder, Kate Markoski, and Joyce Tsai. I would also like to thank Stephen Bann, Claire Barry, Thomas Crow, Ann Hoenigswald, Michael Ann Holly, Simon Kelly, Mark Ledbury, Keith Moxey, Richard Shiff, and Charles Stuckey, who participated in a two-day colloquium on the themes of this project at the Sterling and Francine Clark Art Institute in the summer of 2005.

1. The example cited is the usual one of the "Baroque," which, according to Kubler, had been applied so broadly to all European art made between 1600 and 1800 that it had lost any real meaning. See George Kubler, *The Shape of Time: Remarks on the History of Things* (New Haven and London: Yale University Press, 1962), 126.

2. Kubler's cautioning against the overemphasis on textual meaning fostered by iconology, which in the 1960s had become the dominant brand of art history in the United States, is still instructive today. Kubler argued for an equivalence of form and expression, recommending a better balance between meaning-obsessed iconology and form-obsessed morphology. See ibid., 126–28.

3. Ibid., 76.

4. Ibid., 42.

5. I would like to acknowledge Thomas Crow as the source of this useful metaphor, which he provided in his typically clearheaded discussion of repetition and painting in our two-day colloquium, sponsored by the Sterling and Francine Clark Art Institute during the summer of 2005. I must also thank Dr. Crow for pointing me in the direction of Kubler's *Shape of Time,* which has proven to be an extremely useful point of departure for an otherwise unwieldy theme.

6. See the discussion of Ingres's three versions of the *Oedipus* in Stephen Bann's essay in this volume, pp. 46–47.

7. I mention here just a few of the many publications that have covered related topics: Paul Duro, "The Copy in French Nineteenth Century Painting," Ph.D. diss., University of Essex, 1983; Richard Shiff, "Representation, Copying, and the Technique of Originality," *New Literary History* 15 (Winter 1984), 331–63; idem, "Copyists in the Louvre in the Middle Decades of the Nineteenth Century," *Gazette des Beaux-Arts* (1988), 249–52; *Retaining the Original: Multiple Originals, Copies, and Reproductions,* Studies in the History of Art 20/CASVA Symposium Papers 7 (Washington: National Gallery of Art, 1989); *Copier créer: De Turner à Picasso. 300 oeuvres inspirées par les maîtres du Louvre,* exh. cat., Paris, Musée du Louvre (Paris: Réunion des musées nationaux, 1993); Cornelia Homburg, *The Copy Turns Original: Vincent Van Gogh and a New Approach to Traditional Art Practice* (Amsterdam and Philadelphia: Benjamins, 1996); Patricia Mainardi, "The Nineteenth-Century Art Trade: Copies, Variations, Replicas," *Van Gogh Museum Journal* 2000, 62–73; Richard Spear, "Di Sua Mano," in Elaine K. Gazda, ed., *The Ancient Art of Emulation: Studies in Artistic Originality and Tradition from the Present to Classical Antiquity* (Ann Arbor: University of Michigan Press, 2002), 79–98.

8. For an absorbing exploration of this term as manifested in the vexed if highly generative relationship between master and pupils, see Thomas E. Crow, *Emulation: Making Artists for Revolutionary France* (New Haven and London: Yale University Press, 1995).

9. The classic texts on this topic are Rosalind E. Krauss, *The Originality of the Avant-Garde and Other Modernist Myths* (Cambridge, Mass.: MIT Press, 1985); and Richard Shiff, *Cézanne and the End of Impressionism* (Chicago: University of Chicago Press, 1984). Both authors have published further meditations on this topic, including Rosalind E. Krauss, "The Originality of the Avant-Garde: A Post-Modernist Repetition," *October* 18 (Autumn 1981), 47–66; and Richard Shiff, "The Original, the Imitation, the Copy, and the Spontaneous Classic: Theory and Painting in Nineteenth-Century France," *Yale French Studies* 66 (1984), 27–54. More recently, Marc Gotlieb has written compellingly on the artistic anxiety over originality as lived by Ernest Meissonier (1815–1891), in his insightful treatment of nineteenth-century academic painting in France, *The Plight of Emulation: Ernest Meissonier and French Salon Painting* (Princeton: Princeton University Press, 1996).

10. See Stephen Bann, *Parallel Lines: Printmakers, Painters and Photographers in Nineteenth-Century France* (New Haven and London: Yale University Press, 2001), 18–30.

11. "Edward [sic] Muybridge, Jasper Johns, Larry Poons, Sol LeWitt, Don Judd, Jo Baer, Robert Smithson, Hanne Darbroven [sic], Dorothea Rockburne, Ed Ruscha, Eva Hesse, Paul Mogensen, Dan Graham, Alfred Jensen, William Kolakoski, and myself have used serial methodology." Bochner, in Gregory Battcock, *Minimal Art: A Critical Anthology* (New York: E. P. Dutton, 1968), 100.

12. John Coplans, *Serial Imagery,* exh. cat., Pasadena Art Museum (1968), 9.

13. Ibid., 18.

14. David Lee, "Serial Rights," *ARTnews* 66, no. 8 (December 1967), 42–45, 68.

15. Michael Fried, *Art and Objecthood: Essays and Reviews* (Chicago: University of Chicago Press, 1998), 135, first published as "Art and Objecthood," *Artforum*, January 1967, 12–23.

16. This was the title of the show organized by Fried and exhibited at the Fogg Art Museum at Harvard University from 21 April through 30 May 1965. The catalogue includes an essay by Fried of the same title.

17. Michael Fried, "Manet's Sources, 1859–1869," in *Manet's Modernism, or, The Face of Painting in the 1860s* (Chicago: University of Chicago Press, 1996), 75, first published as "Manet's Sources," *Artforum*, March 1969, 29–82.

18. William Wilson, "Repetition without Boredom in Pasadena," *Los Angeles Times*, 29 September 1968.

19. Alfred Frankenstein, "Variations on a Thing," *San Francisco Examiner-Chronicle*, 6 October 1968.

20. I am grateful to Peter Parshall, curator and head of the department of old master prints at the National Gallery of Art, Washington, for reminding me of this fact.

21. The popular oversimplification of Benjamin's essay as a lament of art's loss of aura in the "age of mechanical reproduction" is noted by Stephen Bann in *Parallel Lines*, 16.

22. Of the many narratives that Bann follows in *Parallel Lines*, his analysis of the long genesis of Luigi Calamatta's (1801–1869) mythical reproductive engraving of Leonardo's *Mona Lisa* is most compelling in this regard. As Bann comments regarding the admiration given to Calamatta's drawing after Leonardo's masterpiece, "Here is the copy drawing as a middle term, neither the painting itself nor yet (and not for many years) the model for the completed reproduction. For the visitors to the studio, 'aura' was thus temporarily invested in an object that epitomized one of the specific stages of the reproductive process, rather than its input or its outcome." Ibid., 17.

23. Useful discussions of this topic include but are not limited to Nicholas Green, "Dealing in Temperaments: Economic Transformation of the Artistic Field in France during the Second Half of the Nineteenth Century," *Art History* 10 (March 1987), 59–78; idem, "Circuits of Production, Circuits of Consumption: The Case of Mid-Nineteenth-Century French Art Dealing," *Art Journal* 48 (Spring 1989), 29–34; and Martha Ward, *Pissarro, Neo-Impressionism, and the Spaces of the Avant-Garde* (Chicago: University of Chicago Press, 1996).

24. See John Klein's provocative essay "The Dispersal of the Modernist Series," *Oxford Art Journal* 21, no. 1 (1998), 123–35.

25. Ibid., 130.

26. Erwin Panofsky, *Studies in Iconology: Humanistic Themes in the Art of the Renaissance* (New York: Oxford University Press, 1939), 11 n.3.

27. Gilles Deleuze, *Difference and Repetition* (1968), trans. Paul Patton (New York: Columbia University Press, 1994), 1, citing Charles Péguy, *Clio*, 3d ed. (Paris: NRF, 1917), 45, 114.

28. Briankle G. Chang, "Deleuze, Monet, and Being Repetitive," *Cultural Critique*, no. 41 (Winter 1999), 184–217.

29. Ibid., 209.

30. Briony Fer, *The Infinite Line: Re-Making Art after Modernism* (New Haven and London: Yale University Press, 2004), 2.

31. Deleuze, *Difference and Repetition*, 23.

32. The title in French given to the painting by David is *Marat à son dernier soupir*. See Daniel Wildenstein and Guy Wildenstein, *Documents complémentaires au catalogue de l'oeuvre de Louis David* (Paris: Fondation Wildenstein, 1973), no. 601.

33. T. J. Clark makes this very point in the opening paragraphs of his essay on the painting, "Painting in the Year Two," *Representations*, no. 47 (Summer 1994), 13–63.

34. I will not replicate the exhaustive bibliography on this painting, which has received the attention of many art historians, conservators, and cultural historians. For a partial overview of the literature on the painting, see Antoine Schnapper and Arlette Sérullaz, eds., *Jacques-Louis David, 1724–1825*, exh. cat., Paris, Musée du Louvre, and Versailles, Musée national du Château (Paris: Réunion des musées nationaux, 1989), 282–85 (no. 188). For an array of more recent essays devoted to this single painting, see *Masterpieces of Western Painting: David's "The Death of Marat,"* ed. William Vaughan and Helen Weston (London: Cambridge University Press, 2000). See also Crow, *Emulation*, 162–69.

35. I have commented elsewhere on David's canny assimilation of the conventions of still life in this martyr portrait, especially those in which dead game are positioned with their heads dangling at a like angle against a stone ledge, as though their bodies are still pliable with life, and so at their "last breath." See E. Kahng, "The Sublimity of the Critic: Pictorial Realism and the Hierarchy of Genres in Eighteenth-Century French Painting," Ph.D. diss., University of California, Berkeley, 1996.

36. Laura Mulvey, "Death 24 Times a Second; The Tension between Movement and Stillness in the Cinema," *Coil*, no. 9/10 (2000).

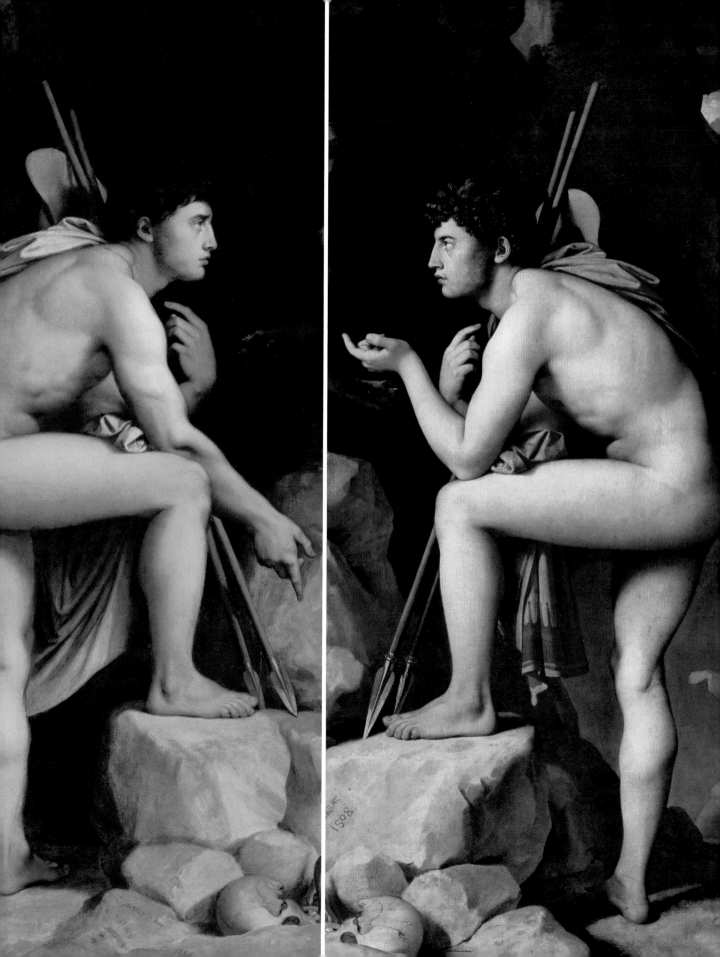

Reassessing Repetition in Nineteenth-Century
Academic Painting: Delaroche, Gérôme, Ingres

Stephen Bann

During the course of the nineteenth century, the conditions for pro-ducing and disseminating visual works of art in the West changed profoundly. This change was not simply a matter of marketing, although the rise of a new type of art dealer with broad international reach was a major factor in stimulating the new developments. New techniques of reproduction, which diffused the fame of living artists, grew at a truly exponential rate, as did the use of existing techniques such as burin engraving and lithography. There was also a boom in new institutions that featured contemporary art as well as the great works of the past. The collection of William T. Walters, composed initially of works acquired in Paris from the most prestigious French artists and dealers of the day, but destined for the transatlantic city of Baltimore, is emblematic of this turn of events. Paul Delaroche (1797–1856) and his pupil Jean-Léon Gérôme (1824–1904) were undoubt-edly prime movers in galvanizing this novel artistic economy and fully recognized as such at the time.[1] Jean-Auguste-Dominique Ingres (1780–1867), whose stock has risen while that of the other two has fallen in relative terms, presents a different scenario. Nonetheless, his defiantly individual practice throws the general picture into relief.

This momentous transformation has, however, received little close attention until recently. The extensive circulation of images in repro-duction that reached hitherto untouched sectors of the population during the nineteenth century underpinned the creation of new collections and the new public institutions that housed them. Yet in the course of the following century such institutions began to operate a kind of unofficial censorship over the so-called academic art of the period. This led also to the obfuscation of the issue of the "repeating image" in academic painting, and consequently to the neglect of the medium of the reproductive print that had been so crucial in spread-ing visual awareness. The concept of "repetition" in academic art has indeed been a red flag to a bull, since it challenges the stable value

28

inherent in the "original" work. Still quite exceptional is a display like that presented at the J. Paul Getty Museum in spring 2006, with three "repeating" works by William-Adolphe Bouguereau (1825–1905), shown side by side and clearly differentiated. *The Virgin of the Angels,* a major painting from the 1881 Paris Salon, later offered for sale in New York, was flanked on the left by a small oil sketch for the composition, and on the right by a small-scale repetition, or "reduction," of the work painted in 1884–85. The latter had been authenticated by Bouguereau's note to the dealer Adolphe Goupil: "the reduction of the Virgin of the Angels was done entirely by my hand."

Here Bouguereau was following a protocol used by academic artists from the beginning of the century. The relative price of such a "reduction" could be carefully calibrated. Still displayed beneath Jacques-Louis David's (1748–1825) portrait of Zénaïde and Charlotte Bonaparte in the Museo Napoleonico, Rome, is the artist's written receipt from 1821 acknowledging that he was paid 4,000 francs for the original (now in the J. Paul Getty Museum) and 2,000 francs for each of two *répétitions* by his own hand, one of which is the Rome version.[2] Moreover David's clear itemization of these three "autograph" versions shows his awareness of a practice of repetition consecrated in Western art from the Baroque period onward—that is, from the stage when issues of authorship became inseparably associated with estimates of artistic value. However, by the early nineteenth century, there appears to have been a need to clarify such questions for the benefit of a wider but less well-informed public. The year after David wrote this receipt, a study was published in Florence indicating how "to distinguish original pictures from copies." The basic point was to understand the tripartite distinction between the "*original . . .* a picture that a painter makes from his own invention or after nature," and two different varieties of repetition: the "*replica* if done by

the same painter" and the "*copy* if painted by another."[3] Such a publication might be regarded as a preliminary course in the practice of "connoisseurship" as it developed over the century. Its concluding table of artistic monograms was a valuable aid to the collector who aspired to identify signs of individual authorship. But here it was largely a matter of identifying paintings by the Italian old masters. Over the next half-century, the task would extend to contemporary work, and such identification would become intensely problematic, not least because of the widespread replication practiced by the painters who were marketed internationally by the Maison Goupil.

The problem was as much geographical as ideological. Even today, curators and collectors occasionally compete to establish that where two versions of the same work exist in different locations, their version is the "original." So did their equivalents in the mid-nineteenth century, seeking reassurance where the situation was unclear; this indeed was often the case. The fact that "repetitions" were not necessarily recognized as such—especially when the work had traveled some distance from its origin—was also a difficulty for the art press. A London columnist for the *Athenaeum* complained in 1854 about an exhibition of paintings by Ary Scheffer (1795–1858), "The pictures now in Pall Mall, exhibited as the original works, are copies made by the artist himself of reduced size, and sold by him as copies." This clarification, however, prompted the suspicion of "whether there has been an unfair reservation of this fact."[4] The writer was reluctant to believe that the illustrious British patrons who had purchased the works had been hoodwinked. He conceded the interesting point that Scheffer was prone to claim his autograph copies as being superior to their originals. But he suspected—no doubt rightly—that the general public would be unable to grasp such fine distinctions. There was also the nagging question of repetitions not "entirely by [the

artist's hand]," but by studio assistants, or even copyists with no direct connection to the master. What status had they?

The *Athenaeum* had already raised this problem in 1850 with regard to a painting by Delaroche included in the annual exhibition of the Royal Academy. Delaroche was then at the height of his international fame, having recently been elected to honorary membership of the Academy, and was supposed to be showing one of his most famous works, *Cromwell and Charles I* (1831). But the *Athenaeum* critic commented acidly that the painting in question, "said to be by Paul Delaroche, was but a repetition, some say a copy executed for him by a pupil from his original picture at Nice which has been so long familiar to the public by the means of engraving."[5] On this matter, the writer was accurately informed, and the young Dante Gabriel Rossetti took note when writing in 1851 of a second showing of "the Nicean duplicate."[6] Yet Rossetti's comments show that such a revelation by no means entailed a unilateral downgrading of the work in question. He wrote of the "duplicate": "Admirable it is in every respect, always taken for granted the artist's view of the subject and personage." Similarly, a London correspondent for the *Bulletin of the American Art-Union,* writing on 19 June 1850 and so surely aware of the *Athenaeum*'s revelation, had remarked in his searching review of the Royal Academy exhibition: "I confess that, on first seeing the picture, I thought it the finest work of the exhibition; and, as regards its technical pictorial qualities, I still think so."[7]

We might well be baffled by the sentiment expressed in this last judgment. How can a work be considered supreme for its "technical pictorial qualities" if the very issue of its authorship is open to doubt? But the anomaly arises perhaps from our own, rather schematic, notion of "originality." To put the other argument, the various judgments quoted here are not inconsistent. It is simply that they reflect a way of thinking about repeating

images that is now foreign to us—one in which the multiple practices of repetition are taken for granted. In this respect, the fact that a print after *Cromwell* is mentioned by the *Athenaeum* columnist is significant. He notes that the "original picture [by Delaroche] has been so long familiar to the public by the means of engraving." The implication is that "familiarity" does not depend exclusively on the viewing of the original painting but also emerges through acquaintanceship with Louis-Pierre Henriquel-Dupont's (1797–1892) widely diffused engraving. Of course it cannot be denied that the painting has features that cannot be revealed by the black-and-white engraving—yet it still counts as a "translation," thus conveying the essential features of the painting and offering a legitimate basis for criticism.

This view of the copy as integral, rather than accessory, to the original applies *a fortiori*, to the painted repetition. Rossetti judges "the Nicean duplicate" to be "admirable . . . in every respect"—except that of the artist's psychological characterization of *Cromwell,* where he would profit from reading the historical writings of Thomas Carlyle. The London correspondent for the *Art-Union* corroborates that this is the level on which the work deserves criticism, querying whether Delaroche has adequately portrayed Cromwell's "fertile imagination."[8] But in neither case is there any question of pointing to a deficiency in the repetition as such, as far as the artist's conception is concerned.

These points might be interpreted as yet another manifestation of the literary tendency of English-speaking critics. "Every picture tells a story" is a slogan traditionally associated with Victorian taste, and the fact that Delaroche rather than Delacroix was the French painter whom the English lionized throughout the mid-century indeed attests to their predilection for literary and psychological over purely plastic values. But the issue cannot be dismissed so easily. This essay emphasizes the Anglo-American reception

of Delaroche and Gérôme, since they provide the first and most dramatic examples of the new, worldwide currency of French art, fueled by the diffusion of high-quality reproductive engravings. But it relates this development to the phenomenon of the repeating image in the European context, looking at the singular case of Delaroche's *Hémicycle* reduction and finally at Ingres's three versions of *Oedipus and the Sphinx,* which span more than half a century of that artist's existence. The overwhelming prestige of Impressionism as a harbinger of Modernism has masked for too long the historical role of such paintings—dismissed as "academic" in the trivial sense—and so obscured their progressive role in the global extension of Western art and its institutions.

An illuminating case to launch the argument is the history of the "reduction" of *Cromwell* used in the preparation of Henriquel-Dupont's previously mentioned print. A necessary stage in the process of creating a reproductive engraving was the provision of a reduced replica close in size to the intended print. It was the artist's responsibility to ensure the quality of the copy, though the painting could be delegated to an approved substitute. In the case of the *Cromwell* reduction (fig. 1), the quality strongly suggests Delaroche's own hand, and as the ensuing aquatint print was shown at the 1833 Salon, it may be inferred that he painted it in 1831/32. We cannot say when it left Delaroche's possession, but by 1846 it was a valued item in the collection of the Hamburg merchant Friedrich Stammann, who gifted it to the city's nascent picture collection in that year.[9] Stammann had joined with a number of like-minded citizens to create the first *Kunstverein* (art union) in Hamburg, which led in due course to the building of the original part of the present Kunsthalle. When the *Deutsches Kunstblatt* reviewed the first public exhibition of the civic collection in March 1850, it did not stint in its praise for the Delaroche reduction, mentioning with

pride its connection to the "print well known to art lovers," and also stressing its prominence among the works on show: "Our picture is of the most exquisite finish, its deeply saturated tone giving so strong an effect that, forming the central focus of a wall, it dominates the larger pictures hanging around it."[10] In sum, neither its origin as a preparation for the print nor its reduced size dampened the excitement of the German critic. Indeed, both features were elevated into positive virtues, with special stress being laid on the painting's plastic quality. Hamburg sustained its admiration for Delaroche, allowing him the privilege of a life-size statue on the façade of the new Kunsthalle, while his French colleagues Horace Vernet (1789–1863) and Ingres were awarded medallions.

It is possible that the sale of Delaroche's *Cromwell* reduction took place through the

Fig. 1. Paul Delaroche, *Cromwell and Charles I,* ca. 1832. Oil on canvas, 38 × 45.8 cm. Hamburger Kunsthalle

intermediacy of the Maison Goupil. However, the detailed account books, which will be used here for the history of the *Hémicycle* reduction, begin only in 1846, and the records from this early period are unhelpful in this case, being confined to entries for works at unspecified dates and indications that they were sold in subsequent decades. What can be safely stated is the initial role played by such reductions in transforming Goupil from being solely a print editor into an editor and picture dealer with an international network of galleries. Where Goupil had financed the production of a print, the reduction habitually reverted to the gallery's possession, and so a stream of saleable works entered the gallery stock.[11] This process of diversification and expansion was much accelerated by the political situation of France in the late 1840s. The prolonged crisis of government following the revolution of 1848 gave a strong impulse to Goupil's search for new markets. By this stage, Delaroche was already established as one of Goupil's most popular house artists with regard to the sale of reproductive prints. It was only to be expected that he would carry the torch in their most ambitious venture to date, which was the opening of their New York gallery under the name of Knoedler. As early as 1850, Delaroche's *Bonaparte Crossing the Alps* was hanging in the drawing room of Mr. Woodbury Langdon, no doubt the scion of a well-known New Hampshire family then resident in New York City.[12]

This sale of a major painting to a transatlantic client surely marked a decisive step in the extra-European reach of the Maison Goupil and indeed in the American reception of contemporary European art. Previously, the cultivated American patrons of the arts had focused their energies on accumulating remarkable collections of reproductive prints, in the belief that the "best pictures" of the old world would never traverse the ocean.[13] Yet Langdon's purchase was ill-fated, since the picture was almost immediately sold back, passing to another of Goupil's clients,

the Liverpool banker James Naylor. The reason for Langdon's disenchantment is instructive, since it illustrates the misconceptions aroused by the protocols of replication, which involved a vexatious dispute in this case. The *Bulletin of the American Art-Union* explored both sides of the argument in December 1850, as a footnote to a report from Paris that celebrated Delaroche's recent sale of another version of the *Bonaparte*. Evidently the New York purchaser was scandalized to discover that this new version had been sold in London for £1,200 and that a reproductive engraving was in the process of being made! Responding to a locally published defense of Langdon's rights as "first purchaser," the editors of the *Art-Union* entered a firm statement of their own opinion on the matter: "We understand the rule to be that artists have the right of duplicating their pictures unless the contrary is expressly stipulated."[14]

This might well be the example of the repeating image in French painting that has led to the most disputation from 1850 until the recent past. Both versions now reside in major European collections, the Langdon version in the Musée du Louvre (fig. 2), and the version purchased in London in 1850 by the Earl of Onslow (fig. 3) in the National Galleries of Merseyside. Indeed, in the course of their respective histories, the wires became crossed, and the Langdon/Naylor painting was understood to have ended up in Liverpool, until Elisabeth Foucart-Walter established the contrary in a definitive article.[15] It would be difficult to summarize her examination of the relationship between the two works, which also originated two contemporary reproductive engravings. If the article were to be revised today, additional factors might still be taken into account, such as Delaroche's reduction of 1853 in the Royal Collection, which is illustrated in a recent article of my own.[16] But the context of the present essay prompts a different question, which was largely avoided in

32 the previous debate, from Langdon's disillusionment onward. Are these two large paintings genuinely "duplicates"? Or, to put it differently, how should we interpret the slight, but significant, variations between the two versions?

Here indeed a practical issue has displaced the more fundamental question. Rarely are there any circumstances in which such works may be directly compared. They invariably end up in different collections, and even a major retrospective of the painter in question is unlikely to waste space on two works that are taken to be nearly identical. Responding to apparently minor differences between the two *Bonaparte*s—different nuances in the treatment of the Alpine landscape, a tricolor cockade making an appearance—it would be easy to credit them to a strategy of "variation." The artist has slipped in a few minor touches, either from sheer boredom at the process of repetition, or (more cynically) to offer the new client something, however slight, to customize his acquisition.

This interpretation may be justified in the case of some artists—though I shall suggest later that it is almost the antithesis of the logic followed in the working procedures of Ingres. Nor indeed does it really apply to Delaroche. We can pass over examples like the reduction of *Cromwell* made to assist the reproductive engraver, since in this case exact replication was clearly required. In several other cases, such as his *Napoleon at Fontainebleau,* Delaroche initiated both large-scale repetitions and small-scale reductions. But in none of these would it appear that any minor additions or adjustments were made. Delaroche did admittedly paint for the accommodating James Naylor what was entered in Goupil's accounts as a "second painting" (*2ème tableau*). This picked up on one of his earlier successes at the 1831 Salon, *Les enfants d'Édouard (Princes in the Tower).* Probably Naylor had requested a repetition of that well-known work but was willing to accept what amounts to a total revision of the scene. No

one could possibly claim that the *Bonaparte Crossing the Alps* that Onslow bought in 1850 involved compositional changes of this magnitude. This makes it all the more revelatory that one contemporary French critic understood the Onslow work to embody an entirely different psychological content. Quoted on the page of the *Bulletin of the American Art-Union* that also mentioned Langdon's dispute is this extraordinary interpretation of the difference:

The new [painting] is a modified reproduction of [the previous one] in many details, but different as regards the principal conception. In both the First Consul is represented as mounted upon a mule, the direction of which he abandons entirely to a guide. He appears insensible to the desolation which surrounds him in the midst of those Alpine solitudes of snows and rocks through which his soldiers toil painfully onwards. His thought is elsewhere—it dwells in the future and in the dreams of his ambition. It is differently translated in the two pictures. In the first, his features have a serene gravity indicating the strong pre-occupation of the thoughts turned back on themselves. In the last, on the contrary, the head has a younger air

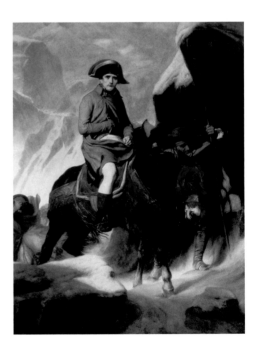

Fig. 2. Paul Delaroche, *Bonaparte Crossing the Alps*, 1848. Oil on canvas, 289 × 222 cm. Paris, Musée du Louvre (RF 1982-75)

and under the fixedness of the gaze which sounds the possibilities of the future, a sort of restrained joy at the dazzling light as it were of his glorious destiny appears through the immoveableness of his silent and meditative features. This secret strife of self-betraying thoughts, this complex expression is one of the most difficult things which painting can attempt and M. Delaroche should be applauded for not having feared to cope with it in his compositions.[17]

What makes this interpretation so surprising is the fact that there appears to be hardly any difference in the rendering of Bonaparte's features in the two pictures, though the second suggests a livelier cast to the eyes. The present opportunity to compare them is admittedly based on the evidence of color reproductions. Yet the French critic who saw the Onslow work in Delaroche's studio would never have seen the two completed pictures together, though he might have had access to its predecessor before it left for America. There is a possibility that he is simply stating Delaroche's intentions with regard to the two works. But this seems unlikely, in view of the phenomenological precision of the description. It is not just a question of scrutinizing Bonaparte's features to understand his frame of mind. The rosier tinge of the Alpine peaks and the brightening of the soldier's cockade are integral to the message of "glorious destiny" in the second painting.

This could well be the only composition by Delaroche for which there is a drawing relating directly to the process of repetition. The exact drawing of *The Guide* (fig. 4) must have been used in the process of duplication. It carries penciled cross marks on the left-hand side that would have aligned it with other sheets reproducing the composition. Yet the fact that landscape and background elements vary considerably in the two paintings suggests that only the central figures would have been recorded in this scrupulous way. Delaroche was known to have taken special pains in working up the figure of

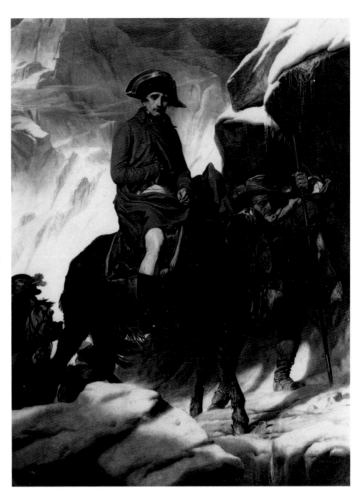

Fig. 3. Paul Delaroche, *Bonaparte Crossing the Alps,* 1850. Oil on canvas, 279 × 214 cm. Walker Art Gallery, National Museums Liverpool (acc. 2990)

Fig. 4. Paul Delaroche, *Bonaparte Crossing the Alps: The Guide,* ca. 1848. Black chalk with white heightening on paper, 42.8 × 58 cm. Williamstown, Mass., Sterling and Francine Clark Art Institute (1990.10)

Fig. 5. "Hémicycle de la salle des distributions de l'École des Beaux-Arts." Wood engraving after a drawing by Auguste Marc published in *L'Illustration*, 1841, 248–49. Paris, Bibliothèque nationale de France, Département des Estampes et de la photographie

the Alpine guide through life drawings, and this ensured that his final effort could be duplicated.[18]

Admittedly, there is a possibility that this unsigned drawing might not be by Delaroche's hand. Over the same period, his former pupil Charles-François Jalabert (1819–1901) was in the Nice studio assisting with the creation of "the Nicean duplicate" of *Cromwell*. It is conceivable that he also assisted with the two versions of *Bonaparte*. The workings of the studio system make it unlikely that this, as well as other such questions pertaining to Delaroche and his academic contemporaries, could be definitively resolved. Nevertheless, through a rare combination of circumstances, it has proved possible to resolve a similar issue in respect of another of Delaroche's major works. Since his signed reduction of the *Hémicycle des Beaux-Arts* (fig. 8) was one of the most expensive and prestigious works to enter the original Walters collection, it is particularly appropriate to discuss the history of this painting at some length. The fact that this history involves so many of the issues relating to repeating images in the

mid-century makes such a discussion specially pertinent to the present exhibition.

About the preeminence of the *Hémicycle* in the Walters collection after its acquisition in 1871 there can be no doubt. Writing in his authoritative study, *The Art Treasures of America,* around 1880, the critic Edward Strahan (himself a former student of Gérôme) asserted: "Among the many paintings of extreme importance decorating the walls of the [Walters] gallery, the palm must be yielded to the 'Hemicycle', by Paul Delaroche. I have seen nothing in America which seems so perfectly to bridge the civilization of the two continents, and place the connoisseurship of the new world in connection with that of the old."[19] Strahan's lengthy sequel to this promising opening begins by commenting on the unusual derivation of the work. Delaroche's "original picture" takes its title from the fact that it is a large wall painting, completed in 1841, and "bent around the semicircular or theatre-shaped lecture-room of the Beaux-Arts School, in Paris [figs. 5 and 7]. . . . The Baltimore picture [fig. 8] is the smaller replica, prepared by Delaroche for the use of the engraver—

Henriquel Dupont—who spent on his large plate about one hundred months." So far, so good. Strahan has appreciated that the Walters reduction was originally destined (like Hamburg's *Cromwell*) to aid the printmaker. Reducing the vast painting in scale, and projecting the semicircular plane onto a flat surface, was the first stage in the preparation of the great engraving project—actually involving three plates, not one—that Henriquel-Dupont brought to fruition in 1853 (fig. 9).

Perhaps Strahan provided his detailed explanation in view of the fact that the Walters *Hémicycle* was already being misidentified. In a handbook of nineteenth-century artists published in Boston in 1884, it was erroneously described as "his finished study, from which he and his scholars painted the 'Hemicycle.'"[20] Strahan well understood that the Walters work came after and not before the wall painting. But even he was puzzled by the evidence of his eyes, when set against the history of its production. He confessed: "I have never happened to see one of Delaroche's small-scale pictures so loosely brushed as the present specimen."[21] This led to mention that the work was attributed "in part to the pupils of Delaroche" in spite of being signed and dated by the master. He resolved the apparent discrepancy in the light of information gleaned from a popular biography of Delaroche by the journalist Eugène de Mirecourt, according to which "the pupils of Delaroche made a copy,

The problem posed by the reduced version of Paul Delaroche's *Hémicycle des Beaux-Arts* in the Walters collection can be simply stated. How far can we trust the contemporary testimony that Delaroche substantially repainted a copy that had originally been prepared by a student to aid the printmaker Henriquel-Dupont in his large three-part engraving? The new findings of the Walters conservation department suggest strongly that this was in fact the case. Delaroche's repainting turns out to have involved several distinct but complementary operations, which are illustrated here with the aid of ultraviolet photography and raking light details. Looking first of all at the central figures, it is possible to pick up the darker areas on the torsos of Apelles and Phidias, where much overpainting has taken place (figs. 6a and 6b). It is apparent that Delaroche overpainted with quite a free hand, also covering the background to a large extent, though a few passages without overpainting still betray the more careful approach of the student. This conclusion relates in a significant way to the comment made around 1880 about the Walters painting by the American critic Edward Strahan. He attested that he had never seen "one of Delaroche's small-scale pictures so loosely brushed."

Perhaps the insistence of Eugène de Mirecourt that Delaroche repainted the copy in the presence of the original at the École des Beaux-Arts provides a clue as to what he was intending to achieve by paying it so much attention. The student copy was commissioned to facilitate what would be an essentially graphic treatment by the engraver, and so foregrounded line rather than the chiaroscuro effects (the light and dark scale) of the original. Delaroche has succeeded in reinforcing the shadows in many areas through his overpainting. As can be observed in striking features like the head of Raphael (fig. 6c), he has also surrounded some of the artists' profiles with a "halo effect," to make them stand out all the more. Evidently he wished the new version not to remain a mere record of the transition from the painting to the engraving, but to be a vivid re-creation, on a small scale, of his original work.

Figs. 6a–c. Ultraviolet-light photographs, 2005, of the Walters *Hémicycle des Beaux-Arts* (37.3)

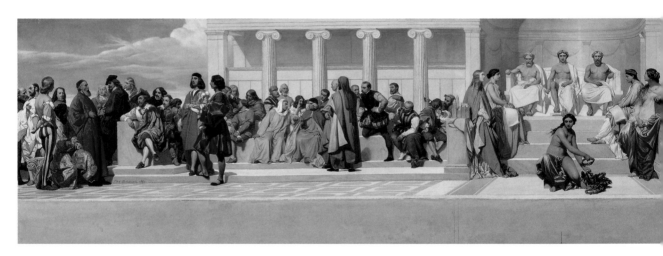

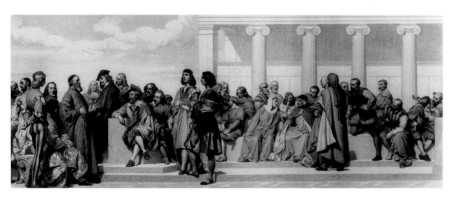

Fig. 7. Planar projection photograph of Paul Delaroche, *Hémicycle des Beaux-Arts,* 1841. Oil and wax on wall, 390 × 2470 cm. Paris, École nationale supérieure des Beaux-Arts

Fig. 8. Paul Delaroche, with Charles Béranger, *Hémicycle des Beaux-Arts,* ca. 1841; repainted and signed 1853. Oil on canvas, 41.6 × 257.3 cm. Baltimore, The Walters Art Museum. Bequest of Henry Walters, 1931 (37.83)

Fig. 9. Louis-Pierre Henriquel-Dupont after Paul Delaroche, *Hémicycle des Beaux-Arts,* 1853. Steel engraving in three parts. Left panel: 53 × 112.5 cm; center panel: 53 × 65.5 cm; right panel: 53 × 112.5 cm. Baltimore, The Walters Art Museum. Gift of C. Morgan Marshall, 1944 (93.113a–c)

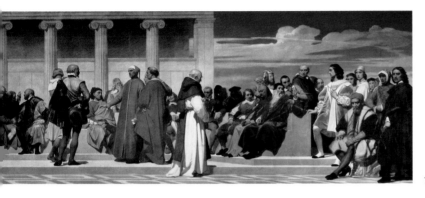

7

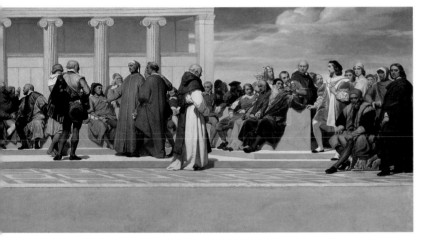

8

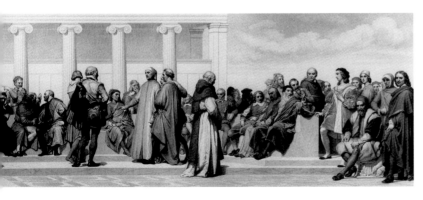

9

which the master insisted on retouching himself."[22] This account, in Strahan's considered view, "[went] to establish the authenticity of the smaller replica as a work really by Delaroche."

For our purposes, such a judgment involving the metaphysics of authorship must take second place to the examination of the various stages involved in the production of this complex work. The Walters *Hémicycle* was recently examined with unprecedented thoroughness, leading to the conclusion that Delaroche did indeed devote considerable attention to its repainting before he signed it in 1853.[23] There is evidence of a comprehensive revision of the color values, which must have been carried out *in situ*. Mirecourt's vivid detail that he spent three weeks engaged in the process in the presence of the original at the École des Beaux-Arts—

Fig. 10. Entries from Goupil & Cie account ledger, book 1:1846–62. Los Angeles, Getty Research Institute, 900239

and had to be wrapped in wool by the porter because of the extreme winter temperatures —may appear fanciful but perhaps is not far from the truth.[24] This check on the credentials of the painting also provides the incentive to investigate its original state and to follow its fortunes up to the period when William Walters acquired it. This essay is the first occasion for telling the story in full.

The anchor for the whole investigation is entry 99 in the first volume of the Goupil account books, which lists a painting of "l'Hémicycle des Beaux-Arts" by "Beranger d'après Paul Delaroche" (fig. 10). Evidence that this is the Walters picture will accumulate in the course of my argument. For the moment, it is worth underlining that this is an attribution not to "the pupils of Delaroche" in general, but to one pupil in particular, and a favored one. Charles Béranger (1816–1853)

studied with Delaroche in the mid-1830s and in 1837 (the year of his first Salon exhibit) was living in the same Bohemian lodgings in Saint-Germain-des-Prés that his master had occupied fifteen years previously. In 1839, he showed a small painting at the Salon that derived directly from a drawing by Delaroche.[25] There is no difficulty in concluding that in 1841—once Henriquel-Dupont had accepted the mammoth task of engraving the *Hémicycle des Beaux-Arts*—this young painter was entrusted with the task of preparing the reduced replica. Moreover, the circumstances of Béranger's life explain an apparent anomaly in the Goupil entry and may clarify the gesture of Delaroche in reassuming responsibility for the work. The anomaly is the vast discrepancy between the cost price (5,000 francs) and the sale price (50,000 francs). This can be explained by the hypothesis that Béranger sold the reduced replica to Goupil in 1850 (a date that correlates with other entries on the same page). It was then in 1853, which was the year of Béranger's death, that Delaroche undertook the task of fully repainting the unsold work, thus achieving a substantial premium over the original cost price. Both the likelihood that the replica reverted to its author after Henriquel-Dupont had finished with it, and the fact that Delaroche adopted (so to speak) the work of a cherished former pupil, are consistent with the sense that there were strong personal ties involved in these arrangements.

It can also be inferred that the commercial status of the work became problematic after 1853. The account books record its final sale in 1860, to "M. Gaillard à Grenoble" (and this previously uncharted episode in the history of the work will be clarified here). In all probability, Delaroche initially held onto the painting that he had reworked, being unwilling to relinquish its poignant associations. This would be consistent with his marked reluctance to sell several of the major works that occupied him throughout a period of increasingly serious illness in the 1850s. At his death

in 1856, however, the anomalous situation of the work that had originally entered Goupil's stock as a Béranger replica needed to be resolved. At the posthumous sale of Delaroche's estate in 1857, it was sold—a second time—to Goupil for the very large sum of 43,900 francs, not far short of the figure it achieved on being purchased by Eugène Gaillard in 1860. The sale catalogue, which indicates that no other work by Delaroche included in the sale fetched as high a price, omits Béranger's name but otherwise provides a broadly accurate description: "This reduction, done in 1841 for the execution of the engraving, was entirely repainted in 1853 by M. Paul Delaroche, with notable modifications."[26]

The decade between 1860 and 1870 during which the work subsequently was in the possession of the Gaillard family is significant since it points to a possible alternative destiny. It opens up the possibility that Delaroche's reduction could have been the crown of another great collection in the process of formation, not to be housed in a transatlantic gallery but in a major civic museum in provincial France. This alternative also indicates the general kinship between the new generation of collectors who bought Delaroche's later work: these men were not the great aristocrats and royalty who competed for his earlier history paintings but wealthy and public-spirited bourgeois figures such as Stammann in Hamburg, Naylor in Liverpool, and indeed William Walters in Baltimore. Eugène Gaillard had been born in 1793 to a peasant family in the Dauphiné. In his career as a banker at Grenoble, he accumulated a considerable fortune, which was estimated at the massive figure of 17 million francs after his death in 1866.[27] But his latter years were largely devoted to public service. From 1858 to 1865, when he retired because of ill health, he served as mayor of Grenoble, and took a special interest in the city's art collection, which was then being rehoused in more commodious premises. In 1859, he presented his

fellow citizens with a fine Renaissance painting, attributed to the Florentine Fra Bartolommeo (1472–1517).[28] In 1865, on the eve of his retirement, he successfully petitioned the comte de Nieuwerkerke, Napoleon III's director of museums, for a modern painting from the recent Paris Salon to be purchased for Grenoble by the state.[29]

May we conclude that the *Hémicycle* reduction, consigned on 15 April 1860 to "M. Gaillard à Grenoble" in the Goupil accounts, was destined for this civic collection? This seems very likely, as the acquisition of the painting would have endowed Grenoble with a prestigious modern work that was also emblematic of the entire history of Western art, and especially the period following the Renaissance. Gaillard could not have failed to notice that the black-gowned figure of Fra Bartolommeo was prominent among the illustrious Italian Renaissance artists in Delaroche's *Hémicycle*, standing midway between Leonardo da Vinci and Raphael. He would obviously have been aware of the original wall painting at the École des Beaux-Arts, and might have calculated that this repetition, dignified by the master's own signature, would fulfill various functions at the same time, being pedagogically useful as well as aesthetically fine—in a word, specially suited to the new collection that was taking shape in Grenoble. Maybe it was only Gaillard's retirement from the mayoralty through ill health—a departure accelerated by the parlous political situation in the country—that frustrated such a plan. On Gaillard's death in 1866, the valuable work would have passed to his heirs, a son and a daughter, both resident in Paris.

Here the journal of the American art agent George Lucas takes over in covering the final stages of the *Hémicycle*'s existence in France. The first indication that Walters might be interested in purchasing works by Delaroche is in the entry for 2 November 1861, when Lucas notes: "With W[alters] & Goupil to see De La Roche's Christian Martyr & to see Gerome and Brion."[30] But it is not till 19 October 1866 that Lucas records in his usual busy daily agenda: "to Gaillards to see Delaroche reduction of the Hemicycle—."[31] This being barely six weeks after the death of Gaillard *père*, it seems as though Émile Gaillard, a Parisian banker, had moved fast in alerting the trade to the fact that one of his father's assets might be on the market. Lucas, however, was willing to play a waiting game. It was 1871 before he located the picture again, having sounded out the indispensable Goupil on two works by Delaroche, "the picture of Marie-Antoinette and the Hemicycle." Goupil volunteered the fact that it had been offered for sale at 80,000 francs by a rival gallery, Georges Petit's, but the price had risen to 100,000 francs plus 10 percent commission.[32] On 8 July 1871, Lucas negotiated with Petit, arriving at a possible price of 90,000 with commission of 5 percent, but "thought if offer was made of 80,000 it might be accepted." Three days later, he wrote to Walters, proposing the final figure of 90,000 francs, which proved acceptable to all parties.[33] It remained simply to commission a splendid frame from the Parisian framemaker Dutocq and to pack the treasure off to Baltimore.

It is worth pausing on the high value that was placed on this singular work, which was undeniably both a repetition and a reduction, even if questions about its divided authorship were dismissed. Comparing the price paid by Walters with the valuations being set on the rising Impressionist school, it is worth recalling that Édouard Manet's 1872 inventory estimated a value of 10,000 francs for a major recent painting like *Le déjeuner (à l'atelier)* (1868); the painting in question in fact sold for 4,000 francs in 1873.[34] This was also the price that Lucas negotiated in July 1871 for a painting by the already fashionable William-Adolphe Bouguereau.[35] In other words, Walters was paying an extraordinarily high price for his hybrid Delaroche. Yet the well-informed Edward Strahan later insisted that he was lucky to have secured it at such a

price, attributing his success to the political crisis brought about by the Paris Commune of 1870, "when the hardest-headed dealers lost their calculating powers, and all confidence in values, even the firmest, was gone." "In ordinary times" he claimed, "every museum in every large French town would be ready to ruin itself rather than let such a masterpiece leave their shores."[36] This statement is probably overconfident, given that the work seems to have been offered for sale before 1870 and found no buyer. But there is no doubting the enthusiasm with which Strahan applauded Walters's coup from the perspective of the 1880s. He concluded: "All things considered, the 'Hemicycle' [was] probably the highest effort of the nineteenth century in academic painting."[37] This judgment must presumably refer to the wall painting at the École des Beaux-Arts, but the Baltimore reduction appeared to Strahan to be fully invested with the aura of its original.

My reasons for giving detailed attention to the *Hémicycle* reduction are, first of all, its perceived centrality within the Walters collection, and second, the exemplary way in which it demonstrates the integral role of repetition in academic art. That Strahan, a former pupil of Gérôme, assessed its achievement in the context of "academic painting" is, of course, hardly accidental. Yet so devalued has the concept of academic painting become over a century of modernist hegemony that it is hard to overcome the derogatory connotations. For Strahan, we must assume, such a prejudice would have been incomprehensible. For him, the complex of principles and practices correctly described as "academic"—

since they were rooted in the traditions of the French Academy—was still the mainstream of Western art. The increasing global reach of an art with its focus in Paris had neither sapped its traditions nor diluted its richness. On the contrary, the timely innovations in the technology of reproduction and the wider commercial diffusion of artworks had enabled academic art to achieve new heights. In the burgeoning private collections and nascent public galleries of the United States, this was, at least up to the last decade of the nineteenth century, the creed to be adopted.

In this context, it fell to the painter Jean-Léon Gérôme to embody, more than any other artist, the continuing vitality of the French academic tradition. By the time that the *Hémicycle* reduction was bought for the Walters collection, Delaroche had been dead for several years, and the majority of his important paintings were already in private and public collections. The knowledge of his work was thus largely diffused through the prints and photographs published by Goupil, which were distributed by galleries such as Knoedler (fig. 11). By contrast, Gérôme, who lived until 1904, caught the full tide of the expanding market for academic art. He sold a high proportion of his major paintings overseas, while simultaneously exploiting the huge demand for reproductive prints and photographs. In two respects, he can be viewed as the lineal successor of Delaroche. First of all, he was regarded (with some justice) as Delaroche's loyal pupil. C. H. Stranahan's synoptic account of French painting, published in New York in 1917, put the matter concisely.

Fig. 11. Robert Jefferson Bingham, albumen print, 1858, of Delaroche/Béranger, *Hémicycle des Beaux-Arts*, 9 × 58 cm. Private collection

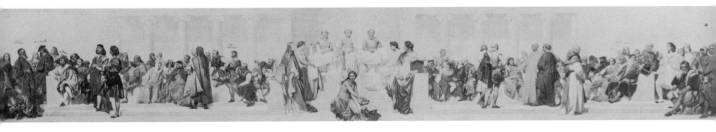

42

From his entry into Delaroche's studio, he "always cherished an affectionate loyalty [for him], seeing a value in his teachings which Millet never found there."[38] This general statement was backed up with the well-known anecdote that Delaroche had wisely overridden his pupil's scruples about sending an early work to the Salon, and so could claim part of the responsibility for his first major success in 1847 with *The Cock Fight*.[39] However Delaroche could take no credit for the second major respect in which Gérôme followed in his footsteps. It was in 1863, after Delaroche's death, that Gerôme married the daughter of his dealer, Adolphe Goupil, thus becoming a house artist who benefited from a special contract comparable to that of his teacher.

This affiliation is again relevant in the context of the Walters collection. Gérôme's

Duel after the Masquerade (figs. 13–15) rapidly acquired a unique position among the artist's works. The prime version shown at the Salon of 1857 (fig. 13) was bought for the collection of the duc d'Aumale, thus underlining a compositional and conceptual kinship with Delaroche's *Assassination of the Duc de Guise* (1834), which had also been commissioned by a royal duke for the Château de Chantilly.[40] Already at the time of the painting's appearance at the Paris Exposition Universelle of 1867, the *Fortnightly Review* was hailing

Gérôme as "unquestionably one of the best artists of the day," while the *Duel* "still attract[ed] more than any of his works."[41] Fanny Field Hering, writing in 1892 in her study of the artist, claimed that there was "an epitome of a hundred passionate novels in this painting, which is worthy of M. Delaroche's best pupil."[42] Despite Gérôme's immense productivity in subsequent years, the work would still be recalled after his death in 1904 as "deserving all of its brilliant reputation." This accolade was then linked directly to its exceptional record in reproduction, which comprised "not only lithography and engraving, but, moreover, being transplanted to the theatre [in 1881]."[43]

Such a reference to the different reproductions of the *Duel* verges on understatement. In the exhibition of 2000–2001 at the Musée Goupil (*Gérôme et Goupil: Art et entreprise*), an entire wall was devoted to them (fig. 12). The exemplary catalogue lists no less than nine separate modes of reproduction, all of which were still being advertised in sale catalogues into the twentieth century. No burin engraving of the work was produced—such as had occupied Henriquel-Dupont for "a hundred months" in reproducing the *Hémicycle*. But the full gamut of less time-consuming techniques was represented, including lithography, etching, photogravure, and photography. In the case of photography alone, three different sizes and prices were offered to the consumer: the tiny *carte de visite* format (9 × 6 cm), the *carte-album* (12 × 9 cm), and the *galerie photographique* print (32 × 22 cm) which, initially priced at 12 francs, cost the same as the basic, uncolored version of Achille Sirouy's (1834–1904) lithograph.[44]

If these multiple reproductions of Gérôme's *Duel* represent a ne plus ultra of the "repeating image" in French nineteenth-century academic painting, they also reveal its pitfalls as far as quality of the reproduced image is concerned. The hand-colored version of Sirouy's 1867 lithograph (fig. 16), based on the Chantilly original, is a striking image

that must have adorned many a salon or drawing room.[45] However, it shows a distinct loss of quality when compared with an initial proof taken from the lithographic stone around 1859. The print was commissioned from Sirouy by the dealer Ernest Gambart, who originally published it in that year, after he had succeeded in selling the Baltimore version of the *Duel* to Walters. At this point, Gérôme had not negotiated his exclusive contract with Goupil. After he had done so, in 1867, Goupil bought the stone from Gambart and republished the lithograph. The new edition, however, shows up some slight marks on the stone, and there is a general deterioration of the surface, which affects the rendering of the forest landscape. The applied hand-coloring perhaps compensates for these blemishes to some extent.

What emerges from this constellation of new forms of reproduction is the virtual disappearance not just of the traditional process of burin engraving, but of the whole philosophy that underpinned this labor-intensive procedure. The reproductive print, now pitted against photography and the hybrid process of photogravure, is no longer envisaged as a form of translation, which would imply that the medium possesses its own graphic language and its own artistic integrity.[46] The addition of hand-coloring, which was despised by traditional reproductive engravers, achieves a welcome dividend precisely because it allows the print to compete with the mimetic values of the photograph. Yet Gérôme himself can hardly be blamed for the far-reaching developments in the technology of reproduction that empowered the widespread diffusion of his images. In fact, he viewed his own reproductive work in a very different spirit. In the case of the Walters *Duel* (fig. 15), he reiterated that he had improved on the Chantilly original, both clarifying the narrative, and adjusting the foreground figures to the landscape background. In a letter to Gambart that was

translated in Hering's study, he argued this point with conviction:

I learn with the greatest pleasure that you have sold the reproduction of the *Duel* that I have done for you, and I am all the more pleased since I hear that it has been bought by a distinguished amateur; one is always glad to know one's offspring is well located. The alterations that I have made from the original picture have singularly improved this composition, especially in its general aspect; some sacrifices made in the background have left to the *premier plan*, that is to say, to the important figures, all their effect, and I regret not to have thought of it at first when I executed the original. This improvement has been most valuable, and you would have been struck with it had you been able to see one with the other. I have modified the head of the savage; it was not well understood at first who was the adversary; now it is plain to every one and confusion is no longer possible. In short, I am happy that it has fallen into the hands of Mr Walters of Baltimore, since I am told he can appreciate things seriously conceived and seriously executed.[47]

To turn from Delaroche and Gérôme to Ingres is to discover a direction in academic art that runs parallel to that of his academic colleagues, but along entirely different lines. Ingres was, indeed, no less persuaded of the desirability of repeating images in the form of reproductive engravings. During his early years in Rome, he himself made drawings after classical sculpture, which were then engraved in the traditional manner. He set great store by burin engravings of his major paintings, at least in the first part of his career, and so forged a close link with the outstanding young Italian engraver Luigi Calamatta (1801–1869), whose reproduction of his *Voeu de Louis XIII* (1824) was displayed at the 1837 Paris Salon.[48] Yet Ingres never established the kind of close contractual link with a print publisher that Delaroche and Gérôme secured from Goupil. Even his relationship with Calamatta, which remained close on a personal level, failed to ensure

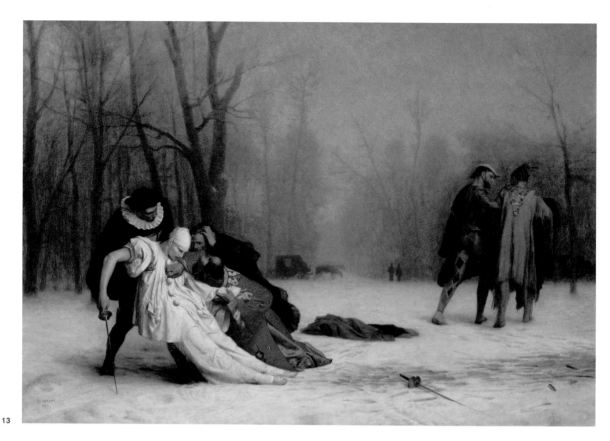

13

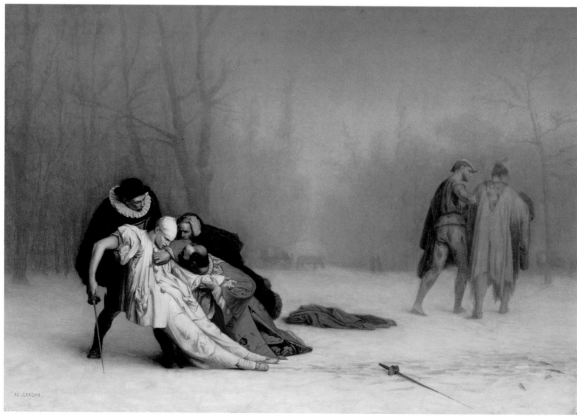

14

15

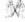

16

Fig. 13. Jean-Léon
Gérôme, *The Duel
after the Masquerade,*
1857. Oil on canvas,
50 × 72 cm. Chantilly,
Musée Condé (PE 533)

Fig. 14. Jean-Léon
Gérôme, *The Duel
after the Masquerade,*
1857. Oil on canvas,
68 × 99 cm. St. Peters-
burg, Russia, The State
Hermitage Museum
(GE 3872)

Fig. 15. Jean-Léon
Gérôme, *The Duel
after the Masquerade,*
1857–59. Oil on canvas,
39.1 × 56.3 cm. Balti-
more, The Walters Art
Museum. Bequest of
Henry Walters, 1931
(37.51)

Fig. 16. Achille Sirouy,
after Jean-Léon Gérôme,
*The Duel after the
Masquerade,* 1859
(1867 print). Lithograph,
impression on a tint-
stone background, hand-
colored with watercolor
and gouache, with gum
arabic highlights, 37.7 ×
54.5 cm. Bordeaux,
Musée Goupil: Direction
des Établissements
culturels de Bordeaux
(98.I.1.5)

46 that a majority of his important works were made available to a wider public in this way. A notorious example for comparison here is his *Apotheosis of Homer* (1827), the large painting displaying a pantheon of the classical tradition that was originally commissioned for the Louvre. Delaroche certainly bore this precedent in mind when he began his more eclectic and historicist wall painting of "Artists of all the ages" in the *Hémicycle* of the École des Beaux-Arts a decade later. By means of Henriquel-Dupont's engraving, he was able to spread the knowledge of his most ambitious work on a scale that needs no further comment here. Ingres, who was soon dissatisfied with the limited membership of his Homeric company, worked for many years on a drawing that was more inclusive, which he invited Calamatta to engrave. But he was not sufficiently satisfied with the new version to release it, and in consequence the print was never forthcoming.

The paradox is that this very failure to take advantage of the commercial possibilities of repetition worked in some ways to Ingres's advantage. Both Delaroche and Gérôme contrived to utilize to the full, in their turn, the new opportunities of patronage arising in an increasingly internationalized market. By contrast, Ingres was prone to retain in his own possession unsold major works or indeed, when a commissioned work had been delivered to a client, to buy it back for further reworking. His portraits apart, he was intent on developing his chosen thematic material, often revising in late career subjects that he had first tackled in his early years. While the ostensible records of this process (as measured by his correspondence) sometimes transmit a feeling of deep dissatisfaction with his own work—and indeed of compulsive reworkings that border on the obsessional—their long-term dividend was certainly positive. These very repetitions and variations have become integral to our perception of Ingres's distinctiveness as an artist.

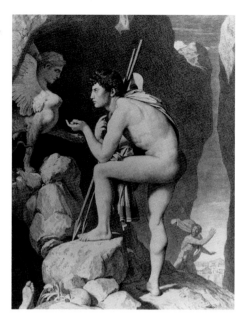

Fig. 17. Ferdinand Gaillard, after Jean-Auguste-Dominique Ingres, *Oedipus and the Sphinx*, 1867. Burin engraving. Private collection

There could be no more satisfying example of this outcome than that of the versions of *Oedipus and the Sphinx* (figs. 18–20). After the artist's death in 1856, Delaroche's achievement was celebrated in a retrospective exhibition of his work—the first of its kind—at the École des Beaux-Arts. But in no case did the organizers choose to juxtapose two near-identical paintings, such as the two versions of *Bonaparte Crossing the Alps* discussed here. In 1867, a similar posthumous exhibition was dedicated to Ingres in which the three versions of *Oedipus* were shown together, and this conjunction became the norm for critical documentation of the artist's work, as with Henri Delaborde's catalogue of 1870.[49] By this stage, of course, all three versions were in private collections, but Delaborde took care, in his catalogue entry, to allude to the lengthy period between 1808 and 1839, when the initial version had remained on Ingres's hands, pointing out that it had been acclaimed so tardily at the Paris Exposition Universelle of 1855. He also noted that the work—reproduced in a lithograph by Jean-Pierre Sudre (1783–1866) from 1853 that was not released commercially—was finally given appropriate exposure after

Ingres's death in a burin engraving by Ferdinand Gaillard (1834–1887) for the *Gazette des Beaux-Arts* (fig. 17).[50]

What, then, did Ingres's commentators make of the three versions of his *Oedipus,* and what are we to make of them now? The catalogue entries follow a simple protocol: both the undated (National Gallery, London) version (fig. 19) and the Baltimore version (fig. 20) are classed as "reduced repetitions," the latter with the indication that "some changes" have been made. Not much more can be said about the small undated version than the hypothetical view of the recent catalogue: that Ingres reworked the original (Louvre) version around 1826/27 and this work "may be a study made in about 1826 in connection with the changes."[51] We can at any rate be fairly sure that it was painted for Ingres's personal reference and not (as with other reductions discussed here) for the use of a reproductive engraver. Ingres's collaboration with Calamatta shows that he required the engraver himself to prepare detailed reproductive drawings.

About the Baltimore version, there is more to be said. It was probably begun as early as 1835, but completed only in 1864 at Ingres's studio in Meung-sur-Loire, after which it entered the collection of Émile Pereire. Among the "changes" introduced, the most important are the right-left reversal of the composition, the omission of the distant Poussinesque figure, and the fact that the Sphinx no longer looks Oedipus in the face, but turns sharply away. Certain of the drawings relating to the composition also anticipate this averted gaze, which seems to signify the Sphinx's acknowledgment of defeat in the game of riddles. It is also, very obviously, a feature of the plaster relief by one of Ingres's students, *Oedipe expliquant l'énigme au Sphinx,* which dates from 1831.[52] But a final piece of evidence suggests that Ingres's long engagement with the subject was not just a matter of successive readjustments: a manuscript

note in Ingres's hand alludes to the content of the Sphinx's riddle, which involves Oedipus in recalling the different ages of man from childhood to old age.[53] We might well conclude that an element of personal allegory played some role in the elaboration over nearly half a century of the composition whose last version he was to sign: "J.Ingres p[inge]bat Aetatis LXXXIII, 1864."[54]

One of Ingres's contemporaries certainly believed that this fine performance of Ingres's old age represented a special triumph over mortality. The painter Jean Gigoux (1806–1894) records: "A few days before his death, [Ingres] showed me in his studio a new interpretation of his *Oedipus,* roughly smaller by half than the picture in the Louvre. He had worked at it *con amore* and he had wished to surpass the first one. It was really superb."[55] We might indeed sympathize with the judgment that Ingres's work acquires a distinctive character through the force of this heroic ambition. Even for the nineteenth-century academic artist, the repeating image could assume an existential rather than a purely commercial significance.

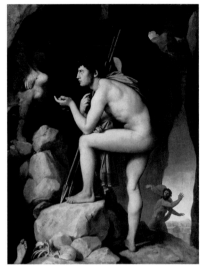 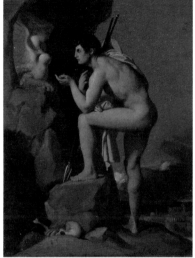 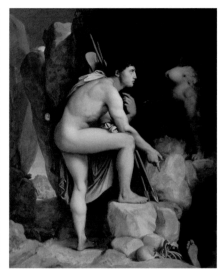

Fig. 18. Jean-Auguste-
Dominique Ingres,
Oedipus and the Sphinx,
1808. Oil on canvas,
189 × 144 cm. Paris,
Musée du Louvre, legs
de la comtesse Duchâtel,
1878 (RF 218)

Fig. 19. Jean-Auguste-
Dominique Ingres,
Oedipus and the Sphinx,
ca. 1826. Oil on canvas,
17.5 × 13.7 cm. London,
The National Gallery,
bought 1918 (NG 3290)

Fig. 20. Jean-Auguste-
Dominique Ingres,
Oedipus and the Sphinx,
1864. Oil on canvas,
105.5 × 87 cm. Baltimore,
The Walters Art Museum.
Bequest of Henry Walters,
1931 (37.9)

Opposite:
Detail of fig. 20

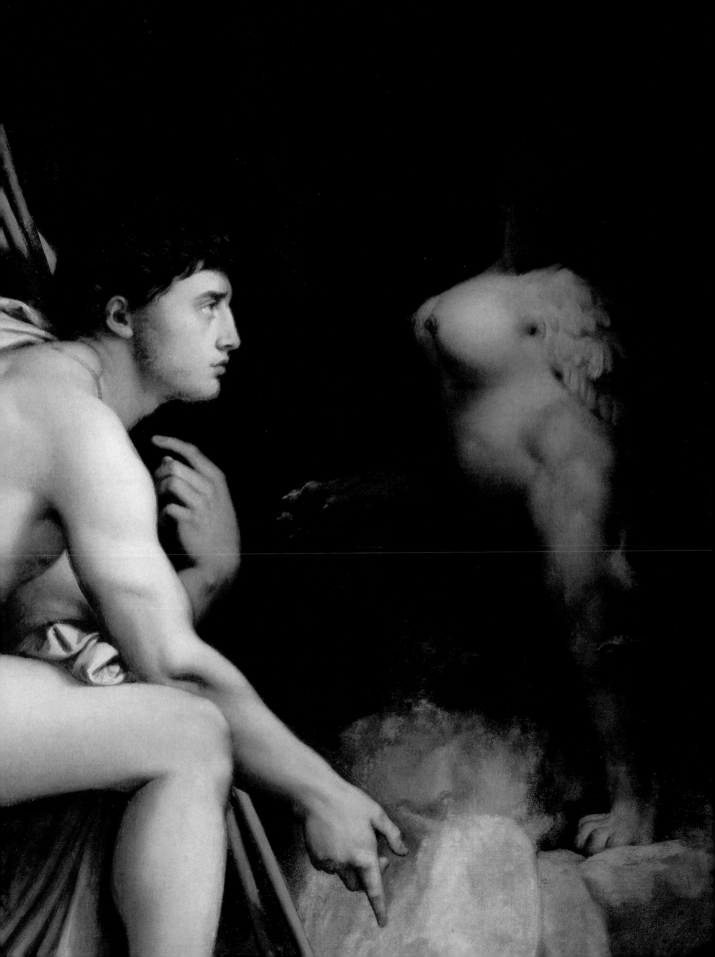

1. For a judicious view of the changes taking place, see the unsigned article "The Present State of Commerce in Art" (*Art Journal*, 1 October 1854), where it is noted that Delaroche's "pictures are always offered to [M. Goupil] this extensive picture and print merchant." Delaroche was one of only three French painters to benefit at the time from this arrangement, the others being Ary Scheffer (1795–1858) and Horace Vernet (1789–1863). It would later apply to Gérôme when he became Adolphe Goupil's son-in-law. The influence of the Maison Goupil in canalizing the new opportunities for the benefit of a small number of "house" artists can only be peripherally acknowledged here. For an excellent account of its pioneering activities, see Hélène Lafont-Couturier, "La maison Goupil, ou la notion d'oeuvre originale remise en question," *Revue de l'art*, no. 112 (1996-2): 56–69.

2. See Museo Napoleonico, Palazzo Primoli, Rome, inv. 923, letter dated Brussels, 25 June 1821. In this case, all three paintings were destined for members of the Bonaparte family, one of the repetitions being customized with a different motif on the upholstery.

3. Michelangelo Prunetti, *Avvertimenti . . . per distinguere quadri originali dalle copie* (Florence: Conti, 1822), ix.

4. *Athenaeum*, no. 1386, 20 May 1854, 628.

5. *Athenaeum*, no. 1176, 11 May 1850, 509. The present view is that Delaroche's pupil Charles-François Jalabert (1819–1901) was indeed responsible for this *répétition*, completed at Nice under the artist's supervision.

6. Dante Gabriel Rossetti, *Collected Works*, 2 vols. (London: Ellis and Elvey, 1890), 2:480.

7. *Bulletin of the American Art-Union*, August 1850, 80.

8. Ibid.

9. See Alfred Lichtwart, *Herrmann Kauffmann und die Kunst in Hamburg von 1800–1850* (Munich: Verlaganstalt für Kunst und Wissenschaft, 1893), 14–15.

10. *Deutsches Kunstblatt: Organ der deutschen Kunstvereine*, March 1850, 102.

11. See Lafont-Couturier, "La maison Goupil," 60–61.

12. The information is provided in *Bulletin of the American Art-Union*, April 1850, 15, where it is prophesied (falsely, as it happened) that "this interesting work of art is to remain permanently in this city." Woodbury Langdon's family origins may be inferred from the fact that the same name was borne by a merchant and judge of New Hampshire (1739–1805). John Langdon (1741–1819) served as governor of the state (1805–12). It is possible that the collector of 1850 is the same "Mr Langdon" resident in the rue de Berry, Paris, in 1866, whose purchase is recorded in the Goupil account books (Getty Research Institute, 900239, box 2, p. 30 [entry 951]).

13. See Helena E. Wright, *Prints at the Smithsonian: The Origins of a National Collection* (Washington: National Museum of American History, 1996), 20.

14. *Bulletin of the American Art-Union*, December 1850, 150. The alternative viewpoint had been aired in another periodical, the *Literary World*.

15. See Elisabeth Foucart-Walter, "Paul Delaroche et le thème du *Passage du Saint-Bernard par Bonaparte*," *Revue du Louvre* 5/6 (1984): 367–84. The occasion for this piece of sustained research was the arrival of the Langdon original in the Louvre in 1982, as a gift from its most recent American owners.

16. See Stephen Bann, "Delaroche, Napoleon and English Collectors," *Apollo*, October 2005, 24–31.

17. *Bulletin of the American Art-Union*, December 1850, 150.

18. See Foucart-Walter, "Paul Delaroche," 374–75, for a series of studies for the figure of the guide that are in the Louvre, Cabinet des dessins. None of these is a full-size drawing duplicating the figure as it appears in the two paintings.

19. Edward Strahan [pseud. Earl Shinn], *The Art Treasures of America* (Philadelphia: G. Barrie, n.d. [ca. 1880]), 82.

20. Clara Erskine Clement and Laurence Hatton, *Artists of the Nineteenth Century and Their Works*, 2 vols. (Boston and New York: Houghton, Mifflin, 1884; repr. St. Louis, Mo.: North Point, 1969), 1:197.

21. Strahan, *Art Treasures*, 82.

22. Ibid. See Eugène de Mirecourt, *Delaroche Decamps* (Paris: Librairie des contemporains, 1871), 33.

23. After cleaning in 2005, Delaroche's additions became clearly evident. In normal light under the microscope, Delaroche's paint has a more full-bodied consistency, and his retouching can be distinguished over and around Béranger's original outlines. When exposed to ultraviolet light, Delaroche's repaint fluoresces a different color. I am grateful to head of paintings conservation Eric Gordon and assistant paintings conservator Gillian Cook at the Walters Art Museum for these observations.

24. Mirecourt, *Delaroche Decamps*, 33. Mirecourt was known for his habit of picking up savory anecdotes from domestic servants, and this one fits the pattern.

25. The address given by both artists on respective occasions was 9, rue Childebert. The painting shown in 1839 represented a scene from the life of Henrietta Maria, queen of Charles I, and is now in a private collection in Germany. The Delaroche drawing is illustrated in Stephen Bann, *Paul Delaroche: History Painted* (Princeton: Princeton University Press, 1997), 158.

26. *Catalogue des tableaux, esquisses, dessins et croquis de M. Paul Delaroche*, sale of 12–13 June 1857 at the Hôtel des Commissaires-priseurs, rue Drouot, Paris, p. 3. The sale prices are inserted in the copy in the

library of the École des Beaux-Arts. As a comparison, it can be noted that one of Delaroche's best-known paintings, *The Assassination of the Duc de Guise* (1834), had reached the price of 52,500 francs when sold from the collection of the duchesse d'Orléans in 1853. The record price for any of his works, obtained after his death and one year before the sale of the *Hémicycle* reduction to William Walters, was 110,000 francs, raised at the sale of the San Donato collection for what probably remains his most famous work, *The Execution of Lady Jane Grey* (1833). See H. Mireur, *Dictionnaire des ventes d'art faites en France et à l'étranger*, 7 vols. (Saint-Romain-au-Mont-d'Or: Artprice, [1911] 2001), vol. 2.

27. For biographical details, see the short entry in *Dictionnaire français de biographie* and the obituaries in local newspapers: *Le Dauphiné*, 9 September 1866, 247, and *Courrier de l'Isère*, 6 September 1866, 2. See also A. Albertin, *Histoire contemporaine de Grenoble et de la région dauphinoise*, 3 vols. (Grenoble: Gratien, 1900–1902), 3:121–22.

28. See Grenoble, Archives municipales, R2/46, for the manuscript of the announcement relating to this gift. The painting, *Descente du Saint-Esprit sur les Apôtres*, is now conjecturally attributed to the Neapolitan painter Giovan Filippo Criscuolo (ca. 1495–ca. 1584); one of the most telling comparisons is with a work by Criscuolo in the collection of the Walters Art Museum, *Three Fathers of the Church* (37.1147). See Marco Chiarini, *Tableaux italiens: Catalogue raisonné de la collection de peinture italienne XIVe–XIXe siècles: Grenoble, Musée de peinture et de sculpture* (1988), 137.

29. The work bought by the state and despatched to Grenoble was a Normandy landscape by the Belgian painter César de Cock (1823–1904).

30. *The Diary of George A. Lucas: An American Art Agent in Paris, 1857–1909*, ed. Lilian M. C. Randall, 2 vols. (Princeton: Princeton University Press, 1979), 2:124.

31. Lucas, *Diary*, 2: 279. It should be noted that the name "Gaillard" is mistakenly indexed here under "Claude-Ferdinand Gaillard," who was a young reproductive engraver working for the *Gazette des Beaux-Arts*.

32. Lucas, *Diary*, 2:337.

33. Lucas, *Diary*, 2:343.

34. See *Manet 1832–1883*, exh. cat., Paris, Galeries nationales du Grand Palais (Paris: Réunion des musées nationaux, 1983), 294.

35. Lucas, *Diary*, 2:343.

36. Strahan, *Art Treasures*, 82.

37. Ibid.

38. C. H. Stranahan, *A History of French Painting from Its Earliest to Its Latest Practice* (New York: Scribner's, 1917), 309.

39. Ibid., 309–10.

40. See Bann, *Delaroche*, 196.

41. Henry O'Neil, "The Picture-Gatherings of Paris," *Fortnightly Review*, n.s., no. 5, 1 May 1867, 523.

42. Fanny Field Hering, *The Life and Works of Jean Léon Gérôme* (New York: Cassell, 1892), 74.

43. See *Les peintres illustres: Gérôme* (Paris: Pierre Lafitte, n.d. [ca. 1910]), 65. The theater production in question was a play by Mme Fould, performed at the Gymnase in 1881.

44. *Gérôme et Goupil: Art et Entreprise*, exh. cat., Bordeaux, Musée Goupil (Paris: Réunion des musées nationaux, 2000), 156.

45. Pierre-Lin Renié's fascinating exhibition *Une image sur le mur* (Bordeaux: Musée Goupil, 2005) featured a Goupil photograph after Jules-Émile Saintin's (1829–1894) painting *L'Indécision* (ca. 1871), in which a print after the *Duel* can be identified on the wall of a bourgeois apartment.

46. For the background to this fundamental change, see Stephen Bann, *Parallel Lines: Printmakers, Painters and Photographers in Nineteenth-Century France* (New Haven and London: Yale University Press, 2001), esp. 169–211.

47. Hering, *Gérôme*, 75.

48. For a detailed discussion of Ingres's connection with engravers, see Stephen Bann, "Ingres in Reproduction," *Art History* 23, no. 5 (December 2000): 706–25; and Bann, *Parallel Lines*, 141–68.

49. See *Catalogue des tableaux, études peintes, dessins et croquis de J.-A.-D. Ingres exposés dans les galeries de l'École impériale des Beaux-Arts* (Paris: Lainé and Havard, 1867), 7; and Henri Delaborde, *Ingres: Sa vie, ses travaux, sa doctrine* (Paris: Plon, 1870).

50. *Catalogue des tableaux*, 211–12. Delaborde also quotes a letter from Ingres to Nicolas-Marie Gatteaux of 29 August 1839, in which he expresses his joy at the sale of the 1808 work to the duc d'Orléans.

51. Christopher Baker and Tom Henry, comp., *The National Gallery—Complete Illustrated Catalogue* (London: National Gallery Publications, 1995), 324.

52. See *Ingres et l'antique*, exh. cat., Montauban, Musée Ingres (Arles: Actes Sud, 2006), 292; and George Vigne, *Dessins d'Ingres: Catalogue raisonné des dessins du musée de Montauban* (Paris: Gallimard, 1995), 18–19.

53. Vigne, *Dessins d'Ingres*, 18. Georges Vigne mentions that Ingres's friend and curator Armand Cambon related this note specifically to the Baltimore version but does not explain his disagreement with Cambon's opinion.

54. "J. Ingres painted at the age of 83, 1864." The Louvre version has simply: "I. Ingres painted 1808," and the National Gallery version "Ingres."

55. Jean Gigoux, *Causeries sur les artistes de mon temps* (Paris: Lévy, 1885), 92.

Simon Kelly

Shortly after the deaths of Jean-François Millet (b. 1814) and Jean-Baptiste-Camille Corot (b. 1796) within a five-week period in early 1875, the critic Henri Dumesnil offered one of the earliest comparisons of the two artists. He noted the differences in their paint handling but observed that "fundamentally, they both shared the same love and respect for nature; each saw it through his own temperament, in a different way, but each shared the same passion in search of truth."[1] Dumesnil's words underscored the intensity of the two artists' engagement with nature. Other early biographers also emphasized Millet's and Corot's exceptional desire to understand the complexity of nature's moods, developing a biographical discourse around artistic "temperament."[2] Some highlighted Corot's intimate, plein-air study, reflected in his extensive travels throughout his career.[3] Others noted Millet's intensely felt and personal renditions of the peasantry and nature of "la belle France."[4] Such views are at the root of modernist notions of mid-nineteenth-century landscape painting that stress close engagement with nature as a sign of the artist's "originality."[5] Yet such a focus has marginalized a fundamental aspect of the output of both artists. Both Millet and Corot drew inspiration not only from nature but also from art—specifically their *own* art. This essay explores the importance of repetition and of the repeating image in the studio practice of these two artists.

The involvement of nineteenth-century painters with the theme of repetition has begun to attract increasing scholarly attention in recent years, prompted by an environment in which the idea of repetition is celebrated rather than denied.[6] Previously, the modernist emphasis on "originality"—the idea of the unique work in the unique hand of the artist—had ensured that the full complexity of the practice of repetition was overlooked. An overview of a nineteenth-century academic dictionary, however, reveals a careful differentiation between different kinds of repeating image or *copie*—from the autograph repetition to

the assistant's replica, to the translation of an image into another medium, such as an etching or lithograph.[7] An autograph *copie* was described more precisely in the *Dictionnaire* as a *répétition,* or "rehearsal." The theatrical analogy is instructive since an initial performance is generally seen as less accomplished than subsequent versions, which benefit from increased experience and knowledge of the material. In this sense, an artist's later version can also be seen as an effort to "improve" on an earlier composition. While the artist's autograph repetition or variant was thus often distinguished by significant changes from the "original," the term *copie* was also used to indicate an exact replica—a kind of painting often produced by students rather than by the artist himself. Another kind of *copie* in the academic dictionary—and one that occupied the lowest place in the hierarchy of repetitions— was the translation of an image into another medium such as engraving or lithography. An artist like Millet might, however, complicate this relationship by developing his images in prints some time before he had painted them.[8]

An exploration of the careers of both Millet and Corot, as we shall see, highlights their interaction with the diverse range of practices that entailed repetition in the mid-nineteenth century. In examining the role of repetition in their careers, this essay navigates between two competing and at times overlapping motivations. First, repetition informed by principally aesthetic reasons, by the (often obsessive) need to refine and improve a composition in what has been termed a "pursuit of perfection."[9] Second, repetition informed by more purely economic or market considerations and driven by a historical context that arguably witnessed the emergence of the first truly modern art market in mid-nineteenth-century Paris. We can turn initially to the former motivation and what might be described as repetition as "rehearsal."

Repetition as "Rehearsal"

The trope of repetition as rehearsal can be used to describe the careers of a number of nineteenth-century artists.[10] It is also a model that particularly helps us to understand the practice of Millet. Over the course of his career, Millet repeatedly sought to develop chosen motifs, often giving his repetitions an ever-increasing sense of monumentality and producing these out of a desire to "improve" on his imagery rather than as necessarily the result of a collector commission. Over three decades, for example, he gradually developed his treatment of milkmaids from the neo-rococo works of the early 1840s to the heroic figures in *contre-jour* of the 1870s.[11] An examination of other seminal themes for Millet, such as sheep-shearing or butter-churning, also attests to his evolving fascination with a particular subject, often in the private space of the studio and often in a variety of media, before culminating in large-scale works intended for public consumption in the spaces of the Paris Salon—the exhibition space that Millet considered the most important for the display of his work.[12]

Millet's practice is well demonstrated in his many versions of the subject of the sower (figs. 2–5)—a work that has subsequently been seen as a modernist icon, conflating a message of political radicalism and artistic innovation.[13] The sowing of winter wheat took place generally in November and in a solemn, ritualistic fashion, with the sower making the sign of the cross with the seed before proceeding to scatter it across the land. Millet's fascination with the subject probably traces its beginnings to his youth in Normandy, but it also may have originated in the biblical parable.[14] His earliest version of the subject dates to his *"manière fleurie"* period of the early 1840s.[15] He then produced a larger painting (fig. 2) with the sower outlined against the bleak hillsides of his native Normandy.[16] A length of cloth is tied across the figure's chest and gathered up in his left hand to form a bag for the seed grain.

Uniquely among all the *Sower* compositions, the right arm is represented here with a sky-blue sleeve. The sower's body seems awkwardly crouched, as large, threatening crows, applied in single, spontaneous strokes, swoop low over the horizon. Two cows are silhouetted on the horizon, while a third has been painted out to the right with a still clearly visible pentimento.[17] It is uncertain whether Millet considered this work "finished"—the paint in the earth is applied very thinly, leaving the pale off-white ground clearly visible—but he never exhibited the painting, and it remained in the private space of his studio until his death.[18]

By the fall of 1850, Millet was working on the well-known version of the *Sower* now in Boston (fig. 3).[19] This painting has been described as "Millet's first great masterpiece."[20] The figure here strides with a powerful momentum not present in the earlier painted version. This sower, rendered in vigorously applied brushstrokes, has a heroic, Michelangelesque presence, while the angle of his face creates a dynamic flat plane. The sower's arm is rendered in powerfully angular brushstrokes; the seed visibly falls from his hand. His outstretched arm echoes the line of his left calf, while both counterbalance the diagonals of left arm and right thigh. The sense of rustic "authenticity" is heightened by the decision to wrap his legs in straw for warmth, rather than the leggings of the previous paintings. His cap is also now pulled down more dramatically over his ears. The time is twilight, and on the horizon, a sticklike farmer rides a harrow attached to two oxen as it breaks up the soil in preparation for the sowing.[21] The new sense of dynamism and energy in this rapidly painted work fully translates the nervous energy of the artist's drawings onto this much larger scale.[22] The lean, striding form of the sower is particularly close to a red chalk preparatory drawing that has been squared up for transfer (fig. 1).[23] The detail of the sower's

outstretched right arm here highlights Millet's especial concern for this area of his composition.[24] The upper contour of the arm is rendered in a dynamic, broken line, with angles almost like a mountain ridge, suggesting the powerful musculature of the sower's arm beneath his sleeve. This effect is reproduced in the painting.

Despite the new sense of heroism in this work, Millet was apparently concerned that his canvas was too small to accommodate the figure of the sower. Étienne Moreau-Nélaton noted more specifically that Millet was concerned that the right hand and foot were too close to the left edge of the composition.[25] He thus began another painting (fig. 4), probably late in October or in November 1850. According to Moreau-Nélaton, he used a tracing to transfer his composition.[26] In this version, the sower is placed lower on the horizon and moved toward the center of the painting, ensuring that he is more contained by the surrounding field.[27] His head is now turned into his shoulder, while his sowing arm is brought down toward his body and his back leg slightly advanced. The cumulative effect of these subtle changes reduces the thrusting monumentality of the Boston image but

Fig. 1. Jean-François Millet, study for *The Sower*, ca. 1850. Pencil and red chalk on paper, 36 × 27 cm. Yamanashi Prefectural Museum of Art

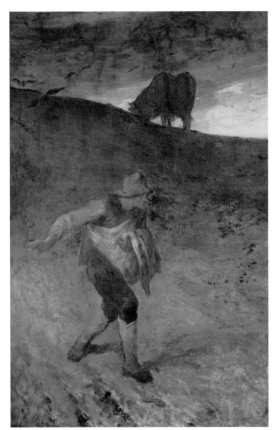

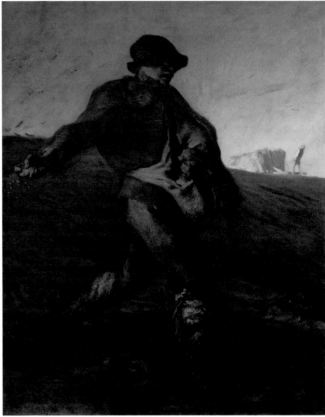

Fig. 2. Jean-François Millet, *The Sower,* 1847–48. Oil on canvas, 95.2 × 61.3 cm. Cardiff, Amgueddfa Cymru–National Museum Wales (NMW A 2474)

Fig. 3. Jean-François Millet, *The Sower,* 1850. Oil on canvas, 101.6 × 82.6 cm. Museum of Fine Arts, Boston, Gift of Quincy Adams Shaw through Quincy Adams Shaw, Jr. and Mrs. Marian Shaw Haughton (17.1485)

Fig. 4. Jean-François Millet, *The Sower,* ca. 1850. Oil on canvas, 99.7 × 80 cm. Yamanashi Prefectural Museum of Art

Fig. 5. Jean-François Millet, *The Sower,* ca. 1872. Oil on canvas, 105.4 × 85.7 cm. Pittsburgh, Carnegie Museum of Art. Purchase: gift of Mr. and Mrs. Samuel B. Casey and Mr. and Mrs. George L. Craig, Jr. (63.7)

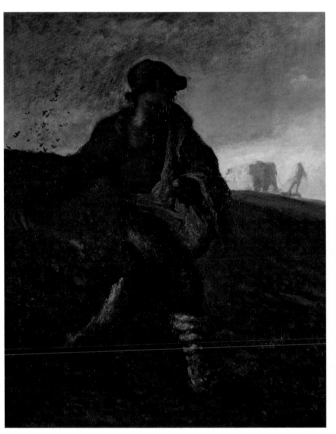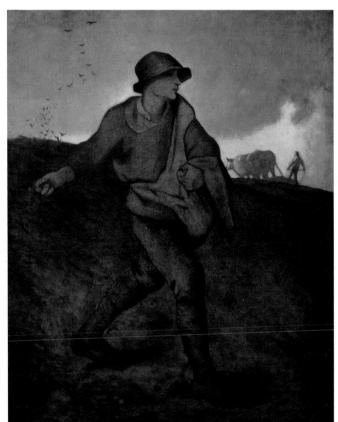

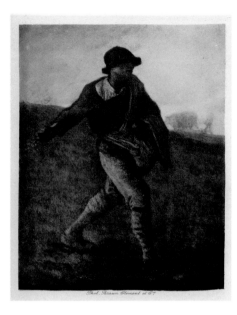

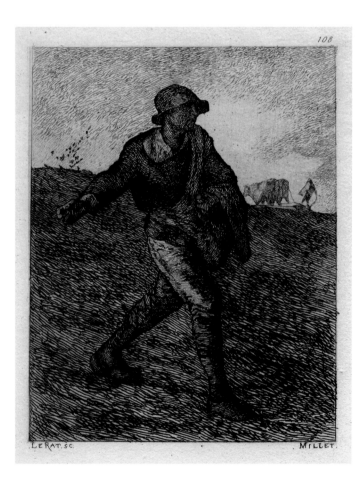

also creates a greater sense of naturalism that seems to mimic more closely the actual labor of sowing. This painting has suffered from over-zealous restoration as well as later retouchings (in areas such as the straw around the calves).[28] An early reproductive print (fig. 6) demonstrates that the form of the sower was once more clearly defined. The paint in this work is still thickly—almost brutally—applied, with the rugged surfaces suggesting the rugged textures of the earth itself.[29] Millet also changed other aspects of the composition, making the sower's off-white collarless shirt more prominent and bathing the harrower and his oxen (whose legs are now visible) in a blonder light, perhaps suggestive of dawn.[30]

In these three painted versions, we can see how Millet sought to evolve his composition. At the 1850 Salon he exhibited a work titled *Un semeur* that was probably the Yamanashi version.[31] His restless experiment in this work inspired a range of controversial commentaries with the painting, inviting two different interpretations. On the one hand, his paint surfaces disturbed many critics. Théophile Gautier, for example, described Millet's technique as "trowel scrapings."[32] At the same time, the work also encouraged more politicized readings from both legitimist and republican commentators.[33] For François Sabatier-Ungher, a Fourierist critic, Millet's sower was the "modern *demos*," the iconic symbol of the modern proletariat.[34] The conservative Auguste Desplaces, writing in the legitimist newspaper *L'Union*, accused Millet of exaggerating the harshness of rural life.[35] As Alfred Sensier noted, he was accused of creating an art that was "too socialist." Millet himself did not deny such an interpretation, although he did also emphasize his generalizing approach to his subject: "I must confess, at the risk of being taken for a socialist, that it is the treatment of the human condition that touches me the most in art."[36] He would continue to develop provocative Salon statements with an undeniable political

charge—such as *The Gleaners* (Musée d'Orsay) and *Man with a Hoe* (J. Paul Getty Museum)—in his avowed aim of "disturbing the fortunate in their rest."[37]

The Yamanashi work—the culminating work in the series—also inspired a number of later repetitions that did not conform so closely to the model of repetition as rehearsal. In addition to Millet's three well-documented Sower paintings, there is also a fourth painted version that is much less well known and whose authenticity has been contested (see fig. 5), largely because of its flat surface.[38] This slightly larger work, painted in transparent oil washes thinned with turpentine, is not referenced by any of Millet's early biographers, while its early provenance is unclear.[39] As Robert Herbert first noted, this is probably the work described by Millet's friend Sensier, in a letter of late 1872, as a large canvas for a "Semeur à venir."[40] The painting may be an unfinished repetition after the Yamanashi work (in its original form, see fig. 6). Still in the state of

an *ébauche,* it probably dates from the early 1870s and was perhaps intended as a personal record of a major painting that had recently been sold.[41] It is also possible that the work was made by Millet's eldest son—the painter François Millet *fils* (1851–1919).[42] François is known to have made copies of his father's paintings as a student exercise in the 1870s,[43] as well as *ébauches* for his father.[44] The Yamanashi *Sower* was also reproduced in a widely disseminated etching by Paul-Edmé Le Rat (1849–1892) in 1873 (fig. 7).[45] This print, in turn, inspired several painted and drawn copies by Vincent van Gogh in the 1880s.[46] In one highly interpretative copy (fig. 8), Van Gogh situated Millet's figure within the more expansive setting of a blue-violet field against an incandescent yellow sun and sky, thus allowing for the resonant play of complementary colors.

Repetition and the Market

The mid-nineteenth century saw the massive expansion of the art market in France and

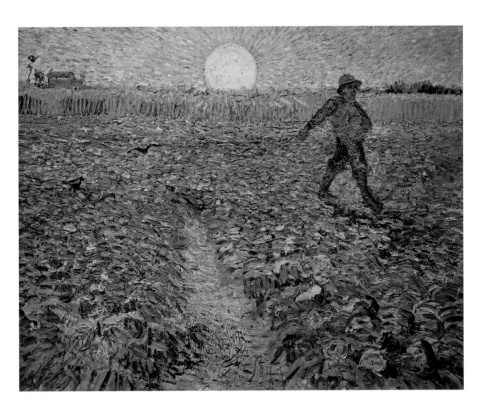

Fig. 8. Vincent van Gogh, after Jean-François Millet, *The Sower*, 1888. Oil on canvas, 64 × 80.5 cm. Otterlo, Rijksmuseum Kröller-Müller

the emergence of a new middle-class audience of urban consumers. At a time of growing urbanization, landscapes were especially popular among collectors.[47] An examination of the careers of Millet and Corot reveals the extent to which they produced repetitions to satisfy this rapidly growing market. These works were principally commissions by dealers or collectors, often after popular Salon compositions. In examining the relationship of these two artists to the market, we can turn first to the example of Corot.

Accounts of Corot have tended to minimize his engagement with the market, perpetuating a notion of artistic naïveté already evident in the artist's earliest biographies.[48] Yet an overview of Corot's production suggests a greater degree of commercial acumen. Perhaps the most notable aspect of Corot's practice of repetition is his output of numerous reductions (or reduced-size repetitions) of his major exhibition works, particularly in the 1850s and 1860s. In the early 1860s, for example, he produced four reductions after *Une matinée,* that idyllic Claudean scene that had signaled a new direction in his work when exhibited at the 1850 Salon (see fig. 25).[49] Generally his reductions replicated this type of work, reflecting the late vogue for his "silvery" pictures rather than his more naturalistic scenes or grand history paintings.[50] Many of Corot's reductions were commissioned by the expanding number of dealers in Napoleon III's Paris. Repetitions were commissioned by major dealers, including Hector Brame and Adolphe Goupil, as well as lesser-known dealers like Tedesco and Cleophas.[51] Although such production was motivated principally by economic motives, Corot also sought to explore different light effects as well as making minor, although noticeable, changes to his staffage. An examination of the "réductions" after *Une matinée* has highlighted the subtle differences in the treatment of dawn and early morning light effects as well as the variation in the treatment of figures.[52] During

the 1860s, Corot also produced a number of variants of a view of Lake Riva that he first treated in a plein-air sketch in 1834 (Saint Gall, Kunstmuseum). In these works (such as *Souvenir of Riva,* Cincinnati Museum of Art), he transforms the naturalistic, morning view of his early sketch into evocative "souvenirs," showing the same location but now at sunset and with a more generalized and abstract effect that suggests the artist's nostalgia for a site imagined through the transforming veil of memory.[53]

Corot's practice of producing reductions is evident in his work surrounding *The Evening Star* (figs. 9–12), a composition inspired by lines from Alfred de Musset's poem "Le saule" (1830), praising the mysteries of Venus.[54] Corot developed his "original" composition (fig. 9) in the early 1860s, and it was later praised by Dumesnil as one of his most successful works.[55] The artist here created a work of mysterious poetry as a young woman addresses the evening star in the distance, while close by a shepherd leads his flock home in the twilight.[56] In the sky, Corot has applied thick impasto in dynamic diagonal lines, while flecks of pink in the foreground suggest the presence of flowers. The outstretched arm of the woman echoes the form of the tree branches above. This woman wears an antique-style costume with a loose-fitting yellow dress and red headband; she may have been based on one of the great opera singers of the day.[57] Her pose, with dramatically upraised arm, also suggests the influence of antique sculpture and particularly the *Wounded Amazon* (Musée du Louvre).[58]

Corot seems to have struggled with this composition and, as was frequently his practice, painted out areas to "purify" his composition. Conservation analysis has shown that the work was painted in two phases.[59] Infrared spectometry has revealed that he originally included three slender trees to the right of the central tree (see fig. 13). Their ghostlike pentimenti can still be made out. The work was also signed on two separate occasions,

first in brown with the date "1864" and then in red.[60] An examination of the early exhibition history of this work may help to establish the chronology of Corot's production. It has not previously been noted that in February 1864, Corot exhibited *L'étoile du soir (paysage)* at the Société nationale des Beaux-Arts on the boulevard des Italiens—an exhibition organized by this artists' society as an alternative to the official Salon.[61] This undoubtedly was the Toulouse painting, and it was probably for this show that Corot first signed (and dated) the work. Recent conservation analysis has suggested that the three trees were still visible at this stage, when the first signature was added.[62] The painting did not sell, and Corot next exhibited the picture at a provincial exhibition at Toulouse in June 1864, where it enjoyed critical success and sold for 3,000 francs.[63] It is probable that Corot reworked his composition in the period between these two shows, painting out the three aforementioned trees. The removal of the largest was particularly crucial, since this provided the opportunity to include the luminous color accent of the orange sunset.[64] Corot subsequently signed the work again in red, surely as a marketing strategy to heighten the visibility of his name.[65]

On 8 February 1864, a reduction of *Evening Star* (fig. 10) was commissioned directly from Corot for 1,000 francs by the American expatriate dealer George Lucas ("mon petit hamericain," as Corot called him) on behalf of the Baltimore collector William T. Walters.[66] The following day, Walters himself visited Corot's studio, when he apparently requested that Corot eliminate the flock of sheep in the reduction, probably because he thought them too "unfinished" in the original. Walters's daughter, Jennie, is also said to have asked Corot to make the distant star brighter. The work was delivered eleven months later with little evidence that Corot took any notice of these requests. The silhouette of the woman is in fact notably less defined than in the original painting. There are other subtle

changes, such as the configuration of the shoots and branches of the central tree, while the rocky escarpment to the right is much darker and covered with far more shrubs. The reduction is a more monochromatic picture without the red color accents of the woman's headband and the shepherd's hat.[67] Corot does, however, replicate the free brushwork of the "original," complicating modernist preconceptions of such gestural paintmarks as exclusively a sign of the artist's unique, "original" work.

Corot may have painted the reduction from the "original" work when it was still in his studio in the early summer of 1864. It is, however, equally possible, given the differences in the composition, that he produced it from memory at a later stage in the year. Corot told his earliest biographer, Théophile Silvestre, in the early 1850s: "When a collector wants a *répétition* of one of my landscapes, it is easy for me to give it to him without seeing the original; I keep a copy of all my works in my heart and in my eyes."[68] Corot's words should be treated with some caution, but they nonetheless probably contain some truth. Corot often produced repetitions after "original" works that he had long since sold.[69] Such an approach ensured inevitable license in the artist's repetitions. In the early 1870s, for example, Corot produced a repetition (private collection) after *Solitude, Souvenir of Vigen* (Museo Thyssen-Bornemisza, Madrid), a work that was no longer in his possession, having been sold to Emperor Napoleon III some years previously. Corot's repetition has significant differences in the configuration of trees and staffage.[70] In contrast to several other Barbizon school painters, there is also no evidence that Corot ever used tracings for his repetitions.[71]

In addition to these two fully documented paintings, there are also two other less well known versions. The first is a rapidly painted small-scale work, similar to the Toulouse painting in its touches of red on the figures as well as the less dense cover of shrubbery

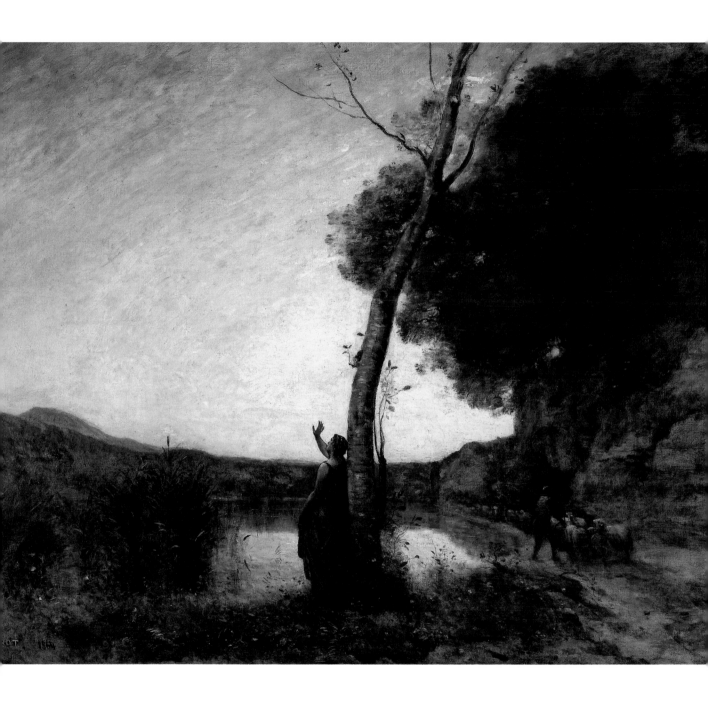

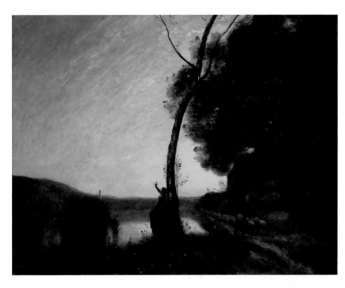

Opposite:
Fig. 9. Jean-Baptiste-Camille Corot, *The Evening Star,* signed 1864. Oil on canvas, 129 × 160 cm. Toulouse, Musée des Augustins (Ro 60)

This page:
Fig. 10. Jean-Baptiste-Camille Corot, *The Evening Star,* 1864. Oil on canvas, 71 × 90 cm. Baltimore, Walters Art Museum. Bequest of Henry Walters, 1931 (37.154)

Fig. 11. Jean-Baptiste-Camille Corot, *The Evening Star.* Oil on canvas, 36 × 48 cm. Present location unknown. Reproduced from *Catalogue des tableaux anciens et des tableaux modernes composant la collection de feu M. Henri Rouart,* Sale, Galerie Manzi-Joyant, Paris, 9–11 décembre 1912, 80, no. 146. Spencer Art Reference Library of The Nelson-Atkins Museum of Art, Kansas City

Fig. 12. Jean-Baptiste-Camille Corot, *The Evening Star,* signed 1863 [1864?]. Oil on canvas, 112.4 × 145.4 cm. Private collection, on deposit at the Saint Louis Art Museum

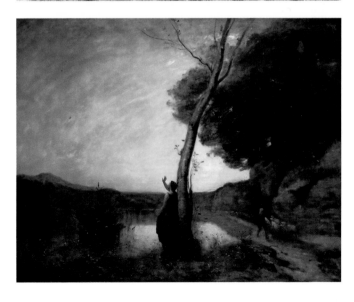

Fig. 13. Digital infrared photograph, August 2006, of the central tree in the Toulouse *Evening Star*

for the rocks to the right (fig. 11). This was once identified as a study for the Toulouse painting.[72] It has more recently been identified by Martin Dieterle and Claire Lebeau—who have devoted many years to ongoing *suppléments* to the original Alfred Robaut 1905 catalogue raisonné—as a repetition of the Toulouse picture.[73] They have dated the work to a period between 1864 and 1870—a date that suggests it was painted from memory in the years after the Toulouse picture had left Corot's studio. They also suggest that it was produced by Corot in collaboration with his favorite pupil, the talented Achille-François Oudinot (1820–91), in response to a dealer commission.[74] Such collaborative practice seems to have been commonplace in Corot's late production as he sought to meet commercial demand. Oudinot prepared a large number of "authentic" works by Corot.[75] He produced, for example, much of a reduction of Corot's 1859 Salon painting *Dante and Virgil* (Museum of Fine Arts, Boston), after the "original" picture (which remained in Corot's studio until the early 1870s).[76]

The second less well-known version (fig. 12), currently on loan to the Saint Louis Art

Museum, is more mysterious and has attracted little attention in the literature.[77] The early provenance of this work is unknown, and, according to the owner, it can be first traced to an exhibition of Corot's work in Paris in 1907.[78] The picture has been identified by Martin Dieterle as a genuine Corot; certainly the feathery touch is characteristic of Corot.[79] The paint surface is considerably thinner than that of the Toulouse version, as is the lighter overall atmosphere. This version is virtually identical in compositional elements to the Toulouse work, although slightly smaller in scale. Both have the carefully outlined form of the woman, the same red color accents and configuration of tree branches, and even the same foreground flecks of pink paint. The similarity of composition and facture suggest that it was painted directly from the "original" painting, perhaps when this was still in Corot's studio.[80] Although this work is dated 1863, it seems probable that is another repetition, perhaps also commissioned from Corot by one of his dealers.[81] As with the previous work, it is possible that this picture was painted in collaboration with Achille Oudinot.[82]

The existence of these four versions of *The Evening Star* highlights the need for continued discussion of the working practices of Corot and the extent to which he may have used assistants to meet the growing demand for work in his later career.[83] Corot's extensive output of reductions suggests that marketing strategies played a role in his artistic production to a degree that has not previously been recognized. Collectors, for their part, do not seem to have been especially concerned that their works were repetitions. Those repetitions that appeared in Corot's 1875 atelier sale sold for among the highest prices of the auction.[84] A couple of years previously, a reduction of *Une matinée* (1850) sold at auction for the considerable sum of 14,000 francs, an amount far in excess of the 1,500 francs that Corot had been paid by the state for the "original" work.[85]

Millet also produced a significant number of repetitions in response to market demand. This is particularly evident in his pastel output, which became increasingly important for him during the 1860s, as he began to attract growing commercial success. Millet had produced pastels early in his career, while in the 1850s he often added pastel to his charcoal drawings. During the early 1860s, he began to emphasize the color in these pastels. Millet modestly described his pastels as "*dessins*" (drawings), and they do not seem to have had as much importance for him as his paintings; indeed, he rarely exhibited them during his lifetime.[86] Nonetheless, Millet's production of such works ensured that he played a principal role in the renaissance of the pastel medium during the 1860s. His pastels have in fact come to be seen as among the most innovative areas of his production, and they were later admired by the Impressionists, including, notably, Edgar Degas (1834–1917) and Camille Pissarro (1830–1903). Yet, his replication of certain motifs has also led to criticism of his complicity with the market.[87] As with Corot, he often, however, made changes to the lighting and composition, producing works that were variants on his "original" composition. He also experimented with a wide range of paper colors—from buff to beige to lilac to gray—to suggest a variety of light effects.

Millet produced pastel repetitions for a range of dealers and collectors during the early to mid-1860s. He modestly used the term "reproduction" in his correspondence to describe pastels that were in fact complex variants.[88] His shift toward pastel production was motivated above all by the patronage of the Parisian architect Émile Gavet (1830–1904), who began to commission pastels regularly from him beginning in September 1865, acquiring some ninety-five such pastels within five years.[89] Around a third of these were repetitions rather than "original" compositions. These included several major pastels such as *Sheepfold, Moonlight* (Glasgow,

Burrell Collection) that reproduced paintings but on a larger and more ambitious scale.[90] Among Millet's pastel reductions was *Shepherdess and Her Flock* (fig. 14), reproducing the painting that had enjoyed a great critical success at the 1864 Salon (fig. 15).[91] In this pastel—one of four pastel reductions—Millet made several changes to the configuration of the flock and placement of the sheep in comparison with the Salon work. Perhaps most notably, he advanced the vigilant sheepdog to make this a more important aspect of the composition. In translating his *Shepherdess and Her Flock* into the medium of pastel, he gave his light effect a new dynamism with rapidly applied lines of white chalk that radiate from the clouds. Millet always sought to take advantage of the graphic qualities of the pastel medium in contrast to oil paint. He experimented here not only with pastel and charcoal but also with pen and ink, to build up a dense surface texture on the thick, rough paper that he favored since it helped the adherence of the pastel.[92] He also worked here with pastel and water (particularly in the clouds), either wetting the stick or working powdery pigment with brush and water to create fluid passages of color.[93]

Millet's production of pastels for the market is further highlighted by an examination of his four pastel versions of the *Sower* in the mid-1860s (figs. 16–19). Rather than producing exact replicas, Millet experimented with variants that are often very different in terms of format, light effect, and facture. He explored light at different times of day as well as different atmospheric effects, reflecting the increasing importance that he ascribed to landscape in his later work. Millet's first pastel version of the *Sower* was produced for his dealer Moureaux in early 1865 (fig. 16).[94] In contrast to the earlier paintings, Millet placed his sower in a more contemporary costume of a loose blue overshirt with full sleeves and heavy brown trousers. The setting also now shifted, from the Normandy hills to the plain of Chailly outside Barbizon

with the landmark of a ruined telegraph tower on the horizon.[95] The oxen in the distance were now replaced by horses pulling the harrow. Millet's interest shifted from the figure to a complex exploration of the textures of the soil as well as the light effects in his luminous sky. Étienne Moreau-Nélaton later wrote of Millet's inventive use of "*trouvailles*" (finds), and here he includes, for the first time, a large rock to the left, providing a further point of interest in the composition.[96] In the representation of the land, Millet defined his composition with a web of black chalk lines, then worked in colored pastels in green, yellow, and brown, and then once again added black chalk on top. Such a process effectively fused line and color. In the sky, he applied pastel rapidly in highly gestural fashion, animating his clouds with lines of pink and yellow, and allowing the cream-beige paper support to show through clearly on the horizon, perhaps suggestive of a dusk effect. He also used a stump (or perhaps his fingers) to create a faint silhouette around the sower, thus emphasizing the figure's presence in the landscape.

Millet's extensive surviving correspondence helps us to trace the sequence of the repetitions of his *Sower* pastel. By May 1865, Millet had received a commission from the collector De Thomas to produce another version of the *Sower* for 200 francs (fig. 17).[97] Millet produced the work in a very different vertical format, although it seems to have been his patron who requested this.[98] This work is more colorful than the first pastel version, with black crayon commingling with a range of yellows, reds, greens, and browns across the furrowed soil. Lines of mauve in the soil are echoed by mauves in the clouds, while, in a visual pun, flecks of black crayon representing the crows are repeated in the falling seed. This version is also far more extensively worked up, with less of the tan paper support visible. Millet's correspondence reveals that he produced this pastel over a five-day period between

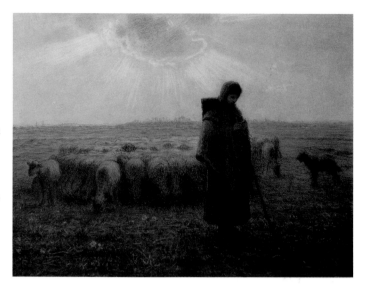

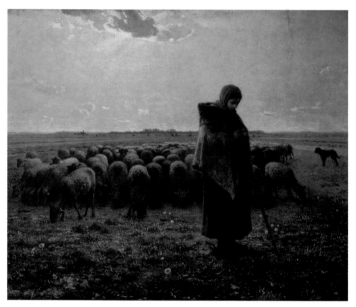

Top:
Fig. 14. Jean-François Millet, *The Shepherdess*, ca. 1865. Pastel and crayon, 39.4 × 50.8 cm. Baltimore, The Walters Art Museum. Bequest of Henry Walters, 1931 (37.906)

Above:
Fig. 15. Jean-François Millet, *Shepherdess Guarding Her Flock of Sheep*, 1863–64. Oil on canvas, 81 × 101 cm. Paris, Musée d'Orsay (RF 1879)

19 May and 23 May 1865.[99] He created here a dynamically animated sky, particularly in the curving, swirling lines to the right.

It was probably around this time that Millet completed another version of the *Sower:* a smaller pastel probably intended as a gift for his friend Alfred Sensier, who was the work's first owner (fig. 18).[100] This vertical pastel is on tan brown paper that has darkened over time but was nonetheless always intended to evoke an autumnal evening light. In this crepuscular scene, Millet suggests the warmth of evening by the use of a line of orange on the horizon echoed by flecks of the same color across the earth.[101] A few rays of light break through the clouds, pointing toward the head of the sower. This work is much less worked up than the Clark version, and it has been suggested that it was a "pastel experiment" and the earlier of the two works.[102] It may equally have been a rapidly worked repetition; Millet's signature indicates that he considered it a "finished" work.[103]

Probably sometime in 1866, Millet produced another pastel version of the *Sower* and now again returned to the horizontal format (fig. 19). This was commissioned by Gavet for 350 francs, nearly twice as much as he had received for his previous variant.[104] Alexandra Murphy has suggested that this is the final version of the theme.[105] Millet here maintained the gestural touch of his earlier horizontal work while giving this new pastel a lighter, more luminous quality—achieved in part by the use of a brownish-gray paper support. Millet closely referenced the composition of the Walters pastel, situating his sower in the same position in the landscape, doing the same with the harrower and team and the clouds. He even replicated his seemingly spontaneous black crayon diagonal hatch marks in his treatment of the texture of the soil.[106] The wheeling flock of crows is, however, given more prominence. The light effect is also different and perhaps reminis-

cent of dawn as a complement to the dusk in the Walters version.

For all his similarities of touch, Millet's four pastel versions of the *Sower* highlight his variations in terms of technique and lighting effect. Collectors do not seem to have privileged the "original" work over the repetitions. Millet himself was often able to charge more for his repetitions than for his "original" pastels.[107] This was also reflected in the prices at the sale of Gavet's collection in the summer of 1875. The repetition of *Sheepfold, Moonlight* (Burrell Collection), for example, sold for 12,100 francs, the second-highest sale price and considerably more than "original" pastels of the same size.[108] This sale was recorded by Vincent van Gogh, who noted his sense of reverence before Millet's pastels: "When I entered the hall of the Hôtel Drouot, where they were exhibited, I felt like saying, 'Take off your shoes, for the place where you are standing is Holy Ground.'"[109]

Print Repetitions

A further important aspect of Millet's and Corot's interest in repetition was their relationship to the burgeoning print market of the nineteenth century. The century saw the proliferation of imagery as a result of the rise of new reproduction processes such as lithography as well as the continuing resonance of older processes like etching.[110] The age also witnessed the emergence of large numbers of illustrated magazines that offered new opportunities for artists to communicate their works to a wide public. Millet and Corot interacted with this new market situation, although in rather different manners.

Many mid-century artists chose to produce prints, replicating their paintings, in order to disseminate their imagery to wider audiences. Millet produced many such prints, first reproducing his work in a lithograph (fig. 20) after his *Sower* painting. The lithograph can be seen, as was often the case in Millet's reproductive prints,

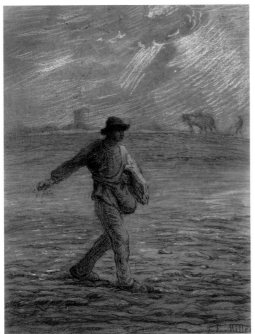 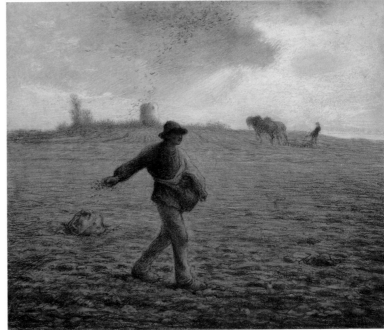

Fig. 16. Jean-François
Millet, *The Sower,* 1865.
Pastel and crayon or
pastel on cream buff
paper, 43.5 × 53.5 cm.
Baltimore, The Walters
Art Museum. Bequest
of Henry Walters, 1931
(37.905)

Fig. 17. Jean-François
Millet, *The Sower,* 1865.
Pastel on paper, 47 ×
37.5 cm. Williamstown,
Massachusetts, Sterling
and Francine Clark Art
Institute. Gift of Mr. and
Mrs. Norman Hirschl
(1982.8)

Fig. 18. Jean-François
Millet, *The Sower,* 1865.
Pastel on tan paper,
29.8 × 24.1 cm. Pitts-
burgh, The Frick Art &
Historical Center (1984.9)

Fig. 19. Jean-François
Millet, *The Sower,*
ca. 1866. Pastel on
black crayon and
pale brown paper,
36 × 43 cm. French
& Company LLC,
New York

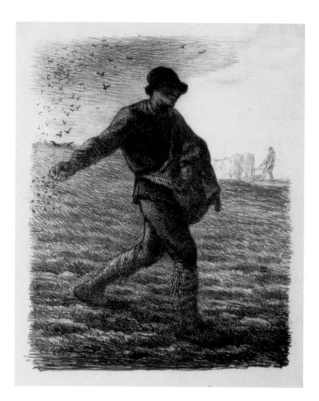

Fig. 20. Jean-François
Millet, *The Sower,* n.d.
Lithograph on cream-
colored paper, plate:
19.1 × 15.6 cm. Pitts-
burgh, Carnegie Museum
of Art. Gift of Andrew
Carnegie (16.18.1)

Fig. 21. Jean-François
Millet, *The Sower.* Original
lithographic stone,
canceled, 27.6 × 21.8 cm.
London, The British
Museum, Department
of Prints and Drawings

as a free interpretation rather than an exact copy, fusing elements from both the Boston and Yamanashi versions.[111] Translating a painting into the print medium of black and white was a complex matter, particularly as Millet had to invert his composition on the lithographic stone (fig. 21). As he worked on the stone (now inscribed "cancelled"), Millet densely rendered his figure while leaving the area of sky to the left untouched in order to suggest a luminous distance. Millet created a powerful silhouette with a strong outline, counterbalanced by the more faintly drawn harrower and oxen in the distance. The rapid, diagonally hatched strokes of the lithographic crayon also successfully suggested the furrows of the field. As a novice to the medium of lithography, Millet may, however, have worried about the difficulty of clearly defining the backlit form of the sower. In January 1852, a proof was pulled for publication in the arts magazine *L'Artiste* but suppressed by Millet and Sensier, who apparently found it mediocre, perhaps concerned by the lack of tonal difference.[112] The figure is indeed very dark, while the complex configuration of the tunic and seed bag is barely discernible. The print was never published in Millet's lifetime, and all known proofs are posthumous, often on various colored papers.[113]

Thereafter Millet focused his printmaking on etchings and, from the early 1850s to the late 1860s, developed an experimental language in order to translate the effects of his paintings.[114] Many of these etchings were produced in limited editions for a small circle of admirers, but occasionally his prints reached a wider public. In 1861, Millet published an etching (fig. 22), after his Salon painting of the same year (fig. 23), in the prestigious art magazine the *Gazette des Beaux-Arts.*[115] In transposing his composition from the large painting to the tiny etching, Millet used a mediating preparatory drawing (Museum of Fine Arts, Boston) of exactly the same size as the etching. As was his practice, he then traced this onto his etching plate.[116] As he

translated his painting into the medium of etching, Millet favored a distinctive shorthand, using much hatching as well as curved marks of the etching needle to suggest a sense of volume. He employed an irregular, broken line to represent the silhouettes of the woman and the baby, particularly evident in the legs of the young child. He also added two drops of pure acid to the etched plate in order to create strong highlights on the heads of the woman and child.[117] The critic Philippe Burty described Millet's etching as "the free and slightly relaxed reproduction" of his Salon painting and continued, "it is greatly to be desired that M. J.-F. Millet himself might reproduce all his compositions in this way. His talent is too personal not to lose something in a reproduction by someone else."[118]

In contrast to Millet, Corot produced no prints after his own work,[119] but he collaborated closely with those who reproduced his work. Perhaps most notably, he worked in close association with his pupil, the painter-lithographer François-Louis Français (1814–1897).[120] From 1840, Français produced several lithographs after Corot's paintings,[121] including a print on lightly tinted blue paper (fig. 24) after *Une matinée* (fig. 25).[122] An accomplished painter, Français was highly

sensitive to Corot's nuanced light effects and succeeded in suggesting the trembling, golden light of early morning in Corot's painting. Français received privileged access to Corot's studio and reproduced the work in a stage before its final completion. There are thus differences to the staffage in the final work. In the painting, two girls emerge from the foliage at right, while, in the inverted lithograph, a young man, with outstretched arm, leads a girl toward the clearing. A shrub to the left of the oncoming couple in the lithograph was subsequently painted out in the picture. Français's work appeared in the prestigious arts album *Les artistes anciens et modernes* and helped publicize Corot's image to a wide audience.[123] The accompanying Latin verses from Horace's "Ode to Sestius" (on the arrival of spring) in the album— probably supplied by Corot himself— provided a classical gloss for the composition not evident from the Salon *livret* (where the painting was listed simply as "Une matinée"). These ran: ". . . Junctaeque nymphis Gratiae decentes alterno terram quatiunt pede . . ." (. . . joined with many a nymph, the comely graces beat the reviving earth with rhythmic tread . . .).[124] The influential arts administrator Philippe de Chennevières emphasized

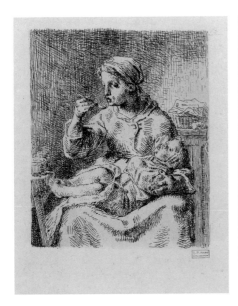

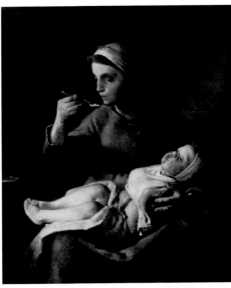

Fig. 22. Jean-François Millet, *Woman Feeding Her Child*. 1861. Etching, 15.4 × 12.8 cm. The New York Public Library

Fig. 23. Jean-François Millet, *Woman Feeding Her Child*, 1861. Oil on canvas, 114 × 99 cm. Marseille, Musée des Beaux-Arts (inv. 299)

Top:
Fig. 24. François-Louis Français, after Jean-Baptiste-Camille Corot, *Dance of the Nymphs (Une matinée)*, 1850. Lithograph. London, The British Museum, Department of Prints and Drawings

Above:
Fig. 25. Jean-Baptiste-Camille Corot, *Dance of the Nymphs (Une matinée)*, 1850. Oil on canvas, 94 × 131 cm. Paris, Musée d'Orsay (RF 73)

the importance of Français's lithograph in noting that it was the print that was largely responsible for Corot's Salon prize as well as for the sale of the painting to the state.[125] Corot himself paid indirect homage to Français's work by producing three repetitions, with varied light effects, after Français's reversed lithograph rather than his original composition.[126]

The wide range of repetitions produced by Millet and Corot navigated a course between aesthetic and market-driven motivations for repetition. In general, the practice of repetition was more important as a creative force for Millet, while for Corot repetition was motivated principally, although not exclusively, by commercial factors. There are also other differences in artistic approach, such as Millet's preference for repetition in multimedia in contrast to Corot's focus on painted repetitions. Nonetheless, an overview of the production of both men indicates that both considered their autograph repetitions—or variants—as "originals" in their own right and thus sought to create works that varied from their first treatment or "performance" of their selected theme. Rarely, if ever, did they produce exact replicas of their own works. Although neither Millet nor Corot intended their works to be exhibited in "series" in the same way as the later Impressionists,[127] they used their repetitions as a means to explore various kinds of invention, whether in terms of compositional and figural refinement or changes in atmosphere and light effects. The prominence of modernist rhetoric has emphasized the "original" compositions of both artists. It is now time to highlight the resonance of repetition within their artistic practice as well as in the wider context of repetition in nineteenth-century France.

Thanks are due to Thomas Crow, Eik Kahng, and Alexandra Murphy for their encouragement in the development of this essay.

1. "Corot tenait en grande estime le talent de Millet, qui, d'une certaine manière, se rapprochait du sien,— non certes par la facture,—mais par la sincérité. Au fond ils avaient tous les deux le même amour et le même respect de la nature; chacun la voyait selon son temperament, d'une façon différente, mais c'était la même ardeur dans la recherche de la vérité." Henri Dumesnil, *Corot: Souvenirs intimes* (Paris: Rapilly, 1875), 91.

2. See Nicholas Green, "Dealing in Temperaments: Economic Transformation of the Artistic Field in France in the Second Half of the Nineteenth Century," *Art History*, March 1987, 59–78.

3. See Alfred Robaut, *Corot* (Paris: Éditions Floury, 1884).

4. See Alfred Sensier, *La vie et l'oeuvre de Jean-François Millet* (Paris: A. Quantin, 1881).

5. This is reflected perhaps most notably in the evident fascination with Corot's plein-air oil sketches. See, for example, Peter Galassi's seminal *Corot in Italy* (New Haven and London: Yale University Press, 1992).

6. See Patricia Mainardi, "The Nineteenth-Century Art Trade: Copies, Variations, Replicas," *Van Gogh Museum Journal* 2000, 63–73; Roger Benjamin, "Recovering Authors: The Modern Copy, Copy Exhibitions and Matisse," *Art History* 2, no. 2 (June 1989): 176–201; Stephen Bann, "Ingres in Reproduction," in Susan Siegfried and Adrian Rifkin, eds. *Fingering Ingres: Essays in the Historiography of a Nineteenth-Century Artist* (Oxford: Blackwell, 2001).

7. See Institut de France, *Dictionnaire de l'académie des beaux-arts,* 6 vols. (Paris, 1858–96), 4:262–65, s.v. "copie." Extracts from the *Dictionnaire* are quoted in Mainardi, "The Nineteenth-Century Art Trade."

8. See, for example, *The Gleaners.*

9. The phrase has been used to describe the career of Jean-Auguste-Dominique Ingres (1780–1867). See Patricia Condon, Marjorie B. Cohn, and Agnes Mongan, "Ingres," in *Pursuit of Perfection: The Art of J-A.-D. Ingres,* exh. cat., Louisville, J. B. Speed Art Museum (Bloomington: Indiana University Press, 1983).

10. For an interesting comparison, see the recent exhibition of John Constable's "six-footer" landscapes with their full-scale preparatory oil sketches. *Constable's Great Landscapes: The Six-Foot Paintings* (Washington: National Gallery of Art, 2006). Millet's close friend and colleague Théodore Rousseau (1812–1867) also produced a full-scale sketch (Amiens, Musée des Beaux-Arts) for his enormous *La descente des vaches* (The Hague, Museum Mesdag) that was notoriously refused at the Salons of 1836 and 1838.

11. See Robert Herbert, "La laitière normande à Gréville de J.-F. Millet," *Revue du Louvre* 30, no. 1 (February 1980): 14–20. An example of the former (private collection) dates to ca. 1840 and is reproduced in Maura Coughlin, "Millet's Milkmaids," *Nineteenth-Century Art Worldwide,* Winter 2003. An example of the latter is in the Los Angeles County Museum of Art.

12. Millet also repeated the theme of the butter-churner over some three decades, culminating in an ambitious painting shown at the 1870 Salon to widespread praise (Yamagata Museum of Art, Japan). The critic Théodore Duret wrote of this work and a landscape, *Novembre* (destroyed in 1945), at this Salon, "il nous semble que . . . dans toute l'école moderne, il n'y a rien de plus grand que ces deux Millet." See T. Duret, "Salon de 1870," reprinted in *Critique d'avant-garde: Théodore Duret* (Paris: École nationale supérieure des Beaux-Arts, 1998), 47.

13. For the extensive literature on the *Sower,* see in particular Alexandra R. Murphy's excellent *Jean-François Millet* (Boston: Museum of Fine Arts, 1984), 31–34, reprinted *in Jean-François Millet: Sessanta capolavori dal Museum of Fine Arts di Boston,* ed. George T. M. Shackelford and Marco Goldin, Brescia, Museo di Santa Guilia (Conegliano: Linea d'ombra libri, 2005). See also Griselda Pollock, *Millet* (London: Oresko Books, 1977), 40–42; and T. J. Clark, *The Absolute Bourgeois: Artists and Politics in France, 1848–1851* (London: Thames & Hudson, 1973; repr. Princeton: Princeton University Press, 1982, and Berkeley and Los Angeles: University of California Press, 1999), 79, 82, 93–96. For a recent article on the *Sower,* see Pierre Rousseau, "'Le Semeur' de Jean-François Millet," in *Le Viquet: Parlers et traditions populaires de Normandie* (2004): 86–101, no. 143.

14. Millet may also have been inspired by the figure of a sower in *Autumn* by Jacopo Bassano (ca. 1510–1592) in the Musée Thomas Henry collection in Cherbourg, founded in 1835.

15. This small painting shows a figure sowing seed above a shoreline that resembles the view from the heights of Gruchy toward Cherbourg. See Lucien Lepoittevin, *Jean-François Millet, 2: L'ambiguité de l'image* (Paris: Laget, 1973), fig. 66. The present location of this work is unknown.

16. This is probably the work that Sensier remembered seeing as an unfinished *ébauche* in Millet's studio in 1847. See Sensier, *La vie et l'oeuvre de J-F. Millet,* 100.

17. Rachel Turnbull, paintings conservator at the National Museum and Gallery, Cardiff, has noted:

"In infra-red, the upper outline of the outstretched arm and the head of the figure is blurred, suggesting Millet's problems in fixing its final position." I am grateful to Ms. Turnbull for her valuable technical analysis of this work.

18. The work is, however, signed in red at bottom right (although it is unclear whether this is a later signature). Following Millet's death, the work was inherited by the artist's widow before being sold in the mid-1880s. It was exhibited in the 1889 Antoine-Louis Barye retrospective exhibition in New York (American Art Association, 15 November 1889–15 January 1890, no. 620), where it was noted in a review (accompanied by a crude line cut) that it had been purchased from the artist's widow "two or three years ago." See *New York Sun,* 19 November 1889.

19. Millet's fellow painter Charles Émile Jacque (1813–1894) apparently saw this version in Millet's studio in the fall of 1850 and told his Parisian friends that it would certainly be a triumph. See Étienne Moreau-Nélaton, *Millet raconté par lui-même,* 2 vols. (Paris: H. Laurens, 1921), 1:85.

20. Murphy, *Jean-François Millet,* 31.

21. No underdrawing is visible in infrared reflectography, and an x-radiograph reveals no evidence of significant compositional change. Thanks are due to Jean Woodward, conservator at the Museum of Fine Arts, Boston, for her assistance in the examination of this painting.

22. Often Millet's ideas first emerged in tiny, rapid jottings; the sense of energy in this figure probably traces its origins to a tiny pencil sketch (Paris, Musée du Louvre). In another drawing, Millet placed the sower in a horizontal composition with a harrower in the distance (private collection). See *Tableaux provenant de la collection d'un amateur,* Paris, Hôtel Drouot, 28 February 1936, no. 92. Two more "finished" drawings, in horizontal format (Oxford, Ashmolean Museum, and Musée de Dijon [donation Granville]), show the sower in an expansive plain. Two study drawings for the *Sower* are listed in Millet's studio sale ("119. Le Semeur. Croquis au crayon noir. 1851" and "120. Le Semeur. Croquis pour le tableau. Crayon noir. 1851"). See *Vente J-F. Millet,* Paris, Hôtel Drouot, 10–11 May 1875. Millet's early biographer, Julia Cartwright (*Jean-François Millet: His Life and Letters* [London: S. Sonnenschein & Co., 1896], 110–12), noted: "From this slight sketch [pen-and-ink work in Sensier] the artist, after his wont, slowly and painfully evolved his noble work. He has left us several drawings which enable us, step by step, to follow the development of his idea through its successive stages. We see how the figure gradually gained in breadth and vigour, and by degrees acquired that solemn majesty and

rhythm, until the homely theme became a grand and sublime poem."

23. The work has been squared up, but the drawing itself seems insufficiently detailed for actual use. On the back of this drawing is a sketch for the 1847 *Quarriers* (Toledo Museum of Art). This does not necessarily support a similar date for the *Sower* drawing, which Millet could have done at a later date.

24. Another sketch of the extended arm appears on the back of a drawing in the Musée du Louvre.

25. The sequence of the *Sower* paintings, from the Cardiff to the Boston to the Yamanashi work, follows Moreau-Nélaton's chronology, which in turn followed that of Alfred Sensier, who had access to Millet's studio around 1850 and whose account of the chronology was thus presumably correct. This has been the chronology followed by Millet scholars, including Robert Herbert, Alexandra Murphy, T. J. Clark, and Griselda Pollock.

26. See E. Moreau-Nélaton, *Millet raconté par lui-même,* 86. There is, however, no evidence of underdrawing in the Yamanashi painting.

27. This painting was originally 105 × 84 cm but has been cut down at left and bottom. This work has been seen as a compromise, largely because the figure does not seem to stride with the same powerful momentum. See Clark, *The Absolute Bourgeois,* 93–94.

28. See in particular the restorations in 1950 and 1965. The work was recently more sensitively cleaned (between December 2003 and March 2004), during which discoloring varnish was removed. See "Restoration and Technical Research of Jean-François Millet's Oil Paintings," *Bulletin of Yamanashi Prefectural Museum of Art,* no. 19 (2004).

29. Moreau-Nélaton (*Millet raconté par lui-même,* 86) noted of this work: "le pinceau febrile jette la pâte avec un emportement furieux."

30. An x-radiograph has shown that Millet, as was occasionally his practice, painted over an earlier image. Here, a figure turning a wheel (a stonecutter from Montmartre?) was originally at the top left of the canvas. Cross sections also reveal a number of paint layers, suggesting that Millet worked on this painting over a longer period than on the Boston work. See "Restoration Report on Jean-François Millet's *The Sower* in the Collection of Yamanashi Prefectural Museum of Art," *Bulletin of Yamanashi Prefectural Museum of Art,* no. 19 (2004): 54.

31. It has not been conclusively established which work was exhibited. Sensier and Moreau-Nélaton both stated that the Yamanashi work was shown at the 1850 Salon. However, the first owner of the Boston painting, William Morris Hunt, who acquired his picture from Millet's colorman and was a friend of the artist

himself, insisted that his work was shown at the Salon. See Murphy, *Jean-François Millet*, 33.

32. See Théophile Gautier, "Salon de 1850–1," *La Presse*, 15 March 1851.

33. In a letter to Millet of 29 January 1851, Sensier recorded the critical response to the work: "Les journaux parlent beaucoup de vos peintures. Taxile Delort [*sic*] les a beaucoup louées. Hier, dans le Vote Universel, on en faisait un bel éloge. L'Union . . . quant au Semeur, . . . trouve que vous calomniez ce type campagnard (c'est son expression): en résumé, que vous faites de la peinture trop socialiste?" Quoted in Valentine de Chillaz, *Inventaire général des autographes: Musée du Louvre* (Paris: Réunion des musées nationaux, 1997).

34. See François Sabatier-Ungher, "Salon de 1851," *La démocratie pacifique* 13 (Paris, 1851): 39–40.

35. "Pourquoi cette rudesse d'aspect, pourquoi ces teintes noirâtres et monochromes? Où M. Millet a-t-il rencontré un laboureur de mine si rebarbative, un ciel si somber, un paysage si désolé au temps de semaille?" See Auguste Desplaces, "Lettres sur le Salon," *L'Union*, 29 January 1851.

36. See Millet to Sensier, February 1851 (Aut. 1716): "C'est le côté humain . . . qui me touche le plus en art."

37. "[C]'est un peu troubler les heureux dans leur repos." See Millet to Sensier, undated but generally ascribed to 1863, quoted in Moreau-Nélaton, *Millet raconté par lui-même*, 2:138–39.

38. The facial expression is also rather different from the more anguished expression on the earlier two *Sowers*, while the use of continuous line is unusual in the context of Millet's more characteristic penchant for a broken line. In a 1942 auction sale, the work was described as "after Millet." See Harry P. Whitney Sale, Parke Bernet, New York, sale of 29–30 April 1942, lot 351. In 1962, Robert L. Herbert (*Barbizon Revisited* [Boston: Museum of Fine Arts, 1962]) considered the work autograph, suggesting that it was a preparatory study for the Yamanashi picture. Later, Herbert maintained this view of its authenticity, dating the work to the 1850s, although noting that Millet continued to work on the picture subsequently. He also referenced doubts expressed "because of its flat surface." Herbert, *Jean-François Millet* (Paris: Réunion des musées nationaux, 1975; London: Arts Council of Britain, 1976), 90. Alexandra Murphy also considers the work to be autograph and has dated it to the 1850s. See Murphy, *Jean-François Millet*, 34. The paint surface in the work is generally flat and thin but not inconsistent with Millet's similar unfinished *esquisses*. See, for example, *Men Digging (Les becheurs)*, Duluth, Tweed Museum of Art, University of Minnesota). A full-scale

drawing exactly replicates the Carnegie work (Collection Bernheim, Charpentier, 7 June 1935, no. 11, repr.). Another drawing closely resembles the picture (Sotheby's New York, 27 October 1998).

39. The name of Millet's dealer and framemaker, Paul Détrimont, was originally on the back of the Pittsburgh canvas (before relining). The Pittsburgh work may be the painting that appeared at the sale of the "Collection of Mr. B***" on 8 March 1883 and sold for the relatively low sum of 1,000 francs, perhaps being purchased by the sale expert, Détrimont. It was described here as an *esquisse* of the *Sower*. There were, however, no catalogue measurements, which makes it difficult to identify the work with certainty. It is also doubtful that the Pittsburgh work can be called an *esquisse* (rather than an *ébauche*). Another smaller painted version of the *Sower* (46 × 38 cm, location unknown) appeared in the sale of the Walter Richmond Collection in 1899. This could have been the work in the 1883 sale.

40. See Herbert, *Jean-François Millet*, 90. On 4 October 1872, Sensier wrote to Millet, "Débarrassez-vous de la grande toile pour *un Semeur à venir* [Sensier's emphasis] en la faisant remiser dans ma maison." Quoted in Chillaz, *Inventaire général* (Aut. 3054). Millet had previously produced a repetition of his *Winnower* in the late 1860s.

41. The painting was acquired by Sensier after the 1851 Salon and hung in the bedroom of his Barbizon home until the early 1870s. The painting was sold by Sensier to the dealer Paul Durand-Ruel on 15 April 1872. Thanks are due to Caroline Durand-Ruel Godfroy for her assistance in providing information in the Durand-Ruel Archives about the *Sower*.

42. Millet *fils* was an accomplished artist in his own right who exhibited work at the Paris Salon in 1870 when he was only 19. Subsequently, he exhibited landscapes and peasant scenes at the Salon in 1879, 1880, and 1881.

43. In 1872, he also made copies after three of his father's paintings—perhaps as student exercises and perhaps including the *Sower*. Sensier's correspondence to Millet in the spring and summer of 1872 documents François *fils*'s evolving practice of copying his father's works (we know that previously he had also copied the work of Théodore Rousseau in the late 1860s). On 11 May 1872, Sensier noted, "Je suppose que . . . François ne souffre plus du tout. S'il ne dispose à travailler, priez-le de mettre en train les copies, afin de mettre le plus tôt possible les originaux à la disposition de Durand" (Chillaz, *Inventaire général*, Aut. 3044). The letter suggests that François was copying paintings recently purchased by Durand-Ruel from Sensier's collection. In April 1872, Durand-Ruel

had bought thirty-four Millet paintings and nineteen pastels from Sensier for 116,450 francs. Of these, the most well known was the Yamanashi *Sower*. On 12 July 1872, Sensier referenced Durand-Ruel's concerns about these copies: "M. Durand vous prie expressément, de ne laisser voir à personne et surtout à Brame les trois copies que fait François; recommendation importante" (ibid., Aut. 3050). On 16 October 1872, Sensier noted, "Voulez-vous dire à François de donner le dernier coup à une ou deux de ses copies, car il est probable que je remporterai au moins l'un des modèles" (ibid., Aut. 3055). This last letter makes it more probable that the *Sower* was one of the models, since this work would soon be on display at the dealer's London show in December 1872.

44. Personal communication to author from Alexandra Murphy, 8 January 2007.

45. The Pittsburgh work is remarkably close to Le Rat's 1873 *Sower* etching (fig. 7). According to Caroline Durand-Ruel Godfroy, there is no evidence that the Pittsburgh work was ever owned by Paul Durand-Ruel, dispelling the possibility that it might in fact have been this work that was the model for Le Rat's etching.

46. Van Gogh found Millet's image highly compelling. In September 1880, he told his brother, Theo, "I have already drawn 'The Sower' five times . . . and I am so completely absorbed in that figure that I will take it up again." *The Complete Letters of Vincent van Gogh*, 3 vols., 3d ed. (Boston: Little, Brown, and Co., 2000), 1:203, no. 135. He also made a drawing copy in 1881 (Amsterdam, Van Gogh Museum).

47. Artists thus responded to this increased demand, with Gustave Courbet creating a studio, while Charles Daubigny's stockbooks also reveal the degree to which he produced *répétitions*.

48. See, for example, Théophile Silvestre, *L'histoire des artistes vivants* (Paris: E. Blanchard, 1856).

49. See A. Robaut, *L'oeuvre de Corot: Catalogue raisonné et illustré*, 5 vols. (Paris: H. Floury, 1905), 3: nos. 1627, 1628, and 1629. For the fourth version, see Jean Dieterle, *Corot: Troisième supplément à* L'oeuvre de Corot *par Alfred Robaut et Étienne Moreau-Nélaton* [. . .] (Paris: Quatre chemins-Éditart, 1974), no. 26.

50. In contrast, Corot had great difficulty selling his more austere, large-scale early history paintings. *Hagar and the Angel* (New York, Metropolitan Museum of Art), for example, remained unsold in Corot's studio until his death. In a letter of 15 January 1873, he noted of this work, "Je n'ai absolument rien de disponible pour l'exposition (de Bordeaux). Je n'aurais qu'un ancient Agar dans le desert; ce n'est pas le chique [sic] aujourd'hui." Quoted in Robaut, *L'oeuvre de Corot*, 3:345.

51. A repetition of *Bathers of the Borromean Isles* (Williamstown, Mass., Sterling and Francine Clark Art Institute) was commissioned from Corot by Maison Goupil around 1872. It remained unfinished at Corot's death and was sold at his studio sale (lot 187) for 4,100 francs to a M. Lolley. A repetition of *Les Gaulois* (location unknown) "preparée par un des auxiliares de Corot, a été légèrement retouchée par lui, puis livrée à M. Cleophas." See Robaut, *L'oeuvre de Corot*, 3:356 (no. 2310).

52. See Renate Woudhuysen-Keller, "Observations Concerning Corot's Late Technique" in *Barbizon. Malerei der Natur—Natur der Malerei* (Munich: Klinkhardt & Biermann, 1999), 192–200.

53. There are at least three later variants of the more naturalistic 1835 Salon painting, *Vue prise à Riva* (Munich, Neue Pinakothek), which was itself based on the earlier plein-air sketch *Soleil couchant, site du Tyrol italien*, shown at the 1850 Salon (Marseille, Musée des Beaux-Arts); *Souvenir de Riva*, 1865–70 (Cincinnati, Taft Art Museum) and *Vue prise à Riva*, ca. 1860 (private collection), bought from Corot by the dealer Adolphe Beugniet. Several of these works were brought together in the 1996 Corot exhibition at the Metropolitan Museum of Art.

54. Musset, the French Romantic poet, had been an early supporter of Corot at the Paris Salon. The lines from *Le saule* ran:

Pâle étoile du soir, messagère lointaine
Dont le front sort brilliant des voiles du couchant,
De ton palais d'azur au sein du firmament,
Que regardes-tu dans la plaine?

(Pale evening star, distant messenger / whose face emerges blazing from the veils of the setting sun / On what object in the plain are you gazing / From your azure palace at heaven's breast?)

55. Dumesnil (*Corot*, 36) described the work as "une de ses compositions les plus délicieuses, pleine de rêverie, peut-être la meilleure de son oeuvre à cette époque."

56. Corot's work was in fact based on a study (now lost) made on a visit to Limousin in central France in 1851. The time of day represented has been the subject of some confusion. The painting was known by 1908 in Toulouse as *L'étoile du matin* and retains this title. Yet, as we shall see, when first exhibited in 1864, it was titled *L'étoile du soir (paysage)*—the title also given to the work by George Lucas, who presumably had heard from Corot himself.

57. Corot probably represents the opera singer Pauline Viardot (1821–1910), whose performances continued into the early 1860s. Viardot made 150 appearances as Orpheus in Gluck's *Orphée et Euridice*—one of Corot's

favorite operas. Hélène Toussaint has also suggested that Corot conflated his souvenir of Musset with his memory of the famous singer Maria Malibran (1808–1836), to whom Musset had dedicated some verses (and whom Corot himself had recorded on stage in some early sketches).

58. Thanks to Eik Kahng and Sabine Albersmeier, respectively, curator of eighteenth- and nineteenth-century art and associate curator of ancient art at the Walters Art Museum, for this suggestion. Corot was making sketchbook studies of antique statues in the Louvre from his early days as a student. See Peter Galassi, *Corot in Italy* (New Haven and London: Yale University Press, 1991), 63.

59. See the recent valuable technical analysis of the Toulouse *Evening Star* (including x-radiographs and infrared reflectograms) by Bruno Mottin, *Compte-rendu d'étude: L'étoile du matin* (Centre de recherche et de restauration des musées de France, 15 September 2006).

60. This date of 1864 was made with the same pigments as the signature in brown underneath and thus was not added at a later stage. Ibid.

61. See Société nationale des Beaux-Arts, 26, boulevard des Italiens, *Catalogue* (Paris: Imprimerie Jules Claye, 1864), Bibliothèque nationale, Cabinet des Estampes. The catalogue indicates that Corot showed four paintings, including no. 65—"*L'étoile du soir (paysage)*." The work was briefly reviewed by Philippe Burty: "Il nous resterait à parler surtout de *l'Étoile du soir*, de M. Corot, une des compositions les plus sereines et les plus réussies que nous connaissons de ce maître toujours jeune; mais l'espace nous fait défaut." See P. Burty, "L'Exposition du Cercle de la rue de Choiseul et de la Société nationale des Beaux-Arts," *Gazette des Beaux-Arts*, 1 April 1864, 371. As has previously been noted (see Gary Tinterow, Michael Pantazzim, and Vincent Pomarède, eds., *Corot* [New York: Metropolitan Museum of Art, 1996], 299), Dumesnil (*Corot*, 36) wrote of this painting that "il était à l'exposition du boulevard des Italiens en février 1860." Dumesnil's memories were, however, often unreliable, and he seems to have confused the dates of these two exhibitions, both of which took place in the same space on the boulevard des Italiens. Corot showed four works at this 1860 exhibition, all of which were of a small scale (certainly considerably smaller than the *L'étoile du soir*). One of these was titled *Crépuscule* (no. 122) but measured only 32 × 52 cm. See Robaut, *L'oeuvre de Corot*, 4:170.

62. See Mottin, *Compte-rendu d'étude.*

63. See Jules Buisson, "Salon de 1864," Union artistique de Toulouse, 25 June 1864.

64. Such practice of removing compositional elements is also evident, for example, in his work on *Orphée* (Houston, Museum of Fine Arts), exhibited at the 1861 Salon.

65. Technical analysis has demonstrated this second signature to be autograph. The pink color of the signature fluoresces in gray under ultraviolet light with an identical tint to the flowers scattered across the foreground, which were probably added at the same moment. Mottin, *Compte-rendu d'étude.*

66. The entries in Lucas's diary regarding this picture read as follows: 8 February 1864: "at Corot's & ordered repetition of evening star for 1000 fs for Ws. . . ."/9 February 1864: "In morning early to Corot with Ws & gave him an order for 2 pictures at 400 fs each & the repetition of the Evening star for 1000 fs & panel for myself for 300 fs—Asked if he could not put the whole at 2000 fs, replied in an indefinite manner that it was too little, but did not positively say that he would not."/5 March 1864: "Corot is to write me 3 days ahead of the completion of 'The evening Star.'/22 June 1864: "At Corot's & paid 1000 fs for Ws picture of 'L'étoile du Soir.'/17 January 1865: "At Corot's & took Ws picture of L'étoile du soir—Carried home to Ottoz to be varnished." Lilian M. C. Randall, ed., *The Diary of George A. Lucas: An American Agent in Paris, 1857–1909*, 2 vols. (Princeton: Princeton University Press, 1979), 2:171–91.

67. Thanks to Eric Gordon, head of paintings conservation at the Walters Art Museum, whose valuable technical analysis of this painting has shown that the Walters *Evening Star* had no underdrawing.

68. "Lorsqu'un amateur désire la répétition d'un de mes paysages, il m'est facile de la lui donner sans revoir l'original; je garde dans le coeur et dans les yeux la copie de tous mes ouvrages." Quoted in Silvestre, *L'histoire des artistes vivants*, 95.

69. It is also, of course, possible that Corot used sketches still in his possession to assist him.

70. Corot, for example, added two cows in the distance.

71. Millet, Honoré Daumier (1808–1879), and Antoine-Louis Barye (1795–1875) all used tracings. Lorenz Eitner suggests that Corot may have used a tracing to create the National Gallery version of *The Artist's Studio*, which is virtually identical to the Louvre version (RF 1974). See his *French Paintings of the Nineteenth Century, 1: Before Impressionism* (Washington: National Gallery of Art, 2000), 72. Fronia Wissman has pointed out to me, however, that the technical notes in the National Gallery of Art catalogue indicate there was no scoring in the Washington image (which would result from tracing), nor was

78

there any underdrawing. This suggests that tracing did not, in fact, take place.

72. The work first appeared on the art market at the Henri Rouart sale in December 1912, when it was identified as a "première pensée" for the Toulouse painting (*Vente Rouart,* Paris, 9–11 December 1912, no. 146).

73. See Pierre Dieterle, Martin Dieterle, and Claire Lebeau, *Corot: Cinquième supplément à L'oeuvre de Corot par Alfred Robaut et Etienne Moreau-Nélaton* (Paris: Librairie Léone Laget, 2002), 126, no. 126.

74. Dieterle and Lebeau suggest that Corot painted the central figure and tree and sunset, while Oudinot produced the remainder of the picture (as well as the underpainting). They also suggest that the work was commissioned by the dealer Tedesco or perhaps the partnership of Alfred Cadart and Jules Luquet, who played a particularly central role among dealers in commissioning repetitions from Corot. See Dieterle, Dieterle, and Lebeau, *Corot: Cinquième supplément,* 126, no. 126. The reduction recently acquired by the Dallas Museum of Art after the 1855 Salon work *Effet de matin* (or *Bath of Diana*) was also (according to Martin Dieterle) commissioned by Cadart and Luquet. Thanks to Heather MacDonald, Lillian and James H. Clark Assistant Curator of Painting and Sculpture, Dallas Museum of Art, for this information.

75. According to Gerard de Wallens, Oudinot, an early teacher of Berthe (1841–1895) and Edma (1839–1921) Morisot was "capable, at his best, of equaling his master." G. de Wallens, *Diana Bathing,* in *Courbet, Corot y los pintores de Barbizon,* Museo Thyssen-Bornemisza Museum, Madrid (www.museothyssen .org). Oudinot's autograph production is very close in subject and style to that of Corot, and his exhibition titles suggest his own penchant for poetic scenes such as *The Evening Star.* Like Corot, Oudinot exhibited more naturalistic views alongside more "poetic" scenes at the Salon. In 1863, he showed a *Méditation* (location unknown) and, in 1864, *Solitude* (location unknown) together with *Bords de l'Oise* (location unknown).

76. This work was also commissioned by Cadart and Luquet. Corot himself may just have added the finishing touches, as well as (perhaps) the animals and figures. See Dieterle, Dieterle, and Lebeau, *Corot: Cinquième supplément,* no. 124.

77. It is not mentioned, for example, in the catalogue entry on *The Evening Star* for the 1996 Corot exhibition (Gary Tinterow, Michael Pantazzi, Vincent Pomarède, *Corot* [New York: Metropolitan Museum of Art, 1996]).

78. The painting was apparently discovered in a house in New Jersey with no accompanying documentation. I am grateful to Fronia Wissman for this information.

79. See Martin Dieterle's 8 March 1998 authentication document on the picture in the file at the Saint Louis Art Museum. The work does not appear in the 2002 fifth supplement to the Corot catalogue raisonné.

80. The picture left Corot's studio in the summer of 1864. If the Saint Louis work had not been painted earlier, it might have been painted at Toulouse.

81. The signature (or perhaps only the date?) may have been added at a later stage and (as was often the case with Corot) by another hand. If the work were a preparatory study, one would expect the inclusion of the trees that have been painted out in the "original" Toulouse version. It was also not Corot's practice to produce works of this scale as preparatory studies.

82. This is perhaps suggested by the degree to which this painting replicates the Toulouse "original." Corot's wholly autograph repetitions, as we have seen, often have significant differences from the "original."

83. For other late collaborative reductions, see the *Saint Sebastian* (Washington, National Gallery of Art), prepared by Alfred Robaut and Louis Desmarest, and another version of the *Dante and Virgil* (private collection), prepared by Georges Rodrigues. His late production for the market might, indeed, be compared to that of Gustave Courbet, who favored the extensive use of studio assistants.

84. See *Vente Corot,* Paris, 1875, 187: Paysage composé et Baigneuses, Variante du tableau lithog. Par Em. Vernier, 4,100 francs. 194: La Solitude, Variante du tableau exposé à Paris, 1866, 2,830 francs. 205: Les Nautoniers; soleil couchant, Répétition du tableau gravé par Marvy, 3,505 francs.

85. See *Vente Laurent-Richard,* Paris, Hôtel Drouot, 7 April 1873.

86. Millet did not exhibit his pastels at the Salon but may have displayed them at the private arts club of the Cercle des Arts on the rue de Choiseul. In early 1865, for example, he exhibited a group of drawings. Sensier wrote on 12 March 1865: "J'ai longuement causé avec Petit de votre exposition rue de Choiseul. Il constate que vous y avez un grand succès. Vos dessins ont triomphé de tous. Tout le monde m'en parle. . . . Je vous ai dit que vos dessins devaient de vendre aussi cher que ceux de Bida". . . . (Chillaz, *Inventaire général,* Aut. 2751). These "dessins" (Millet's own word for his pastels) may well have included pastels.

87. "Their [Gavet and the dealer Hector Brame] demands were insatiable and although they undoubtedly relieved Millet's financial difficulties they were perhaps responsible for a certain monotony in his later more finished drawings, particularly those in which color is introduced." See Kenneth Clark, *Drawings by Jean-François Millet* (London: The Arts Council of Great Britain, 1956).

88. "J'ai envoyé hier à Feydeau pour M. Delaporte un dessin, reproduction de la composition en grand de *l'hiver*." Millet to Sensier, 24 March 1865, Chillaz, *Inventaire général*, Aut. 2089. This large-scale pastel is now in the Burrell Collection, Glasgow.

89. Gavet was a major collector of Italian Renaissance art as well as contemporary painting. Not only did he commission pastels regularly beginning in 1865, providing Millet with a monthly stipend, but he also exercised creative input, providing the artist with different kinds of colored paper support.

90. This was commissioned by Gavet in the spring of 1868 for 1,000 francs, after the painting that Millet had exhibited in the early 1860s to critical acclaim (Walters Art Museum). Other large-scale repetitions for Gavet for 1,000 francs each included *Man Standing after Work* (Rochester), *Winter* (Glasgow, Burrell Art Collection) and *Men Digging* (Boston, Museum of Fine Arts).

91. Millet's biographer, Étienne Moreau-Nélaton, praised the artist's ability to make subtle changes to these pastel repetitions in order to keep the images fresh. Of a group of pastels completed for Gavet in April 1866 he noted, "la plupart de ces petits poèmes ne sont que des redites de sujets traits déjà à l'huile, au crayon, ou même au pastel. Mais Millet, on le sait, possède le talent de se répéter deux, trois, quatre fois ou davantage, en variant son theme de telle façon qu'il a l'air, sans cesse, de créer l'inédit."

92. Other reductions are in the Museum of Fine Arts, Boston, and the J. Paul Getty Museum. The work in the former also has pen-and-ink added.

93. Thanks to Elissa O'Loughlin, senior objects and paper conservator at the Walters Art Museum, for her observation of the "fibrous clumping" in the clouds, indicative of the presence of water.

94. At the beginning of January 1865, Millet received a commission from Moureaux, who asked him "de lui faire pour 1,000 francs de dessins." See Chillaz, *Inventaire général*, Aut. 2074). On 12 May 1865, Millet noted that he had sent two drawings to Moureaux: *Le semeur* and *Deux jeunes filles* (see ibid., Aut. 2098). Moureaux had played a prominent role in the print society, the *Société des Dix*, in the early 1860s, and previously acquired a number of Millet's paintings and drawings. The pastel was acquired by William Walters (through his agent George Lucas) in July 1884 for 10,000 francs. On 2 July 1884, Lucas wrote, "Paid Montagnac cash 10,000 fs for Pastel Millet 'Le Semeur.'" See Randall, *Diary of George A. Lucas*, 2:590.

95. This building has been identified as a telegraph tower (see *Jean-François Millet, Drawn into the Light* [New Haven and London: Yale University Press, 1999], 50) but was identified as a ruined windmill in Millet's estate sale. *La Tour du Moulin à Vent. Esquisse. Ruines d'un vieux Moulin dans la plaine de Chailly* (The Hague, Museum Mesdag), 1873.

96. Moreau-Nélaton wrote of Millet's pastel repetitions: "La veine de Millet a beau se cantonner dans son cycle familier, elle se renouvelle sans cesse et excelle aux trouvailles ingénieuses pour éviter les redites banales." See Moreau-Nélaton, *Millet raconté par lui-même*, 2:176–77.

97. De Thomas is first mentioned in a letter to Millet from Sensier on 3 February 1865: "J'ai une commande de Monsieur De Thomas le fils, [frère de la dame qui vous a acheté votre Bêcheur 200 francs]. Il désire un pastel, dessin en hauteur; nous en causerons" (Chillaz, *Inventaire général*, Aut. 2742). On 13 February, Sensier again wrote to Millet, "M. Dethomas fils m'a remis la mesure du dessin qu'il désire de vous. Il voudrait de sujet des Glaneuses . . . ou bien le Semeur, pareil à celui qui est dans ma chambre à Barbizon [Yamanashi Museum of Art *Sower*]. Je lui ai dit que vous choisiriez plutôt le premier, parce que vous n'aviez pas encore jugé d'une reduction definitive sur ce sujet que vous n'aviez traité qu'en grand. C'est du reste à votre choix" (ibid., Aut. 2744). Millet, however, seems to have put this project aside for three months and, in the meantime, to have produced his first *Sower* reduction—the pastel for Moureaux (Walters Art Museum—in horizontal, rather than vertical format).

98. On 12 May 1865, Millet wrote to Sensier asking again for details of the De Thomas commission: "envoyez-moi je vous prie aussi promptement que vous le pourrez la dimension du dessin pour Mr De Thomas, car l'heure vient de m'occuper de ma fin de mois qui est très lourde. Le sujet doit être des Glaneuses? Quel en est le prix, afin que je connaisse au juste mes resources?" (Chillaz, *Inventaire général*, Aut. 2098). On 17 May 1865, Sensier wrote to Millet, "Le dessin de Mr Dethomas sera payé 200 francs, il desire ou des glaneuses ou un semeur *en hauteur* [Sensier's emphasis]. Je lui ai écrit de vous envoyer la dimension" (ibid., Aut. 2762).

99. On 20 May, Millet wrote to Sensier, "J'ai reçu hier seulement les mesures du dessin pour Mr. Dethomas. Mon papier était tout tendu, j'ai commencé tout de suite. . . . Comme vous me disiez pour le dessin de Mr. Dethomas, des Glaneuses ou un Semeur, je fais un Semeur revenant à peu près à celui que j'ai fait pour Mr. Moureaux mais arrangé en hauteur" (ibid., Aut. 2099). On 23 May, he again wrote to Sensier, "Je termine le dessin de Mr. Dethomas" (ibid., Aut. 2102).

100. The paper has again discolored, although examination of unaffected sections on the edge indicates that it was originally fairly dark.

101. See *Jean-François Millet, Drawn into the Light*, 50.

102. In producing the figure of the sower in this and the other, smaller pastel (fig. 18, the Gavet work), Millet may have used a chalk drawing of exactly the same size (Museum of Fine Arts, Boston) as a template. The figure in this drawing has heavy, reworked lines, indicating its use for transfer. This is confirmed by the black chalk rubbing on the back of the drawing. This drawing has been dated to ca. 1858 (see Murphy, *Jean-François Millet,* 113) but it seems more probable that it in fact dates to the mid-1860s. There is a related drawing in the National Gallery of Art, Washington. Another drawing in the Louvre shows the same figure cut at the knees.

103. This may have been among the group of seven pastels that Gavet acquired in mid-April 1866. On 17 April 1866, Millet wrote, "Mr. Gavet est venu Dimanche dernier. Il a remporté 7 dessins dont il paraissait très-content" (Chillaz, *Inventaire général,* Aut. 2125).

104. See Alexandra Murphy, "Jean-François Millet: The Sower," *Nineteenth-Century European Paintings, Drawings, Watercolors and Sculpture,* Christie's, New York, 15 February 1995, 69, lot 84.

105. Since he knew Moureaux well, he could quite easily have copied the "original" work. That Millet's approach here was premeditated rather than spontaneous is further indicated by the record of the American painter Edward Wheelwright (1824–1900), who spent several months close to Millet in the mid-1850s and was a frequent visitor to the artist's studio. Wheelwright commissioned a repetition (New York, Metropolitan Museum of Art) after the *Shepherdess* (Cincinnati Museum of Art). He later recorded the artist's progress on both works: "Millet . . . worked upon the two pictures alternately, carrying first one and then the other a little in advance of its competitor, and in this way making both, as he himself thought, better than either would have been without this rivalry, as it were, between them. . . . *In several instances a touch, that might at first look like an accident, a slip of the brush, would be found to be identically the same in both, showing it to be the result, not of carelessness, but of deliberate intention.*" Edward Wheelwright, "Personal Recollections of Jean-François Millet," *Atlantic Monthly,* September 1876, 257–76 (emphasis supplied).

106. See the curatorial file at the Frick Art & Historical Center, Pittsburgh, indicating a provenance of Sensier and then Lebrun before the work was acquired through M. Knoedler and Co. by Henry C. Frick on 8 March 1899.

107. See, for example, the repetition of *Shepherdesses Watching a Flight of Geese,* sold to Gavet for 350 francs in 1866, in comparison to the 200 francs that the collector Adolphe Mame had paid for an earlier version.

108. See *95 Dessins de J.-F. Millet composant la collection de M. Gavet,* Paris, Hôtel Drouot, 11 and 12 June 1875, copy annotated with prices, Los Angeles, J. Paul Getty Museum.

109. See Vincent van Gogh to Theo van Gogh, 29 June 1875, in *Letters of Vincent van Gogh,* 1:28, no. 29.

110. For a valuable overview of the variety and importance of reproductive methods in mid-nineteenth-century France, see Stephen Bann, *Parallel Lines: Printmakers, Painters and Photographers in Nineteenth-Century France* (New Haven and London: Yale University Press, 2001).

111. The physique of the sower and particularly the contour of his prominent striding leg and the angle of his legs (with the back leg thrust back) are closest to the Boston version, as is the treatment of the straw around his legs. The horizon line also meets his arm in the same place as the Boston work. The configuration of the oxen and harrow in the distance are, however, closest to the Yamanashi work. The horizon line to the right also meets the seed bag in the same place as the latter painting.

112. On 16 January 1852, the collector and newspaper editor Ernest Feydeau wrote to Sensier that he had managed to cancel the printing only a few days before the print was due to appear: "je suis parvenu à faire supprimer la planche du Semeur. Mais comme on en avait déjà tiré un assez grand nombre (elle devait paraître Dimanche) il faut que Millet refasse gratis la même lithographie" (see Chillaz, *Inventaire général,* Aut. 2375). In a letter to Millet of the following day, Sensier continued to discuss the possibility of the printing of a lithograph: "Je vous envoie la lettre de Feydeau au sujet de la publication de votre Semeur. Le résultat n'est pas excellent comme produit: mais, si vous voulez faire la lithographie en tirant une cinquantaine d'épreuves pour vous, vous en tirerez une centaine de francs" (ibid., Aut. 2376). Millet never seems to have produced these "50 or so proofs."

113. Twenty-five prints appeared in 1889, numbered and signed by Millet's son-in-law, Heymann. The original lithographic stone (fig. 21) survives, now in the British Museum, with indication of the cancellation of the stone (at an unknown date after 1889). The fact that the stone was inscribed "cancelled" indicates that this was not done in France. The initials CF (or FC), however, are unexplained.

114. The importance that Millet ascribed to prints is, indeed, further suggested by the fact that many of his compositions (such as *The Gleaners, Two Men Digging,* or *Woman Carding*) were produced *first* as etchings.

115. This accompanied a catalogue of his prints by the critic, Philippe Burty. See Philippe Burty, "Les eaux-fortes de M. J-F. Millet," *Gazette des Beaux-Arts,* 1st series, 11 (September 1861), 262–66.

116. On 16 November 1863, for example, Millet noted of his progress on his etching, *Going to Work:* "Je commence aujourd'hui même à décalquer ma composition pour l'eau-forte, sur ma planche" (Chillaz, *Inventaire général,* Aut. 2020). There are around forty known tracings by the artist. Seven appeared in his posthumous sale. See *Vente Millet,* Paris, 1875: *Les Glaneuses.* Calque. 1857, 163. *Départ pour les champs.* Calque. 1857, 164. *La Cardeuse.* Calque. 1857, 170. *La Fin de la journée.* Calque. 1858, 185. *La Baratteuse.* Calque. 1860, 206. *Départ pour le travail.* Calque. 1865, 258. *Le Berger et la Mer.* Calque. 1872.

117. See Burty's account of his visit to Bracquemond's studio, quoted in Loys Delteil, *Le Peintre-graveur illustré (XIX et XX siècles),* 1: *J.-F. Millet, et al.* (Paris, 1906), no. 17.

118. Burty, "Les eaux-fortes de M. J-F. Millet," 265, quoted with translation in Murphy, *Jean-François Millet,* 132 n.13.

119. An exception is his cliché-verre of *Le petit berger* (Musée de Metz) from the 1840 Salon.

120. Dumesnil wrote of the friendship between Corot and Français: "Aussitôt qu'ils se sont rencontrés, une sympathie réciproque les attira promptement l'un vers l'autre et ils ses sont liés d'une amitié aussi profonde que durable; ils ont travaillé ensemble, et on connait les belles lithographies faites par Français d'après Corot; parfois il complétait quelques details, tout en conservant le sentiment très-juste de l'oeuvre de son ami, lequel voyant ces libertés de traduction ne s'en plaignait pas et a dit souvent: 'Voilà qui est bon, je me servirai de ça.' Et en effet, dans plusieurs de ses ouvrages il a mis à profit ce qu'il avait trouvé bon dans les interpretations de Français." See Dumesnil, *Corot,* 60.

121. Robaut recorded an interesting opinion, from Corot's father, about Français's first lithograph after Corot (*Le petit berger* after Corot's 1840 Salon work). Corot's father apparently considered Français's lithograph to be more important than his son's "original" painting. See A. Robaut, *Camille Corot* (repr. La Rochelle: Rumeur des âges, 1996), 27–28.

122. Jean Gigoux later highlighted Français's images after Corot as masterpieces of reproductive lithography. For discussion of *Une matinée* and the reproductive lithograph, see Renate Woodhuysen-Keller, "Observations Concerning Corot's Late Painting Technique," in *Barbizon: Malerei der Natur—Natur der Malerei,* 197–98.

123. Two reproductive prints by Français after Corot's work appeared in the album *Les artistes anciens et modernes,* no. 29; Corot, *Une matinée* and no. 118; Corot, *Soleil couchant.* One print after Millet appeared in this album, no. 100, by Adolphe Mouilleron after the *Couturières de village* (then belonging to Sensier). Français's first lithograph after Corot appeared in *L'Artiste* after *Le petit berger,* shown at the 1840 Salon. He also produced a lithograph of Corot's 1841 Salon painting *Democritus* that appeared in the "Illustration des arts de la littérature."

124. See the gloss at the beginning of *Les artistes anciens et modernes:* "Il semble qu'en introduisant dans son paysage ce groupe de figures antiques, le peintre se soit souvenu de ces deux vers d'Horace. . . ." The verses are from *Ad Sextium,* IV, book 1.

125. See Philippe de Chennevières, *Lettres sur l'art français en 1850* (Paris: J. B. Dumoulin, 1851), 75.

126. See, for example, the repetition in the Musée d'Orsay.

127. Nonetheless, it is noteworthy that posthumous exhibitions of their work—notably Millet's enormous retrospective at the École des Beaux-Arts in 1887—offered an opportunity for the display of various repetitions in ways that had never occurred in the artists' lifetimes. Such exhibitions served to highlight the range of Millet's and Corot's practice of repetition and may conceivably have affected the practice of the Impressionists. Pissarro, for example, visited the Millet retrospective and recorded his admiration for the artist's drawings and pastels. His overall attitude was more ambiguous. He noted "Les gens ne voient que le petit côté en art; ils ne voient pas que les dessins, certains dessins de Millet sont cent fois mieux que sa peinture, qui a bien vieilli." Letter to Lucien, 16 May 1887, in *Correspondence,* 2:169.

Charles Stuckey

Claude Monet's 4–16 May 1891 exhibition at the Galerie Durand-Ruel in Paris, featuring fifteen closely related paintings of wheat-stacks (*meules*), all but one painted within the past year and all sold within days of the opening, was a turning point in the artist's career. Henceforth Monet's near-exclusive concerns as a modern painter were the production and exhibition of multiple variations on a few compositions featuring a single subject: *Poplars* (exhibited 1892); *Rouen Cathedral, Floe Ice on the Seine, View of the Seine at Port-Villez, The Church at Vernon, The Village of Sandviken*, and *Mount Kolsaas* (all exhibited 1895); *The Fiord near Christiana, The Cliffs at Pourville, Petit-Ailly, and Dieppe, The Coast Guard Lookout House at Varengeville, Morning on the Seine* (all exhibited 1898); *The Water Lily Pond* (exhibited 1900); *Views of the Thames* (exhibited 1904); *Water Lilies* (exhibited 1909); and *Views of Venice* (exhibited 1912). Indeed, aside from his leading role during the 1860s and 1870s in the development of stenographic Impressionist brushwork as an idiom to record the capricious flux of visual sensations, Monet's dedication to making works in series and presenting these works as ensembles was his most important, influential, and abiding legacy to modern art. Even today, more than a century after Monet's historic 1891 exhibition, countless visual artists (not just painters) still make multiple versions of a single subject (representational or abstract) and present these together in solo exhibitions, as if the display of variations on a single theme in itself was inherently a modern mode of art expression. In an acclaimed exhibition in 1968 at the Pasadena Art Museum John Coplans made the case that Monet's works in series, coincidentally related to the development beginning in the 1870s of mathematical theories of serial order, provided the foundation for the ubiquitous series art of such heralded post–World War II innovators as Josef Albers (1888–1976), Ad Reinhardt (1913–1967), Andy Warhol (1928–1987), Donald Judd (1928–1994), and Frank Stella (b. 1936), to name but a few.[1]

Just what sorts of related works constitute series art is open to debate. Generally speaking, works in a series are made at the same time approximately, but there are cases (such as works by Albers) of variations ongoing over years, even decades. Moreover, the term "series" would seem to be limited to art motivated by some reason beyond the fulfillment of market demand for a particular image. The reason might equally well be conceptual (as the representation of stages in a changing sequence) and/or decorative (as in the multiplication of a single image in order to partly or completely surround a given space to create a mood). While the presentation of the related works as an exhibition ensemble seems integral to the fulfillment of series art, Monet, his predecessors, and his successors have seldom required that works in a particular series remain together.

The enormous significance of Monet's late works in series notwithstanding, for a variety of reasons there is surprisingly little available information about them. The disinclination to study series art seemingly has to do with the old-fashioned notion that great art transcends monetary issues, including commercial art displays. State-sponsored museum acquisitions of unique works in conjunction with large state-sponsored group exhibitions still provided the core structure for the development of contemporary art in the 1850s and 1860s. But already during these same years an international commercial gallery network very quickly began to provide artists with unprecedented exhibition opportunities and with access to ever more numerous clients. Monet's series exhibitions simply would not have been possible without the commercialization of contemporary art. While individual paintings representative of Monet's various series groups have always enjoyed acclaim, including museum status, in 1968 at the time of the Pasadena *Serial Imagery* exhibition, no scholar had yet bothered to determine the specific contents of any of Monet's series exhibitions in its entirety.

That began to change in 1972 with the publication of a catalogue raisonné of Monet's *Nymphéas* paintings by Denis Rouart and Jean-Dominique Rey. In their book, which includes listings of seventy paintings of water lilies done during the first decade of the twentieth century, these authors starred the specific works (now scattered by market transactions to museums and collections worldwide) that had been among the forty-eight listed in the catalogue of Monet's 6 May–5 June 1909 exhibition at the Galerie Durand-Ruel (*Les nymphéas: Séries de paysages d'eau*).[2] As if it lacked any interest, however, they provided no account of how or why they determined which works to star. This book was an inspiration to me as a young scholar in Paris in the late 1970s, when I was welcomed by Charles Durand-Ruel and his staff to consult the archives and library of the Galerie Durand-Ruel. Nearly every day I invented some new way to ask them for any scrap of information about the specific appearance of Monet's famous series exhibitions. But no installation photographs had ever been taken to show the order in which works were installed or how they were framed. No one had ever made, or bothered to keep, any installation diagrams. Although M. Durand-Ruel could show me some of the wine-red fabric that had served as the gallery's standard wall covering, the archives lacked an architectural ground plan of the exhibition space, with which it might have been possible to speculate generally as to how paintings on display had been grouped. Aside from coded gallery transaction records (invaluable as they are), all that was available to reconstruct the exhibitions were brief catalogues (with checklists and introductory essays) and, of course, widespread, if generally superficial, press coverage. It is worth considering how the exclusively literary record concerning Monet's series exhibitions has resulted in a history of Impressionism far more concerned with what was written about publicly displayed art than with what specifically was on view.

The publication beginning in 1979 of the last four (of five) volumes of Daniel Wildenstein's model Monet biography and catalogue raisonné was a milestone with respect to the establishment of concrete information about Monet's one-artist exhibitions. Wildenstein's publications brought together reproductions of every known work by Monet and determined, as far as it is possible to do so, which specific works were included in every exhibition that Monet himself helped to organize.[3] In retrospect, it seems unfortunate that Wildenstein, given his access to all these reproductions, stopped short of providing a special exhibition-by-exhibition section for his catalogue with the contents of each individual show during the artist's lifetime reunited photographically to provide a vivid composite "picture" of what constituted these remarkable art events. Such an unprecedented catalogue feature would have done some justice to Monet's revolutionary innovations as a series artist. Unfortunately, the enormous difficulties and costs of arranging for loans or even reproduction rights continues to thwart exhibition and publication attempts to study the history of series art in concrete terms. Seldom if ever illustrated in surveys or even in monographs, the ensembles comprising the complex events in the evolution of series art continue to be disregarded. What is needed to grasp the foundational issues of modern series art in the second half of the nineteenth century is a fully illustrated reconstruction (with "blanks" to indicate any apparent gaps), of whatever can be salvaged about the contents of private sector exhibitions. An introductory compilation (in outline more than in depth) of some of the key events connected with Monet's series, this present essay should ideally include hundreds of illustrations. While I understand the need to do without them from financial and administrative necessity, their absence is a considerable shortcoming to be kept in mind.

1891–1892

Reporting on the prospect of Monet's 1891 *Wheatstacks* exhibition in an often-quoted 9 April letter to his eldest son, Lucien, Camille Pissarro (1831–1903) expressed dismay about his longtime friend: "I do not know how it is that Monet is not annoyed by limiting himself to this repetition of the same subject; such are the terrible effects of success."[4] As far as Pissarro could tell, aside from the accommodation of eager buyers, Monet had no other motivation to paint the same picture over and over. To be fair, Pissarro was rather exaggerating the repetition involved, since the fifteen *Wheatstacks* that Monet included in his 1891 exhibition were based on six or seven distinct compositions (figs. 1–13). This jealous outburst notwithstanding, by the end of the same year Pissarro was himself at work on his own series of paintings of the landscape observed from an upstairs window of his home at Eragny, not far upstream on the River Epte from where Monet lived at Giverny. "I was afraid that repetition of the same motif would be tiring," he wrote to Lucien on 26 December. "But the effects are so varied that everything is completely transformed, and then the compositions and angles are so different."[5] Pissarro's quick conversion to painting variations hardly comes as a surprise considering how series fever swept through the French art world of the 1890s. What comes as a big surprise, however, is how Pissarro at first disregarded the many ways in which Monet's *Wheatstacks* exhibition related to a steady flood of art based on variations, going back to their student days in the late 1850s.[6]

Series art was greatly at issue in the few months leading up to and following Monet's *Wheatstacks* exhibition in May 1891. In March the Galerie Durand-Ruel was at the disposal of Monet's series-minded mentor, Eugène Boudin (1824–1898), who presented thirty-four paintings (many with similar motifs), as well as an astonishing two hundred and

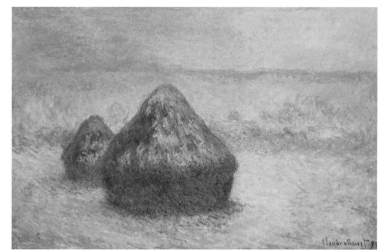

2

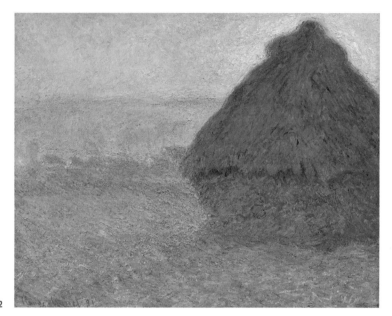

3

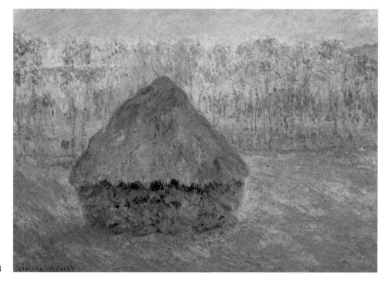

1

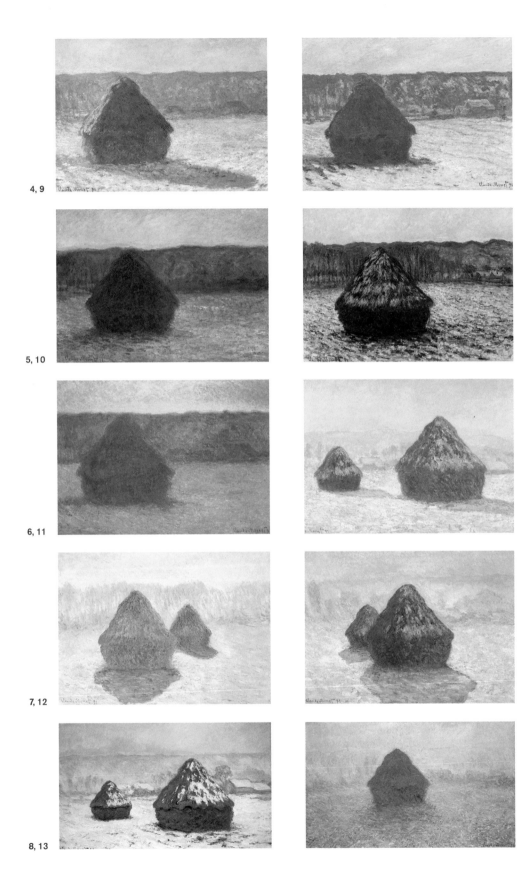

4, 9

5, 10

6, 11

7, 12

8, 13

Page 86:
Figs. 1–13. Claude Monet, *Meules (Wheatstacks)*, 1890–91. Oil on canvas.

Fig. 1. *Stacks of Wheat (Sunset, Snow Effect)*, 1890–91. 65.3 × 100.4 cm. The Art Institute of Chicago, Potter Palmer Collection (1922.431).

Fig. 2. *Grainstack (Sunset)*, 1891. 73.3 × 92.7 cm. Museum of Fine Arts, Boston, Juliana Cheney Edwards Collection, 1925 (25.112)

Fig. 3. *Grainstack in Winter, Misty Weather*, 1891. 65 × 92 cm. Private collection, courtesy of Ivor Braka

Page 87:
Fig. 4. *Grainstack (Snow Effect)*, 1891. 65.4 × 92.4 cm. Museum of Fine Arts, Boston, Gift of Miss Aimée and Miss Rosamond Lamb in memory of Mr. and Mrs. Horatio Appleton Lamb (1970.253)

Fig. 5. *Stack of Wheat (Thaw, Sunset)*, 1890/91. 64.9 × 92.3 cm. The Art Institute of Chicago, Gift of Mr. and Mrs. Daniel C. Searle (1983.166)

Fig. 6. *Haystacks at Sunset, Frosty Weather*, 1891. 65 × 92 cm. Private collection

Fig. 7. *Haystacks (Effect of Snow and Sun)*, 1891. 65.4 × 92.1 cm. New York, The Metropolitan Museum of Art, H.O. Havemeyer Collection, Bequest of Mrs. H.O. Havemeyer, 1929 (1929.100.109)

Fig. 8. *Grainstacks, Snow Effect*, 1891. 60 × 100 cm. Shelburne, Vermont, Shelburne Museum, Gift of Electra Havemeyer Webb Fund, Inc., 1972 (27.1.2-106)

Fig. 9. *Stack of Wheat (Snow Effect, Overcast Day)*, 1890–91. 66 × 93 cm. The Art Institute of Chicago, Mr. and Mrs. Martin A. Ryerson Collection (1933.1155)

Fig. 10. *Stack of Wheat*, 1890–91. 65.6 × 92 cm. The Art Institute of Chicago, Restricted gift of the Searle Family Trust, Major Acquisitions Centennial Endowment; through prior acquisitions of the Mr. and Mrs. Martin A. Ryerson and Potter Palmer collections; through prior bequest of Jerome Friedman (1983.29)

Fig. 11. *Wheatstacks, Snow Effect, Morning*, 1891. 65 × 100 cm. Los Angeles, The J. Paul Getty Museum (95.PA.63)

Fig. 12. *Haystacks, Snow Effect*, 1891. 65 × 92 cm. Edinburgh, National Gallery of Scotland (NG 2283)

Fig. 13. *Grainstacks, Sun in the Mist*, 1891. 60 × 100.3 cm. Minneapolis Institute of Arts, Gift of Ruth and Bruce Dayton, The Putnam Dana McMillan Fund, The John R. Van Derlip Fund, The William Hood Dunwoody Fund, The Ethel Morrison Van Derlip Fund, Alfred and Ingrid Lenz Harrison, and Mary Joann and James R. Jundt (93.20)

Opposite:
Fig. 14. Eugène Boudin, *Sky*, ca. 1854–60. Pastel on beige paper, 21.5 × 28.6 cm. Paris, Musée d'Orsay, donation Claude Roger-Marx (RF 36795)

Fig. 15. Eugène Boudin, *Cloudy Sky*, ca. 1854–60. Pastel on gray paper, 21.5 × 29.6 cm. Paris, Musée du Louvre (RF 16795)

Fig. 16. Eugène Boudin, *Sky at Sunset*, ca. 1854–60. Pastel on beige paper, 21.5 × 29.1 cm. Paris, Musée du Louvre, donation Camondo (RF 36795)

14

15

16

sixteen pastels, watercolors, and drawings. Given the dearth of studies devoted to Boudin's works on paper, it is all but impossible to reconstruct the contents of the March 1891 exhibition, which likely included works similar to the cloud studies that first got Monet thinking about series thirty-two years before (figs. 14–16). At the Salon des Indépendants, which opened in Paris on 20 March 1891, several artists showed groups of similar works nearly as interrelated to one another in composition as the various *Wheatstacks* in Monet's exhibition. For example, Georges Seurat (1859–1891) presented four closely related paintings showing the port of Gravelines near the Belgian border, and Henri de Toulouse-Lautrec (1864–1901) exhibited four separate portraits of male friends in evening dress. To be sure, lacking installation photographs of this large group exhibition, there is no way to know whether or not these works were displayed in tandem. Nevertheless the presentation of such similar works at the same venue is a good indication of how widespread series art was by early 1891. In early April 1891, when Pissarro wrote his cranky letter about Monet's upcoming solo exhibition, he himself showed what he referred to as "series" of pastels, watercolors, and etchings at the Galerie Durand-Ruel as part of a small display of his works together with those of his old friend Mary Cassatt (1844–1926), herself a longtime advocate of making closely related works and showing them in tandem.[7] It was at this April 1891 exhibition that Cassatt first showed her now famous suite of ten complex color etchings of everyday female activities. Cassatt displayed only one example of each of the ten etchings in the set at the Galerie Durand-Ruel exhibition, but with considerable effort, she had printed some two-dozen examples of every single image in the suite, no two colored alike. Presumably admirers could ask the gallery staff to show them variant impressions. Delighted with different states or impressions of a single image, such late nineteenth-

century print artists as Edgar Degas (1834–1917), Cassatt, and Pissarro often showed multiple versions of the same image together, sometimes in a single frame. For example, one of the items by Pissarro listed in the catalogue to the 1880 Impressionist group exhibition was "One frame: Four states of a landscape to be published in [a never-realized print periodical to be called] *Le jour et la nuit*." Keeping in mind the longstanding appreciation among print connoisseurs for different states and impressions, in 1891 Pissarro ought to have understood Monet's *Wheatstacks* exhibition as a way, without resorting to mechanical processes, to provide the same sorts of exquisite variations, challenging observers to appreciate slight differences between two or more otherwise similar images.

Like the different impressions of any one of Cassatt's etchings contemplated together or in sequence, the fifteen works in the May 1891 *Wheatstacks* exhibition constitute a "performance" of variations on a set theme, analogous in concept to the concert variations popularized earlier in the century by Nicolo Paganini, Franz Liszt, or Johannes Brahms. Hardly as abstract as modern music, however, Monet's variations record specific times of day and/or seasons of the year, and so as a group imply narrative sequence, documentation of the transformative powers of coming and going light. Since medieval times painters often created bookish cycles of works related in narrative sequence, sometimes as monumental decorative ensembles, the parts subservient to the whole. During the nineteenth century, suites of related images were widely available as albums of prints devoted to a single theme or as book illustrations, most often focused on the activities of figures. Considering his landscape bias, Monet may have had little special interest in book illustration, but like Cassatt he passionately admired Japanese master woodblock prints. As Edmond de Goncourt pointed out in 1896, all of the Impressionists were deeply indebted to Katsushika Hokusai's (1760–

1849) great suite of broadsheet horizontal-format woodblock prints, *Thirty-six Views of Mount Fuji,* published beginning around 1831.[8] Monet would have been aware of Hokusaï's famous cycle of landscape prints (promptly extended from thirty-six to forty-six views) already in the 1860s, and he would eventually acquire nine of the set for his own collection. Keeping in mind his decision to exhibit *Wheatstacks* paintings in series in 1891, it is worth noting that Hokusaï's works were featured in the large survey of Japanese prints presented in Paris in April 1890 at the École des Beaux-Arts.[9] It was the display of prints by Nishikawa Sukenobu (1671–1751) and Kitagawa Utamaro (1753–1806) at this same exhibition that prompted Cassatt to undertake her set of ten etchings to be printed in unique color variations.

Printmakers' ambitions aside, duplicate versions and variations had controversial importance to nineteenth-century sculptors, many of whom authorized limitless reproductions of their most popular works. In an ingenious commentary on the proliferation of mass-produced sculptures, Auguste Rodin (1840–1917) realized that he could compose complex figure groups by combining two or more casts of the same sculpture, as in the case of his so-called *Three Shades* (fig. 17), conceived as the pinnacle element for *The Gates of Hell.*[10] Indeed, this unorthodox work, composed of three identical figures, was among the thirty-six sculptures by Rodin included in a summer 1889 two-artist exhibition with one hundred and forty-five paintings by Monet at the Galerie Georges Petit in Paris. As if in dialogue with his friend Rodin, Monet made romantic paintings during the 1880s featuring more and more "sculpted" shapes—for example, isolated rocks, trees, or wheatstacks—and he included two, three, four, even six versions of some of these 1880s motifs in this in-depth exhibition.[11] A rather remarkable 1891 event in the history of modern French sculpture in editions must have been of considerable interest for Rodin. In

order to add *Ratapoil,* the controversial 1851 plaster sculpture by the late Honoré Daumier (1808–1879), to the state's modern art collections at the Musée du Luxembourg, on 16 February the Ministry of Fine Arts ordered an example in bronze. Although the state had never issued regulatory guidelines to control the number of versions made of any sculpture, it seemingly arranged for the casting of *Ratapoil* to be limited to as few as eight examples, each numbered in the bronze.[12] The Musée du Luxembourg obtained cast number "4" in December 1891. While the history of sculpture castings in the nineteenth century is far from satisfactory, to the best of my knowledge the 1891 casting of *Ratapoil* is among the earliest numbered editions on record.[13] With respect to prints, sculptures, or paintings, Monet and his associates, painters no less than dealers, were all well aware by 1891 that similar virtuoso objects released in multiple but strictly limited numbers had enormous appeal in the rapidly developing international contemporary art market.[14]

Fig. 17. Jacques-Ernest Bulloz, silver gelatin proof, undated, of Auguste Rodin's plaster of *Three Shades,* 26.5 × 33.1 cm. Paris, Musée Rodin (PH 2410)

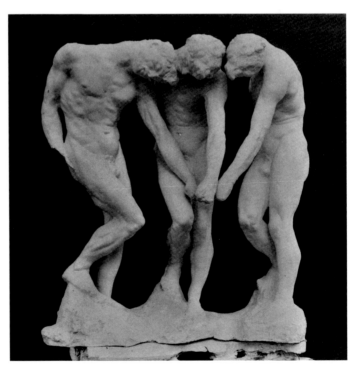

As interesting as they may be, such parallel series events taking place in 1891 provide little indication of what Monet hoped to achieve by creating works in series. Presumably his guiding motivations grew out of his own frustrations and ambitions during more than thirty years of painting landscapes directly from nature. But whatever his multifaceted reasoning, Monet was evidently somewhat taken by surprise by a conceptual question that arose when he exhibited fifteen of his *Wheatstacks* together in the same room: should the group of related works be kept together? During a chance encounter at Durand-Ruel's with the Dutch essayist Willem Byvanck, Monet explained, "[the individual paintings] acquire their full value only by comparison [with the others] and in the succession of the full series."[15] Probably lacking much expectation that individual collectors might buy multiple *Wheatstacks*, Monet had already begun to sell individual canvases by 1889. But the early ownership history of these pictures helps explain how very quickly the market for contemporary art changed in reaction to series works. Although little is known about Monet's transactions with James F. Sutton, the American dealer owned two of the earliest *Wheatstacks*. It seems likely that Sutton bought them in 1889 and thus may deserve the credit for pioneering a trend that snowballed in the months ahead. Following Sutton's lead, American collectors Alfred Atmore Pope and Harrison Whitmore each obtained first one, then a second, *Wheatstacks* painting, as if one all by itself was insufficient to convey the series artist's overriding idea. The Chicago hotel magnates Berthe and Potter Palmer did not see the May 1891 *Wheatstacks* exhibition in Paris, yet beginning in July they quickly bought one after another of these paintings, and by the summer of 1893 they owned eight or nine of them. Sadly, no photographs of the interior of their Chicago mansion show whether the Palmers installed them as an ensemble. Whether they bought the paintings

Figs. 18–20. John Leslie Breck, *Studies of an Autumn Day*, 1891. Oil on canvas, each 32.7 × 40.8 cm. Chicago, Terra Foundation for American Art

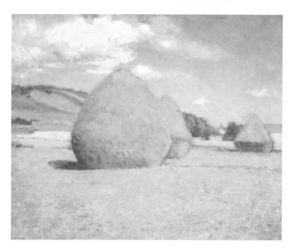

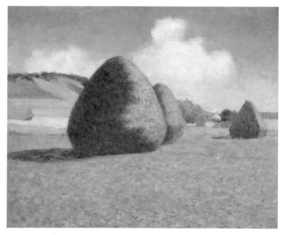

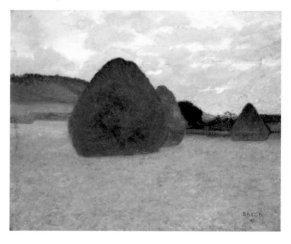

on speculation or out of some unprecedented conviction that works in series are best kept together, such patronage immediately bolstered Monet and other artists in the enterprise of making interrelated works for ensemble display.

While Monet was providing works for the Palmers in July 1891, the brilliant young American painter John Leslie Breck (1860–1899) returned to Giverny after a hiatus of nearly two years, engaged now to an American woman. Although his fiancée was not with him, Breck's mother, brother, and sister-in-law joined him there. Among the founding members of the international art colony in Giverny, Breck was perhaps closer to Monet and his family than any other young American. He stayed in the village nearly year-round from 1887 through the autumn of 1889, when his mother (possibly fearful about his affections for the daughters of Monet's partner, Alice Hoschedé) seems to have obliged him to return with her to Boston. In the autumn of 1891, while Monet was working from his studio boat on his *Poplars* series, Breck remarkably enough, undertook his own *Wheatstacks* series, fifteen small paintings (twelve of which are known to survive) with identical compositions, which he titled collectively *Studies of an Autumn Day* (figs. 18–20). Working in the field next door to Monet's house, where the older artist had already painted his celebrated *Wheatstacks* from 1888 through 1891, Breck for his part seemingly traced the outlines of the stacks and the Giverny hills in the background from one canvas to the next. Next Breck differentiated each painting in terms of colors and shadows in order to chart the course of a single day hour by hour. In the event, it took Breck three days to complete his paintings, which he subsequently arranged high on his studio wall, one work directly adjacent to the next, as if the ensemble had something like the decorative integrity of a frieze.[16] Considering the risks of ostracism in the art colony, it is hard to imagine that Breck would undertake this project without first obtaining Monet's blessing. Could it be that Monet encouraged Breck's experimental, albeit simplistic, approach to the series idea? After all, Monet himself would subsequently show a growing interest in the idea that a series of similar paintings could constitute décor. In 1897 he mentioned that he hoped to paint a group of *Water Lilies* paintings to be displayed around a dining room.[17] But in the autumn of 1891 something went seriously wrong with respect to any series dialogue between Monet and Breck. After the departure of Breck's mother and brother, in November 1891 Monet confronted Breck about his unacceptable treatment of the Hoschedé daughters and asked him to leave the village.[18] Regardless of whether Monet took displeasure with Breck as Lothario or as plagiarist, the American left with his *Studies of an Autumn Day*, and in 1893 he presented these paintings unframed as a dado at the Chase Gallery in Boston. This possibly was the first series exhibition in the United States. As far as is known, none was sold.

Meanwhile in Paris at the end of 1891 the Ministry of Fine Arts began to consider the acquisition of a painting by Monet's best friend, Pierre-Auguste Renoir (1841–1919), culminating in the purchase on 2 May 1892 of *Young Girls at the Piano*. With his models posed indoors and thus immune to the sort of shifting light conditions that transformed landscapes while Monet was at work, Renoir had no inherent motivation to develop this particular subject in five or six slightly different full-size versions, but nevertheless he did just that. A 4 April letter from the poet Stéphane Mallarmé to Roger Marx—his "accomplice" (in lobbying for this particular state purchase)—provides the first indication that Renoir was duplicating his picture. Mallarmé explained to Marx that the director of fine arts, Henry Roujon, had delayed his visit to Renoir's studio for health reasons and that the painter had taken advantage of the

extra time "to make the same painting just next [to the first version], and you will be at a loss to choose [between them]."[19] Although he made no reference to the fact, it should be presumed that Mallarmé was aware that Renoir had already sold a (third) version of the same subject to his dealer, Durand-Ruel, on 2 April.[20] It is unknown whether Renoir informed Roujon about this recent transaction when the director of fine arts finally came to his studio, nor whether Roujon saw more than a single version of the subject at that time. Whether to promote the state's new acquisition or Renoir and his dealer, Roujon gave permission to include the Musée du Luxembourg's latest acquisition in the context of a large exhibition of Renoir's paintings upcoming at Durand-Ruel's in May. It was presented on an easel in a separate room adjacent to the rest of the display. Apparently the dealer and Renoir chose not to display any other version rather than risk controversy with respect to the state's new purchase. It is not clear what to make of the dealer's purchase of another version of the same picture in June 1892. Had he already sold the version purchased in April to a foreign buyer? Or, the state sale finalized, had Renoir completed a new version and offered it to the dealer?

As if to respond to concerns about the state's acquisition of a non-unique work, an anonymous insider published information about the atypically numerous versions of *Young Girls at the Piano* in a newspaper article on 9 August under the subheading "La conscience du peintre" (The painter's integrity): "But we can testify that this canvas was preceded by five or six [others], begun over entirely one after another, and differing in nuances from one another. And we are not counting the numerous studies for each separate detail. Such is the extreme conscientiousness of M. Renoir. He knows and practices that profound and indisputable art axiom that time does not respect what is done too quickly."[21] The author of the article

may have been Arsène Alexandre, who had provided a preface to the catalogue for the May 1892 Durand-Ruel Renoir exhibition. Many years later, Alexandre contended that Renoir made so many different versions simply to achieve one that might be worthy of purchase by the state. If so, he had no scruples about selling the other versions immediately, as if, thanks to Monet's *Wheatstacks* exhibition, the market now authorized any artist to produce multiple series versions of any single subject.

Oddly enough, Renoir inscribed one of the versions of *Young Girls at the Piano* as a gift to his old friend, the painter Gustave Caillebotte (1848–1894). Perhaps Renoir wished to express gratitude for the important loans that Caillebotte provided from his personal collection to his important May 1892 Durand-Ruel exhibition. Perhaps Renoir wished to acknowledge how much he admired Caillebotte's own more dour treatment of the same theme of two woman at a piano, painted already in 1881 and subsequently a centerpiece in the collection of their mutual friend, Monet. However, since Renoir was the executor of Caillebotte's estate and thus aware of his longstanding determination to give his extensive collection of Impressionist art to the Musée du Luxembourg, should it not be asked whether Caillebotte and Renoir in 1892 shared an ambition to see two versions of a single work on display together at a French museum? Curiously, after Caillebotte's death in 1894, Renoir seemingly opted to omit *Young Girls at the Piano* from the list of controversial works offered to the state. Whether or not Renoir ever saw fit to exhibit similar works together à la Monet, he surely subscribed to thinking about art in series. According to his son Jean Renoir, "This question of 'subject,' as we know, concerned him not at all. He told me one day that he regretted not having painted the same picture—what he wanted to say was the same subject—throughout his entire life. That way, he could have devoted himself entirely to what constitutes creation

in painting: the relationships between forms and colors, which vary infinitely within a single motif, and which variations one grasps better when one no longer needs to concentrate on the motif."[22]

1859

What could be understood as the first series incident in the history of modern French art came about by accident, when during a visit to Honfleur in the spring of 1859 Gustave Courbet (1819–1877) met Boudin, who kept a studio there. At the time Courbet's old friend Charles Baudelaire was staying with his mother in Honfleur while composing an account of the Salon of 1859 (on view in Paris at the time) to be published in installments in the *Revue française*. Weary of writing reviews of the enormous Salon exhibitions of contemporary art, as he had since 1845, Baudelaire wanted in 1859 to describe the culture spectacle as if he had never bothered to go and see it. So rather than report about Boudin's painting on display at the Salon in Paris, Baudelaire decided to praise this emerging artist on the basis of works in the Honfleur studio—little quick sketches that would be out of place at any large public exhibition. Visiting Paris specifically to see the Salon of 1859, the nineteen-year-old Claude Monet must have been amazed to read about his mentor in the July installment of Baudelaire's review:

During a recent visit with Boudin (who, be it said in passing, exhibited a very good and sensible painting, *le pardon de Sainte Anne Palud*) I saw several hundred studies improvised in pastels while facing the sea and the sky. . . . [Boudin] has no pretension to consider these notes as pictures. Later he will certainly astound us with realized paintings of the prodigious magic of air and water. So quickly and faithfully sketched from what is most transient, what is most impossible to grasp in terms of form or color, from waves and clouds, these studies are always inscribed marginally with the date, the hour, and the wind condition, thusly,

for example: *8 October, noon, northwest wind*. If you have sometimes had the leisure to get to know such meteorological beauties, your memory would allow you to verify the precision of M. Boudin's observations. Place your hand over the inscription and you would be able to guess the season, the time of day and the wind condition. I am not exaggerating. I saw. In the end all these clouds with fantastic luminous forms, these chaotic shadows, these green-and-pink expanses, suspended and superimposed upon each other, these gaping furnaces, these firmaments of black or purple satin, crumpled, rolled up, or torn to shreds, these mournful horizons streaming with molten metal, all these depths, all these splendors, surged through my brain like a heady drink or the eloquence of opium. Curiously enough, it never once occurred to me in front of one of these liquid, aerial forms of magic to complain about the absence of man.[23]

Some of this commentary might equally well apply to the sky and sea photographs of Gustave Le Gray (1820–1882) celebrated in Paris already by 1857 and featured in the third Salon of the Société française de photographie held adjacent to the Salon of 1859 for conventional contemporary art.[24] Is it possible that Baudelaire (who vigorously disclaimed photography as a mere commercial enterprise) celebrated Boudin's cloud studies as a foil to Le Gray's efforts? Whatever the case may be, never before or afterward did any critic respond so passionately to any of Boudin's works in any medium. Courbet, Monet, and Boudin's other friends familiar with his sky studies must have assumed that he would quickly realize a group of exhibition paintings to fulfill the expectations of the influential Baudelaire. But Boudin never chose to do so, and so series painting got off to something of a false start. Be that as it may, the 1859 episode prefigured by some thirty years what would become Monet's ultimate ambitions as a painter: the loving accumulation of images of a constantly changing landscape spectacle observed with meteorological exactitude and

Fig. 21. André-Adolphe-
Eugène Disdéri, *The Legs
of the Opéra*, ca. 1864.
Albumen print carte
de visite, 8.8 × 5.1 cm.
Rochester, George
Eastman House, Gift of
Eastman Kodak Com-
pany, ex. coll. Gabriel
Cromer

Fig. 22. Félix Tournachon
(Nadar), *Twelve Self-
Portraits from Different
Angles: Study for a
Photo-Sculpture,*
from Petit folio vol. 1,
Eo 15b. Paris, Biblio-
thèque nationale de
France, Département
des Estampes et de
la photographie

poetic wonder. And Monet's lifelong series art rival, Edgar Degas, would arrange to buy not one, but as many as six cloud pastels by Boudin at the posthumous sale of works from the artist's studio in 1899.[25] Strictly by coincidence, it was also in 1859 that the American painter Martin Johnson Heade (1819–1904) dated the first of more than fifty paintings in which he would feature haystacks in New England marshes and meadows. But Heade, who invented new variations on the theme as late as the mid-1880s, is not known ever to have exhibited his paintings of haystacks in ensemble fashion.

Both in the United States and France in 1859 the most ubiquitous ensembles of similar images were those produced by professional photographers to meet the swelling demand for *cartes de visite*. Thanks to a process patented in Paris in November 1854 by André-Adolphe-Eugène Disdéri (1819–1889), a single collodion plate could be exposed section by section to capture the same sitter multiple times (most often six or eight). While the vast majority of these gridded multi-image prints were cut up into their component units to serve as fashionable illustrated calling cards, several photographers realized the appeal of composite sheets showing slightly differing poses of a single sitter.

1864

Disdéri took advantage of his own process to create a grid image of small photographs of the legs of dancers at the Opéra (fig. 21), and in order to take advantage of the sales potential of this pioneering series image, in 1864 he submitted an example to the dépôt legal in conformity with French reproduction laws.[26] Such early composite images in series prefigure in an astonishing way drawings made a decade later by Degas showing multiple close-up views of a single figure's head or feet. It was probably also in 1864 that Baudelaire's remarkable friend Félix Tournachon

(1820–1910), known as Nadar, made a composite photograph showing himself in the round, so to speak, the twelve different exposures on the single print, each registering his appearance from a different angle as he rotated his pose in 30-degree increments (fig. 22).

The earliest premonitions of Monet's series mindset date to 1864, when he began to paint duplicate versions of some works, presumably in accord with an entry in one of Boudin's notebooks from around the same time: "Resolution: Do not waste a minute. As much for my own instruction as for a likely profit, [I resolve to] undertake copies which I will make to see to it that I keep a duplicate for myself, in order to put it in my future salon."[27] Such duplicate versions aside, in 1864 Monet was hardly yet as series-minded as Courbet, who tended to produce groups of distinct works based on similar themes, like hunting, even though he never exhibited such works together as ensembles during the 1850s. With market opportunities in mind, however, Courbet wrote to his dealer, Jules Luquet, in the spring or summer of 1864: "I went to the source of the Loue recently and did four landscapes 1.4 meters long, more or less like those you have."[28] Of course, Courbet's most successful contemporaries took advantage of wide market interest in a single work by creating replica versions. For example, Jean-Léon Gérôme (1824–1904), after selling his much-acclaimed *Duel after the Masquerade* from the Salon of 1857 to the dealer Arthur Stevens, made two replicas in 1859 for the international market, one smaller than the original, one larger (see above, pp. 44–45, figs. 13–16). What significantly distinguishes Courbet's strategy with respect to his *Source of the Loue* variations is the fact that he painted these uniform-format works at the same time on speculation, without being commissioned. Such entrepreneurship would be essential to series art.

One final 1864 event to mention in connection with the early history of series is the

auction sale in February at the Hôtel Drouot of the works in Delacroix's estate. Baudelaire's passionate familiarity with the art of Delacroix notwithstanding, the poet-critic was evidently unaware that the leading Romantic artist had himself occasionally captured sky subjects with pastels. Otherwise in 1859 Baudelaire could not have been so surprised by the hundreds of sky pastels to be seen in Boudin's Honfleur studio. But Baudelaire would have finally seen these works at the preview to the Delacroix auction, as would Boudin, Degas, Manet, Monet, and everyone else in Paris with an interest in contemporary art. Seventeen studies of skies were among the pastels in lots 608–613. Coming as a revelation in series mode, Delacroix's pastels provided considerable momentum to a revival of chalk-based art during the remainder of the century.

1865–1867

In August 1865 Courbet took what he intended as a brief excursion to the seashore at Trouville and ended up spending three months there. He was joined in October by the American artist James Whistler (1834–1903) and his partner, Jo Heffernan. Miss Heffernan served as Courbet's model for a soulful painting of a woman caressing her hair while looking at a hand mirror, today known in four nearly identical versions.[29] Whether or not Courbet painted all four versions in quick succession, which seems unlikely, there is no record that he ever exhibited more than a single version of this "portrait." But the far more numerous versions of the Trouville seashore that Courbet painted in oils during the same months (as if determined to realize the full potential of the quickly drawn sky pastels of Delacroix and Boudin) would indeed be presented together in Paris and thus constitute nothing less momentous than the birth of series painting for exhibition. It goes without saying that presenting a group of nearly identical works in series could never be done at

Fig. 23. Gustave Courbet, *Seacoast (Marine)*, 1865. Oil on canvas, 45.8 × 53.5 cm. Cologne, Wallraf Richartz Museum (WRM 2905)

Fig. 24. Gustave Courbet, *Low Tide at Trouville*, 1865. Oil on canvas, 59.6 × 72.6 cm. Walker Art Gallery, National Museums Liverpool (acc. 6111)

Fig. 25. Gustave Courbet, *Marine*, 1866. Oil on canvas, 50.2 × 61 cm. Pasadena, The Norton Simon Foundation (F.1970.12.P)

the state-organized Salon, where individual artists were restricted by limited wall space. But series display was possible in the emerging theater of commercial gallery exhibitions, and the very possibility stimulated artists after Courbet to orchestrate related works in new modes of display.

Taken separately, Courbet's relatively small Trouville paintings (figs. 23–25), roughly ten of them lacking anything at all vertical, introduced a radical simplicity into modern French art, representing the vast "empty" space extending across sea and sky as a matrix for the most far-reaching vision, elemental yet cosmic. The caricaturist Gilbert Randon (1814–1884) summed it up enthusiastically in 1867: "Just as God extracted the sky and the earth from the nothingness, so M. Courbet extracts his seascapes from nothing, or almost nothing: three tones on his palette, three strokes of his brush, as he knows how to apply them, and, behold, an infinite sky and sea. Fantastic! Fantastic! Fantastic!"[30] Quite likely unaware of Courbet's precedent, such series-minded artists as Mark Rothko (1903–1970) and Brice Marden (b. 1938) would continue a century later to address the abstract implications of these heroically "empty" 1865 paintings of balanced rectangular zones. As if commemorating a truly signal event, Whistler immediately painted a "portrait" of Courbet observed from behind, standing on the beach to behold the spectacle that so obsessed him as a series painter. Curiously, Whistler's painting (which he repeated in a second version) amounts to a reprise of a unique 1854 seascape by Courbet that the American artist had never seen (since it had always belonged to the Montpellier collector Alfred Bruyas). Courbet's 1854 painting, borrowed from its owner for his large 1867 retrospective in Paris, includes a tiny figure of the artist making an apostrophe to the sea. Did Whistler undertake his so-similar painting in 1865 at the request of his French friend? (Or, did Courbet himself add a Whistleresque little figure to the

Bruyas painting when he borrowed it to include in his 1867 retrospective exhibition in Paris?) Courbet made no reference to the figure in his 1854 seascape when he mentioned that very painting in a January 1866 letter to Bruyas: "Last summer I went to Trouville for three months. . . . I did thirty-eight paintings in that place, including twenty-five seascapes similar to yours and . . . twenty-five autumn skies, one more extraordinary and free than the next."[31] Unfortunately, somewhat fewer than twenty of the works mentioned here by Courbet are accounted for today. Whatever the case may be, by April 1866 Courbet had exhibited a group of these Trouville seascapes at Luquet's gallery at 79, rue de Richelieu in Paris. The only record of this unprecedented exhibition, for which there was no catalogue, is contained in a letter from Courbet to his closest childhood friend, Urbain Cuénot, with whom he had shared the excitement of his first visit ever to the sea twenty-five years earlier: "Luquet's exhibition was very beneficial. I had twenty-five paintings, old and new, including my Trouville seascapes. Those seascapes done in two hours sold for twelve or fifteen hundred francs apiece. In certain painters' circles they call me a charlatan, a hoaxer, a humbug. . . ."[32] While he made no reference to the recent exhibition as such, the well-informed critic Théophile Thoré described Courbet's 1865 Trouville sea paintings in his review of the Salon of 1866: "And every morning, the [light] effects of the vast waters and the vast sky always changing, every morning [Courbet] did a study on the beach of what he saw, what he called 'sea landscapes.' He brought back forty paintings of an extraordinary perception ['impression'] and [the] rarest quality."[33] It is simply not known how many of the paintings in the Luquet exhibition sold, much less whether any single buyer thought to buy two or more similar compositions.

Perhaps motivated by the financial success of the Luquet exhibition, there were

increasing incidents of early serial art in the late 1860s. Courbet wrote to a Paris dealer named Bardenet in early 1867 about a new venture: "I have a series of snow landscapes that will be similar to the seascapes."[34] As of yet there has been no attempt to determine exactly which works Courbet referred to as an ongoing snow series, but roughly a dozen similar compositions datable to 1866 or 1867 are known, all indicative of Courbet's admiration for Japanese woodblock print motifs. Especially as concerns the wildlife portrayed, however, these paintings are rather more different one from the other than his seascapes, and as far as is known Courbet never showed the snowscapes together.[35] Presumably the painter had not made sufficient progress on this new series to include examples at the extensive retrospective exhibition of his works that he presented in Paris beginning at the end of May 1867.

It is most unfortunate that Courbet did not hire a photographer to take installation photographs of this historic 1867 exhibition. Consequently, it is not known whether he displayed similar works together in groups. He did divide his works into categories in the catalogue. For example, he included seven pictures (five can be identified) under the catalogue heading "snow landscapes." But these works differ greatly from one another and hardly constitute the series mentioned in the letter to Bardenet. Courbet's marine paintings were listed together in the same catalogue under the heading "sea landscapes" (*paysages de mer*), a neologism that Monet would evidently remember more than forty years later, when he used the term "water landscapes" (*paysages d'eau*) as a subtitle for the forty-eight *Water Lilies* he exhibited as a group in 1909. Among the "sea landscapes" in Courbet's 1867 retrospective were thirteen individual works showing boats and rocks and storms, to judge from the listed titles. Six of these thirteen works were borrowed from owners identified by name. But, as if they all still belonged to Courbet, no owner

was named with respect to ten other paintings, grouped together here as "various seascapes." Presumably these ten were among the forty or so 1865 Trouville paintings, grouped together now in the catalogue since there was no easy way to distinguish between them by title as variations on a single composition.

"Nothing, nothing, and nothing in this Courbet exhibition," noted Edmond and Jules de Goncourt in their diary on 18 September 1867. "At best, two ocean skies."[36] Yet Courbet's 1865 beach paintings would seemingly have served as ideal examples of the imaginary works described in *Manette Salomon*, the Goncourts' novel (which appeared in installments beginning in January 1867) about modern landscape painters at work at Normandy sites (including Trouville) capturing a series of successive changing effects of light.[37]

1868–1872

Early in 1868 yet another mostly undocumented event can be presumed to have greatly encouraged the series attitude: the 25 March auction sale organized at the Hôtel Drouot by Boudin, which included around a hundred of his pastels and watercolors. The near-impossible task of determining what works may have constituted this sale has never been attempted to my knowledge; yet it would seem likely that a group of pastels like those praised by Baudelaire in 1859 was included, as well as other small-format works with Boudin's specialty beach subjects.[38] Judging from the dates ("68," "1868") inscribed on three landscape pastels by Monet, Boudin's sale may have immediately prompted his protégé to make small, potentially saleable works. Executed in closely interrelated sequences of from three to six landscape images, Monet's pastels (the majority not inscribed with dates) constitute his earliest significant body of art in series. Yet these fragile works, seldom exhibited or even reproduced, remain unstudied in

relationship to his paintings, much less in relationship to works by his colleagues during the 1860s.[39] As for the group of more than forty seaside landscape pastels done by Degas in the late 1860s, nearly a dozen with similar compositions limited to sea and sky, recent studies have discussed them as an assimilation of the highly simplified and concentrated images by Delacroix, Boudin, and Courbet among others. Important to stress here is the fact that Degas likely created his own body of serial landscape work in response to seeing art in series on public display, whether at Courbet exhibitions or at the Boudin auction. In his remarkable 1993 exhibition catalogue, *Degas Landscapes,* Richard Kendall stressed the surprising fact that Degas (famously reluctant to release any of his works publicly), signed and dated eight of these pastels "69," as if he had special plans for them. Kendall speculated that Degas may have intended to put them on exhibition at that early date, possibly in a commercial gallery. Indeed, one could speculate even further that Degas hoped to collaborate with such colleagues as Boudin, Monet, and even Berthe Morisot (1841–1895) on some unrealized or unrecorded group exhibition or auction project featuring landscape pastels.[40] Whether or not there is any merit to such a hypothesis, it is worth noting that while seven of the signed Degas landscape pastels of the late 1860s are identical in dimensions, all but three show distinctly different compositions, suggesting that Degas was not as yet prepared to display very many too similar works together. All such speculation aside, Degas's relatively rare landscape series campaign in the late 1860s has rather enormous implications considering how fundamental the series concept would be throughout the remainder of the artist's astonishing career.

Series activity was intense during the summer of 1869, when Courbet worked at a little fisherman's house on the beach at Étretat, painting more than twenty versions of a single composition limited to a wave breaking as it comes ashore, demonstrating his virtuoso ability to observe and record nature's fastest transformations. When the sea was calm, he worked at other nearby motifs, including the cliff at the west of Étretat with its famously pierced rock formation extending into the sea like the buttress of a Gothic cathedral. He devoted as many as eight paintings to this particular motif, which would subsequently obsess Monet in the early 1880s. During the summer of 1869 Monet was working in tandem with Renoir on the Seine at La Grenouillère, a leisure establishment where Parisians came by train to boat and swim. Working side by side, each of the artists made three closely related "sketches" of the same locale. While they both intended to develop these into exhibition pictures, it seems nevertheless worth noting how their efforts this summer were carried out collaboratively in series fashion. But Renoir and Monet's incipient interest in series art was sidetracked, as were all contemporary art trends, by the outbreak of war in the summer of 1870.

As is well known, Courbet initially took an active role in the Commune, the provisional government established in Paris in March 1871, which soon splintered into extreme factions and collapsed when French national troops invaded the capital at the end of May. Seriously implicated in the destruction of the Vendôme Column on 16 May, Courbet was arrested in June and sentenced to spend six months at the prison of Sainte-Pélagie. But by the end of 1871 he was paroled for health reasons to house arrest at a clinic in Neuilly. Unable to cope with ongoing persecution in France, Courbet would soon flee to Switzerland, where he died in exile on the final day of 1877. Needless to say, Courbet immediately lost his status as France's leading contemporary artist, and even today many of his achievements remain overlooked. Given his pioneering role as a series artist, Courbet's sudden fall from favor seems, at least briefly,

Fig. 26. Gustave Caille-
botte, *Sky Study, Clouds,
1,* before 1879. Oil on
canvas, 24 × 37 cm.
Private collection, cour-
tesy Comité Gustave
Caillebotte, Paris

Fig. 27. Gustave Caille-
botte, *Sky Study, Clouds,
2,* before 1879. Oil on
canvas, 24 × 35 cm.
Private collection, cour-
tesy Comité Gustave
Caillebotte, Paris

Fig. 28. Gustave Caille-
botte, *Sky Study, Clouds,
3,* before 1879. Oil on
canvas, 24 × 32 cm.
Private collection, cour-
tesy Comité Gustave
Caillebotte, Paris

to have put an end to the growing momentum for art made as variations on a particular composition. As for himself, however, Courbet continued to make works in multiple variations. While in prison, for example, he began an extensive group of still lifes of fruits, mostly apples, possibly because the red color had left-wing political overtones. In five of these paintings the apples seem to turn brown on the ground underneath a tree. In another two the apples are on the seat of a stool. But in the greatest number of examples the apples (sometimes in conjunction with a pear or a pomegranate) are presented close-up, grouped on a tabletop, as if the artist was intrigued with the apple variations as he had once been with the variations in skies or waves. Never exhibited in Paris during Courbet's lifetime, these apple still lifes were seemingly known as a group only to those of his supporters, like Boudin and Monet, who visited him at the Neuilly clinic in 1872. There is no record of any visit paid by Paul Cézanne (1839–1906), the artist perhaps most deeply under Courbet's spell during the 1860s.[41] Yet, around 1877–78 Cézanne undertook a group of modest close-up images of apples on chair seats and tabletops in the spirit of Courbet, albeit evidently never intended for ensemble exhibition.

1873

It was thanks to Whistler that Paris again confronted the option of art in series. The London-based American expatriate had been with Courbet at Trouville in 1865 as the idea for series painting came of age, and in the coming years Whistler would revolutionize art with his demonstration that a commercial exhibition in itself could be orchestrated as an art event with the capacity to transcend the significance of any particular work on display. In January 1873 the Galerie Durand-Ruel in Paris presented an exhibition of Whistler's works about which too little is known.[42] The artist himself explained in

a letter to a colleague that in order to enhance a pervasive harmony to this exhibition he had designed his own frames, marked with his butterfly monogram, as were his pictures. The exhibition was briefly described by an unidentified journalist, who mentioned, aside from Whistler's *Self-Portrait* and *The Balcony*, "some views of the banks of the Thames in fog or at the end of the day. Everything is strictly monotone, either greenish blue or light yellow. . . . There is a glaring ambition to achieve the candor of Japanese prints."[43] There are relatively few views of the Thames that might be described as light yellow monotones: *Battersea Reach from Lindsey Houses* (Hunterian Museum and Art Gallery, University of Glasgow); possibly, *Nocturne in Blue and Gold—Southampton Water* (Art Institute of Chicago). But many of Whistler's similar-format blue-green Thames views survive. As individual works they are at least as similar to one another as are Courbet's 1865 Trouville beach scenes or Monet's *Wheatstacks,* begun in the late 1880s. Surpassing the simplification of Courbet's starkly divided compositions with two zones, Whistler limited himself to nocturnal scenes when sea and sky all but coalesce in visual terms.[44] With these variations Whistler verged on what today would be called "field" painting. If twentieth-century abstract painting can be said to begin anywhere, it would be with these monotones, first shown together, at least some of them, in Paris at the beginning of 1873. If Whistler's achievement gets virtually no credit in the history of Impressionism, that is because ensemble displays are fundamentally transitory, with the individual units dispersed by market decisions. Its enormous role in the history of modern art notwithstanding, series art still escapes historical notice because so little of it is left to see as first intended.

1874

The early 1873 Paris exhibition of Whistler's misty nocturnal river views aside, there is

unfortunately no way to know what prompted Jules de Goncourt to express the following series art wish in his diary for 24 February 1874: "If I were a painter, I would make an outline engraving of the background of Paris visible from the top of the Pont Royal. I would print a hundred proofs on coated paper [*papier collé*], and I would amuse myself by recording on them in watercolors all the tints awakened by the watery fogs of the Seine, all the magical colors with which our autumn, our winter paint this horizon with grayed plaster and blackened stone."[45] Despite Degas's exhortation to do so, Whistler opted not to join the French artists soon to be dubbed Impressionists, and, judging from his diary, Goncourt never went to see their historic first exhibition, which opened on 15 April 1874. It included a few series items, most notably groups of related pastels and watercolors by Boudin. Presuming that he framed them individually, Boudin showed four sky studies of the sort that had so enchanted Baudelaire back in 1859. Monet showed seven pastels, six of them framed as pairs, suggesting that variant views of the same image were on display. Serial or not, these relatively small-scale works on paper by Boudin and Monet were entirely disregarded by the many journalists who published accounts of the exhibition focused on the controversial paintings.

1876

One of the exhibitors in 1874 and again at the second Impressionist group exhibition in 1876 was the printmaker Ludovic-Napoléon Lepic (1839–1889), who had been close friends since the early 1860s with Monet and Degas. While Lepic did not show series art at these exhibitions, in 1876 he published a remarkable album of prints, titled *L'eau-forte mobile*, with a prologue explaining how he became an unconventional etcher who never inked his plate twice the same way. Capturing nearly as many variations as Goncourt had fancied in his 1874 diary entry, Lepic

explained: "My different versions are filed alphabetically at Cadart's publishing house and can be inspected by anybody. A landscape of the banks of the Escaut has been transformed in eighty-five different ways."[46]

Meanwhile, according to the catalogue of the 1876 Impressionist group exhibition, Degas showed five different images of laundresses (four paintings and a drawing), distinct compositions on a theme, rather than variations on a set composition, and he showed more than that number of works featuring ballet dancers. The fact that similar subjects are seldom listed sequentially in the catalogue suggests that his repetition of any particular theme has no significance beyond his catering to perceived market preferences. Entirely out of character, Degas's decision to present so many related works in 1876 was likely intended as a way to raise money following the deaths of his father and uncle and the eventual revelation of substantial family business debts. Besides what was on view in Paris at the Impressionist group show, Degas had works with Durand-Ruel's partner in London, Charles Deschamps. In April 1876 Deschamps sold four different dance paintings to the Brighton collector Henry Hill.[47] Berthe Morisot, the only female artist in the Impressionist group, used the 1876 Paris exhibition as an opportunity to display eleven works (out of a total of seventeen listed in the catalogue) made during the course of her 1875 honeymoon to the Isle of Wight: three pastels (listed as a single item, possibly displayed together in the same frame), three watercolors, and five small oils painted out-of-doors. The two of these bold, quickly painted works that can be identified on the basis of descriptions in newspaper accounts of the exhibition both feature a steamboat, and one of these two does not even bear the artist's signature as testimony that it is finished in any conventional sense (figs. 29 and 30).[48] This unsigned picture corresponds very closely to two other stenographic paintings by Morisot showing the same Isle of Wight

promenade alongside a yacht-filled harbor. Although one of the works is larger than those mentioned in the newspaper accounts, nevertheless it seems clear that she painted them one immediately after the other in sequential series fashion. There is nothing to indicate, however, that she included all of these works in the 1876 Impressionist exhibition as a series display à la Courbet or Whistler. But whether the five Isle of Wight paintings that she exhibited included close variations or not, Morisot's decision to show so many works painted in a single locale set an important precedent for Monet, who would soon undertake an even greater number of related paintings with the comings and goings, not of ships on a Channel Island resort, but of trains at the Gare Saint-Lazare in Paris.

1877

On display together in a room all their own, the twenty-three paintings and pastels exhibited by Degas (along with three groups of monotypes) at the third Impressionist exhibition in 1877 included eight pictures of the ballet, three pictures of spectators watching performers at café-concerts, and three showing women with bathtubs. But works on a particular theme are not necessarily listed together in the catalogue, nor did any press account discuss especially significant juxtapositions or groupings of similar works. Indeed, for the most part the differences among Degas's exhibited work on any single theme are as notable as the similarities. Supposedly both Degas and Pissarro used (long-lost) white frames for at least some of their works at the third Impressionist exhibition, although oddly enough such an innovation did not receive attention in the press.[49] Supposing these artists did introduce unconventional white frames, such framing would inevitably create a decorative association among different works on display by the same artist, and so foster a series mood. But the absence of press commentary about white frames or any other sort of ensemble

Top:
Fig. 29. Berthe Morisot, *West Cowes, Isle of Wight*, 1875. Oil on canvas, 48 × 36 cm. Private collection, United States, courtesy Galerie Hopkins-Custot, Paris

Above:
Fig. 30. Berthe Morisot, *Harbour Scene, Isle of Wight*, 1875. Oil on canvas, 38 × 46 cm. Private collection, United Kingdom, courtesy Pyms Gallery, London

installation suggests that series was not at issue. Many critics of the 1877 Impressionist exhibition were struck by one or another of Monet's paintings showing the glass-roofed shed of the Gare Saint-Lazare and the tracks extending beyond it, bustling with smoking trains, railway workers, and crowds of tiny passengers. But no writer mentioned that there were seven of them on display in total, variations on a single theme, nor that they were exhibited next to one another, as might be expected at this stage in the evolution of series art. They were not listed one after the other in the catalogue. Two were larger than the rest.[50] When the paint was likely still wet, Monet sold three of the *Gare Saint-Lazare* variations (including one of the large-format ones) to his most active collector, Ernest Hoschedé. But it seems unlikely that Hoschedé understood his particular group as a series "triptych," since he loaned only two of his newly acquired *Gare Saint-Lazare* paintings to the April Impressionist exhibition. Moreover, the fact that Monet sold a fourth *Gare Saint-Lazare* in March 1877 to a different collector before the opening of the exhibition indicates that he never had any interest in keeping the group of seven together as an ensemble. Monet apparently chose to paint so many examples of the train station theme for the same reason that Courbet in 1863 had painted so many versions of the *Source of the Loue*—because the dramatic paintings seemed likely to have broad market appeal.

Whatever Monet's original motivations, however, the seven *Gare Saint-Lazare* paintings in the 1877 Impressionist exhibition constitute the first documented act of series painting in the career of the artist who would come to personify series art. Moreover, there may be special significance to the fact that Monet's fellow Impressionist, Gustave Caillebotte, obtained three *Gare Saint-Lazare* paintings in March 1878. Sufficiently well-off to collect works by his colleagues, Caillebotte had written a will in 1876 specifying that his

art collection would be donated to the French national museums. His decision to acquire three *Gare Saint-Lazare* variations therefore might suggest that he and Monet now realized how a group of these related works had special significance beyond what any single work might have on its own. If they indeed thought this way, it was in vain, since only one of the *Gare Saint-Lazare* variations was eventually accepted when the bequest was negotiated with the Musée du Luxembourg in 1896.

Already by 1877 Caillebotte had himself caught series fever. An avid boater, Caillebotte executed two paintings and one pastel showing men rowing canoes and sculls on the Seine near his summer residence at Yerres. Expanding the group the following year beyond Monet's seven train-station paintings, Caillebotte eventually had a group of ten river sports scenes to show at the fourth Impressionist exhibition in 1879. But Caillebotte's conversion to series painting is probably first manifest in groups of small uniform oil studies done on his Yerres property. Quite similar in appearance to pastels by Boudin and Monet (examples of which he had seen at the 1874 Impressionist exhibition), four of Caillebotte's oil studies capture various cloud formations over the Briard Plain (see figs. 26–28), and six show a park lawn at different times of day.[51] Caillebotte's concern with recording the ever-different configurations of the same scene were shared this year by best-selling novelist Émile Zola, at work on the eighth of his interrelated Rougon-Macquart novels, *Une page d'amour* (serialized episodes of which began to be published in December 1877). As if emulating the concerns of his Impressionist painter friends, Zola structured this novel with a sequence of panoramic views of Paris observed at different times under different conditions, playing the role of a sort of Greek chorus as comment on the actions of his protagonists.[52] Since Caillebotte's Impressionist studies lack Zola-esque dramatic

108 overtones, however, and were evidently not intended for public display, it might be more appropriate to think of them as informal meteorological documentation. Mounted together as an ensemble, Caillebotte's studies would provide some of the same information organized in systematic grid-format meteorological charts. For example, the 25 May number of *La Nature* included an article about daily weather fluctuations in April 1878 with a full-page illustration consisting of a calendar grid of thirty identical little maps of France, each superimposed with a differing "map" of shifting daily air-pressure patterns (fig. 31).

1878–1880

The 14 December 1878 issue of *La Nature* introduced the French public to a break-through in the history of series art: the sequential images of a galloping horse and of a horse pulling a sulky, proto-cinematic photographs made in California by the British-born Eadweard Muybridge (1830–1904). While single images by Muybridge provided accurate new information about the appearance of bodies at particular stages of locomotion too fast for the human eye to see, sequences of his photographs demonstrated as never before the inescapable scientific value of images in series (fig. 32). As important, such strips of sequential photographic images established expectations about what series art should be and how to organize its display. For example, although Monet always avoided any sense of system in the presentation of his various series ensembles, some of his closest admirers expected him to arrange his paintings to show a logical sequence related to the measured passage of time. In 1895 Georges Clemenceau badgered Monet to let him rearrange the twenty *Rouen Cathedral* variations (see figs. 51–53) more systematically for the final ten days of their display at the Durand-Ruel gallery.[53]

As if commenting on the excitement of documenting movement with mechani-

Fig. 31. "Cartes quotidiennes du temps en avril, 1878, d'après le *Bulletin international de l'Obervatoire de Paris*," *La Nature: Revue des sciences*, sixième année, no. 260 (25 May 1878), 400

cal means, in the catalogue for the 1879 Impressionist exhibition, Degas listed among his usual variety of dance subjects, a painting titled *Dancer Posing for a Photographer*. At this exhibition Degas showed five ballet subjects in fan format, while Pissarro presented eleven fans decorated with farm scenes.[54] Needless to say, the format itself inevitably brought attention to these works as variations in series fashion. Aside from the already mentioned ten paintings on river sports subjects presented by Caillebotte, the series spirit was most evident at the fourth Impressionist exhibition in the room of works by the American newcomer, Mary Cassatt, four of which showed young women with fans in theater boxes, each distinct in composition and size but all orchestrated in tones of pink, red, and yellow, whether rendered in oils or pastels. These three artists—Degas, Pissarro, and Cassatt—began already in May 1879 to collaborate on plans for *Le jour et la nuit,* a journal with etchings to be issued the following

year. While never realized, the project nevertheless was responsible for groups of interrelated prints by all three artists at the 1880 Impressionist exhibition. As already mentioned, Pissarro listed in the catalogue a single frame containing four states of one landscape image selected to appear in *Le jour et la nuit.* In the same 1880 catalogue, Degas listed one item as "Eaux-fortes. Essais et états de planches" (Etchings. Impressions and states). Seemingly at issue was a printing known today as *Mary Cassatt at the Louvre: The Etruscan Gallery,* but it is not known how many of the nine states of this complex print he presented together as a work in process "sequence."[55] Cassatt herself listed two different states for two of the etchings in her section of the same exhibition. For some reason she preferred not to exhibit *Interior Scene,* which she had worked through thirteen different states, all of them acquired around this time by Degas, probably as a gift. For all of these artists the full set of different states of a single printed image clearly had a special significance beyond that of any particular image taken out of the sequence context, so it is to be regretted that the thirteen states of Cassatt's print were dispersed after the auction of Degas's collection in 1918.[56]

Meanwhile, during the severe winter at the beginning of 1880 Monet was trapped in

the village of Vétheuil when the frozen Seine thawed, creating icy havoc along its entire course. With only this single landscape subject at hand, Monet made around twenty closely related paintings. Although he never attempted to show these topical paintings as a group, from now on Monet made more and more versions of single motifs, as if the experience at Vétheuil had provided an unprecedented opportunity for him to realize the full potential of transcribing the same scene over and over, each time transformed by shifting atmospheric conditions.[57] With so many similarly composed paintings under way at the same time in his Vétheuil workspace, Monet presumably had a particularly meaningful opportunity to sense the potential beauty of serial art display. But at first Monet worked in series because of the considerable practical advantages. Instead of expending extra time getting himself and his supplies from one site to another, an out-of-doors Impressionist artist working in series could switch from one canvas to another as conditions changed. Returning to the same site day after day with the expectation that similar light effects would recur around a particular time, a painter could devote repeated sessions to the same subject, as long as there were no figures to take into account. This way, with the possibility of

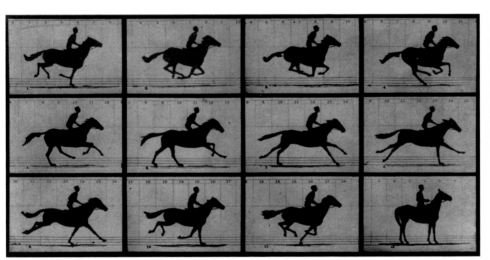

Fig. 32. Eadweard Muybridge, *"Sallie Gardner," owned by Leland Stanford, running at a 1:40 gait over the Palo Alto track, 19th June 1878.* Albumen print, 1878. Washington, Library of Congress, Prints and Photographs Division

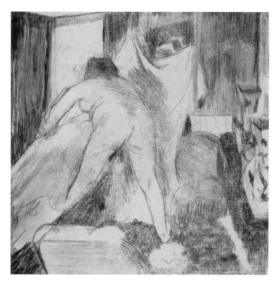

33

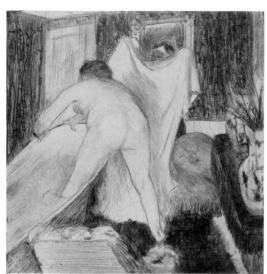

34

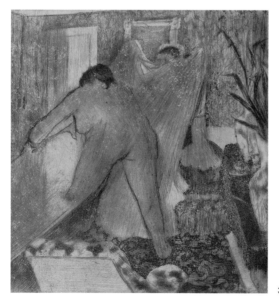

35

Figs. 33–42: Edgar Degas, *Leaving the Bath,* ten states, 1879–80. Approximate plate dimensions: 12.8 × 12.8 cm.

33. 2nd state. Etching and drypoint with burnishing. Fine Arts Museums of San Francisco; Museum purchase (1973.9.13)

34. 7th state. Electric crayon, etching, drypoint, and aquatint on laid paper. Ottawa, National Gallery of Canada, Purchased 1976 (18662)

35. 21st state. Electric crayon, etching, drypoint, and aquatint. Washington, National Gallery of Art, Rosenwald Collection (1950.16.47)

36. 11th state. Electric crayon, etching, drypoint, and aquatint. Austin, Blanton Museum of Art, The University of Texas at Austin, Archer M. Huntington Museum Fund, 1982 (1982.705)

37. 12th state. Drypoint and aquatint on laid paper. New York, The Metropolitan Museum of Art, Rogers Fund 1921 (21.39.1)

38. 13th state. Drypoint and aquatint. Northhampton, Massachusetts, Smith College Museum of Art, Gift of Selma Erving, class of 1927 (SC 1972:50-19)

39. 14th state. Etching and aquatint. Williamstown, Massachusetts, Sterling and Francine Clark Art Institute (1969.19)

40. 15th state. Drypoint and aquatint on wove paper. New York, The Metropolitan Museum of Art, Harris Brisbane Dick Fund, Rogers Fund, The Elisha Whittelsey Collection, The Elisha Whittelsey Fund, 1972, by exchange (1972.659)

41. 16th state. Etching, aquatint, and drypoint on wove paper. Williamstown, Massachusetts, Sterling and Francine Clark Art Institute (1971.39)

42. 20th state. Electric crayon, etching, drypoint, and aquatint. Washington, National Gallery of Art, Rosenwald Collection (1950.16.48)

43. Impression from canceled plate, printed 1959. Etching, aquatint, and drypoint. The Baltimore Museum of Art, Blanche Adler Memorial Fund (BMA 1960.128)

36, 40

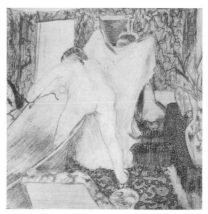 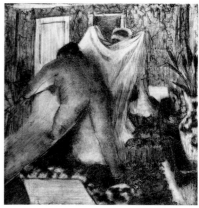

37, 41

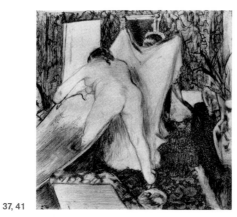 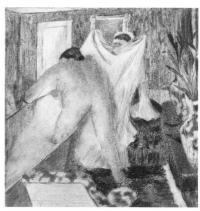

38, 42

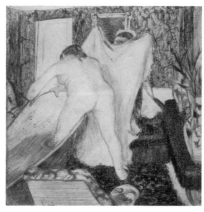 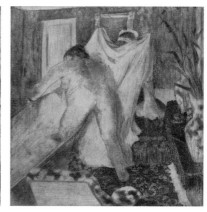

39, 43

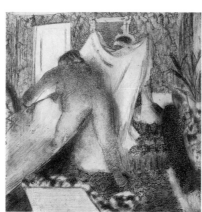 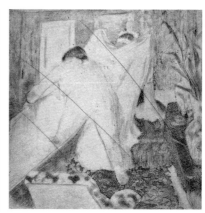

working on the same painting briefly day after day, the orthodox Impressionist committed to the truthful transcription of sensory experience, no matter how fleeting, and obtained extra time to achieve ever-richer detail in the transcription of very specific and fugitive appearances. One problem was that a painter might need to transport ten or more canvases to the same site. If the painter lived near his chosen subject, as had been the case in 1877 when Monet painted the Gare Saint-Lazare or in 1880 when he recorded the dramatic winter at Vétheuil, the transport of art supplies was relatively simple; but logistics were far more complex when Monet worked away from home, as he often would throughout the 1880s. For example, he needed slotted cases to transport a sufficient supply of canvases, all the same size in accord with the dimensions of each particular case. Similar subjects repeated on canvases of uniform format encouraged other forms of standardization—framing for example—and the simplification of such practical matters must be taken into account as factors in Monet's increasing predilection for making art in series, culminating in the 1891 exhibition of fifteen *Wheatstacks* that so annoyed Pissarro at first.[58]

1881–1884

Perhaps the most interesting early evidence of Monet's eagerness to make variations is a 9 December 1880 letter to his old friend Théodore Duret, confiding how he would like to spend a month in London making views of the Thames.[59] Nearly twenty years would pass before Monet could begin to realize this particularly Whistlerian series project, with roughly twenty to forty variations on three key compositional themes. In the meantime Monet went no further than the Normandy coast, where he now made three, four, and five examples of single motifs. Most significantly, having recently reestablished business dealings with Durand-Ruel after nearly a decade's lapse, in May 1881 Monet began to

sell two versions, sometimes three, of his most recent motifs to the dealer. In other words, the market immediately encouraged Monet's incipient series enterprise, and by 1882 the word "series" began to enter into the painter's correspondence with increasing frequency.

Returning to the Channel coast in February 1882 Monet now painted even more variations of individual subjects, especially views of isolated little houses overlooking the sea, treated in more than a dozen canvases. Again, as at Vétheuil in early 1880, the experience of surrounding himself with so many variations in his hotel room underway presumably heightened Monet's interest in groups of related works, as suggested in a 25 March 1882 letter to Durand-Ruel: "I will be in Paris for Easter, by which time I hope to have finished all my canvases. I already have some finished ones, but if it does not matter to you, I would prefer to show you the entire series of my studies at once, as I wish to see them all together at my home [in Poissy]."[60] In letters to his partner, Alice Hoschedé, he explained that he was devoting ten or more sessions to many of his individual paintings, without wasting any time during the day by relocating himself from one motif to another. He informed her, moreover, that he had gone so far as to hire a caddy to help him carry so many canvases to where he was working.[61] In what was becoming standard business between them, come April 1882 Durand-Ruel purchased three and four versions of some subjects from Monet's latest campaign. Moreover, while Monet was hard at work this way in Normandy, Durand-Ruel helped to arrange for a selection of his new works to be included in the sixth Impressionist group exhibition, which opened in Paris on 1 March. Judging from the exhibition checklist, there were no fewer than three versions of the same landscape image observed from the cliffs at Fécamp looking west. While Monet's stenographic brushwork in these uniform

format works greatly appealed to some journalists and greatly upset others, none addressed the series issue and its implications. Not surprisingly, Monet developed an approach to series art that would ultimately silence those critics who complained that Impressionist art was too hurried and sketchy. Predicated on the possibility of returning to the same site day after day at the same time to refine his work on the same canvas, Monet's practical approach to series allowed him to observe and render scenes with the sort of rich precision absent from early Impressionist painting. But no matter how much progress Monet made on this score, it would take him years to assert the decorative implications of serial display already so crucial for Whistler.

Indeed, there was no evidence of sympathy for series art where it might be most expected, for example, at the large retrospective Courbet exhibition in Paris in May 1882. A set of installation photographs of this Courbet exhibition indicates that the organizers, while including a few similar works as matching pairs, mostly avoided the central role of variations in his art. So preoccupied was Monet with painting Courbet-like variations on the coast of Normandy that he may not have taken the time to see this historic, albeit flawed, retrospective. But by the end of that same year, Monet urged Durand-Ruel to mount retrospective one-artist exhibitions (rather than group shows) in his relatively small gallery space. Exceeding such expectations, in February 1883 the dealer rented a larger space on the boulevard de la Madeleine and presented consecutive solo shows, starting with one devoted exclusively to works by Boudin—150 paintings, as well as pastels and watercolors. Given the extremely limited range of Boudin's motifs, this particular exhibition must have been something of a milestone in the history of display with serial overtones. But, as with so many of the likely constituting events in the history of series art, there has never been any special interest

in this timely survey of Boudin's profoundly influential art. For his part, Monet evidently missed Boudin's exhibition while he readied works for his own retrospective at Durand-Ruel's, opening at the end of February, with some sixty paintings, fifty-six of them listed in the catalogue. Of these, five (catalogue numbers 3, 27, 33, 42, and 47) showed various views of the abandoned coast guard lookout house at Petit Ailly.

But, again, without installation photographs, there are only two ways to evaluate the series component of Monet's 1883 exhibition, both inconclusive: the contents of the exhibition can be reconstructed, at least in part, from the gallery catalogue checklist; and press accounts, generally more abundant in the 1880s for commercial gallery displays, can be consulted. But do they provide anything like complete and careful coverage for issues of serial production and ensemble display? While several journalists in 1883 indeed praised Monet's achievement in demonstrating the fact that a single subject was entirely different when observed under transmuted conditions of atmospheric light, none mentioned any unusual matching or grouping as an installation feature to promote this essential serial issue.[62] As happens all too often, lack of press commentary encourages ongoing historical disregard.

Monet was greatly preoccupied when his exhibition closed—first of all, with moving his large household into a new home in Giverny and, second, with the death of his longtime friend Édouard Manet. Consequently he likely did not see the most remarkable of all series art displays on view in Paris in the spring of 1883. I refer to a group of works by Whistler, who only weeks earlier in London, in February 1883, had staged the most controversial yet of his artist-designed exhibitions—this, an installation of his Venice etchings.[63] Invited by Durand-Ruel's rival, Georges Petit, to show work at his gallery's second annual Internationale exhibition, which opened on 11 May, Whistler presented four so-called

Fig. 44. Edgar Degas, *Little Milliners,* 1882. Pastel on paper, 48.9 × 71.7 cm. Kansas City, The Nelson-Atkins Museum of Art, Purchase: acquired through the generosity of an anonymous donor (F79-34)

Nocturnes, according to titles listed in the checklist. The minimal seascape painted in Trouville late in 1865, with the miniature figure of Courbet observing the spectacle of clouds and waves to the far horizon, may have been the work listed as *Harmony in Blue and Silver.* Otherwise, it has been impossible to determine specifically which of Whistler's (presumably horizontal format) landscapes were exhibited at Petit's. Some vague idea of this key series presentation was, however, captured by the novelist J. K. Huysmans: "These were veiled horizons, glimpsed in another world, twilights shrouded in summery showers, river fogs, poetic flights of blue mist, a spectacle of indistinct nature, floating cities, languishing waters, everything mixed up in a daydream."[64] Why were not more journalists struck by Whistler's pictorial magic? Nationalist zeal?

It seems reasonable to assume that any emphasis on the refined display of pictures in series in 1883 was open to charges of commercialism at odds with the high-minded traditions of art created outside a market context. It is probably worth noting that 1883 was the year of publication for Zola's eleventh Rougon-Macquart novel, *Au bonheur des dames,* a somewhat troubling commentary on the burgeoning retail world of Paris department stores with ever-more-opulent displays of merchandise. Zola's

concern with shopping has its closest parallel, of course, in the series of pastels developed by Degas in 1882 on the theme of hat shops (fig. 44). As if both spoofing and endorsing serial art, Degas in each of these works includes near identical shop girls handling near identical hats. But, of course, throughout the 1870s, with his racehorse pictures (figs. 45, 46) and those devoted to the ballet, Degas had incorporated the series concept into scores of individual pictures of regimented look-alike figures.

Judging from the excited letters that Monet wrote from the Mediterranean village of Bordighera, where he suddenly installed himself in January 1884, the painter expected the opportunity to exhibit his ongoing series later that same year at Durand-Ruel's large rented gallery space on the boulevard de la Madeleine. Indeed, he even anticipated the imminent publication of an illustrated brochure about his art by Gustave Goetschy. (No such publication was realized.) In his excitement Monet went so far as to order frames for his only-just-begun works, to be ready upon his eventual return to Giverny. Even though he learned from Renoir at the beginning of February that Durand-Ruel had decided not to renew the lease on his large rented gallery space, thus foreclosing hopes for any exhibition, Monet nevertheless extended his Mediterranean campaign for another two months, making up to four versions of some motifs. But he never had any appropriate opportunity to show these works, and consequently his evolution as a series artist was stalled and frustrated in 1884.

Fig. 45. Edgar Degas, *Before the Race,* ca. 1882. Oil on panel, 26.5 × 34.9 cm. Williamstown, Massachusetts, Sterling and Francine Clark Art Institute (1955.557)

Fig. 46. Edgar Degas, *Before the Race,* 1882/84. Oil on panel, 26.4 × 34.9 cm. Baltimore, The Walters Art Museum. Bequest of Henry Walters, 1931 (37.850)

45

46

While he was in Naples on family business in January 1886, Degas famously wrote to his sculptor friend Albert Bartholomé (1848–1928), advising, "You must repeat the same subject ten times, one hundred times. Nothing in art must look accidental, even movement."[65] How similar in spirit to a description of Monet at work by Guy de Maupassant that was published in late September that same year: "[Monet] went along followed by children who carried his canvases, five or six canvases all depicting the same subject at different hours of the day and with different effects. He would take them up in turn, then put them down again, depending upon the changes in the sky. Standing before his subject, he waited, watched the sun and the shadows, capturing in a few brushstrokes a falling ray of light or a passing cloud and, scorning false and conventional techniques, transferred them rapidly onto his canvas."[66] Maupassant had himself witnessed Monet at work at the Normandy fishing village resort of Étretat, where during various campaigns from 1883 to 1885, Monet had painted more than twenty variations of the same image of the cliff at the western edge of the town, with its famous buttress and needle formation at the water's edge. Remarkably enough, given Monet's determination to paint in series this way and his ability to sell the variations, there was never an opportunity for him to show a substantial group of these works as an ensemble.

Degas, however, had such an opportunity, come 15 May, with the opening of the eighth and final Impressionist group exhibition. In addition to exhibiting several of his 1882 pastels showing the repetitious routines of hat retailing, Degas submitted ten pastels devoted to a single theme that had obsessed him already for a decade: nude women grooming in the privacy of their apartments. "Suite of nude women bathing, washing, drying, wiping, and combing themselves or having their hair combed" was how Degas

titled the group as a whole in the exhibition catalogue. Several of these pastels show slightly different stages in the ritual of a woman washing at a round floor tub, as if Degas shared the ambition fulfilled by Muybridge in 1887 with the publication of his classic *Animal Locomotion* to see images of different stages of a single action in proto-cinematic sequence.[67] As for the decorative ensemble quality of Degas's "suite" display, intentional or not, it may have had an influence on the young Georges Seurat, whose vast *Un dimanche à la Grande Jatte* dominated the 1886 Impressionist group show. Seurat spent the summer of 1886 in Honfleur, where he made six decoratively interrelated and notably stylized paintings of the port where Boudin had long ago amazed Baudelaire with his endlessly varied studies of clouds. As for Monet, who had already made an effort to acquire one of Degas's pastels of a woman at her tub (as he would finally manage to do in 1887), his participation in the final Impressionist group show was precluded by the terms of his invitation to show works at the fifth Internationale exhibition at the Galerie Georges Petit. Surprisingly enough, he opted to show a variety of different works at Petit's, rather than orchestrate a group of his variations, as Whistler had done at the same gallery three years earlier.

One wonders whether Monet, before leaving on 12 September for a long campaign on the Atlantic island of Belle-Île, saw a copy of the historic 5 September 1886 issue of *Le journal illustré,* which celebrated the one hundredth birthday of the great scientist Eugène Chevreul. For the occasion, Monet's longtime associate Nadar interviewed the venerable celebrity while his son Paul took sequential photographs of their conversation, a dozen of which were published now in series fashion, four to a page, a milestone achievement in photo-journalism (fig. 47).[68] Surely the painter could appreciate the parallels between these remarkable photographs and the five and six versions of single motifs

that he would capture at Belle-Île, working
through November on canvases of several
different formats (suggesting that he used
more than one shipping case), carried for
him by a porter. Still more commercially
successful than his 1880s works done in
Normandy or along the Mediterranean,
Monet's Belle-Île paintings constituted a
sort of series pictorial manifesto when the
artist included ten of them among the seven-
teen or more works that he put on display at
Petit's sixth Internationale, which opened on
8 May 1887. With only sparse documentation
it is impossible to determine exactly which
ten works were at issue or whether they were
grouped together, as would seem to have been
nearly unavoidable. It is likewise impossible
to determine exactly what Whistler included
at this same exhibition, although the titles
listed in the catalogue suggest that the Amer-
ican expatriate showed several groups of
related works among fifty small oils, water-
colors, and pastels. Although lacking any
reference to the subject of ensemble dis-
play, Monet's correspondence nevertheless
makes it clear that he hoped to show together
with Whistler—the innovation's foremost

advocate—at Petit's gallery again the follow-
ing year, if possible with Morisot and Rodin.

With this exhibition prospect in mind, in
January 1888 Monet returned to the Mediter-
ranean, where he painted from two to five
versions of some ten different motifs. In a
letter sent from Antibes, Monet confessed to
Alice Hoschedé his need to be wary of allow-
ing himself to go on with versions of a single
motif.[69] Meanwhile in Paris, Degas agreed
to show a group of his nudes again, this time
under the auspices of Theo van Gogh at the
Galerie Boussod et Valadon. The dealer's
brother, Vincent, would have seen this little
presentation prior to his departure for Arles,
where he immediately set to work as a series
artist. Writing to Theo in mid-April, Vincent
explained: "That will make six canvases of
orchards in bloom. . . . I dare hope for three
more, matching in the same way, but so far
they have got no further than embryos or
fetuses. I should like very much to do this
series of nine canvases. You see, we may
consider this year's nine canvases as the
first design for a final scheme of decoration
a great deal bigger (it would consist of size
25 and 12 canvases), which would be carried
out along just the same lines next year at the
same season."[70] By August, Vincent hoped to
decorate his studio in Arles with half a dozen
pictures of sunflowers.[71]

Both van Gogh brothers considered Monet
to be the greatest living landscape painter,
and Theo in June 1888 scored a coup when
he arranged to buy ten of Monet's brand-new
Antibes paintings (only two showing the
same motif) and negotiated the privilege of
first refusal as the painter's works might
come to market. Immediately Theo put the
"suite" of Antibes works on exhibit, to con-
siderable but hardly unanimous acclaim.
Pissarro reported to Lucien that Degas "con-
siders these paintings to have been made to
sell. Besides, he always maintains that Monet
made nothing but beautiful decorations."[72]
Used here disparagingly, to invoke superficial
and vulgar backgrounds little more ambitious

Fig. 47. Félix Tournachon
(Nadar), portrait photo-
graphs of Eugène
Chevreul, *Le journal
illustré*, 5 September
1886, p. 284. Paris,
Bibliothèque nationale
de France, Département
des Estampes et de la
photographie

than wallpaper, the concept of "decoration" was held in great esteem by, among others, Whistler, van Gogh, and Monet, all of whom aspired to orchestrate related works as an ensemble with greater significance than any of its constituent parts. The brilliant young critic Félix Fénéon was also unenthusiastic about the display at Boussod et Valadon, worried that Monet's new works showed no progress beyond the Étretat series that had so impressed him at the 1886 Internationale exhibition.[73] By 1888 Fénéon was altogether familiar with the series tendency in contemporary art, both its pros and cons. Reviewing the group exhibition staged concurrently at Durand-Ruel's gallery, the critic noted that Alfred Sisley's (1839–1899) paintings were not as interesting as his pastels, six of which showed the same desolate winter landscape in series fashion. Yet a few months later, in December 1888, when the critic reviewed a small exhibition of Sisley's new paintings at the Galerie Georges Petit, he complained that Sisley, who had "none of Monet's decorative genius," tended always to paint the same unattractive view of the Loing River, twenty times over in recent years.[74]

Fénéon expressed somewhat the same boredom when, during the summer of 1889, he saw the vast retrospective exhibition of Monet's art, in tandem with a Rodin retrospective, staged at the Galerie Georges Petit

Left to right:

Fig. 48. Edgar Degas, *Trotting Horse, the Feet Not Touching the Ground*, ca. 1881. Bronze, 23.2 × 27 × 12.4 cm. Fine Arts Museums of San Francisco; Museum purchase, Gift of Jay D. McEvoy in memory of Clare C. McEvoy and Partial Gift of the Djerassi Art Trust (1989.16)

Fig. 49. Edgar Degas, *Horse Walking*, model early 1870s, cast ca. 1920/1925. Bronze, 21 × 26.6 × 9.8 cm. Washington, National Gallery of Art, Gift of Mrs. Lessing J. Rosenwald (1989.28.2)

Fig. 50. Edgar Degas, *Rearing Horse* model early 1880s, cast 1919/1921. Bronze, 31 × 25.5 × 20.2 cm (with base). Washington, National Gallery of Art, Collection of Mr. and Mrs. Paul Mellon (1999.79.38)

during the Paris Exposition Internationale. Noting how many writers had described Monet's elaborate method of bringing several canvases to a given site and then switching from one to the next as light conditions changed in order to do justice to the beauties of diversity, Fénéon nevertheless felt that so many versions of a single scene rather exuded monotony.[75] He must have been referring to the presence of no fewer than six versions of a single landscape motif painted earlier on the Creuse River.[76] His brief commentary made no mention of two paintings each showing a pair of wheatstacks in a field at Giverny. Repeated again and again as serial variations during the next year, these *Wheatstacks* would finally establish Monet as the preeminent series artist of his generation when he exhibited fifteen of them at the Galerie Durand-Ruel in 1891.

After 1891

There is not space enough even to list, much less comment upon, the flood of series art incidents that followed the presentation of fifteen *Wheatstacks* paintings at Monet's 1891 solo exhibition at Durand-Ruel's gallery in Paris. Artists all over the world working in every medium are part of the story, from Henri de Toulouse-Lautrec, with his roughly sixty differently colored impressions of the famous 1893 lithograph showing the dancer

Loie Fuller; to Constantin Brancusi (1876–1957), who, not long after the presentation in 1908 of Monet's forty-eight *Nymphéas* paintings at Durand-Ruel's, began to sculpt his hallmark motifs, like sleeping heads and totemic birds, in ever more refined variations; to the impresario Alfred Stieglitz (1864–1946), whose photographs of clouds (*Music—A Sequence of Ten Cloud Photographs,* 1922) amount to a reprise in rich blacks and whites of the Boudin pastels that so amazed Baudelaire in Honfleur in 1859. In her diary for 26 March 1965, Susan Sontag opined, "Jasper Johns—Duchamp painted by Monet." The issues of virtuoso brushwork evoked by such an equation aside, Sontag somehow intuited here how, Marcel Duchamp's (1887–1968) outspoken disdain for repetition in art notwithstanding, the notion of series has been inescapable for such modern masters as Johns (b. 1930), with his obsessive reiterations of nearly every subject in his repertoire.[77]

Asked about his series over and again, Monet explained how he developed his method of painting variations in order to capture every shift in the envelope of colored light by undertaking as many distinct canvases as there were distinct spectacles. While he stressed the honesty and practicality involved for him in painting this way, however, Monet (unlike his friend Whistler) showed little concern for the most significant implications, whether decorative or philosophical, of presenting his variations as ensembles. Only in the summer of 1897 did Monet confide to a journalist that he hoped to decorate a circular room with paintings of the water lilies luxuriating in his famous garden pond; and, of course, he devoted the last decade of his life to painting mural-size *Nymphéas* to be permanently installed in two adjacent rooms at the Orangerie in Paris only months after his death.[78]

Rooms conceived with no other purpose than aesthetic delectation and meditation,

the Orangerie display is the culmination of Monet's series mode. Yet it is far from clear when and why Monet felt so obliged to perpetuate this way the full potential of series art that he had so concerned him throughout his career. After completing any given previous series, Monet had never made any effort to show it in whole or part at his famous Giverny home. Visitors commented that at best the painter was able to keep for himself but one example of each of his famous series. Still obscure and unstudied, a few remarkable events related to his paintings of the façade of the Cathedral of Notre-Dame at Rouen (see figs. 51–53) perhaps offer insight into Monet's evolving ambitions. Sensing the importance of these particular works, rival dealers and collectors sought to reserve examples in advance of the May 1895 exhibition at Durand-Ruel's Paris gallery, including a room with twenty *Rouen Cathedral* variations. According to the catalogue checklist, eight of the twenty already belonged to collectors, four of these to the Constantinopolitan banker Count Isaac de Camondo, who had recently begun to acquire key Impressionist works for his spectacular collection, intended as a legacy to France. Put on view at the Louvre in 1914 just weeks before the outbreak of World War I, the four *Rouen Cathedral* paintings that Camondo had acquired from Monet in the late summer of 1894 effectively established museum status for series art.[79] There is no way to know the extent to which Monet guided Camondo's extraordinary patronage, or whether the artist encouraged the collector to chose examples rendered in each of four distinct color modes, but it can be presumed that the sale was conditional on the promise that all four paintings would be included in the May 1895 exhibition.

That particular exhibition overwhelmed Monet's close friend Georges Clemenceau, future prime minister. Praising the exhibition on the front page of his nearly bankrupt newspaper, *La Justice,* Clemenceau called

upon the president of France to acquire the entire group, as if such an unprecedented purchase might still be possible, considering the fact that so many of the individual works were already sold. Using the sort of language characteristic of Baudelaire's most enthusiastic art writing, Clemenceau ventured that Monet's twenty works could be "divided into four series that I would call gray series, white series, rainbow series, blue series," and he further expressed the wish that the twenty works installed together in the same room could be arranged in series fashion: "Imagine them aligned on the four walls, as today, but serially, according to transitions of light: the great black mass in the beginning of the gray series, constantly growing lighter, the white series, going from molten light to bursting precisions that develop and culminate in the fires of the rainbow series, which subside in the calm of the blue series and fade away in the divine mist of azure."[80] When the greatly acclaimed exhibition was extended for eight days, Monet evidently invited Clemenceau to realize his notion of how best the works might be installed.[81] Whether the exhibition was indeed reinstalled this way is not known, but if so, each wall would have included one of the works obtained by Camondo, quite possibly with the intention to provide an abbreviated Monet series in perpetuity for the Louvre.

The enlightened criticism and patronage of Clemenceau and Camondo aside, series art has been its own worst enemy from a historical point of view. Seldom available to be viewed, except in fragmentary ways, too often beyond the means of collectors or institutions to purchase or accommodate, from its earliest beginnings series art has suffered from a sort of oblivion resulting from unavoidable deinstallations and dispersals. As a largely invisible force, however, the idea of series art continues still today to pervade the fundamental meaning of modern art when it seeks the insights that can come from looking lovingly at being in its flux, as often as it might take to perceive how things are.

 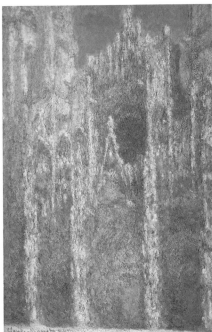 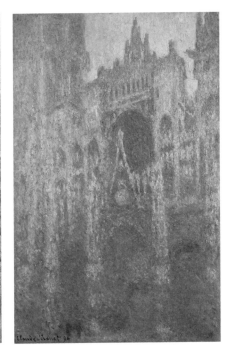

Opposite:
Detail of fig. 53

Fig. 51. Claude Monet,
*The Cathedral at Rouen
in the Fog,* ca. 1893. Oil
on canvas, 100 × 70 cm.
Museum Folkwang Essen

Fig. 52. Claude Monet,
Rouen Cathedral, Façade,
1894. Oil on canvas,
100.6 × 66 cm. Museum
of Fine Arts, Boston,
Juliana Cheney Edwards
Collection (39.671)

Fig. 53. Claude Monet,
*The Portal of Rouen
Cathedral in Morning
Light,* 1894. Oil on
canvas, 100.6 × 64.9 cm.
Los Angeles, The J. Paul
Getty Museum (2001.33)

1. John Coplans, *Serial Imagery*, exh. cat., Pasadena Art Museum (1968).

2. Although it omits any reference to Monet's 1909 gallery show (out of uncharacteristic oversight) Donald E. Gordon's *Modern Art Exhibitions: 1900–1916*, published in 1974 (Munich: Prestel), provides the contents of most other early twentieth-century exhibitions as listed in the original gallery checklists. In 1981 Garland Publishing issued a series of reprinted nineteenth-century exhibition catalogues, some institutional, others commercial, compiled by Theodore Reff.

3. For a compendium of the new information, see Daniel Wildenstein, *Claude Monet: Biographie et catalogue raisonné, 5: Supplément aux peintures: Dessins, pastels, index* (Lausanne: Wildenstein Institute, 1991), 295–303.

4. Janine Bailly-Herzberg, ed., *Correspondance de Camille Pissarro, 3: 1891–1894* (Paris: Éditions de Valhermeil, 1998), 60 (letter 652).

5. Ibid., 175 (letter 737). The artist's eldest son, Lucien Pissarro, wrote to the collector Georges de Bellio on 26 February 1893, that his father would be in Paris for an exhibition of his work at Durand-Ruel in March to include "une série de paysages qu'il a fait par sa fenêtre où le clocher de Bazincourt apparaît comme le Fuji Yama des japonais, au milieu de toutes sortes d'effets." See Maison Chavary, *Lettres autographes et documents historiques*, no. 754 (Paris, December 1974), no. 36,377.

6. See Joachim Pissarro and Claude Durand-Ruel Snollaerts, *Pissarro: Catalogue critique des peintures*, 3 vols. (Paris: Wildenstein Institute Publications/Skira, 2005), 1:73–74; 2:55–64.

7. Bailly-Herzberg, *Correspondance de Camille Pissarro*, 3:55 (letter 650).

8. Edmond de Goncourt, *Hokousai* (Paris: Bibliothèque Charpentier, 1896), quoted in Geneviève Aitken and Marianne Delafond, *La collection d'estampes japonaises de Claude Monet à Giverny* (Giverny: Maison de Monet, 1983), 70–71.

9. *Exposition de la gravure japonaise à l'École nationale des Beaux-Arts à Paris du 25 avril au 22 mai: Catalogue* (Paris: Imprimerie Chaix, 1890). The best recent survey of the subject is David Bromfield, et al., *Monet & Japan*, exh. cat., Canberra, National Gallery of Australia (2001).

10. Nicole Barbier, "Assemblages et répétitions dans l'oeuvre de Rodin," in Anne Pingeot, ed., *La sculpture française au XIXe siècle*, exh. cat., Paris, Galeries nationales du Grand Palais (Paris: Réunion des musées nationaux, 1986), 107–9.

11. For a brilliant, fully illustrated reconstruction of this historic exhibition, see Jacques Vilain, ed., *Claude Monet-Auguste Rodin, Centenaire de l'exposition de 1889*, exh. cat., Paris, Musée Rodin (1989).

12. Édouard Papet, in *Daumier 1808–1879*, exh. cat., Ottawa, National Gallery of Canada (1999), 282–87 (no. 143).

13. The best overviews of the complex sculpture of nineteenth-century sculpture editions are Jacques de Caso, "Serial Sculpture in Nineteenth-Century France," in Jeanne L. Wasserman, ed., *Metamorphoses in Nineteenth-Century Sculpture*, exh. cat., Cambridge, Fogg Art Museum (1975), 1–28; and Catherine Chevillot, "Édition et fonte au sable," in Pingeot, *La sculpture française*, 80–94.

14. For the most insightful assessment of Monet's series and commerce, see John Klein, "The Dispersal of the Modernist Series," *Oxford Art Journal* 21, no. 1 (1998): 121–35.

15. A translation of Byvanck's remarks are included in Charles F. Stuckey, ed., *Monet: A Retrospective* (New York: Hugh Lauter Leven Associates, 1985), 165–66.

16. Kathryn Corbin, "John Leslie Breck, American Impressionist," *Antiques*, November 1988, 1142–49.

17. Maurice Guillemot, "Claude Monet," *La revue illustrée* 13, no. 7 (15 March 1898).

18. Wildenstein, *Claude Monet: Biographie et catalogue raisonné, 3: 1887–1898, peintures*, 265 (no. 1139).

19. Stéphane Mallarmé, *Correspondance*, ed. Henri Mondor and Lloyd James Austin, 5: 1892 (Paris: Gallimard, 1981), 61–62; and John House, "Young Girls at the Piano, nos. 89–91" in *Renoir* (London: Hayward Gallery, 1985), 260–62. See also Albert Kostenevich, *Hidden Treasures Revealed: Impressionist Masterpieces and Other Important French Paintings Preserved by the State Hermitage Museum, St. Petersburg* (New York: Abrams, 1995), 112–15, for a discussion of a version formerly in the Krebs Collection, the provenance history of which needs to be established. Michel Hoog pointed out the connection between Monet's *Cathedral* series and Renoir's serial work in *Musée de l'Orangerie: Catalogue de la collection Jean Walter et Paul Guillaume* (Paris: Réunion des musées nationaux, 1984), 190.

20. The first version to be purchased by Durand-Ruel is now in the Metropolitan Museum of Art, New York, which provides this information on its website: www.metmuseum.org/Works_of_Art/.

21. "Nos artistes: Le peintre P.-A. Renoir chez lui," *L'éclair*, 9 August 1892.

22. Jean Renoir, *Pierre-Auguste Renoir, mon père* (Paris: Gallimard, 1981), 431–32. Renoir undertook no fewer than four paintings of a wave crashing on a beach.

These four are in the Art Institute of Chicago, the Dixon Art Gallery, Memphis, the Sterling and Francine Clark Art Institute, and in a private collection (John House, *Renoir, Master Impressionist*, exh. cat. Brisbane, Queensland Art Gallery [Sydney: Art Exhibitions Australia, 1994], no. 30). Executed around the time that Courbet died, they may be understood as an acknowledgement by Renoir of Courbet's status as a pioneering series artist.

23. Charles Baudelaire, *Oeuvres complètes,* ed. Claude Pichois, 2 vols. (Paris: Gallimard, 1975–76), 2:665–66. Both Baudelaire and Boudin could have been aware of the numerous oil studies of clouds by British artist John Constable (1776–1837). C. R. Leslie's description of these was published in French translation in the August and October 1855 issues of *Magasin pittoresque*. To the best of my knowledge, Constable never showed any of his cloud studies, much less a group of them in tandem. As for Constable's great rival, in 1841–42 J. M. W. Turner (1775–1851) made no fewer than three serially related exhibition watercolors showing Mont Rigi observed across Lake Lucerne. Although they were part of a group of ten similar-format Swiss views to be sold by his dealer, Thomas Griffith, there is no indication that they were put on display together at Griffith's premises, nor that French Impressionist artists had any access to them. See John Russell and Andrew Wilton, *Turner in Switzerland* (Dubendorf: De Clivo Press, 1976), 20, 27, 86 ff., and 138.

24. *Catalogues des expositions organisées par la Société française de photographie: 1857–1876,* 2 vols., repr., Paris: Durier/Place, 1987), 1:38, nos. 772–74 ("Marines").

25. Colta Ives et al., *The Private Collection of Edgar Degas: A Summary Catalogue* (New York: Metropolitan Museum of Art, 1997), 4 (nos. 18–20).

26. Elizabeth Anne McCauley, *A. A. E. Disdéri and the Carte de Visite Portrait Photograph* (New Haven and London: Yale University Press, 1985), esp. 45 and 96.

27. See Gustave Cahen, *Eugène Boudin: Sa vie et son oeuvre* (Paris: Floury, 1900), 188. By "salon," Boudin meant either exhibition or, more literally, the living room of his own home. John House, *Monet: Nature into Art* (New Haven and London: Yale University Press, 1986), 193–94, mentions Théodore Rousseau (1812–1867), Charles-François Daubigny (1817–1878), and Johan Barthold Jongkind (1819–1891) as other artists who may have influenced Monet's interest in duplicate versions. See also Stephen Z. Levine, "Monet's Pairs," *Arts* 49, no. 10 (June 1975): 72–75.

28. Petra ten-Doesschate Chu, ed. and trans., *Letters of Gustave Courbet* (Chicago and London: University of Chicago Press, 1992), 243 (no. 64-11). See also Ann

Dumas, "The Source of the Loue 1864," in Sarah Faunce and Linda Nochlin, eds., *Courbet Reconsidered,* exh. cat., Brooklyn Museum (1988), 153–57 (nos. 47 and 48). To my knowledge there has as yet been no careful study of the Delacroix exhibition in August 1864 at the Galerie Martinet in Paris, and it seems doubtful that Courbet came to Paris to see it. Judging from a painting of the display by Édouard Albertini (Paris, Musée Carnavalet), the exhibition did not feature Delacroix's multiple paintings of single subjects.

29. Ann Dumas, "Portrait of Jo, the Beautiful Irish Girl 1865(?)," in Faunce and Nochlin, *Courbet Reconsidered,* 162–66, nos. 53–56.

30. G[ilbert] Randon, "Exposition G. Courbet," *Journal amusant,* no. 598 (29 June 1867). Randon's comments are connected with a lost work in Robert Fernier, *La vie et l'oeuvre de Gustave Courbet: Catalogue raisonné* (Lausanne and Paris: Bibliothèque des Arts, 1977), 1:272 (no. 520). For a recent assessment, see Laurence des Cars, "Les 'paysages de mer' de Gustave Courbet, un enjeu moderne," Musée Malraux (le Havre), *Vagues: Autour des* Paysages de mer *de Gustave Courbet* (2004).

31. Chu, *Letters of Gustave Courbet,* 273 (no. 66-3).

32. Ibid., 273 and 277 (nos. 66-3 and 66-7).

33. Théophile Thoré, "Salon de 1866," in *Salons de W. Bürger, 1861 à 1868,* 2 vols. (Paris: Renouard, 1870; repr., Paris: Place, 1987), 1:281–82.

34. Chu, *Letters of Gustave Courbet,* 303 (no. 67-2).

35. Fernier, *Courbet: Catalogue raisonné,* nos. 385, 560, 562–65, 614–17, 648–50, 653. Without any special emphasis on the series issue, Courbet's snowscapes are discussed by Charlotte Eyerman in *Courbet and the Modern Landscape* (Los Angeles: J. Paul Getty Museum, 2006), 91–93.

36. Edmond and Jules de Goncourt, *Journal: Mémoires de la vie littéraire,* ed. Robert Ricatte, 22 vols. (Monaco: Éditions de l'Imprimerie nationale, 1956–58), 8:55.

37. Among the possible inspirations for the novelist brothers was a series of nine watercolors done at Bay of the Trépassés in Brittany by Paul Huet (1803–1869) during sunset on a single evening. These are cited by John House, *Monet: Nature into Art* (New Haven and London: Yale University Press, 1986), 243 n.6, referring to Heim Gallery, *Paul Huet,* exh. cat. (London, 1969), nos. 97 A-I.

38. See John House, "Boudin's Modernity," in Vivien Hamilton, ed., *Boudin at Trouville,* exh. cat., Glasgow Museums (London: J. Murray, 1992), 22–23. He points out that fellow artists bought most of the works on paper at this auction.

39. Indeed, the extent of Monet's work in pastels was evident only with the publication of Wildenstein,

124 *Claude Monet: Biographie et catalogue raisonné*, 5: *Supplément aux peintures: Dessins, pastels, index*, 155–75. Noting how difficult it is to know when and by whom these works were in fact initialed and dated, Wildenstein does not attempt to give a precise date for Monet's 1860s series of five sequential black crayon drawings (three of them signed) showing a boat stranded on a beach. Ibid., 123–24.

40. Richard Kendall, *Degas Landscapes* (New Haven and London: Yale University Press, 1993), 85–107. Kendall raises the possibility that Degas's concern for the landscape at Beuzeval may have something to do with his dialogue with Morisot. Only a few of her early landscape pastels survive, and these were eventually assigned a date of 1864, without taking into account their similarity to the Degas pastels. See M.-L. Bataille and G. Wildenstein, *Berthe Morisot: Catalogue des peintures, pastels et aquarelles* (Paris: Les Beaux-Arts, 1961), 51 (nos. 417–18).

41. Although Courbet was not allowed to take part at the Salon of 1872, his recent apple still lifes were sufficiently widely known to be the subject of caricatures published in conjunction with that event. Indeed at the time of the Salon, one was displayed in the window of the Durand-Ruel gallery. See Klaus Herding, "Courbets Modernität im Spiegel der Karikatur," in Werner Hofmann, ed., *Courbet und Deutschland*, exh. cat., Hamburg, Kunsthalle (Cologne: Du Mont, 1978), 518. For a recent discussion of these works, see *Courbet et la Commune*, exh. cat., Paris, Musée d'Orsay (Paris: Réunion des musées nationaux, 2000), in particular the essay by Laurence des Cars, "Le silence de la peinture."

42. See Robin Spencer, "Whistler's First One-Man Exhibition Reconstructed," in Gabriel Weisberg and Laurinda Dixon, eds., *The Documented Image: Visions in Art History* (Syracuse, N.Y.: Syracuse University Press, 1987), 28; and Deanna Marohn Bendix, *Diabolical Designs: Paintings, Interiors, and Exhibitions of James McNeill Whistler* (Washington and London: Smithsonian Institution Press, 1995), 212–13.

43. Quoted in Andrew McLaren Young et al., *The Paintings of James McNeill Whistler*, 2 vols. (New Haven and London: Yale University Press, 1980), 1:84 (no. 138).

44. For the classic account of Whistler's Nocturnes, see E. R. and J. Pennell, *The Life of James McNeill Whistler*, 2 vols. (London: Heinemann, 1909), 1:161–67.

45. E. and J. de Goncourt, *Journal*, 10 (1871–75), 166.

46. Michel Melot, *The Impressionist Print*, trans. Caroline Beamish (New Haven and London, Yale University Press, 1996), 123. Nine of sixteen versions now belonging to the Baltimore Museum of Art are reproduced in *The Painterly Print: Monotypes from the Seventeenth to the Twentieth Century*, exh. cat.,

New York, Metropolitan Museum of Art (1980), 20–21 and 94–95.

47. See Michael Pantazzi, "1873–1881," in Jean Sutherland Boggs, ed., *Degas*, exh. cat., Ottawa, National Gallery of Canada, and New York, Metropolitan Museum of Art (1988), 214.

48. The identifying press accounts are reproduced in Ruth Berson, ed., *The New Painting: Impressionism 1874–1886, Documentation*, 2 vols. (San Francisco: Fine Arts Museums of San Francisco, 1996), 1:54 and 105.

49. The unconventional frames are mentioned in a short 1890 biography of Pissarro; see Isabelle Cahn, *Cadres de Peintres* (Paris: Réunion des musées nationaux, 1989), 65–68 and 85 n.55; and Matthias Waschek, "Camille Pissarro," in Eva Mendgen, ed., *In Perfect Harmony, Picture + Frame, 1850–1920*, exh. cat., Amsterdam, Van Gogh Museum (1995), 142.

50. The most helpful summaries of studies about Monet's *Gare Saint-Lazare* paintings are Berson, *The New Painting*, 2:76 (no. III-97 note); and Juliet Wilson-Bareau, *Manet, Monet, and the Gare Saint-Lazare* (New Haven and London: Yale University Press, 1998), 103–29 and esp. 188 n.83.

51. Pierre Wittmer, *Caillebotte and His Garden at Yerres* (New York: Abrams, 1991), 72, 77, 254–58, and 275–76.

52. Rodolphe Walter, "Émile Zola et Claude Monet," *Les cahiers naturalists* 10, no. 26 (1964), 57.

53. Charles F. Stuckey, *Claude Monet, 1840–1926*, exh. cat., Art Institute of Chicago (New York and Chicago: Thames and Hudson/Art Institute of Chicago, 1995), 228 (24 May entry).

54. See George T. M. Shackelford, "*Pas de deux:* Mary Cassatt and Edgar Degas," in Judith Barter, ed., *Mary Cassatt, Modern Woman*, exh. cat., Art Institute of Chicago (New York and Chicago: Thames and Hudson/Art Institute of Chicago, 1998), 115–16.

55. Sue Welsh Reed and Barbara Stern Shapiro, *Edgar Degas, The Painter as Printmaker*, exh. cat., Boston, Museum of Fine Arts (1984), 169 (no. 51).

56. *Catalogue des estampes anciennes et modernes . . . composant la collection Edgar Degas*, Paris, Hôtel Drouot, 6–7 November 1918, lot 54.

57. Charles Stuckey, "Love, Money, and Monet's Débâcle Paintings of 1880," in *Monet at Vétheuil: The Turning Point*, exh. cat., Ann Arbor, University of Michigan Museum of Art (1998), 58–61.

58. Stuckey, *Claude Monet, 1840–1926*, 12–13.

59. Wildenstein, *Claude Monet: Biographie et catalogue raisonné*, 1: *1840–1881, peintures*, 441 (letter 203).

60. Wildenstein, *Claude Monet: Biographie et catalogue raisonné*, 2: *1882–1886, peintures*, 217 (letter 260).

61. Ibid., 218 (letters 264, 266, and 270).

62. For the 1883 exhibition, see ibid., 13–17, and vol. 5, *Supplément aux peintures: Dessins, pastels, index*, 295; and Steven Z. Levine, *Monet and His Critics* (New York and London: Garland Publishing, 1976), 52–62.

63. Bendix, *Diabolical Designs*, 223–30.

64. Joris-Karl Huysmans, *Certains* (first published 1889) (Paris: Union Générale d'Éditions, 1975), 327.

65. Marcel Guérin, ed., *Lettres de Degas* (Paris: Éditions Bernard Graset, 1945), 119 (no. 90).

66. Guy de Maupassant, "La vie d'un paysagiste," *Gil-Blas*, 28 September 1886; translated in Stuckey, *Monet: A Retrospective*, 121–34.

67. See Gary Tinterow, "1881–1890," in Boggs, *Degas*, 448 (no. 211).

68. Michèle Auer, *Le premier interview photographique: Chevreul, Félix Nadar, Paul Nadar* (Neuchâtel: Éditions Ides et Calendes, 1999).

69. Wildenstein, *Claude Monet: Biographie et catalogue raisonné*, 2: *1882–1886, peintures*, 225 (letter 808).

70. *The Complete Letters of Vincent van Gogh*, 2d ed., 3 vols. (Boston: New York Graphic Society, 1978), 2:545 (letter 477).

71. Ibid., 2:511 (letter B15 [19]).

72. Bailly-Herzberg, *Correspondance de Camille Pissarro*, 2 (1986), 239 (letter 492).

73. "Calendrier de juin," *Revue indépendante*, July 1888; reprinted in Félix Fénéon, *Oeuvres plus que complètes*, ed. Joan U. Halperin, 2 vols. (Geneva and Paris: Librairie Droz, 1970), 1:113.

74. "Tableaux de Sisley," in Fénéon, *Oeuvres plus que complètes*, ed. Halperin, 1:133.

75. "Tableaux: Exposition de M. Claude Monet, Paris, Galerie Georges Petit, 8, rue de Séze, 5e Exposition de la Société des Artistes Indépendants, Paris, 84, rue de Grenelle," in Fénéon, *Oeuvres plus que complètes*, ed. Halperin, 1:162. For other accounts of serial imagery and Monet's 1889 show, see Levine, *Monet and His Critics*, 109–10.

76. For an illustrated reconstruction of this exhibition based on Wildenstein's research, see Vilain, *Claude Monet-Auguste Rodin*, 73–105.

77. See "On Self: From the Notebooks and Diaries of Susan Sontag, 1958–67," *New York Times Magazine*, 10 September 2006, 56.

78. For Monet's 1897 comments, see Maurice Guillemot, "Claude Monet," *La revue illustrée* 13, no. 7 (15 March 1898).

79. See Félix Fénéon, "Les grands collectionneurs: I.—Isaac de Camondo," *Bulletin de la vie artistique*, 1 April 1920, reprinted in *Oeuvres plus que complètes*, ed. Halperin, 1:345–46. For some unknown reason,

Fénéon refers here to three, not four, *Rouen Cathedral* paintings.

80. Georges Clemenceau, "Révolution des cathédrales," *La justice*, 20 May 1895; Joachim Pissarro, *Monet's Cathedral: Rouen, 1892–1894* (London: Pavilion, 1990), 29–30.

81. Wildenstein, *Claude Monet: Biographie et catalogue raisonné*, 5: *Supplément aux peintures: Dessins, pastels, index*, 206 (letter 2,938).

Risible Cézanne

Richard Shiff

Paul Cézanne was the originator, the master of the [symbolist] movement of 1890. [Although] his work involves no theory, it exercised considerable influence on the evolution of painting. This great artist had a singular weakness, being incapable of practicing an art of which he was not the [sole] creator.

—MAURICE DENIS, 1917[1]

Unleashed

For most of Paul Cézanne's life, history held him in reserve. In November 1895, at the age of fifty-six, he had his first comprehensive exhibition, an event only indirectly his doing. Ambroise Vollard, aided by the painter's son, gathered as many as 150 works to be shown at his Paris gallery.[2] Cézanne accepted this initiative, despite being leery of public exposure, which his antisocial attitude continued to discourage. Inured to isolation and without financial worry, he had been enjoying the good working conditions that accompany public neglect. "An artist wishes to elevate himself intellectually as much as possible, but"—he declared, shortly after his exhibition closed—"the man should remain obscure. Gratification ought to come [only] in working."[3] "He creates in solitude," critic Gustave Coquiot wrote retrospectively, "and he needs none of our admiration."[4] Granted, there are indications to the contrary; Cézanne often welcomed visits from appreciative young painters and writers.[5] But by and large, Coquiot's judgment holds, for Cézanne's practice was self-sustaining technically, intellectually, and psychologically. Although he drew after sculptures and paintings in the Louvre, by the norms of his era his art hardly followed their model. He was creating himself: "I am the primitive of my own way"—this, supposedly, was his self-assessment.[6]

After 1895, Cézanne's apparent indifference to his public presence and to the standards set by others had little effect on the increasing

frequency of his exhibitions; nor did it slow the spread of the fame that accompanied his notoriety. He had reason to be uneasy about his new situation, symptomatic of a general problem. In 1902, he complained that the expansion of museums and the increasing number of commercial exhibitions had become a pernicious distraction for artists, their vision transfixed not by earth and sky but by constellations of stylish brushmarks: "We no longer view nature; we keep seeing paintings. We should be looking at the work of God!"[7] If painting had in fact devolved into a narrowing repetition of painting for painting's sake, with the forms of one exhibited body of work responding to the forms of another, the irony was that Cézanne had been an unwitting catalyst.

Throughout the twentieth century, the majority of critics and historians perceived Cézanne as a master of structured composition, but this opinion solidified only gradually after his death in 1906. Before that time, the interpretation of his controversial work varied considerably. Nearly all of the early commentary nevertheless alluded to a single physical feature: the peculiarly insistent way that Cézanne applied colored marks to canvas. Gustave Geffroy described a full range of the effect, from surfaces "executed over an extended period, with thin layers, which in the end become compact, dense, and velvety," to thicker, coarser finishes (perhaps more typical), "coagulated and luminous." At times "the forms grew awkward with the represented objects becoming confused"; in every instance, however, Cézanne's vital intensity was evident.[8] Those who noticed were impressed even by works of small scale, such as the relatively late *Group of Bathers* (see fig. 28) and the relatively early *Three Bathers* (fig. 1), which Henri Matisse (1869–1954), who certainly noticed, purchased from Vollard in 1899.

That same year, Georges Lecomte, a young critic close to the impressionist Camille Pissarro (1830–1903), succeeded

in capturing the curious circumstances of Cézanne's reception. He referred to the effect of the painter at "two successive stages of art," meaning impressionism—during the 1890s, still entirely credible as an advanced aesthetic position—and the symbolism of the following generation, led by Paul Gauguin (1848–1903). Gauguin was only a decade younger than Cézanne; Matisse, three decades younger and the same age as many of the symbolists, represented a third generation, Lecomte's own. The critic had enough distance to realize that first in the eyes of impressionists like Pissarro, then in the eyes of symbolists like Gauguin, Cézanne's style "met the strange fate of being lauded less for its good qualities than for its faults."[9] Before Lecomte, Geffroy and others had noted the "faults"; they were matters of omission, neglect of the technical niceties. A contour would turn too abruptly and spoil the anatomical coherence or the sense of volume. A passage of color would seem to lack its proper transitional elements, as in situations where a stroke of red lay incongruously beside a green within an area of foliage,

Fig. 1. Paul Cézanne, *Three Bathers*, 1879–82. Oil on canvas, 52 × 54.5 cm. Paris, Musée du Petit Palais, Don Monsieur et Madame Henri Matisse, 1936 (2099)

or a blue abruptly confronted a yellow within the torso of a nude. In addition, Cézanne's painted surface tended to be irregular, some sections thick and others thin or even bare. Certain critics regarded this pictorial coarseness as the sign of a painter's immediacy of vision; others derived from it a commitment to naïveté and sincerity (just the necessities, no embellishments, no rhetoric). By Lecomte's clever reckoning, as far as the older generation of impressionists was concerned, the Cézanne syndrome indicated a heroic rejection of the conventions of academic art risked for the sake of observing nature directly, even if no final resolution should come of the effort. To the symbolists, the same constellation of features signaled a return to techniques of the European "primitives" (the pre-academic styles of late Gothic and early Renaissance masters) as well as to the "classical" tradition of a faded but grand Mediterranean culture. Beyond these associations, with or without links to naturalism, primitivism, and classicism, Cézanne's technique offered a fundamental advantage to impressionists and symbolists alike: increased emotional force. Viewers of the 1890s perceived emotion in the brilliance of his color and the directness of his paint application—stroke by stroke by stroke— with the marks lined up as if to record a sequence of autonomous moments of visual sensation, each bearing its particular quantum of emotional energy.

With its evident directness, Cézanne's art caused the studied rendering of Nature's traditional idylls to appear all the more artificial and obsolete, affecting even the reveries of the most "natural painter" of the previous generation, Jean-Baptiste-Camille Corot (1796–1875). The record of response to the two artists in their different eras establishes certain parallels. Like Cézanne, for better or worse, Corot had the reputation of being "content to arrange attractive colors on a canvas."[10] Praise that began and ended with his visual merits implied that his art was

Fig. 2. Jean-Baptiste-Camille Corot, *The Evening Star* (detail), 1864. Oil on canvas, 71 × 90 cm. Baltimore, The Walters Art Museum. Bequest of Henry Walters, 1931 (37.154)

deficient intellectually. This natural painter of nature was paint-oriented, not Nature-oriented; he lacked a *concept* of Nature. Corot, many believed, dealt with material appearances to the exclusion of ultimate meanings, as if he would prefer a viewer of *The Evening Star* (fig. 2) to pass over the starstruck figure for the sake of concentrating on the cascade of paint in the upper sky—yellow, pink, grayish blue. The depicted figure contemplates Nature. Corot's painting encourages a viewer to contemplate paint and its color, no matter how much or how little it depicts.

During Corot's lifetime, numerous critics complained that his thematic clichés, presented with his characteristic range of color and light, were mindlessly repetitive even when the scene varied: "It becomes quite difficult to distinguish one of his [visual] melodies from the next. . . . He simply composes a scene, but has never composed more than one."[11] The monotony of Corot's typical effect—a relatively even tonality across each canvas surface, similar from one painting to the next—nullified the variation in his mythological fantasies. Just as often, writers

nevertheless concluded that his homegrown technique resulted in a "poetic" and "emotionally moving" art.[12] "Don't analyze Corot by dissecting his painting," Alfred Sensier stated, "love him as you love a bountiful tree."[13] (No one objects when apples from the same tree look and taste alike.) This type of appreciation came despite the fact that detractors, or nearly anyone taking stock of Corot's technique, could "so complacently point out its faults."[14] Although simplicity and spareness might be faults, they held an obvious advantage: "[Corot] reduces technique to its most elementary form and puts on the canvas only just enough painting to say what he feels."[15] As in Cézanne's case, viewers had the initial impression that neither intellect nor method sustained this art; rather, it was feeling—both sensation and emotion.[16] The concern for feeling among those involved with mid-nineteenth-century landscape painting opened a door of acceptance not only to the technical antipodes of monotony and irregularity but even to an execution that bordered on incompetence. In 1847, Paul Mantz admitted his attraction to landscapists "less able in execution than most others, barely initiated into the subtleties of their craft." He described one painter's technique as "simple to the point of awkwardness, following in Corot's tracks"—that is, like Corot in this potentially pejorative regard, but more so. Concerning an entire group of amateurish landscapists showing at the Salon, Mantz noted what truly mattered: "Their painstaking incapacity is not without a strange seductiveness."[17] A strange seduction indeed: rhetorical finesse and pictorial skill were not seducing Mantz; it was their absence.

Half a century later, Lecomte's commentary of 1899 tacitly acknowledged the effect of a cumulative mass seduction: Corot, Barbizon, Realism, Impressionism. Along with desirable qualities such as naturalness, these shorthand references called forth visions of monotony, irregularity, awkwardness, and coarseness, technical features readily associated with mistakes, misjudgments, and utter incapacity. Yet all was being excused in the name of feelings that more polished techniques would never generate. Lecomte recognized that Cézanne, if not in practice then in his reputation, had benefited from a heightened sensitivity to what counted as direct emotional expression and what did not. During the decade preceding Vollard's inaugural show, his art had gained a special audience—a cult following among painters and writers linked to or inspired by Gauguin and his emerging pictorial version of the symbolist literary program. In many ways, Gauguin's approach marked a radical departure from impressionist naturalism. Not surprisingly, it never met Cézanne's approval.[18] He identified with the impressionism of the 1870s and, in his opinion, had been extending it.[19] This did not prevent the younger generation from running off with what they viewed as his inventions. "I had a little sensation, just a little, little sensation. . . . But it was mine," Cézanne said, probably half joking, half serious: "One day this guy Gauguin, he took it from me."[20]

Symbolist images were more suggestive than representational, and more obviously charged with emotion than was customary. This is not to claim that emotion became the exclusive province of symbolists. Impressionists, naturalists, and realists, as well as most others, understood that painting of any kind conveyed the emotion necessarily instilled in it as it was created. Awareness of this issue was ubiquitous. When reviewing the Impressionist exhibition of 1877, Mantz, by then eminently established as a writer, argued that Corot—"poetic," "emotionally moving"—was himself "the foremost impressionist in the world," superior to all those newcomers who, like Pissarro and Cézanne, were claiming the name.[21] Implicit in the conflict between older naturalists and newer impressionists, and eventually between impressionists and symbolists, was the question of whether to *stress* the emotionality that few if any doubted—

the range of feelings linked to externals as well as to an artist's self. Once committed to extending emotional boundaries, an artist still had to decide how far to take representational liberties for the sake of those feelings, how insistently to mark the primacy of emotion in painting and in life.[22] Allowed its due, emotion was likely to overwhelm representational articulation. Its range was greater than what any rule of representation accommodated.

For the sake of emotion, an artist can attempt to adjust the balance between an inherited order and what feels as if it were free sensation. An intensification of color— bold in the view of some, crude as seen by others—will often signify an unrestrained intensification of emotion: "We find . . . the emotions of Cézanne in the interrelationship of colors," the constructivist Theo van Doesburg (1883–1931) stated in 1916.[23] Gauguin had reasoned in 1885: "People complain about our unblended colors, each one set against the other. . . . [Yet] a green beside a red does not yield a reddish brown, as in physical mixture, but rather two vibrant notes" (see *Still Life with Peaches* [fig. 3]).[24] The practice of juxtaposing strokes of abruptly contrasting hue, which Gauguin had come to admire in the work of Cézanne, violated the conventional order of tonal variation, designed to convert planar images to naturalistic illusions. Standard art-historical accounts still identify early modernist art,

Fig. 3. Paul Gauguin, *Still Life with Peaches*, ca. 1889. Oil on cradled panel, 16 × 31.8 cm. Cambridge, Massachusetts, Harvard University Art Museums. Gift of Walter E. Sachs (1958.291)

either Cézanne's or Gauguin's, with this shift from three-dimensional illusion to a rudimentary two-dimensional planarity or flatness—from an imaginary, metaphorical vision to a literal materiality. For twentieth-century historians, what it all meant became a vexed question. In the case of Cézanne, interpreters usually associated the move from illusion to materiality with a fundamental reduction, a search for forms having an essential presence.[25] In the case of Gauguin, primitivist fantasy was the likely association. The two artistic ends are clearly related; and during the 1890s and into the early twentieth century, the essential and the primitive were hardly distinguished by the many critics who approved of both.

When interpretation stagnates, look for an alternative, attend to whatever has been neglected. Believing that early twentieth-century writers focused too rigidly on formal, technical features, later critics and scholars delved into Cézanne's subject matter, attempting to identify the details and relate them to specifics of his cultural environment. They also speculated on his personal psychology. This orientation toward identifying the represented people, objects, and locations, as well as the various sources in earlier art, continues to yield remarkable results on several fronts. But the method goes against the grain of most of the record of early reception. The more personal and local references made by Cézanne's paintings—and recovered, rightly or wrongly, by scholarship—went undetected by his critical audience at the time. Whatever such references were, they contributed little if anything to the actual effect that an ambitious commentator like Lecomte had to confront, blind to what today's art historians see. During the 1880s, Gauguin had responded more directly to Cézanne's mark than to his thematics; and as he spoke freely of this experience, it proved crucial to how the Cézanne effect unfolded.[26] This is the same Gauguin otherwise so concerned with complex allegories, narrative programs, and

arcane symbology; in Cézanne's case, to the contrary, it was the painter's mark that became Gauguin's issue. Between the early twentieth-century applications of formal analysis and the late twentieth-century methods of cultural and social history, many aspects of the position of a Gauguin or a Lecomte go unrepresented. Interpretive paths remain to be taken, alternatives that might better capture the cultural shock Cézanne produced around 1895, when history, in the person of Vollard, unleashed his wildness.

Loss of Subject
The subject disappears, there is only a motif.
—PAUL SÉRUSIER, as quoted by Maurice Denis, 1907[27]

Whatever Cézanne did during the 1890s built on his initial impressionist experience of the 1870s. Regarded as an exercise in impressionist sensation at either historical moment, his technique of discrete, parallel brushstrokes converted still images to moving images—"moving" in the sense of projecting an emotion as well as being physically in a state of transition. What might have become the picture of a fixed, fully realized concept or theme became instead a dynamic corporeal and psychological response to immediate experience. An objection is likely: each of Cézanne's blunt, truncated strokes of paint is itself an arrested movement; the effect is of building blocks, discrete units, segments, the antithesis of organic change and flux. So here interpretation is at liberty to divide. It can establish Cézanne's individual mark of color or line as an essential structural element, or it can follow each mark as a gesture, perhaps futile, at a passing sensation.

Take the latter direction. In both paintings and drawings, Cézanne fragmented the outer contours of representational forms and did so even in instances of a single figure with a monumental presence, where a more resolved linearity would be expected; a work probably of the early 1880s, *Bather with Outstretched Arms,* is an example.[28] More to the

Fig. 4. Paul Cézanne, *Bather with Outstretched Arms*, ca. 1883. Oil on canvas, 33 × 23.2 cm. Collection Jasper Johns

point, Cézanne kept the outer contours of figures fragmented and tentative even when they join a presumably preparatory series of studies and variants, which in this case would include a smaller *Bather with Outstretched Arms* (fig. 4) and any number of related drawings. It is as if he were forever painting the image for the first time, each and every element of it suspended in sensation, never passing into the structures of memory. Memory would allow a more complete image to be established quickly, efficiently. When Cézanne did create generic figures of bathers from memory, his marks remained tentative, performing acts of re-animation.[29] Some of the marks passed through pictorial segments without striking any clear representational pose. In this respect, Cézanne granted his material technique autonomy; he released his marks from a single, specific descriptive function. In a composition of the early 1890s, *Bathers* (fig. 5) he gave the curving, tangled shape of foliage to a central area of background

situated between two standing bathers
(one with a towel, the other with swimming
trunks); but he colored this area as if it
were a continuation of the distant mountain.
Thematically, it might be either. His tech-
nique leveled the pictorial image, eliminat-
ing or at least obscuring potential hierarchies
of value among its thematic components.
This was not an unusual effect for painters
of an impressionist orientation. Leveling,
evenness of tonality, color equally distributed
among the representational elements: all
this evoked a pervasive atmospheric light.
Less directly, pictorial leveling alluded to
republican and anarchist ideals of a society
in which rank and order lost all authority,

Fig. 5. Paul Cézanne,
Bathers, 1890–92. Oil
on canvas, 54.3 × 66 cm.
Saint Louis Art Museum.
Funds given by Mrs. Mark
C. Steinberg (2:1956)

in which aristocratic and oligarchic privilege
faded into historical distance, into a past to
be forgotten.

In Cézanne's art, more than with his
impressionist peers, what ought to have been
conceptually secure became evidence of an
anxious sensory movement, associated more
with the repetitive marking of an act of paint-
ing than with the resolution of an established
theme. His marks were in motion but had
no preconceived moral end. His painting
lived in the present. Perhaps this caused him
intellectual frustration without accompany-
ing bodily discomfort. His art was oriented
toward the physical, toward feeling; and in
this regard, it succeeded aesthetically. Yet this

did not mean that he considered himself a cultural or social success. His analytical, reasoning mind and his emotive, sensing body may have been moving at cross-purposes. Taking stock of Cézanne retrospectively, Pablo Picasso (1881–1973) perceived the "anxiety" his art reflected, while Maurice Merleau-Ponty found evidence of a "schizoid temperament."[30] As a painter, Cézanne was a traditionalist with a modernist sensibility. If a resolution to his mind-body divide ever arrived through his art—and perhaps, from certain interpretive perspectives, it did— he was in no psychological state to have acknowledged it.

While twentieth-century notions of anxiety and even of schizophrenia may apply to Cézanne's case, his late nineteenth-century interpreters, close to the scene, advanced a less scandalous vocabulary. Gauguin's acolyte Paul Sérusier (1864–1927) epitomized Cézanne's situation, and Maurice Denis quoted him: "The subject disappears, there is only a motif."[31] A motif does not equal a subject.[32] Conceptualized to a lesser degree, if at all, a motif lacks a subject's stability. An artist's representational subject—preselected, fixed in place—ought to be paramount, a guide to the process of rendering. But in Cézanne's art, the subject was diminished to an unusual extent, even suffering an "absence" (Sérusier's term) in relation to the motif.[33] Loss of the subject may have been the most common understanding of the troubled state of modern representational practice, to which Gauguin and his associates directed their contemporaries. They saw both the problem and its potential solution in Cézanne. Honoring Gauguin upon his death in 1903, Denis wrote of a special accomplishment: "He revealed Cézanne's work to us not as the product of an independent agent of genius . . . but as the conclusion to a long struggle, the necessary result of a great crisis."[34] Loss of subject was the crisis. By Denis's account—or was it Gauguin's?—Cézanne was the nodal point of disruptive forces deep within modern culture; if his aesthetics posed a problem, this was everyone's problem. The painter too eccentric to follow society's lead, too schizoid to have accepted his own traditionalist instincts, presented the most telling example to his better-adjusted peers.

Prominent as a theorist among the young symbolists, Denis offered a compromise concerning Cézanne's relation to tradition: he had reconstituted classical composition, but not as one would have expected, not as a consequence of rigorous academic study. It was as if classical form were generated from within Cézanne's body, soul, and psyche—a classicism identified with his unique "sensation" (the term he preferred) or with his instinctive emotional response to his cultural environment (a viable alternative). In 1907, Denis eulogized Cézanne as having neither model nor true counterpart within the tradition he joined: "so naturally a painter and so spontaneously classical."[35] A spontaneous movement is a physical contradiction in that it reacts to nothing; it lacks an external cause. Eccentric and even flawed, Cézanne's spontaneous classicism did not result from his indoctrination, and he never adhered to the Mediterranean tradition as strictly as he might have wished. It was in this sense that his independence, safeguarded by his social isolation—in Denis's words, his "being incapable of practicing an art of which he was not himself the creator"—became a "weakness," potentially self-defeating.[36]

Classical by inclination, spontaneously, Cézanne fit a tradition yet followed his singular way. Though the subject might be classical and arcadian—bathers beside a stream, a distant mountain—the motif was the painter's. The presumptive subject was no more than a "pretext," Denis remarked, with the theme of bathers converted from classical to what could only seem nonsensical: "nude figures, unrealistically grouped in a nonexistent landscape."[37] In fact, Cézanne's compositions of bathers were hybrids pieced

together from copies of individual figures he used repeatedly, lifted out of their original contexts and recombined—hence, the "unrealistic" or unnatural bearing of these representational elements, even in terms of myth and fantasy (fantasy, too, has its regularity, its conventions). Problematically, Cézanne freed his motif from the normative restraints of the subject. Because many of the physical aspects of his art failed to correspond to the existing classical paradigm, his supportive critics were obliged to explain. They resorted to modifiers. Cézanne was a "modern" classic, a "primitive" classic, a "spontaneous" classic. His classicism was in the form, in the color, in the composition. The early critics applied any number of cultural categories and technical terms to acknowledge the disjunction between subject and motif, obvious enough to anyone who looked.

Wild Apples

Creator of work resembling nothing that could be seen before it. . . . [Cézanne] makes apples his own. . . . They are to him as an object is to its creator.

—THADÉE NATANSON, 1895[38]

Responding to Vollard's exhibition, Thadée Natanson presented the paradox of Cézanne's

theme of apples: it was as if no apples, at least none like those depicted, existed before Cézanne painted them, before he made them "his own" (fig. 6). The apples resembled each other but not the appearance of any other apples, real or pictorial, despite the artist's custom of making arrangements of fruit in his studio before painting what he considered their image. Cézanne's theme of apples became a repetitious imitation of itself: "He restricted his effort at painting for the love of certain forms he had invented."[39]

Viewers encountered the "apples" as a set of sensory qualities that existed only because Cézanne painted them: his particular reds, his rhythms of rounded contours—his apple motif. Denis implied that any illusion of a real apple must be secondary, alluding again to a statement by Sérusier: "He is the pure painter. . . . Of an ordinary painter's apple you say, 'I could take a bite out of it.' Of Cézanne's apple you say, 'How beautiful!'"[40] A conventional apple is suitable for nourishment; Cézanne's apple suits only the senses. Having read Denis's commentary, Sérusier added: "Cézanne can't be described in words. He's too pure a painter."[41] Both Sérusier and Denis suggested that the beauty Cézanne created reflected a moral order, a paradigm for living, an ethic of truth to oneself and one's practice. This was consistent with a romantic-realist tradition that stressed the central importance of each person's experience, their personal, observational perspective (which could nevertheless be quite anonymous). In a different context, the scandal surrounding publication of *Madame Bovary* in 1856, Gustave Flaubert had stated the operative principle: "The morality of art"—its moral value or social justification—"is found in its beauty itself."[42] Beauty can be independent of the subject. Cézanne's apple ranked high on beauty. "Facing [a] Cézanne, we think only of the [material] painting," Denis wrote; "neither the object represented nor the subjectivity of the artist holds our attention."[43] Absence of subjectivity as well

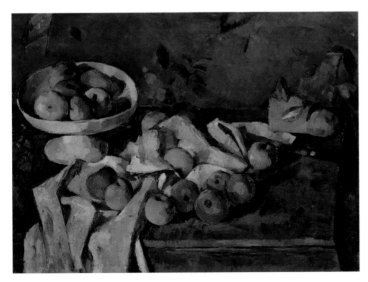

Fig. 6. Paul Cézanne, *Compotier, pommes et miche de pain*, 1879–80. Oil on canvas, 55 × 74.5 cm. Winterthur, Sammlung Oskar Reinhart "am Römerholz" (1921.2)

as of the subject: this was the work of "too pure a painter."

Absence of subjectivity in Cézanne's case meant absence of the familiar signs of subjectivity, indications of a personal statement. This did not imply that his painting lacked personal feeling. In fact, to be a "spontaneous" classic was to be among those romantics who insisted on following their natural inclinations as opposed to cultural precedents, to be among those who conceived of art as the untutored realization of inner feelings, thoughts, and character. (There remains the question whether the feelings a person experiences as "inner" *are* inner, whether that person's immersion in a culture eliminates this possibility, substituting social forms for personal ones. I will return to this.)

Eugène Delacroix (1798–1863), hedging Romantic-versus-classic bets, claimed that he had achieved an independent mastery; because of this, others would copy him as their classic model, but he would have no need to imitate anything outside himself (figs. 7–12).[44] In 1846, critic Théophile Thoré prefigured the Cézanne problem by arguing that true artists defy classification according to lineage; they exist as "the sons of no one [and] go forth from their own innateness."[45] The classical tradition had been marked by the repetition of both thematic and stylistic forms. In what might be identified as a modernist reorientation, the new romanticism (Delacroix), realism (Flaubert, Gustave Courbet [1819–1877]), and impressionism (Pissarro) reiterated only what belonged to each artist alone: a personal style. Cézanne's apple, classical or not, belonged to no category other than his.

Inadvertently, Cézanne inspired the symbolist school to depart from both academic and impressionist standards of representation. Symbolists believed that impressionists and the academics who preceded them were painting apples as a subject, whether real or imaginary, whereas Cézanne was painting "beauty," setting it arbitrarily into the form of an apple. To some, this beauty was a material property, available primarily to sensation; to others, an abstract essence. All the while, without making quite the same "symbolist" claims, Cézanne's initial impressionist colleagues—Pissarro, Edgar Degas (1834–1917), Claude Monet (1840–1926), Pierre-Auguste Renoir (1841–1919)—remained true to their early appreciation of his talents. On visiting the exhibition at Vollard's gallery, Pissarro spoke of how deeply he and the others had been affected by this "refined savage [*sauvage raffiné*]." "All of us," he wondered, "are we mistaken? . . . I don't think so."[46] For two different groups of informed viewers, then, the 1895 exhibition confirmed existing beliefs and even strengthened them. To the contrary, for the newer public audience, the same body of work generated a savage shock; its forms appeared devoid of the mitigating refinement that both artists like Pissarro and critics like Natanson could perceive because they were already seasoned in Cézanne's wildness. Concentrating on the beauty, they refrained from condemning as utter mistakes the technical blemishes that might appear in a painted apple and elsewhere. And if Cézanne, like Delacroix before him, was becoming recognized as an independent but classic master, then his "mistakes," like Corot's, would seduce others to repeat them.

Reviews of Vollard's show, whether positive or negative, duly registered its controversial nature. Among the more detailed accounts was Natanson's, which, coincidentally, adopted the terms of Pissarro's judgment, perhaps because the oppositional play of refinement and savagery was such a cliché, these contradictory terms having been fully assimilated into the prevailing critical discourse. Natanson presented savagery—that is, wildness—as a feature of merit (not an unusual position then or now). Cézanne had rejected "any disingenuous seduction"; and if there was seduction, it was not intended. Natanson continued: "He dares to be coarse,

as if he were wild and uncultivated." The writer's precise words, *fruste et comme sauvage*, connoted a lack of refined culture that might have applied to the man as much as to his art.[47] But Cézanne's wildness, even if evident in his art, was questionable in view of who he was to those who knew him—a wealthy, well-educated bourgeois, religious, and relatively conservative in his politics. Despite a reputation for isolation, antisocial behavior, and even misanthropy, he was hardly uncultivated. In conversation he cited Virgil and the Latin classics.[48] Witness accounts indicate that when intellectually stimulated, he joined in speculation on matters of current philosophical debate: Does a sensitive person perceive feelings that belong to elements of nature, as if the trees themselves were conscious? Or do we project our feelings onto the trees that surround us? This question motivates an exchange recorded by Joachim Gasquet, the son of one of Cézanne's boyhood friends. Little should be taken verbatim, yet Gasquet's text captures issues of plausible concern to the painter. It poeticizes Cézanne's thought, which becomes phenomenological and pantheistic: "In a [vision of] green my brain flows along with the sap of the tree. Moments of conscious awareness of the world live on in our paintings."[49] Translation: Cézanne was painting his motif. Coquiot invoked the same harmoniousness more succinctly: "Cézanne adds his soul to the soul of things."[50]

If it was true (not merely Gasquet's projection) that Cézanne's mind moved through layers of philosophical speculation, this may have had little bearing on his immediate practice of painting. As if cognizant of his mind-body problem, he distinguished clearly between verbal and visual modes, abstract thought and concrete sensation: "The literary type [the theorist] expresses himself with abstractions, whereas the painter makes his sensations, his perceptions concrete."[51] Gasquet dutifully recorded Cézanne's frustration over too much talk when out in the landscape

ready to paint: "No theories! Works. Theories ruin people."[52] Yet the artist was no doubt at home with words. His upbringing provided access to literary culture, and he had considered becoming a writer.[53] In later life he often drew on his cultural privilege, sometimes with complicated ironies, for he mixed crudeness into his daily habits and speech. One of his young acquaintances became convinced that he acted strangely only to cause others to leave him alone—to paint.[54] On the few occasions when he was observed at work, he may nevertheless have appeared lost in contemplative thought rather than absorbed in visual sensation, not an easy distinction to make. Gasquet referred to him "sometimes remain[ing] still for twenty minutes between two strokes of the brush."[55] What was happening? Was he mentally plotting refinements to the image? Or was he immobilized by the raw intensity of the sensation, tantamount to his emotion? This was emotion that, for the moment, did not allow him to move.

We have to assume that Cézanne experienced intense sensation as well as the movement people feel as emotion. At times, he was led to wild, passionate painting, at times to doubt and immobility.[56] In so many respects, he was a paradox. If he sacrificed much of his inherited aesthetic culture to his innovations, it seemed to Natanson that this happened for the sake of a competing aesthetic good— "bold coloring, astonishing in its crudeness . . . work that is exclusively painting, which can please only those totally enamored of painting." Cézanne's guiding intention corresponded to that of the most radical innovators of past eras: "to create a number of new signs [*quelques signes neufs*]."[57] To change the sign is to change the culture, to instill in it a new mentality. The representational sign for an object, event, or psychic state is already an interpretation imposed on the course of living. When the interpretation is new, even its creator will have doubts. At one end of the artistic spectrum of the 1890s was "disingenuous seduction," skillful manipulation

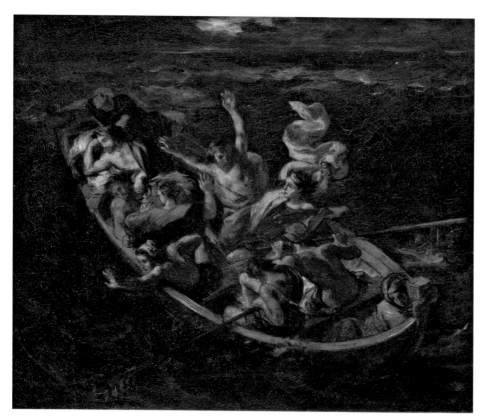

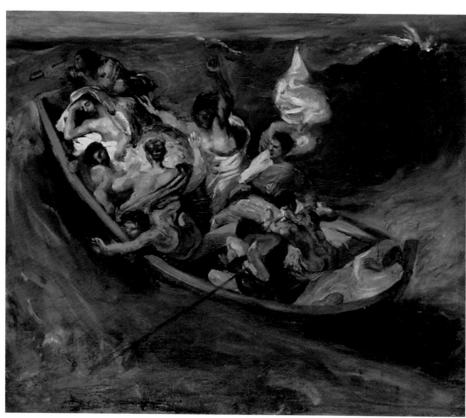

Fig. 7. Ferdinand-Victor-Eugène Delacroix, *Christ on Lake Genasareth,* 1853(?). Oil on canvas, 45.1 × 54.9 cm. Portland, Oregon, Portland Art Museum, Gift of Mrs. William Mead Ladd and children (31.4)

Fig. 8. Ferdinand-Victor-Eugène Delacroix, *Christ on the Sea of Galilee,* ca. 1841. Oil on canvas, 45.7 × 54.6 cm. Kansas City, Missouri, The Nelson-Atkins Museum of Art. Purchase: Nelson Trust through exchange of the gifts of the Friends of Art, Mr. and Mrs. Gerald Parker, and the Durand-Ruel Galleries; and the bequest of John K. Havermeyer (89-16)

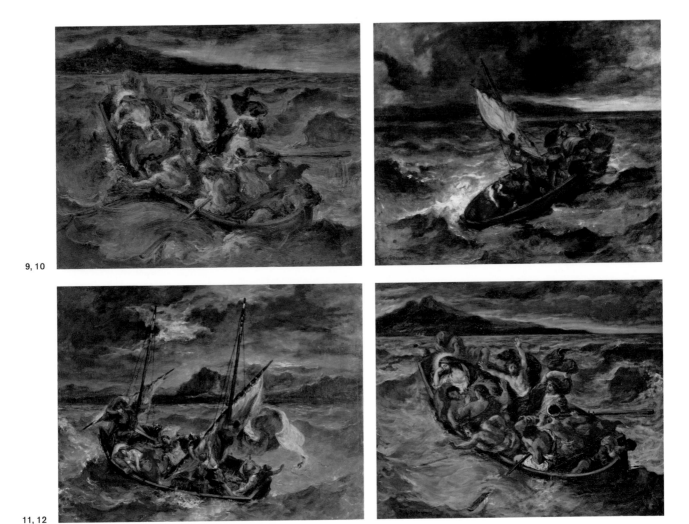

9, 10

11, 12

Fig. 9. Ferdinand-Victor-
Eugène Delacroix,
*Christ Asleep during the
Tempest,* 1853. Oil on
canvas, 50.8 × 61 cm.
New York, The Metropoli-
tan Museum of Art,
H.O. Havemeyer
Collection, Bequest of
Mrs. H.O. Havemeyer,
1929 (29.100.131)

Fig. 10. Ferdinand-Victor-
Eugène Delacroix, *Christ
on the Sea of Galilee,*
1853. Oil on composition
board, 47.6 × 58.1 cm.
Philadelphia Museum of
Art, Gift of R. Sturgis and
Marion B.F. Ingersoll,
1950 (1950-6-1)

Fig. 11. Ferdinand-Victor-
Eugène Delacroix, *Christ
on the Sea of Galilee,*
1854. Oil on canvas,
59.8 × 73.3 cm. Baltimore,
The Walters Art Museum,
Bequest of Henry
Walters, 1931 (37.186)

Fig. 12. After Ferdinand-
Victor-Eugène Delacroix,
*Christ on the Lake of
Gennesaret,* 1854. Oil
on paper mounted on
Masonite, 25.1 × 31.4 cm.
Museum of Fine Arts,
Boston, Bequest of
Josiah Bradlee, 1903
(03.741)

of the viewer by means of conventional signs. At the other end was its ethical antidote: crudeness, coarseness, wildness (with or without Cézanne's tenuous anchor in Virgil and the ancients, a safeguard against his doubt).[58] Trying to accommodate the one—classical pictorial rhetoric—while being drawn to the other—"nothing that could be seen before"—sometimes brought Cézanne's sensation and emotion, as well as the associated movements of his brush, to a standstill. No wonder that he believed, very late in life, that he had achieved only "slow progress."[59]

Manet / Cézanne

[Manet] had nothing that would have been needed to tame a "savage." His elegance, worldly manners, the urbane wit of his conversation, all this worked to distance Cézanne.
—GEORGES RIVIÈRE, 1923[60]

I don't offer my hand, Monsieur Manet; I haven't washed in a week.
—CÉZANNE, upon meeting Manet in 1866[61]

The purpose of culture is to bring moral order to the physical world, regulating the body and mind, setting standards for behavior and even thought. Culture tames wildness in both people and their world of things. Like an ideology, a cultural order relies on the "rhetorical eloquence" of its representational signs, which constitute projections of authority. Eloquence—proper, effective discourse—ensures that the message of the sign is convincing with respect to both its logic and its sincerity. Because we fully expect rhetoric to be eloquent, the phrase "rhetorical eloquence" is pleonastic. Here I quote it from Georges Bataille, a twentieth-century critic and theorist associated primarily with the surrealist generation of French artists. In Bataille's reasoning, as with the ancients who debated the use and abuse of rhetoric, "rhetorical eloquence" shades into what Natanson called "disingenuous seduction." Rhetoric is value-neutral but inherently seductive. Its purpose

is to lead people where they would otherwise be disinclined to go—from one mental frame to another, one moral state to another.

Despite his surrealist orientation, Bataille took an interest in impressionist painters of the late nineteenth century, Cézanne included. In 1955, he published a short book on the impressionism of Cézanne's somewhat older contemporary Édouard Manet (1832–1883). He offered this characterization, ironic in relation to Manet's refined manners and speech: "Every element of rhetorical eloquence, true or false, is eliminated. There remain the strokes of different colors [literally: spots, *taches*]. . . . This is the negation of painting that expresses, as language does, a specific feeling."[62] According to Bataille, Manet's art abandoned eloquent articulation and with it the possibility of expressing a fully defined "specific feeling," feeling subject to classification. A specific feeling is a familiar emotion, already bearing a name, easily discussed and managed. Feelings of this type neither overwhelm nor threaten. In Bataille's estimation, feelings to be derived from Manet's art would be otherwise: just as specific yet unattached to language and its usual rhetorical forms—uncultivated, wild.

Lacking eloquence, Manet's sign, his picture in its bare material manifestation, would have to locate its beauty elsewhere than in rhetoric. It risked the appearance of crudeness and even ugliness. Worse than that, Manet's manner of rendering seemed incomplete and malformed, as if he had abandoned any pretence to an accomplished naturalism and realism. His crudeness was quantitative: in the context of an essay on Cézanne, Denis noted that Manet's *Fifer* of 1866 (fig. 13) displayed a mere "four shades" of gray, whereas a typical impressionist painting would introduce a full palette to take advantage of every nuance of every hue in the spectrum.[63] Cézanne might have seemed like a full-palette Manet, using a relatively small number of discrete strokes or juxtaposed patches of saturated color to

constitute a human figure or an object (see *The Bathers [Baigneurs]*, fig. 14).

Rhetorical eloquence enables a communicative medium, whether a picture in colors or a description in words, to appear not only authoritative and comprehensible but also—paradoxically—natural, that is, without need of rhetorical eloquence. The representation passes through the cultural environment fluidly, effortlessly. Culturally sanctioned, a "natural" sign affirms itself in repeating its allusions to an established constellation of values. When social life is agreeable and individuals are in easy command of their discourse, no need arises to question the collective cultural order; it feels "natural" despite the artificiality and arbitrariness of its coding.

For whatever reason—matters of political resistance, aversion to authority, personal conflict—an individual artist may decide on or merely drift along a countercultural path. He or she assumes an open, incredulous

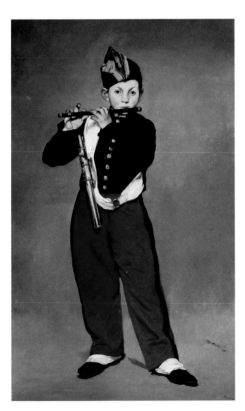

Fig. 13. Édouard Manet, *The Fifer*, 1866. Oil on canvas, 1,610 × 970 cm. Paris, Musee d'Orsay (RF 1992)

attitude toward prevailing social forms and their media rhetoric, seeking to separate the "genuinely" natural from whatever the culture has merely naturalized: its rhetorical "seductions." Natanson's account of Cézanne implied that the painter had returned to natural forms of visual expression through his aesthetic wildness. His art was distinguished not for its culturally approved thematics (bathers, apples, and so on) but for "all the remainder, which is nothing but painting itself."[64] Easy enough to announce in concept, in practice this shift was momentous and troubling even to those who brought it about. Natanson's "remainder," "painting itself," corresponded to Sérusier's and Denis's "motif"—a complex of felt emotion, physical movement, and natural form (form suited to the material medium). At a distance of sixty years, Bataille would reach Natanson's, Sérusier's, and Denis's shared conclusion, still problematic. He framed the question in terms of a void rather than a remainder. Manet's art filled him with "the strange impression of an absence."[65] Sérusier and Denis had also spoken of a loss, a subject disappearing, replaced by a motif. Analogously, Bataille invoked "the destruction of the subject."[66] But did anything replace the subject when it was gone?

Converting disorderly human sensation into moral order, culture reduces selective aspects of experience to intellectual abstractions, mental constructions suited to the memory. Bataille was one of those twentieth-century critics who perceived nineteenth-century art in terms of what it had lost, that is, failed to remember. Among other things, it lost its capacity for generalized conceptual abstraction—the "subject." If nineteenth-century painting had been moving toward the kind of twentieth-century abstract art that lacked a subject, then its "abstraction" was more sensory than intellectual, addressing the body rather than the mind. According to Bataille, Manet's "absence" contributed to an aesthetic, sensory withdrawal from

ideologically organized systems of reason; and for its destruction of the rational subject, Manet's painting was to be valued. The loss was welcome. For Natanson, Cézanne's wildness—*fruste et comme sauvage*—had had much the same effect. Both Manet and Cézanne contributed to (or merely reflected) the loss of a secure sense of morality and its abstract concepts. Manet's and Cézanne's "strokes of different colors" belonged with all that was physical in art, a physicality outside ideological control on the far side of any steady moral line.

Painting for Itself

With impressionism, painting attained autonomy, but Cézanne alone made forceful use of the freedom it offered. . . . [He paints] what we see, without reflecting on it intellectually, without assimilating it to linguistic formulations.
—GEORGES BATAILLE, 1956[67]

What we remember may be no more than a fraction of what we sense. In passing, we glimpse a rose that displays both red and blue hues; we remember it as red, not blue, because this is our customary abstraction of a rose. "Roses are red" is a thought more than an observation, a lasting concept (moral) rather than a transient sensation (physical). Any reversal or inversion in the system of generalized signification presents a danger, for regression from the abstraction of events and phenomena to raw sensation threatens to undermine the intellectualized cultural order, even when the ensuing complications are slight. Mere sensation makes no sense in itself, and a society can tolerate only so many nonsensical appendages to its streamlined forms of communication. Speakers intend more than the pleasing alliteration of "red rose," an aural sensation that may seem free of context. Beyond the aesthetics of the sound, we equate such words with accepted notions, believing in the case of roses that they actually are red and ought to be. Beyond the color lie the connotative meanings: love, sex, death. Although the poetic sound of the verbal sign aids in our remembering the redness and these social facts, it would be destabilizing for the concept and meaning of the rose to depend on a capricious appeal

to the senses, an arbitrary repetition of *r*. The conventional perception of a rose (red, not blue), together with its standard metaphoric meanings, constitutes the moral content of this physical thing. Morality is cultural. Inessential aspects of the verbal or visual representation of a rose, such as its full range of color, inhabit a physical realm outside the established moral order.

To turn away from the representational meaning of a sign, drawing attention to its physical, sensory character—in our example, to dwell on the alliterative *r* in an aural description or on variations of hue in the visual image—is to foster cultural anarchy. Modern critics have accepted the consequences, stressing the value of physicality and materiality for the very reason that the physical realm promises release from hierarchies of conceptual abstraction grown too rigid within a cultural structure.[68] Culture can deaden as well as enliven. In a fully constructed world, certain modes of art presume to offer an unconstructed anti-world. Do they? Artists often believe so. Perhaps this is no more than my fantasy (our collective fantasy?), a beneficial fiction I would like to believe despite suspicions to the contrary. When the intellectual abstractions of a culture prove restrictive, an individual can test out an escape through the realm of the physical. Gauguin did so, leaving Parisian civilization for the fantasia he would fashion from Tahiti.

What about Cézanne, far less revealing than Gauguin in his personal statements? Laying down his little marks of color, he arrived at his own countercultural position. How radical he intended to be, if at all, may be impossible to know. Artists sometimes surprise themselves. Gauguin during the 1880s took the lead in appreciating Cézanne's art for the cultural liberation it seemed to offer.[69] Many others followed. In 1891, Gauguin's erstwhile colleague Émile Bernard (1868–1941) included a bold claim in the first publication devoted exclusively to the enigma of Cézanne: "He opened to art this amazing

door: painting for itself."[70] Natanson repeated the claim in 1895. And in 1899, Félicien Fagus (pseudonym of Georges Faillet) wrote similarly of Cézanne's love of "color for its own sake. . . . Through color he composes, [disdaining] every aspect of theory, every [established] technique, every method." To this use of color, Fagus linked a challenging practice then becoming known as "pure painting": "Cézanne sometimes copies onto his canvases scenes from popular prints and almanacs . . . faithful to them at least in terms of the moral content," that is, the thematics.[71] The critic's phrasing was *tenir vrai . . . moralement,* to hold true to the source morally. The painter's copy would faithfully preserve the subject matter and its familiar cultural connotations—the moral factor—even as he converted black-and-white graphic sources to brilliant color, which then became the salient feature of the image, and rather striking: "color for its own sake," "painting for itself," the physical element rendered paramount. By this reasoning, Cézanne's art preserved the moral thematics of a generalized classical tradition and specific (often popular) sources, but in an etiolated form, merely as a hollow shell. In contradistinction, color and its materiality, now liberated from the image, forged an aggressively autonomous way.[72] As the moral abstraction weakened, the physical abstraction strengthened. Paul Signac's (1863–1935) description of Cézanne's technique, also from 1899, captured much the same sense of its significance—"strokes rectilinear and pure, concerned with neither mimeticism nor artfulness."[73]

In 1904, Bernard had the good fortune to observe Cézanne directly at his studio in Aix-en-Provence, conversing with him over a period of several weeks. "To my great astonishment," he wrote subsequently, "Cézanne had no objection to a painter's use of photography; but in his case, it was necessary to interpret this exact reproduction just as he would interpret nature itself" (see *Melting Snow, Fontainebleau* [fig. 15]).[74]

144

This statement confirms what Fagus had surmised from seeing an array of exhibited works: Cézanne converted black-and-white images to his chosen range of color, just as he converted a natural scene to colors suited for painting on canvas. The colors were of his painting but not necessarily derived from the concept of the subject matter, nor from the chemistry of photography, nor even from whatever objects he may have observed in nature. Both the color and the thematic content would affect the emotions, but their affirming coordination—a moral factor normally established by rhetorical eloquence—appeared diminished or entirely absent. Cézanne's art reduced its culture to an awkward stutter. Or perhaps a snigger: reflecting on Cézanne's initial public, a twentieth-century advocate of modernist practice recalled that during the nineteenth century, "smiling at a painting meant one disliked it."[75]

Laughing *at* Painting

In his works, Cézanne is a Greek of the golden age . . . and the ignorant souls who laugh in front of his Baigneurs *[Bathers at Rest, fig. 16] look to me like barbarians criticizing the Parthenon. . . . These laughs and these cries stem from a bad faith that people don't even try to hide. . . . This is forced laughter.*

—GEORGES RIVIÈRE, 1877[76]

Fig. 15. Paul Cézanne, *Melting Snow, Fontainebleau*, 1879–80. Oil on canvas, 73.5 × 100.7 cm. New York, The Museum of Modern Art. Gift of André Meyer (373.61)

To Manet, who sacrificed meaning, and Vincent van Gogh (1853–1890), who sacrificed himself, the surrealist-inspired Bataille added Cézanne as a paradigmatic modernist artist, one who may have sacrificed both.[77] Bataille's thoughts on the shock value of nineteenth-century painting draw on the distinction between morality and physicality, applicable in all three cases: Manet, van Gogh, Cézanne. He warned of an indoctrinated public's tendency to deny, disregard, or discredit the value of physical and material aspects of experience that fail to relate to immediate, conscious needs. In a work of art, a material factor lacking obvious representational function might generate this type of useless sensation. An excessive physical or material presence would be likely to provoke a fit of anxious laughter in dismissal, and perhaps indignation: What is *that* smear, *that* daub, supposed to be doing?

In 1956, Bataille reviewed several historical studies of impressionism, including the newly translated French edition of John Rewald's *History of Impressionism* as well as Maurice Raynal's *Cézanne*. He stressed what had by then become common interpretive points both in France and in America:

At first the [nineteenth-century] public showed an aptitude for laughing at whatever seemed new. . . . Painting should imitate, it should copy the real world.[78] No doubt. But [only] as convention would see it, entirely opposed to what the eye sees, if the eye—instead of seeing what the cultivated mind, the intellect, represents to it—should suddenly reveal the world.[79]

Bataille repeated the well-known story of Monet's encounter with his aggrieved teacher Charles Gleyre (1808–1874), who criticized his pupil for stupidly representing the big feet of a model whose feet unfortunately were big. Monet's mistake was to render the figure in its true proportion, a disproportion.

Bataille then added to the anecdote an observation more his own: Monet's vision accepted "the *incongruity* of things as they are."[80] Reality was not merely a truth, but an unwelcome, unruly, unaccommodating truth, inconsistent with any conceivable order of logical truth. The reality of nature included, and perhaps featured, physical deformations of "a striking incongruity, somewhat comical but all the more discomforting, mysteriously linked to a profound seductiveness."[81] No construction, no resolution, would contain reality's formlessness, attractive in its repulsiveness.

In 1929, long before his accounts of Manet, Cézanne, and impressionism, Bataille had been writing for the surrealist-oriented journal *Documents;* there, in a more overtly theoretical mode, he presented the release of the sensing eye from the reasoning intellect as tantamount to absolute liberty, a terrifying prospect: "The substitution of natural forms for today's philosophical abstractions . . . would risk going much too far: in the first place, it would result in a feeling of utter freedom, the availability of the self to itself in every respect, which for most people would be intolerable."[82] Through his concern for such an "intolerable," perhaps intoxicating sensation of boundless freedom, we readily associate Bataille with radical social theory in general and, more specifically, surrealism in the art and literature produced between two catastrophic European wars. Yet there should be no fixed division between the culture of Cézanne's nineteenth century and Bataille's twentieth. Bataille's sensitivity to extremes of physicality was spurred by the late romanticism of figures like Friedrich Nietzsche and Charles Baudelaire.[83] And he was well aware of the challenge posed by Delacroix's romanticism and Courbet's realism. He argued that their art nevertheless had its self-imposed limitations, for Delacroix's flights of imagination and Courbet's earthiness paralleled the working of language; in their different ways, these painters gave meaning to the objects they represented, even if not a standard meaning. Manet, however, did something else, "substitut[ing] for the conventional view of things an unforeseen aspect *that has no meaning.*"[84] Manet's art would result in a sensory flow amounting to nonsense, a non-meaning that dominates the given iconic subject, which as a result loses contact with any meaning that might be derived from its cultural origin.

Bataille knew that the public had often greeted Manet's paintings with a shrug accompanied by laughter.[85] This was not the same laugh that had been directed at Delacroix and Courbet, whose innovations could be analyzed as a comedy of pictorial errors (analogous to the response to Corot's technique, where viewers would "so complacently point out its faults"). Manet's public laughed instead as they encountered a truth "not to be reached by conscious knowledge"—an abrupt, confounding shock to reason. Pondering Manet in 1955, Bataille may have hit on the source of the laughter Georges Rivière observed during showings of Cézanne eighty years previously— the "forced laughter," the laughter in "bad faith" that greeted *Bathers at Rest* (fig. 16).[86] According to Bataille, Manet's public realized that "superficial appearances [can] hide a complete absence of what one expects [in a particular object of art]. . . . The laughter . . . is unleashed in the void of thought created in the mind by the object."[87]

An unregulated encounter of mind and art object, perceiver and perceived, becomes itself the source of the laughter. The object occupies the mind, totally—like an unassimilated foreign body. Despite its overt representational subject, it assumes the paradoxical form of a semantic void, a no-name, a nothing. Its force remains unaffected by any logical line of thinking. Thought and feeling, intellect and emotion, descend from their hierarchical order of conceptualization into a formlessness that grants to feeling and emotion an unaccustomed plenitude. The laughter responds to a condition that has

become not comical but . . . risible. Here, like Bataille, with no logic to invoke, no analysis to follow to conclusion, I resort to tautology. A person laughs at what is "risible," a category outside the purview of literary theories of the comic.[88] Associating laughter with the risible is as empty an analytical gesture as linking the behavior of cows to a bovine temperament.

The engulfing plenitude of laughter is simultaneously an empty "effacement." Positive becomes negative, negative becomes positive, and calculated logic loses its form—like "spit," as Bataille would say.[89] Regarding Manet's works of the 1860s, he wrote: "The text"—the cultural meaning, the theme ordinarily pondered and interpreted—"is effaced by the painting. And what the painting signifies is not the text, but the effacement."[90] As if it were involved in a familiar play of modernist reform, Manet's painting eliminates accumulated culture and empties the mind of its accustomed thought—all thought. Yet it does not deactivate the mind; sensing the effacement of the subject, the mind is free to go elsewhere. Something alien occupies it: a feeling, a sensation (as Cézanne might say)—feeling so strong that neither painter nor viewer nor any other agent of culture would think to claim possession of it. Instead, the

Fig. 16. Paul Cézanne, *Bathers at Rest*, 1876–77. Oil on canvas, 82 × 101.2 cm. The Barnes Foundation, Merion, Pa. (BF 906)

Opposite:
Fig. 17. Paul Cézanne, *The Small Bathers*, 1896–97. Brush and tusche and crayon color lithograph, 22.3 × 27.3 cm. The Baltimore Museum of Art: The Cone Collection, formed by Dr. Claribel Cone and Miss Etta Cone of Baltimore, Maryland (BMA 1950.12.605)

Fig. 18. Paul Cézanne, *The Large Bathers*, 1896–97. Brush and tusche transfer and crayon color lithograph, 48 × 56.5 cm. The Baltimore Museum of Art: The Cone Collection, formed by Dr. Claribel Cone and Miss Etta Cone of Baltimore, Maryland (BMA 1950.12.681.1)

moment possesses the person: "Only by eliminating, or at least neutralizing in ourselves every operation of rational understanding, are we in the moment, without it slipping away. This can happen under the force of intense emotions that shatter, interrupt, or cast aside the continuous flow of thought."[91]

Like other artists of his generation, Cézanne referred to sensations as if they were tantamount to his personal identity: "I paint as I see, as I feel, and I have very strong sensations."[92] Yet we wonder whether this way of putting it does not simply represent a failing of the language of Cézanne's day. He made this statement in 1870, not long after Manet created his greatest scandals, exhibiting *Le déjeuner sur l'herbe* in 1863 and *Olympia* in 1865. The feeling of "very strong sensations" that Cézanne described cannot have been personal and specific to him alone. It was his version of what in Manet was risible. Cézanne's "strong sensations" were wild, ridiculous, too strong even for him to control with a moral thematics, despite his allusions to Poussin, classicism, arcadian themes, childhood memories, the Provençal landscape, and so on. People laugh at what overwhelms their habitual sense of order, their sense of self. Like the catastrophe of war, sensation overwhelms. Cézanne's sensation was catastrophic.

For Bataille, as for most art historians before and after, Manet's innovation was not only chronologically but logically Cézanne's precedent. However eccentric his account of the various nineteenth-century painters is in its details, Bataille committed his interpretation to the existing, canonical outline of the history of modernist art. Ironically, he is best known (certainly in America) for his immersion in the utter baseness and baselessness of "formless" matter: think again of the elusive qualities of spit. Art historians have had difficulty in adjusting to Bataille's out-of-character references to Manet's "pure painting," a term favored by the likes of

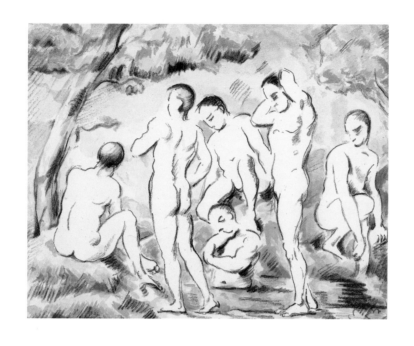

Bernard, Natanson, and Denis, which the surrealist-inspired critic accepted as he found it.[93] How "pure" is the formlessness of spit? We have inherited the notion that "pure painting" must possess form rather than lack it, an arbitrary generalization that tends to go unquestioned.[94] Accordingly, recent writers insist on distancing Bataille from the deceptively anodyne statements he repeats. T. J. Clark, 1985: "Whatever else one might wish to say of this criticism [Bataille on Manet's *Olympia*], it has little to do with the simpler narratives of modernist art history."[95] Rosalind Krauss, 1986: "Is it really Bataille who is telling us—once again—that Manet's achievement was the destruction of subject matter so that in its place . . . should arise pure painting—'painting,' as he writes, 'for its own sake'?"[96] Put off by Bataille's approach to Manet, Clark and Krauss nevertheless treat him as a figure of heroic proportion who would never accept the standard interpretation. But it seems that he did, and this confounds them.[97] If not for his stature, today's critics would laugh at Bataille's text or snicker discreetly: What naïve art history! Yet something more subversive than generally acknowledged may hide within the late-nineteenth-century argument that painting had become "pure." Purity need not act as culture's cleansing agent. Closer to early modernism than we are, Bataille was better positioned to sense the transgression in things rendered pure.

As a solution to the dilemma we can explore the canonical account with Bataille's degree of conviction. Since we take Bataille seriously, why not take his attitude toward pure painting and the "destruction of subject" just as seriously? He must have had his reasons. It turns out that he followed the standard view only so far. When he spoke of Cézanne, a particular element of the canonical interpretation went missing. I refer to the rational, systematic use of color that Lawrence Gowing ascribed to Cézanne in a frequently cited essay of 1977, characterizing the method with a phrase drawn from the painter himself: "the logic of organized sensations."[98] The dominant critical approach that evolved through much of the twentieth century, from Denis to Gowing, found evidence of "classical" order and organization within Cézanne's art of visual sensation. At the base of Cézanne's style, supposedly, one would discover a logic, a structure, a formal geometry. In 1910, Guillaume Apollinaire referred to this argument as if it were already common knowledge: "They say that Cézanne made himself primitive to prepare a new classicism. . . . While painting from nature, he concentrated the effort of his genius on raising impressionism to an art of reason and culture."[99] Apollinaire put all the pieces together: a commitment to nature, a primitive wildness, a new (rather than renewed) classicism, "an art of reason and culture." This combination is consistent with Denis's belief that Cézanne's art led the younger generation out of its cultural confusion, even as the painter remained withdrawn and thoroughly idiosyncratic.

By the 1950s, the classical-order thesis had become all the more entrenched as the lingua franca of Cézanne criticism. Denis's account and that of his British translator Roger Fry are early twentieth-century versions; Gowing's is a late twentieth-century version.[100] Elements of the thesis were evident in the four mid-century books Bataille reviewed for his 1956 article on impressionism, including Raynal's *Cézanne,* which appeared in the same series from the Skira publishing house as Bataille's own contribution, *Manet.* Raynal wrote: "Cézanne saw in geometrical features only an expression of the essence of the form." The form was the content, a kind of idealist abstraction. It inspired the cubist painters at an early stage; but in the hands of certain others who took Cézanne's inventions "more by the letter than the spirit," it reduced them to "quite conventional signs." According to Raynal— but this was hardly a unique opinion—

Cézanne in his last years stressed emotive as opposed to structural qualities, redressing a proper balance.[101] Bataille himself took a simpler tack, eliminating the question of geometrical order from his interpretive equation.[102] Instead, he shared with Raynal the belief—originally Gauguin's and Bernard's notion—that Cézanne instilled painting with "autonomy."[103] Both writers noted the physical appropriation of moral order in acts of "pure painting." Raynal wrote that Cézanne "was removing from his art all the worldly, referential factors that the approach of death rendered alien to him, attending only to a supreme exaltation of the specific reason for his living: painting itself."[104]

Raynal may have caused the "reason for [Cézanne's] living" to appear all too reasonable. Here I think of one of Bataille's touchstones, Nietzsche, who referred to "those who suffer from the over-fullness of life."[105] For Bataille, mindlessness, empty-headedness, thought reduced to nothing, assumed a certain literal value, inconsistent with any claim that artistic creation should be logical, organized, and constructive. In his view, reason and logic were intellectual accoutrements of language and of codified academic art, factors of moderation and standardization that would only inhibit those committed to what might be called the "over-fullness" of modernist painting. As Bataille put it, Cézanne had been overwhelmed by his "attraction to the excessive and the prodigious [and was] aware of the impossibility of communicating the grandiose emotion that persisted in agitating him, which he experienced as a sovereign emotion." A "sovereign" emotion so rules over a person as to reduce *him* to *it*—the semiotic void, the "nothing" (Bataille's term) that fully occupies a person.[106] "Nothing" is the pure form—the formless form, the chance movement—of something. Of what? It would have to be something without a name, category, or definition. Caught up in his sovereign autonomy-without-reason, Cézanne broke

from his cultural codes even more violently and scandalously than Manet had.[107] From the start, he had recognized, or perhaps fantasized, his difference, his supersession: "I don't offer my hand, Monsieur Manet. . . ."

Bataille's view of Cézanne was not as eccentric as it may seem from paraphrases. He derived it in the process of reviewing four books that were offering rather standard histories of the impressionist movement—better documented and better illustrated than ever before, but hardly revisionist. We can profit from the canonical elements in Bataille's understanding, especially when filtered through the critic's corporeal metaphors, which recuperate the moral force of the physical tensions in Cézanne's art. Bataille's manner of interpretation bears on the issue of pictorial repetition: repetition can be conceptual; but, even more so, it is physical. Fundamental to Bataille's reasoning is the traditional distinction between the moral, intellectualized side of human experience and the unorganized excesses of physical sensation: the moral and the physical. Along with other early twentieth-century figures now associated with cultural resistance, Bataille understood this distinction just as painters and critics of Cézanne's generation did, though he developed it more explicitly. He shared this opposition (moral versus physical) with those who wished not only to justify the nature of Cézanne's practice, but also to explain the complicated public reaction. The public laughed at Cézanne's art; they felt threatened; and yet they experienced an emotional frisson. This response seemed illicit. Why?[108]

Bataille stated what many earlier writers were reluctant to admit: when experienced in its fullness, physicality presents an unbearable freedom. Ironically, it was Cézanne's fate to be labeled a classical master of compositional order by more members of Bataille's generation than of earlier ones. This may well have been the most expedient way to acculturate or domesticate the physical wildness

of Cézanne's art, especially for those political and social conservatives among the earlier voices, such as Denis. He admired Cézanne's paintings aesthetically but had political cause to want to defuse their effect.[109] He credited Gauguin as the first to recognize an autonomous beauty in Cézanne's material technique and to understand its "primitive" implications. Eventually, he linked Gauguin's sense of Cézanne to the vogue for German Romanticism—a "taste for whatever is simple, primitive, wild." Denis implied that this variety of Romanticism was as French as it was German, at least as personified in Gauguin. But it had been taken too far: "The influence of these [Romantic] ideas reached its maximum in France in Gauguin's era [the symbolist decade of the 1890s]. Assuming an almost animal meaning, the notion of instinct replaced that of genius, and everything that was not rude, infantile, coarse, and even uncouth seemed to merit our disdain."[110] Through his evolving interpretation, Denis reformed Cézanne by substituting rational order for his wildness. To a Cézanne who had lost too much of the "subject," a Cézanne whose "motif" teetered at the edge of control, Denis restored the rule of art. But Bataille did the opposite. We are left with two competing characterizations of Cézanne's practice: one leading to moral coherence and intellectual order, the other leading to physical instability and sensual excess.

Moral, physical . . .

*[The author] is fine to read when he deals with the moral value of the artist's work [*la valeur morale: *the thematics] . . . but he dodges the question whenever the difficulty pertains to art itself [its materiality and physicality].*
—PAUL MANTZ, reviewing a new book on Poussin in 1858[111]

I see. By strokes of color [taches]*. . . . One touch* [touche] *after the other. . . . Sensation before all else.*
—Cézanne's words, as reported by Gasquet and Denis[112]

[Cézanne] can't put two strokes of color on a canvas without it [already] being very good.
—PIERRE-AUGUSTE RENOIR, 1906, as reported by Denis[113]

Cézanne died on 23 October 1906. Charles Morice, formerly Gauguin's literary collaborator and eventually his biographer, had a substantial record of commenting on Cézanne but was not among the first to report the sad news. Because he wrote for the biweekly *Mercure de France,* critics for the dailies preceded him. This positioned Morice to allude not only to Cézanne's achievement but also to the ambivalence of its summary assessment. His own announcement, dated 1 November, began with the suggestion that rival commentators had glossed over their dilemma: "They report that the painter Paul Cézanne passed away in his sixty-sixth year 'full of glory.' They don't dare write: full of controversy."[114] In the course of reviewing new work by Matisse in 1904, Morice himself had identified Cézanne's example as exercising a "beneficial tyranny over the younger painters."[115] Essentially this was praise, but with phrasing that cut both ways depending on whether a critic approved of the current level of accomplishment of Matisse and others of his generation. Regarding this, Morice wavered. His contemporary Raymond Bouyer was more decisive, vilifying Matisse for being "more Cézannean than Cézanne," whom he had already classed among the "feeble-minded [and] infirm."[116]

Morice was candid enough to acknowledge the continuing divergence of evaluative opinion at the time of Cézanne's death. What was its cause? It was not the subjects Cézanne represented, however bizarre they sometimes appeared. The lasting problem was instead the physical character of the material surface of Cézanne's images—a certain insistence and repetitiveness that seemed to establish his physicality as a feature apart from his thematics. This point requires further explanation, if only because the repetition of a

thematic element (as opposed to repetitive-ness in technique) would normally increase its significance, with or without aspects of material form joining the effort. In Cézanne's case, for example, a critic might infer that the theme of bathers in a landscape was para-mount because it appeared so often within the oeuvre. But still-life pictures of apples appeared with equal frequency. Traditionally, the theme of bathers, with its mythological connotations, was grand, whereas still-life themes were decorative and slight: hence, Meyer Schapiro's effort to reveal an allegori-cal pattern of deep cultural and psychological meaning centered on apples, as if to redeem Cézanne's disproportionate investment in a trivial subject.[117] Studies like Schapiro's are a rearguard scholarly action. Cézanne's art had already done its cultural damage (the loss of subject). Repetitiveness in his practice leveled traditional hierarchies of value, as opposed to articulating the meaning of the repeated elements by setting them into ranked order. By restoring the "subject" to articulate cul-tural significance, scholars have undermined the radical effect of Cézanne's art within its original social context. They have been mak-ing familiar kinds of sense out of an art that was significant for the very fact that it made no sense (Cézanne the proto-dadaist, the proto-surrealist, the Cézanne of Bataille).

There must have been something odd about Cézanne's repetitions, because other painters of his era also reduced thematic differences, yet never became so controver-sial. On his part, Morice neither elevated Cézanne's art above aesthetic law, nor balked at its peculiarities, including the repetitions of compositional form and scale that would cause one work to resemble another in sig-nificance, even when the subjects differed. Cézanne's art frustrated critics, who failed to derive any moral meaning from his portrayal of a range of themes. The root of this frustra-tion was evident enough to early observers. In a text of 1906, quoted appreciatively by Morice the following year, Théodore Duret

(who had been close to Manet) referred to Cézanne's large-scale paintings of female bathers "where figures are placed side by side, without being given distinctive gestures, above all put there to be painted."[118] Put where? It seemed that any one position on the surface—left, right, up, down, front, back—counted much the same as any other. Cézanne's compositional positions, like his points of thematic focus, were exchangeable.

As Fagus and other early reviewers indi-cated, Cézanne's accentuated marking and coloring of figures was distinctive enough to give these quasi-independent characteristics the sense that they had reached their proper end with no higher, synthetic order destined to appear. From Cézanne's material specifics, critics derived neither intellectual abstraction nor expressive generality.[119] Duret wrote that the "expression of abstract feelings [senti-ments abstraits] and states of mind always remained outside [Cézanne's] ken."[120] For better or worse, depending on the attitude of the critic, with the painter's technique so evenhandedly applied, the effect of the most humble themes equaled that of the most exalted: "A still life—some apples and a napkin on a table—acquired a certain gran-deur, to the same degree as a human head or a landscape by the sea."[121] Opinion divided on this issue, which had appeared in Manet's case before Cézanne's. Thoré wrote in 1868: "[Manet's] present vice is a kind of pantheism that values a human head no more than a slipper [and] paints everything almost uni-formly."[122] As it happened, Bataille said much the same but without echoing Thoré's dis-tress. In The Execution of Maximilian (fig. 19), Manet "painted the death of the condemned man with the same indifference that he would have felt had his chosen subject been a flower or a fish."[123]

Assume that Duret in 1906 correctly identi-fied the trouble caused by coarsely composed, hyper-physical art: the loss of subject, the leveling of values. It follows that Cézanne's painting, as much as Manet's, laid the ground

for a general statement with which Bataille began one of his early theoretical essays: "It is vain to see in the appearance of things only those intelligible signs that allow various elements to be differentiated one from another. What strikes human eyes determines not only knowledge of the relations between various objects, but just as much a specific, inexplicable state of mind."[124] This "state of mind" belonged to the viewer, not the artist. It was not something fixed in advance of painting and set up for representation like a model in a studio, already a kind of intellectual abstraction. It was instead an unstable psychic condition coming in response to the unfathomable complexity of material and sensory relations at a given moment. In 1905, Morice captured the problem in a sentence, aided by a clever pun: "Cézanne takes no more interest in a human face than in an apple, and in his eyes neither has any [moral] value beyond being [color] 'values.'" Still more succinctly, he provided a variant of his formulation: "The humanity in [Cézanne's] paintings has only the [moral] value of a [color] value"—*la valeur d'une valeur*.[125] Each stroke of paint with its specific color was a "value," a physical element. Cézanne's extreme concentration on

the physical arrangement of color appeared to have eliminated the moral value, the moral side of his life. To put it another way: his physicality, his sensation, became the only moral basis that remained to him.

. . . comical: Laughing *with* Painting

A situation is comical if it calls our attention to a person's physical state when the moral state is at cause.
—HENRI BERGSON, 1899[126]

When Cézanne repeated representational themes such as his bathers, the sequence of works did not lead to a culminating masterwork, nor were different versions of a theme produced to meet market demands or to complement each other in display. The individual paintings remained no more than variations of one another. Even his late, large-scale compositions appeared as if each might yet resume its progress. In this sense, all of Cézanne's works were "studies"; none was definitive. He referred to his paintings as *études*: studies, exercises, attempts.[127] Attempts at what? Bernard observed one of the grand compositions of female bathers unfinished in Cézanne's studio in March 1904 (fig. 20) and again, still unfinished, about a year later on a second visit to Aix. According to his account, the picture was "hardly more advanced, despite obstinate effort; several of the figures had changed position, the color having been thickened by successive layers."[128]

Like Morice (in the obituary notice of November 1906), Bernard acknowledged that the case of Cézanne lacked resolution: "He takes his secret to the grave."[129] Privileged in having had direct contact, even Bernard was uncertain that he comprehended Cézanne's methods and motivation. In 1904, he may nevertheless have captured the essence of the problem with an allusion to "abstraction": "The more he works, the more his work removes itself from the external view [and] the more he abstracts

Fig. 19. Édouard Manet, *The Execution of Emperor Maximilian of Mexico, 19 June 1867*, 1868/69. Oil on canvas, 252 × 302 cm. Städtische Kunsthalle, Mannheim

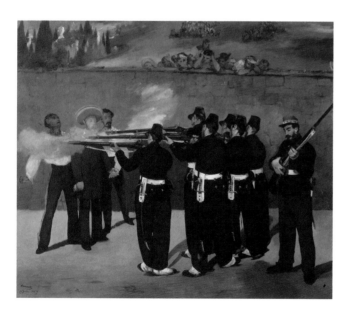

the picture."[130] When "abstraction" became the issue, it sometimes meant that conceptualization was displacing a natural empirical order. But use of this word could also indicate the contrary situation, when the mute materiality of lines and colors, lacking clear referential function, interfered with every conceivable intellectual classification. Anarchic physicality, a kind of abstraction, disrupts the moral, cultural order.

Some years later, in 1914, the writer Octave Mirbeau imagined how Cézanne might have explained his artistic achievement: "I know how to put greens, blues, and reds on a canvas."[131] However evasive, a statement of this type connects with Bernard's reduction to material "abstraction." Mirbeau always looked favorably on Cézanne's art, probably because his good friends Pissarro and Monet did. By reducing its essence to the composition of color, he was not demeaning but merely char-

Fig. 20. Paul Cézanne in his studio at Les Lauves, in front of the *Large Bathers*. Photograph by Émile Bernard, 1904. John Rewald Papers, National Gallery of Art, Washington, Gallery Archives

acterizing. Cézanne used color; he painted. His significance would have to be found there—in the color and the paint.[132]

Yet certain of Cézanne's compositions hardly seem consistent with Mirbeau's sense of color or Bernard's sense of "abstraction." He was not always so removed from thematic organization and manipulation. At times his work seems to plot out a scene with deliberate visual wit, verging on the absurd or the comical. What should be distanced comes near; things that should remain apart converge—

effects Geffroy noticed in his review of 1894, dismissing such confusions as by-products of the painter's aggressive technique.[133] *Still Life with Plaster Cupid* (fig. 21) exemplifies the problem. Its array of studio props—a plaster statuette, apples, onions, a serving dish, a decorative cloth, some canvases in progress—has been composed so that it undermines the normal logic of the representational process.[134] Cézanne positioned the patterned cloth as if he were determined to break the illusion of a coherent volume of space. The cloth extends from a table in the depicted studio foreground to a table within a still-life canvas situated against a rear wall. This picture-within-the-picture becomes the pictorial background plane, overlapped by the foreground table and its objects. The distinctive blue cloth is forced to occupy two spaces that cannot be one, passing from a fictive reality (the depicted table with its objects) to a fictive fiction (the depicted painting of a similar table with its own objects).

The central element of the foreground composition, a plaster cupid, replays similar relationships. Pictorially, Cézanne set it against a stretched canvas shown lying behind it. This canvas centers and frames the cupid's torso, yet does not fully contain it. Unlike the depicted painting accommodating the blue cloth, this background canvas appears blank, devoid of an image. Apparently, the cupid itself fills it, as if this otherwise unarticulated canvas surface had been awaiting its proper image—any image. How suited is *this* image, the plaster cupid, to the surface behind it? A reflective painter knows how easy it is to confuse what lies behind in space (according to the moral, conceptual order of pictorial illusion) with what lies underneath on the material plane (according to the physical order or layering of actual substances). The cupid extends beyond its surrounding pictorial frame; its fit is hardly perfect. A visual logic of likeness nevertheless confirms the strange relationship, for the background canvas leans at an angle

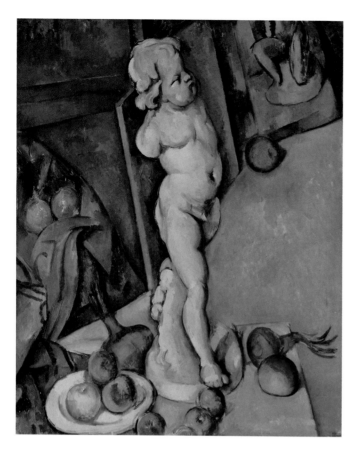

sympathetic to the dynamic tilt of the statuette. This provides the cupid with compositional support and, moreover, a sense that it makes contact with the surface it overlaps. In addition to likeness (a metaphoric element), the relationship of cupid to canvas depends on contact (a metonymic element). The two represented objects, statuette and blank canvas, adhere in tactile intimacy. Once we notice how they relate, we can imagine the fictive space of Cézanne's painting as if it were compressed or compacted to a single, energized plane—a plane of sensory color, of formal "abstraction." The foreground image projects onto the background area; the background becomes equivalent to the foreground. Perhaps what Cézanne discovered in composing his cupid reflects on what he learned from positioning his patterned cloth: a depicted object can be situated in two different kinds of fictive space because each of its articulated elements

Fig. 21. Paul Cézanne, *Still Life with Plaster Cupid*, ca. 1894. Oil on paper, mounted on panel, 70.6 × 57.3 cm. London, Courtauld Institute of Art Gallery (P1948SC59)

has the same material base—the surface that the painter physically touched, his "greens, blues, and reds."

Once Cézanne set his studio objects in place as a compositional "model" to be represented—arranging his plaster cast, his apples, his onions, perhaps even the unfinished canvases in the background—his hand struck only the flat plane of his painting. His cupid retained its volume and weight in a figurative, not a literal sense; depicted, it consisted only of paint, a material normally of negligible volume and weight when applied to cover a surface. Here, the figurative sense grows twofold, for the depicted cupid and the depicted canvas behind it occupy the same area of a single painting in progress. A logical response is to imagine that the sculpture could be a painting of a sculpture. But this is precisely what the "sculpture" is. We view it as if it had been painted twice: on the one hand, illusionistically; on the other hand, as a composition in the flat. To create his visual pun with its comedic effect, Cézanne took advantage of a confusion of the figurative and literal senses of any painted representation. The image is figurative; the material is literal. The "sculpture" within Cézanne's painting becomes a "painting"—materially flat like the surface that supports it. Its existence as illusion moves one step closer to material reality, still without reaching it.

Still Life with Plaster Cupid sacrifices moral coherence and resolution for the sake of an increase in literal physicality. In this respect, philosopher Henri Bergson, Cézanne's contemporary (but younger by twenty years), becomes his theorist:

Most words have a physical meaning [*un sens physique*] and a mental or moral meaning [*un sens moral*], depending on whether we take them literally or figuratively. Every word originates, in effect, by designating a concrete object or material action; gradually, however, the meaning of the word dematerializes, becoming an abstract relation or a pure idea. . . . When attention focuses

[back] on the materiality of a metaphorical figure, the idea expressed becomes comical.[135]

It seems that when Cézanne resorted to primitive materiality, it gave a classic comedic structure to his operation. In 1877, Rivière had observed people laughing at *Bathers at Rest* (see fig. 16)—as wrongheaded as laughing at the Parthenon, he claimed.[136] Perhaps something quite specific struck those viewers as comical, such as a confusion of gender identities, since Cézanne's four bathers have awkwardly ambiguous body types.[137] Even so, the public may have sensed something risible beyond anything comical—an excessive physicality in the rendering of the bathers, masses of pigment that neither a science nor a mythology of trans-gendering would explain.[138]

Bergson noted that the base, material properties of phenomena become evident through repetition. No matter how animated in themselves, movements when repeated degenerate into a mechanism, stiffly inanimate. The effect is comical.[139] Repetition imposes consciousness of materiality in situations where it would normally be ignored or suppressed. In the case of "red rose," the physicality of the phrase—its sound, whether grating or mellifluous—should have only a secondary, connotative bearing on its moral, rational meaning. But an insistent repetition of the physical element inverts the hierarchy, with the sound first dominating, then obliterating the meaning, perhaps to the point of ridiculousness because the listener remains aware of the inappropriateness of the inversion. We understand what the moral meaning ought to be, simultaneously realizing that under the immediate physical conditions, we cannot take its sense seriously. Every artist of the nineteenth century who, like Cézanne, abutted one discrete stroke of paint against another, risked creating a condition in which the juxtaposition of similars, intended as nuance, was transformed by its inherent

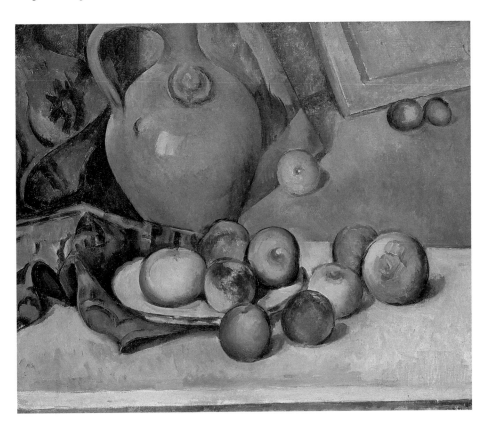

Fig. 22. Paul Cézanne, *Pichet de grès*, 1893–94. Oil on canvas, 38 × 46 cm. Riehen/Basel, Fondation Bayeler (inv. 99.7)

156 structure into material repetition. To those who perceived mere repetition rather than a set of unique variations, the painter's marks were a distraction or an outright annoyance. Viewers either sloughed off the encounter with a laugh or demanded from criticism a deeper understanding. Pondering his experience with the risible, Bataille eventually provided one.

Risible Repetition

Art reduced to technique ceases to be art and becomes a science—a new kind of science, useless.

—CHARLES MORICE, 1905[140]

Witticism changes character on the second appearance. A joke told repeatedly becomes a demonstration of a principle or a formal exercise in timing. Useless as information (we already know what direction it takes), it may still provoke a psychophysical response. Repeated, the comic effect retains its structure while losing what remains compelling about its ironic logic (this is another way of referring to the "loss of subject").[141] As the logic fades, it becomes appropriate to wonder whether the words or pictures had ever revealed any serious meaning. Do we laugh anxiously, suspecting that the forms and structures we perceive do not, and never did, have a moral reason to be?[142]

Cézanne created some curious repetitions, not always recognized for what they are. His *Pichet de grès* (fig. 22) proves to be a companion piece to *Still Life with Plaster Cupid;* it plays out the same joke. Although neither work should be regarded as a study for the other, the doubling suggests that Cézanne deliberately constructed this set of pictorial relationships (at least the second time around), as if he were involved in a studio exercise, practicing his comic timing. His activity may have been more physical and sensory than intellectual, but any repetition-with-variation calls for an analysis of the physical, material differences

to gauge whether they convey meaning. Meaning fulfills the critical impulse, advanced by formalized methods: beyond the compositional analysis of pictorial orders, a critic might apply semiotic analysis or rhetorical analysis, or even (as psychoanalysis) the geometric and linguistic structuralism of Lacanian mimicry and mirroring.[143] Whatever the mode of analysis, a salient parallel, a kind of repetition, defines Cézanne's two paintings structurally: like the statuette in *Still Life with Plaster Cupid,* the large jug in *Pichet de grès* converges with and is framed by a studio canvas behind it; it functions simultaneously as foreground and background.[144] Other pictorial contradictions— or better, incompossibles (but it is a strange word)—exist among the relationships that *Pichet de grès* establishes. To grasp Cézanne's absurd joke, more risible than comical, we need only notice the mutually metaphoric semblance of the two central "figures": one, a statuette, convex with a dimpled belly; the other, a jug, convex with a dimpled embossment. Improbably, these objects look alike: improbably, because the resemblance is relational as much as morphological, and its force depends on the structuring of each picture as a whole. All the more improbably, an apple mediates the crucial likeness, for in each composition the figural convexities echo the form of an apple shown lying on Cézanne's studio floor (large and yellow-green, it must be a hedge apple).[145] The relationship of the statuette to the jug is surely metaphoric—yet also metonymic. Resemblance in form is the metaphoric factor; an analogous structural and compositional function, exchangeable from one pictorial environment to the other, is the metonymic factor.

The implied exchange of the two objects, statuette and jug, drains whatever moral, thematic specificity the plaster cupid or figure of Eros may have connoted on its own, independent of the repetitive structural motif. Does the jug, as the cupid's semblance, nevertheless receive erotic energy

as Cupid's moral equivalent? If so, Cézanne was indulging in a double sublimation: depositing his sexual desire in the painted figure of Eros, then embalming Eros within the jug. Inured to Cézanne's material innovations and physical assertiveness, late twentieth-century writers have freely interpreted his thematic elements according to a variety of theoretical and cultural orders, an option his early critics were not at ease to take, given their degree of agitation. Struck by his tactile mark, they experienced interpretive paralysis, whether staring in wonder or laughing in nervous stupefaction. They were hardly disposed to entertain elaborate, sublimatory hypotheses to explain away the disturbance they sensed; they invented no psychological narratives as background for the painter's nudes.[146] In their experience of the works, a physical shock preceded any moral shock; it was the paint that had received the painter's erotic investment, not the culturally constructed image. This eroticism went beyond

the cultural thematics of sexuality. Thematics of any kind hardly mattered. In cases where Cézanne reworked a heavily painted canvas or imposed one configuration on another, his artistic act exchanged one charged set of marks for the next, the two equally eroticized, equally invested with somatic and psychic energy. His early critics surmised that his images became "abstract" as a consequence of his having immersed himself in the material compulsions of painting. This was a physical and emotional abstraction, to be distinguished from the intellectual, allegorical abstraction of Cupid-Eros. Mentally preoccupied by the physical intensity of his act, Cézanne, so his initial viewers believed, was blind to complex cultural and social values. This accounted for the abstract or abstracted look of his work as well as its primitivism, all contributing to its loss of subject. Many of his paintings, especially the densely marked landscapes, appeared to contain little more than repetitive strokes of color, the famous "little sensations," which Gauguin once threatened to "steal."[147]

Sensation is distracting. Absorbed in it, Cézanne developed a procedural tic, which left its traces nearly everywhere. It shows most blatantly in his modest sketchbook drawings, never intended for public viewing. He had a habit of linking disparate images by their happenstance form, as well as exchanging pictorial positions, with no apparent concern for thematic consistency. (Consistency can nevertheless be private and *inapparent*, but this contributes nothing to what the critical viewer sees unless provided with access to privileged information.) In his sketchbooks, it seems that Cézanne let moral identities go unacknowledged; only physical placement counted. In a multifigured drawing sheet of the early 1880s (fig. 23), he combined a horizontally oriented head of Ceres (derived from Peter Paul Rubens [1577–1640]) with a vertically oriented striding female bather, and juxtaposed this hybrid to a portrait head of his young son, also oriented

Fig. 23. Paul Cézanne, *Head of Paul Cézanne, fils; Bather; Head after Rubens: Ceres*, early 1880s. Graphite pencil on wove paper, 22 × 12.5 cm. Private collection

vertically, but inverted.[148] By all appearances, the three figural elements resulted from three different directional uses of the sketchbook. The images, unlikely to have been drawn at a single sitting or intended to be thematically coordinated, form a single composition, with the first two elements thoroughly interlocking and the third held in subtle tension by the near conjunction of the boy's collar and the bather's lower leg. Collar and leg break off in the same way, so that one is a vertical variant of an open convex form and the other is its horizontal counterpart. Many more graphic analogies can be discerned within this drawing sheet. Thematically laughable, the combinations are formally—that is, physically, even sensually—moving ("I have very strong sensations," Cézanne said). The sensual aspects of the marks in this casual composition page, released from standard thematic controls, become risible and "sovereign" in a Bataillean sense.

In Cézanne's works on canvas, a similar effect comes about through the juxtaposition of diverse thematic elements caused to resemble each other by their contiguity and common motif: see the sequence of tree trunk, bifurcated towel, and leg of a striding bather at the left of *Three Bathers* (fig. 1), or the sequence of tree trunk, arm, and bather's torso at the left of *Bathers* (fig. 5), or, in the same painting, the sequence of parallel strokes that articulates the foliage

Fig. 24. Paul Cézanne, *Female Bathers and a Swan*, 1885–1900 (Sketchbook II, page XXXVI recto). Graphite pencil on wove paper, 11.6 × 18.2 cm. Philadelphia Museum of Art: Gift of Mr. and Mrs. Walter H. Annenberg, 1987 (1987-53-65a)

of the leaning tree as it passes into the extended hand of the leftmost standing bather. The semblances seem to develop of their own accord, as if the artist were powerless to resist the thematically confusing but graphically compelling force of each motif. In the multifigured drawing just discussed, even the diagonal stroking of the background, to the right of the boy's head, may represent a response to the diagonal thrust and background stroking of the bather below. And nothing guarantees that Cézanne would not have returned from a later drawing on his page to an earlier one, compulsively rendering the morally unlike alike—a countercultural travesty.

Another drawing (fig. 24)—comical? risible?—converts the buttocks of a striding female bather into a motif of rhythmically spaced, bowed verticals, which double as the legs of a swan. On the same sheet, Cézanne drew a more developed version of the striding bather, inserting a plane of diagonal pencil strokes that fill the background space between the figure's legs. He continued this diagonal stroking throughout the body and beneath an extended hand, giving the entire figure a sense of vectored movement: physically assertive, morally mute.[149] The position of the swan's tail, inverted in relation to the

bathers, complements the hand of the figure to its left. It becomes difficult to dissociate the curves and angles of the swan from those of either bather because they fulfill each other's implied graphic intentions. Yet we would hardly think to integrate these forms thematically, as, say, "Leda and the Swan."[150]

A similar situation, thematically noncommunicative but formally satisfying: a fragment after Pierre Puget's (1620–1694) sculpture of Atlas closes off the leftward end of a double spread from the sketchbook that contains the page of striding bathers with a swan (figs. 25a, b) The double page shows studies for a composition of male bathers that Cézanne often repeated (compare figs. 5 and 28). Logically, we would have to assume that the Atlas fragment preceded the images of bathers, for why begin a figure in a space insufficient to complete it? Yet the position of this fragment, especially its curving bottom edge, extends the implied recession suggested by the shift in scale of the two variants of a single figure to its right. It even echoes the curving, angled legs of the seated bather on the facing page, whose left-hand position it occupies in exchange. Coincidence? As an art historian, this drawing makes me laugh nervously. I fail to understand its moral or rational stance. One way or another, I could

Opposite below:
Fig. 25a. Paul Cézanne, *Standing Male Bather, Puget's Atlas*, 1885–1900 (Sketchbook II, page L recto). Graphite pencil and graphite offset from page XLIX verso on wove paper, 12.9 × 21.6 cm. Philadelphia Museum of Art: Gift of Mr. and Mrs. Walter H. Annenberg, 1987 (1987-53-79a)

Below:
Fig. 25b. Paul Cézanne, *Male Bathers*, 1885–1900 (Sketchbook II, page XLIX verso). Graphite pencil and graphite offset from page L recto on wove paper, 12.9 × 21.6 cm. Philadelphia Museum of Art: Gift of Mr. and Mrs. Walter H. Annenberg, 1987 (1987-53-79b)

devise a cultural link between Atlas and the bathers and their own sources in the art of Cézanne's past, but it would be speculative invention, not the type of "meaning" potential viewers would have perceived. Only the physical positioning, the motif, introduces sense; but this is limited to a formal, structural type of sense. Instead of directing his composition at its traditional end, enhancing and clarifying the thematic message, Cézanne either engaged his technique in a confusing, subversive play with thematics, or he kept form, color, and movement independent of his nominal subject—in either case, a situation that frustrates analysis.

Exchange of position or place is an extreme case of the mutual exchange that Cézanne's analogies of form produce. Returning to Eros: one of Cézanne's sketchbook drawings copies an antique "Aphrodite and Eros" sculpture from the Louvre; Eros forms a short vertical to the right of Aphrodite's long vertical (fig. 26). On the facing page, Cézanne repeated this proportional relation by combining an image of a dog with an unrelated standing male bather (fig. 27). Either drawing could have preceded the other. Cézanne set the dog into a position ("condition" might be a better term) analogous to the one Eros holds on the Aphrodite page. He had to rotate the placement ninety degrees. The naturalistic horizontality of the dog becomes arbitrarily vertical, so long as we allow the standing bather to determine the orientation of this compound image. Here the dog assumes the pictorial position not only of Eros but also of numerous male bathers reduced in vertical stature because they sit on a river bank or stand partly immersed in the stream, beside the full vertical of a standing figure. Cézanne developed this motif—long vertical, short vertical, long vertical, short vertical—in *Group of Bathers* (fig. 28), where the standing figure toward the right corresponds to the bather of the drawing, and the immersed bather at the extreme right of this painting corresponds to (the position or condition of)

Fig. 26. Paul Cézanne, *Antique Aphrodite and Eros*, 1885–1900 (Sketchbook II, page XXXVII verso). Graphite pencil on wove paper, 18.2 × 11.6 cm. Philadelphia Museum of Art: Gift of Mr. and Mrs. Walter H. Annenberg, 1987 (1987-53-66b)

Fig. 27. Paul Cézanne, *Standing Male Bather and Dog*, 1885–1900 (Sketchbook II, page XXXVIII verso). Graphite pencil on wove paper, 18.2 × 11.6 cm. Philadelphia Museum of Art: Gift of Mr. and Mrs. Walter H. Annenberg, 1987 (1987-53-67a)

the dog. The "values" of both drawing and painting are physical not moral, at least in the sense that Bergson and Bataille brought to this distinction. Bergson might have argued that Cézanne's arbitrary exchanges of position gave his images a mechanistic quality, hence comical. Noting how far from discursive language Cézanne pushed his physical paintings, Bataille considered them risible.

Value, Value

[Contemporary life] not only separates each one of us from others but also divides us internally, divorcing our feelings [sensibilité] from our intellect.

—CHARLES MORICE, 1905[151]

To Bergson and Bataille, we can add Morice: he perceived an increasingly fraught separation of feeling (both sensation and emotion) from the intellectual, cultural order that would regulate it. Unlike Bataille, he resisted casting his moral lot entirely on the side of

the physical. He may have been suffering the schizoid tension he attributed to his depressed and desiccated society (his characterization)—separation of sensation from reason, the physical from the moral. In his opinion, Cézanne suffered from the same cultural disorder.

Morice's realization, already noted, came in the guise of a pun. It depended on the happenstance capacity of a single word, *valeur* (value), to refer to distinct realms of experience that had become—like Cézanne's bathers, swans, and dogs—fluidly exchangeable. What is moral assumes the form of established cultural values. What is physical assumes the form of color values or tonalities, both a source and a reflection of sensory and emotional feeling (and also of science and technical skill). So—here I repeat—Morice wrote of *la valeur d'une valeur:* "Cézanne takes no more interest in a human face than in an apple, and in his eyes neither has any value beyond being

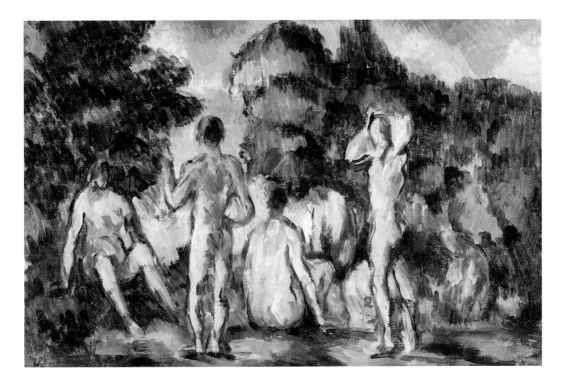

Fig. 28. Paul Cézanne, *Group of Bathers*, ca. 1895. Oil on canvas, 20.6 × 30.8 cm. Philadelphia Museum of Art: The Louise and Walter Arensberg Collection, 1950 (1950-134-34)

'values'"; "The humanity in his paintings has only the value of a value."[152] Morice did not intend this remark, potentially humorous, as a sanguine observation on the advanced state of modern culture; to the contrary, Cézanne seemed to be reflecting contemporary society's misfortune. Morice appreciated the painter's intensity, but the results disturbed him.

Denis was more of a committed advocate (or apologist) for Cézanne than Morice was. He argued that artists of his generation were being dehumanized by the leveling effects of their modern urban existence—its mechanization, its commodification, its standardization, its social regulation—all factors leading to impoverishment of intellectual and spiritual life, the moral life. Denis claimed that the remedy could be found in what, for a brief moment in 1905, he was willing to call "an abstract ideal . . . the expression of inner [mental] life or a simple decoration for the pleasure of the eyes."[153] Under the circumstances, the representational arts should strive to mask out dull environmental realities and "evolv[e] toward abstraction."[154] How-

ever much this kind of "abstraction" might appeal to the intellect or the imagination, it was crucial for it to retain a distinct material component located in a purified form and a straightforward procedure. This was what Denis meant by speaking of "simple decoration"—form from which viewers could take simple pleasure. Cézanne was exemplary because his marks of color and even his arbitrarily positioned figures appeared independent of complex thematic and theoretical motivations; it was all so very physical, representing a material, not a conceptual, abstraction of the painting process. Denis nevertheless soon decided that "abstraction" and "form" were being pushed so far that neither sensible reason nor human feeling, but only misguided theorization, could justify such practices. After Cézanne died, Denis decided to salvage the painter's reputation from such associations, insisting that he had never "compromised" his pictorial synthesis "with any abstraction"; his art of pure painting had remained rooted in nature.[155]

Morice, too, linked the emerging problem of abstraction to social and cultural modernity.

162

For him, there were two "abstractions" visible at the beginning of the twentieth century: the abstract marks of the neo-impressionist followers of Georges Seurat (1859–1891), derived (Morice believed) from a mistaken faith in science and what it could do for technique; and Cézanne's abstract marks, which, significantly, were more of a product of withdrawal and isolation.[156] With science or without, the cultural impact was the same—a loss of humanistic content. After Cézanne's death, Morice summarized the situation: "We hardly dare say that Cézanne lived; no, he painted. . . . [His is] painting estranged from the course of life, painting with the [sole] aim of painting. . . . [His art constitutes] a tacit protest, a reaction [to society]. . . . He put everything in question."[157] How does a painting—of apples, say, or a repetitive grouping of bathers—"put everything in question"?

Like Denis, Morice believed that a collective culture of scientism and technocratic efficiency was deadening all spiritual life. One could either join this new society or withdraw into personal sensory experience. For a painter, it would mean withdrawing into pure painting. The fact that Cézanne disapproved of electric street lighting—it spoiled the twilight in Marseille—may be symptomatic of his actual position.[158] Acting in opposition to his new society, Cézanne (it seemed to Morice) purged his life of all moral values, for which he substituted his color values. This did not mean that Cézanne abandoned his political, religious, and philosophical beliefs; in fact, the conversations that Gasquet reconstructed would be full of such "moral" issues. Rather, the problem was that theoretical and ideological concerns could no longer guide Cézanne's practice, nor any artist's practice. It was left to the technique of painting, not the worldly subject matter it represented, to become the means, as Morice wrote, of a "tacit protest." Acknowledging the obscurity of Cézanne's inner feelings,

Morice added: "Was [his action] fully conscious? I don't know."[159]

This was the essential mystery of Cézanne, who not only resisted the culture around him by concentrating so resolutely on the physicality of his painting, but also resisted revealing his moral motivations—if he actually knew them, which cannot be assumed. Morice's central observation, that Cézanne substituted painting for living, seems prognostic, given the number of major twentieth-century artists who appear to have lost their social selves in concentrated studio practice, often highly technical and experimental. Morice feared that artists of this type, Seurat first among them, would do little more than produce "a new kind of science, useless."[160] Those young artists who drew from Cézanne's "pure painting" while failing to see that its seductions had something to do with his, as well as their own, anxiety over the cultural surroundings, rendered his art morally inconsequential.

Two or three decades later, Bataille and his colleagues were accustomed to associating art with alienation and useless excess. To put their situation another way, they understood that the most challenging art would strike the public and even themselves as risible—meaningful in being meaningless. Morice and Denis had struggled to channel Cézanne's art toward a beneficial moral lesson about modern life. Their interpretation prefigured Bataille's, though he inverted its primary features. He, too, sought an exemplary lesson, but unlike his predecessors, found his moral redemption in a physicality that obliterated all ordinary sense of the moral. He made no apologies about the excesses of modern painting, all those cases in which the physical marking system and the artistic gesture became more rewarding for the viewer than the subject of the picture. As much as it might be expressing something coming from inside the artist, this physicality (Bataille would argue) was significant for the fact that it penetrated and occupied the inside

of whoever encountered it, purging people of their normative culture, the ideological values that directed them.

Cézanne sought to represent sensation (how the object or the atmosphere looked and felt—to him) while expressing emotion (how *he* felt). As categories of feeling, the two phenomena may have been differentiable by the terms of logical analysis but not by lived experience. Through painting, Cézanne realized that separating one of the two sides of representational practice from the other would misrepresent or even nullify both. Perhaps he developed his tendency to exchange the positions of thematically unrelated objects—I called it a mere tic—because he intuited the need to overcome categorical distinctions. He understood that he and his objects were exchanged in his acts of representation, that sensing was tantamount to expressing, that objects occupied the consciousness of subjects and subjects occupied the consciousness of objects. Yet something is amiss: objects do not have a consciousness to be occupied. Do they? It had been said repeatedly that Cézanne painted people as if they were apples. It might just as well have been said that he painted apples as if they were people (an explanation, in fact, for the impulse to allegorize his still lifes and other images of inanimate things). His living presence and active attention animated the world that his senses engaged, as if things, like people, might be sentient. Speculation on the possibility of sentience in inanimate things and substances was a relatively familiar notion during Cézanne's lifetime.[161] When Gasquet attributed to him a kind of pantheistic vision—"In a green my brain flows along with the sap of the tree. Moments of conscious awareness of the world live on in our paintings"—the writer may have been drawing from a prominent current of theory as much as imaginatively rephrasing what he thought the painter had attempted to communicate.[162] The concept of "motif" actually covered it all.

The aesthetics of art is a science of feeling as much as of representing (mimesis is both). In 1889, the aesthetician Paul Souriau, a near-contemporary of Cézanne, published a statement that seems remarkably germane but appears only as a footnote. Perhaps Souriau believed that the issue did not merit being addressed centrally, or that he himself lacked a sufficiently specialized understanding of painting to pursue it. Whatever the case, he observed that French academic artists were often criticized for the artificiality of their figures' gestures; he found the complaint justifiable because the academics relied on preconceived models and standardized compositions, depicting only "those postures we adopt to express our feelings to show them on the outside." Souriau's interest was feeling from the inside: "Truly expressive postures are those that do not set about to express anything, but are unconsciously determined by a deeply felt emotion."[163] This conclusion—if uttered today, it would seem vaguely Freudian—suggests that subtle movements accurately reflecting a person's emotional state will appear to represent nothing in particular. Following no stock thematic structures, their expressive language becomes a non-language. Bataille said of Manet that he "substituted for the conventional view of things an unforeseen aspect that has no meaning," and of Cézanne that he painted "without assimilating it to linguistic formulations."[164]

A "deeply felt emotion," the correlative of a specific sensation, would appear only between the lines of whatever expressive cliché an artist chose to represent the situation "on the outside." The majority of Cézanne's subjects were ordinary enough to be described as thematic clichés in this respect—moral clichés. Traditional cultural identities and mythologies might transfer readily from the masters in the museums to the figures that Cézanne copied; but the emotional content would be something else, located in fragments of meaningless excess

164

between one conventional, repeatable element of expression and another. The motif of a painting encompasses this excess. Like Bataille's "sovereign emotion," a motif extends beyond the nominal subject to occupy all the physical space within the materialized image; its extremes of physicality affect the moral, psychological space of reception. With unusual directness, Cézanne's technique revealed this modernist principle, at once pure and transgressive: painting left to its own devices is all motif, all excess. To those early viewers who noticed what Cézanne's art made happen, the effect was either wondrous or risible and just as likely, both.

Fig. 29. Paul Cézanne, *Standing Bather Seen from Behind*, 1879–82. Oil on canvas, 27 × 17.1 cm. The Henry and Rose Pearlman Foundation; on long-term loan to Princeton University Art Museum (L.1988.62.1)

Notes

1. Maurice Denis, "L'impressionnisme et la France" (1917), in *Nouvelles théories: Sur l'art moderne, sur l'art sacré 1914–1921* (Paris: Rouart et Watelin, Paris, 1922), 67–68. Pursuing his argument, Denis added that Cézanne drew Latin culture "from the rich depths of his psyche," whereas others depended on labored study of the ancient monuments. All translations are mine unless otherwise indicated. I thank Caitlin Haskell for essential aid in research and Terence Maloon and Cord Bynum for acute reading.

2. For Vollard's account of the circumstances, see Ambroise Vollard, *Paul Cézanne* (Paris: Georges Crès, 1919 [1914]), 75–79. Vollard's narrative is now disputed, interestingly but willfully, by Robert Jensen, "Vollard and Cézanne: An Anatomy of a Relationship," in Rebecca A. Rabinow, ed., *Cézanne to Picasso: Ambroise Vollard, Patron of the Avant-Garde* (New York: Metropolitan Museum of Art, 2006), 29–47. This new study glosses over the crucial, yet perhaps indeterminate, role played by Cézanne's son (in effect, the artist's agent), as well as the degree to which Cézanne may have neglected or mistreated his paintings (compare the memories of one of Cézanne's country lessors, Eugène Couton, in Erle Loran Johnson, "Cézanne's Country," *The Arts* 16 [April 1930]: 532–35). Jensen draws a number of unambiguous conclusions from ambiguous documentation. One example: he supports his statement, "We know that Cézanne had been looking for a dealer before he was contacted by Vollard," by a crossed-out line to this effect in an incomplete draft of a letter to the writer Octave Mirbeau, published in John Rewald, ed., *Paul Cézanne, correspondance* (Paris: Grasset, 1978), 241–42. Rewald's editorial notes speculate plausibly regarding the circumstances—Cézanne's having recently encountered Mirbeau, Mirbeau's having mentioned him favorably in print, the death earlier that year of Cézanne's Paris "dealer," the paint merchant Julien Tanguy—none of which Jensen mentions, all of which complicates an omniscient "we know" (see Jensen, "Vollard and Cézanne," 42, 46 n.82). Might a less tendentious alternative be developed along Jensen's lines? I don't know.

3. Cézanne, letter to Joachim Gasquet, 30 April 1896, in Rewald, *Paul Cézanne, correspondance*, 249.

4. Gustave Coquiot, *Les Indépendants 1884–1920* (Paris: Ollendorff, 1920), 36.

5. Prominent among Cézanne's admirers was Maurice Denis, to whom he wrote a polite note of gratitude upon learning that Denis had painted a scene of homage to him, shown at the Salon of 1901: Cézanne, letter to Denis, 5 June 1901, in Rewald, *Paul Cézanne, correspondance*, 274.

6. Cézanne, statement reported by Joachim Gasquet, *Cézanne* (Paris: Bernheim-Jeune, 1926 [1921]), 70. On Cézanne as "primitive," see Richard Shiff, "The Primitive of Everyone Else's Way," in Guillermo Solana, ed., *Gauguin and the Origins of Symbolism* (Madrid: Fundación Colección Thyssen-Bornemisza, 2004), 63–79.

7. Cézanne, statement recorded in 1902 (not necessarily verbatim), in Jules Borély, "Cézanne à Aix," *L'art vivant* 2 (1 July 1926): 493.

8. Gustave Geffroy, "Paul Cézanne" (1894), *La vie artistique*, 8 vols. (Paris, Dentu [vols. 1–4], Floury [vols. 5–8], 1892–1903), 3:257–59.

9. Georges Lecomte, "Paul Cézanne," *Revue d'art* 1 (9 December 1899): 86.

10. Gustave Kahn, "Seurat," *L'art moderne* (Brussels) 11 (5 April 1891): 108. Kahn was contrasting Corot's naturalness with Georges Seurat's artificiality. On the significance of Corot, see also Richard Shiff, "Natural, Personal, Pictorial: Corot and the Painter's Mark," in Andreas Burmester, Christoph Heilmann, and Michael F. Zimmermann, eds., *Barbizon: Malerei der Natur—Natur der Malerei* (Munich: Klinkhardt & Biermann, 1999), 120–38.

11. Paul de Saint-Victor, *La presse*, 10 June 1866; Félix Jahyer, *Deuxième étude sur les beaux-arts: Salon de 1866* (Paris: Librairie centrale, 1866), quoted in Pierre Miquel, *Le paysage français au XIXe siècle, 1824–1874*, 3 vols. (Maurs-la-Jolie: Martinelle, 1975), 2:48.

12. Paul Mantz, *Salon de 1847* (Paris: Sartorius, 1847), 98–99.

13. Alfred Sensier, "Conférence sur le paysage" (1870), *Souvenirs sur Théodore Rousseau* (Paris: Léon Techener, 1872), xiv.

14. Mantz, *Salon de 1847*, 98–99.

15. Charles Clément, "Les paysagistes français contemporains" (1853), *Études sur les beaux-arts en France* (Paris: Michel Lévey frères, 1869), 336. On Corot's taking care not to introduce more painting than needed, see also Charles Baudelaire, "Salon de 1845," *Oeuvres complètes*, ed. Claude Pichois, 2 vols. (Paris: Gallimard, 1975–76), 2:389–90.

16. Thoré-Bürger (Théophile Thoré), "Salon de 1844," *Les Salons*, 3 vols. (Brussels: Lamertin, 1893), 1:35.

17. Mantz, *Salon de 1847*, 102–3. In response to the same Salon, Théophile Thoré (to some extent, Mantz's mentor) had similar thoughts about the expressive potential of a naïve attitude toward representing nature; Thoré-Bürger, "Salon de 1847," *Les Salons*, 1:477–79, 538.

18. Cézanne disapproved of the linear "abstraction" and unmodulated color apparent in the style Gauguin derived from him; see his letters to Émile Bernard, 15 April 1904 and 23 October 1905, in *Paul Cézanne, correspondance*, 300, 315. See also Cézanne's words as reported in Émile Bernard, "Souvenirs sur Paul Cézanne et lettres inédites," *Mercure de France* 69 (1, 16 October 1907): 400. Bernard was a willing receiver of Cézanne's complaints and may have solicited them; he had long before distanced himself from Gauguin's methods.

19. On aspects of Cézanne's impressionism, see Richard Shiff, *Cézanne and the End of Impressionism* (Chicago: University of Chicago Press, 1984).

20. Cézanne's remark came in conversation at a luncheon hosted by Monet in November 1894; see Octave Mirbeau, "Préface du catalogue du Salon d'automne 1909," *Combats esthétiques*, ed. Pierre Michel and Jean-François Nivet, 2 vols. (Paris: Séguier, 1993), 2:485.

21. Paul Mantz, "L'exposition des peintres impressionnistes" (1877), reprinted in Ruth Berson, ed., *The New Painting, Impressionism 1874–1886: Documentation*, 2 vols. (San Francisco: Fine Arts Museums of San Francisco, 1996), 1:166.

22. As an early twentieth-century champion of Cézanne, Clive Bell gave a succinct statement of the problem: "People had grown so familiar with the idea of a cup, with that purely intellectual label 'cup,' that they never looked at a particular cup and felt its emotional significance. Also, professional painters . . . neither felt things nor expressed their feelings. . . . A determination to free artists from utilitarian vision and the disastrous science of representation was the theoretic basis of that movement which is associated with the name of Cézanne" (Clive Bell, *Since Cézanne* [New York: Harcourt, Brace, 1922], 49–50). Art-historical writing of recent years tends to obscure the crux of the matter—emotion and the expression of emotion. Early twentieth-century changes in the form of representational art were motivated by perceived emotional needs, not form for the sake of form; see Richard Shiff, "From Primitivist Phylogeny to Formalist Ontogeny: Roger Fry and Children's Drawings," in Jonathan Fineberg, ed., *Discovering Child Art: Essays on Childhood, Primitivism, and Modernism* (Princeton: Princeton University Press, 1998), 157–200.

23. Theo van Doesburg, "De Nieuwe Beweging in de Schilderkunst, II," *De Beweging* 12 (June 1916): 222; translation by Mette Gieskes.

24. Paul Gauguin, "Notes synthétiques" (1885), *Oviri: Écrits d'un sauvage*, ed. Daniel Guérin (Paris: Gallimard, 1974), 24.

25. And through this reduction to essence, Cézanne became for many critics the source of cubist practice: "Cubism appears as the final outcome of the work of simplification undertaken by Cézanne. . . . The cubists

166

have cast out from their domain all those characters that the painters habitually took from fables, mythology, history[;] they aspire to the essence, to the pure idea" (Michel Puy, "Les indépendants," *Les marges*, July 1911, reprinted in Edward Fry, *Le cubisme* [Brussels: La Connaissance, 1968], 65).

26. When Gauguin described Cézanne's *Allée d'arbres* (ca. 1879) as having "trees set in rank like soldiers, with cast shadows in tiers like a staircase," he was making a statement about the distribution of the separate, repeating strokes rather than attributing significance to the represented scene; see Gauguin, letter to Camille Pissarro, between 25 and 29 July 1883, in Victor Merlhès, ed., *Correspondance de Paul Gauguin (1873–1888)* (Paris: Fondation Singer-Polignac, 1984), 51.

27. Maurice Denis, "Cézanne" (1907), *Théories, 1890–1910: Du symbolisme et de Gauguin vers un nouvel ordre classique* (Paris: Rouart et Watelin, 1920), 252.

28. For a reproduction, see plate 122 in Philip Conisbee and Denis Coutagne, eds., *Cézanne in Provence* (Washington: National Gallery of Art, 2006), 250.

29. On Cézanne's composing bathers without a model, see Francis Jourdain, *Cézanne* (Paris: Braun, 1950), 11; Jourdain visited Cézanne in January 1905.

30. See Christian Zervos, "Conversation avec Picasso" (1935), in Marie-Laure Bernadac and Androula Michael, eds., *Picasso: Propos sur l'art* (Paris: Gallimard, 1998): 36; Maurice Merleau-Ponty, "Le doute de Cézanne" (1945), *Sens et non-sens* (Paris: Nagel, 1966), 35.

31. Denis, "Cézanne," *Théories*, 252.

32. Cézanne appears to distinguish between subject matter (*sujet*) and motif (*motif*) in a letter to his son Paul, 8 September 1906, in Rewald, *Paul Cézanne, correspondance*, 324. On the general concept of "motif," including Cézanne's use of the term, see Georges Roque, "Au lieu du sujet, le motif: la quête des peintres depuis l'impressionnisme," *Ethnologie française* 25/2 (1995): 196–204; Richard Shiff, "Sensation, Movement, Cézanne," in Terence Maloon, ed., *Classic Cézanne* (Sydney: Art Gallery of New South Wales, 1998), 13–27; Richard Shiff, "Mark, Motif, Materiality: The Cézanne Effect in the Twentieth Century," in Felix Baumann, Evelyn Benesch, Walter Feilchenfeldt, and Klaus Albrecht Schröder, eds., *Cézanne: Finished— Unfinished* (Ostfildern-Ruit: Hatje Cantz, 2000), 99–123.

33. Denis, "Cézanne," *Théories*, 253.

34. Denis, "L'influence de Paul Gauguin" (1903), *Théories*, 168.

35. Denis, "Cézanne," *Théories*, 251.

36. Denis, "L'impressionnisme et la France," *Nouvelles théories*, 67–68.

37. Denis, "Cézanne," *Théories*, 252.

38. Thadée Natanson, "Paul Cézanne," *La revue blanche* 9 (1 December 1895): 500.

39. Natanson, "Paul Cézanne," 500.

40. For Sérusier's statement, see Denis, "Cézanne," *Théories*, 252.

41. Paul Sérusier, letter to Maurice Denis, 27 November 1907, in Paul Sérusier, *A B C de la peinture* (Paris: Floury, 1950), 131.

42. Gustave Flaubert, letter to Louis Bonenfant, 12 December 1856, in Jean Bruneau, ed., *Flaubert, correspondance*, 4 vols. (Paris: Gallimard, 1973–1998), 2:652.

43. Denis, "Cézanne," *Théories*, 247.

44. See Alexandre Dumas, "L'École des beaux-arts," *Paris Guide*, 2 vols. (Brussels: Librairie internationale, 1867), 1:858.

45. Thoré-Bürger, "Salon de 1846," *Les Salons*, 1:290.

46. Camille Pissarro, letter to Lucien Pissarro, 21 November 1895, in Janine Bailly-Herzberg, ed., *Correspondance de Camille Pissarro*, 5 vols. (Paris: Presses Universitaires de France [vol. 1]; Valhermeil [vols. 2–5], 1980–91), 4:119.

47. Natanson, "Paul Cézanne," 499. Developing the notion favorably, Joris-Karl Huysmans had invoked a similar image of the artist, who painted "pears and apples that are brutal, coarse [*frustes*], plastered as if with a trowel"; J.-K. Huysmans, "Trois peintres," *La cravache parisienne*, no. 389 (4 August 1888), n.p.

48. For evidence of Cézanne's invocation of Virgil, see, for example, Paul Gauguin, letter to Émile Schuffenecker, 14 January 1885, in Merlhès, *Correspondance de Paul Gauguin (1873–1888)*, 88. See also Paul Smith, "Joachim Gasquet, Virgil and Cézanne's Landscape: 'My Beloved Golden Age,'" *Apollo* 148 (October 1998): 11–23; "Cézanne's Late Landscapes, or the Prospect of Death," *Cézanne in Provence*, 58–74.

49. Gasquet, *Cézanne*, 150, 153. For aspects of the context of this anecdotal account of Cézanne's philosophical speculations, see Nina Maria Athanassoglou-Kallmyer, *Cézanne and Provence: The Painter in His Culture* (Chicago: University of Chicago Press, 2003), 176–81.

50. Coquiot, *Les indépendants 1884–1920*, 36.

51. Cézanne, letter to Émile Bernard, 26 May 1904, in Rewald, *Paul Cézanne, correspondance*, 303.

52. Gasquet, *Cézanne*, 132. See also Georges Rivière, *Le maître Paul Cézanne* (Paris: Floury, 1923), 41: "Cézanne forgot [his theories] whenever he had a brush in hand." Statements against the use of theory

and intellectual abstraction (as opposed to physical abstraction) were common in Cézanne's day. See, for example, Louis Vauxcelles, "Le Salon des 'Indépendants,'" *Gil blas*, 20 March 1906, reprinted in Philippe Dagen, ed., *Le fauvisme* (Paris: Somogy, 1994), 74: "In art, it's necessary to ward off the plague of theories, system, and abstraction."

53. See Rivière, *Le maître Paul Cézanne*, 2–6.

54. Edmond Jaloux, *Les saisons littéraires*, 2 vols. (Fribourg: Éditions de la librairie de l'Université, 1942), 1:75.

55. Gasquet, *Cézanne*, 152.

56. An account from Renoir, recorded by Geffroy, conveys Cézanne's intensity: "It was an unforgettable sight, Cézanne standing at his easel, painting, looking at the countryside: he was truly alone to the world, ardent, focused, attentive, respectful" (Geffroy, "Paul Cézanne," *La vie artistique*, 3:256).

57. Natanson, "Paul Cézanne," 498–99.

58. Gauguin referred to the two poles by opposing himself to Pierre Puvis de Chavannes (1824–1898), whom many of the young symbolist-oriented painters (Gauguin included) lionized: "He is Greek [civilized] whereas I am a savage [or wild animal], a wolf in the forest without a collar"; Paul Gauguin, letter to Charles Morice, July 1901, in Maurice Malingue, ed., *Lettres de Gauguin à sa femme et à ses amis* (Paris: Bernard Grasset, 1946), 300.

59. Cézanne, letter to Émile Bernard, 21 September 1906, in Rewald, *Paul Cézanne, correspondance*, 327. Given the pretentiousness that Cézanne perceived in Bernard, his reference to "slow progress" might contain an element of false modesty.

60. Rivière, *Le maître Paul Cézanne*, 20.

61. Cézanne's statement, according to an anecdote transmitted through Monet; see Marc Elder (Marcel Tendron), *A Giverny, chez Claude Monet* (Paris: Bernheim-Jeune, 1924), 48. Elder's book consists of a series of interviews with Monet, apparently conducted around 1920–22. An account of the same incident, probably also stemming from Monet, appears earlier in Octave Maus, "L'art au Salon d'automne," *Mercure de France* 65 (1 January 1907): 66–67.

62. Georges Bataille, *Manet* (Geneva: Skira, 1955), 52, 55 (order of phrases reversed). On Manet's evasion of language, see also Georges Bataille, "L'impressionnisme" (1956), *Oeuvres complètes*, ed. Michel Foucault, 12 vols. (Paris: Gallimard, 1970–88), 12:373–74.

63. Denis, "Cézanne," *Théories*, 250.

64. Natanson, "Paul Cézanne," 498.

65. Bataille, *Manet*, 55.

66. Ibid., *Manet*, 61.

67. Bataille, "L'impressionnisme," 12:380, 376.

68. In the course of this essay, I may at times verge on equating materiality and physicality, but there is a difference: *materiality* refers to an artist's manipulation of a physical medium as material substance; *physicality* refers to the experience of a medium or a representation in relation to one's sense of one's own body. For elaboration, see Richard Shiff, "Breath of Modernism (Metonymic Drift)," in Terry Smith, ed., *In Visible Touch: Modernism and Masculinity* (Chicago: University of Chicago Press, 1997), 184–213.

69. See Gauguin, letter to Camille Pissarro, ca. 10 July 1884, and letter to Émile Schuffenecker, 14 January 1885, in Merlhès, *Correspondance de Paul Gauguin (1873–1888)*, 65, 87–89.

70. Émile Bernard, "Paul Cézanne," *Les hommes d'aujourd'hui* 8, no. 387 (February–March 1891), n.p.

71. Félicien Fagus, "Quarante tableaux de Cézanne," *La revue blanche* 20 (15 December 1899): 627. On Fagus, see André Salmon, *Souvenirs sans fin: Première époque (1903–1908)* (Paris: Gallimard, 1955), 73–77.

72. Here, "autonomous" refers to techniques of painting developing apart from any system in which the "abstract" conceptualized theme would determine or limit the character of its "abstract" material representation. Critical commentary referring to such autonomy around 1900—an autonomy itself not absolute, but a condition to be assessed relative to prevailing standards—has often been read as a much stronger claim to an "autonomous" aesthetic practice independent of forces of a more general nature, such as the economics determining the market for art. This extreme of historical autonomy is an intellectual leap attributed to critics who did not take it. By no means does an autonomy of the painter's mark entail it.

73. Paul Signac, *D'Eugène Delacroix au néo-impressionnisme*, ed. Françoise Cachin (Paris: Hermann, 1978 [1899]), 117.

74. Bernard, "Souvenirs sur Paul Cézanne," 609. For Cézanne's photographic source, see John Rewald, *Paul Cézanne, a Biography* (New York, Schocken, 1968), 94.

75. Thomas B. Hess, "Introduction to Abstract," *Art News Annual* 20 (1951 [November 1950]): 146.

76. Georges Rivière, "L'exposition des Impressionnistes," *L'Impressionniste, journal d'art*, 14 April 1877, reprinted in Lionello Venturi, *Les archives de l'impressionnisme*, 2 vols. (Paris: Durand-Ruel, 1939), 2:315 (order of sentences reversed).

77. On van Gogh, see Bataille, "La mutilation sacrificielle et l'oreille coupée de Vincent Van Gogh" (1930), "Van Gogh Prométhée" (1937), *Oeuvres complètes*, 1:258–70, 497–500.

78. Here Bataille virtually equates imitating and copying, which is characteristic of twentieth-century writers and certain earlier theorists who abandoned the old academic distinction between the two practices. On this issue, which bears on the question of repetition, see Richard Shiff, "The Original, the Imitation, the Copy, and the Spontaneous Classic: Theory and Painting in Nineteenth-Century France," *Yale French Studies* 66 (1984): 27–54; "Original Copy," *Common Knowledge* 3 (Spring 1994): 88–107.

79. Bataille, "L'impressionnisme," 12:372–73.

80. Ibid., 12:372, 374 (emphasis added). Bataille also described the nude body of Manet's *Olympia* in terms of its "incongruity" (*Manet*, 67).

81. Bataille, "Les écarts de la nature" (1930), *Oeuvres complètes*, 1:229.

82. Bataille, "Le langage des fleurs" (1929), *Oeuvres complètes*, 1:178.

83. See, for example, Bataille, "Baudelaire" (1946), *Oeuvres complètes*, 9:202, where the author, as on many other occasions, finds cause to cite Nietzsche.

84. Bataille, "L'impressionnisme," 12:373–74 (emphasis added).

85. With regard to Manet's *Olympia*, Bataille cites the observation of Théophile Gautier to this effect; Bataille, *Manet*, 62.

86. Rivière, "L'exposition des Impressionnistes," 2:315.

87. Bataille, "Non-savoir, rire et larmes" (1953), *La part maudite: La souveraineté* (1954), *Oeuvres complètes*, 8:216, 254.

88. Compare Bataille, "Non-savoir, rire et larmes," *Oeuvres complètes*, 8:214. *Risible* is a general term that operates, like laughter itself, in metonymic reciprocity. It signifies both the capacity to laugh and the capacity to induce laughter. When we laugh anxiously at something unexpected or disturbing, our laughter causes others to laugh, though they may or may not be experiencing the same anxiety.

89. Bataille, "Informe" (1929), *Oeuvres complètes*, 1:217.

90. Bataille, *Manet*, 67.

91. Bataille, *La part maudite* (1954): *La souveraineté*, *Oeuvres complètes*, 8:254. These various passages from Bataille have parallels in writings of his friend in Paris during the 1930s, Walter Benjamin: "By means of its technical structure, the film has taken the physical shock effect out of the wrappers in which Dadaism had, as it were, kept it inside the moral shock effect" (Walter Benjamin, "The Work of Art in the Age of Mechanical Reproduction" [1936–39], *Illuminations*, ed. Hannah Arendt, trans. Harry Zohn [New York: Schocken, 1969], 238).

92. "Je peins comme je vois, comme je sens, et j'ai les sensations très fortes": Cézanne's words as quoted by the journalist "Stock," *Le Salon*, 20 March 1870; see John Rewald, *Histoire de l'impressionnisme* (Paris: Albin Michel, 1986), 163.

93. Bataille, "L'impressionnisme," 12:380.

94. "Pure" visual art stimulates feeling as opposed to providing the intellect with referential links. The feeling is just as likely to be disorderly and discomfiting as orderly and assuring: "The [pure] picture or statue exhausts itself in the visual sensation it produces. There is nothing to identify, connect or think about, but everything to feel" (Clement Greenberg, "Towards a Newer Laocoon" [1940], in John O'Brian, ed., *Clement Greenberg: The Collected Essays and Criticism*, 4 vols. [Chicago: University of Chicago Press, 1986–1993], 1:34).

95. T. J. Clark, *The Painting of Modern Life* (New York: Knopf, 1985), 139, note.

96. Rosalind Krauss, "Antivision," *October* 36 (Spring 1986): 147.

97. Yve-Alain Bois explains the later critics' sympathetic questioning of Bataille, without considering that they might just as well have accepted his position at face value, no rationalization required; Yve-Alain Bois, "The Use Value of 'Formless,'" in Yve-Alain Bois and Rosalind E. Krauss, *Formless: A User's Guide* (New York: Zone Books, 1997), 14–15.

98. Émile Bernard attributed this phrase to Cézanne, presumably having heard it when he visited the artist in 1904: Cézanne stated that an artist should develop his eye in terms of the vision of nature, and his brain in terms of "la logique des sensations organisées" (Émile Bernard, "Paul Cézanne," *L'Occident* 6 [July 1904]: 23). See Lawrence Gowing, "The Logic of Organized Sensations" (1977), in Michael Doran, ed., *Conversations with Cézanne* (Berkeley: University of California Press, 2001), 194. Here the emphasis is on the form, not the formlessness of a sovereign sensation.

99. Guillaume Apollinaire, "Figures de Cézanne chez Vollard" (1910), *Chroniques d'art (1902–1918)*, ed. L.-C. Breunig (Paris: Gallimard, 1960), 116–17.

100. Roger Fry, *Cézanne: A Study of His Development* (Chicago, 1989 [1927]).

101. Maurice Raynal, *Cézanne* (Geneva: Skira, 1954), 114, 118, 120.

102. Bataille, "L'impressionnisme," 12:371, note.

103. Raynal, *Cézanne*, 30. On autonomy, see above, note 72.

104. Raynal, *Cézanne*, 105.

105. Friedrich Nietzsche, *The Gay Science*, trans. Walter Kaufmann (New York: Vintage, 1974 [1887]), 328.

106. Bataille, "L'impressionnisme," 12:379. On "sovereignty," see Bataille, *La part maudite: La souveraineté, Oeuvres complètes*, 8:247–61.

107. Bataille, "L'impressionnisme," 12:380.

108. Compare thinking related to Bataille's from a parallel critique of modern, bourgeois culture: "For civilization, pure natural existence, animal and vegetative, was the absolute danger. . . . Any reversion to [a superseded state of development] was to be feared as implying a reversion of the self to that mere state of [physical] nature from which it had estranged itself with so huge an effort, and which therefore struck such terror into the self"; Max Horkheimer and Theodor W. Adorno, *Dialectic of Enlightenment*, trans. John Cumming (New York: Seabury, 1977 [1944]), 31. It was not only Cézanne's art that was unnervingly risible, but also the man. Two decades after his death, his old neighbors "would begin snickering" at the mere mention of his name (Johnson, "Cézanne's Country," 544–45).

109. On the political and religious beliefs factored into Denis's aesthetic theory, see Jean-Paul Bouillon, "The Politics of Maurice Denis," in Guy Cogeval, ed., *Maurice Denis 1870–1843* (Ghent: Snoeck-Ducaju & Zoon, 1994), 95–109; and Jean-Paul Bouillon, "Le modèle cézannien de Maurice Denis," in Françoise Cachin, ed., *Cézanne aujourd'hui* (Paris: Réunion des musées nationaux, 1997), 145–64.

110. Maurice Denis, *Journal*, 3 vols. (Paris: La Colombe, 1957–59), 2:172 (entry for autumn 1914). The timing of Denis's remark is significant in relation to political tensions between France and Germany.

111. Paul Mantz, "Un nouveau livre sur le Poussin," *L'artiste* 4 (30 May 1858): 56.

112. *Taches, touche*: Gasquet, *Cézanne*, 136, 196. *Sensation*: Cézanne's statement as recorded in Denis, *Journal*, 2:29 (entry for 26 January 1906).

113. Statement reported by Denis, who visited Renoir just after seeing Cézanne in 1906: Denis, "Cézanne," *Théories*, 252. For a variant of the statement, referring to only one stroke, see Georges Rivière, *Cézanne, le peintre solitaire* (Paris: Floury, 1936), 19.

114. Charles Morice, "Mort de Paul Cézanne," *Mercure de France* 64 (1 November 1906): 154.

115. Charles Morice, "Exposition Henri Matisse," *Mercure de France* 51 (August 1904): 534.

116. Raymond Bouyer, "Le procès de l'art moderne au Salon d'automne," *Revue politique et littéraire [Revue bleue]* 2 (5 November 1904): 604–5.

117. Meyer Schapiro, "The Apples of Cézanne: An Essay on the Meaning of Still-life," *ARTnews Annual* 34 (1968): 34–53. As another example of an interpreter's allegorization of Cézanne's imagery—intelligent and plausible, yet necessarily inconclusive because of its tendentiousness—see Mary Louise Krumrine, *Paul Cézanne: The Bathers* (Basel: Öffentliche Kunstsammlung Basel, 1989), 239–42.

118. Théodore Duret, *Histoire des peintres impressionnistes* (Paris: H. Floury, 1906), 173. For Morice's use of this passage, see Charles Morice, "Paul Cézanne," *Mercure de France* 65 (15 February 1907): 592.

119. In semiotic terms, the character of the signifier was dominating both the representational referent and the expressive, interpretive signified. If critics were to derive a meaning from a painting by Cézanne, they would have to associate this sense directly with the materiality of the signifier (the painted surface).

120. Duret, *Histoire des peintres impressionnistes*, 173.

121. Duret, *Histoire des peintres impressionnistes*, 180.

122. Thoré-Bürger, "Salon de 1868," *Les Salons*, 3:532.

123. Bataille, *Manet*, 52. We might also recall Flaubert's divergence of subject and style (the "beauty" of his writing) in this regard.

124. Bataille, "Le langage des fleurs" (1929), *Oeuvres complètes*, 1:173.

125. Charles Morice, "Le XXIe Salon des Indépendants," *Mercure de France* 54 (15 April 1905): 552: "Cézanne ne s'intéresse pas plus à un visage qu'à une pomme, et celui-là comme celui-ci n'ont d'autre valeur à ses yeux que d'être des 'valeurs.'" Charles Morice, "Le Salon d'automne," *Mercure de France* 58 (1 December 1905): 390: "Il est inquiet, mais uniquement de savoir si ses valeurs sont justes, et l'humanité dans ses tableaux n'a que la valeur d'une valeur." The pun on *valeurs*/values works in both French and English.

126. Henri Bergson, *Le rire: Essai sur la signification du comique* (Paris: Presses universitaires de France, 1981 [1899]), 39 (emphasis eliminated).

127. See Jean-Claude Lebensztejn, "Études cézanniennes" (2004), *Études cézanniennes* (Paris: Flammarion, 2006), 61–78.

128. Bernard, "Souvenirs sur Paul Cézanne," 621.

129. Émile Bernard, letter to Mme Bernard, 25 October 1906, "Lettres inédites du peintre Émile Bernard à sa femme à propos de la mort de son ami," *Art-Documents* (Geneva), no. 33 (June 1953), 13. For details of Bernard's involvement with Cézanne, see Rodolphe Rapetti, "L'inquiétude cézannienne: Émile Bernard et Cézanne au début du XXe siècle," *Revue de l'art*, no. 144 (June 2004): 35–50; Shiff, *Cézanne and the End of Impressionism*, 125–32.

130. Bernard, "Paul Cézanne" (1904), 21.

131. Octave Mirbeau, *Cézanne* (Paris: Bernheim-Jeune, 1914), 10. Mirbeau dedicated little of his writing directly to Cézanne; but when the critic mentioned him, it was with approval. In 1891, he associated Cézanne with Chardin and referred to him as an "unrecognized genius" (Mirbeau, "Rengaines" [1891], *Des artistes*, 2 vols. [Paris: Flammarion, 1922–24], 1:140). In 1894, he included him as an equal within a group of better-known impressionists (Mirbeau, "Le legs Caillebotte et l'État" [1894], *Combats esthétiques*, 2:70).

132. Of course, this emphasis on color inverts the usual moral order. Traditionalists expected linear design to dominate decorative color. Charles Blanc took up the issue, explaining it in terms of gender, with feminine color properly subordinate to masculine line: Charles Blanc, *Grammaire des arts du dessin* (Paris: Henri Laurens, 1880 [1867]), 22.

133. See Geffroy, "Paul Cézanne," *La vie artistique*, 3:257–59.

134. Cézanne painted *Still Life with Plaster Cupid* on paper, mounted on panel, an unusual support for him; but the properties of this painting do not differ appreciably from works on canvas. The painting has been extensively discussed: see Richard Shiff, "Cézanne's Physicality: The Politics of Touch," in Salim Kemal and Ivan Gaskell, eds., *The Language of Art History* (Cambridge: Cambridge University Press, 1991), 129–80; and other scholarly works cited there.

135. Here Bergson makes a distinction basic to traditional French philosophy, commonly introduced into commentary on art—"sens physique" as opposed to "sens moral": Bergson, *Le rire*, 87–88 (emphasis eliminated). The notion that the physical, material meaning must precede the moral, intellectual one is disputed by Jacques Derrida, "Signature Event Context," *Margins of Philosophy*, trans. Alan Bass (Chicago: University of Chicago Press, 1982 [1972]), 307–30. On Bataille's attitude toward Bergson, see his autobiographical note (1958?) in Bataille, "Notes Conférences, 1951–53," *Oeuvres complètes*, 8:562.

136. Rivière, "L'exposition des Impressionnistes," in Venturi, *Les archives de l'impressionnisme*, 2:315. *Bathers at Rest* generated controversy again in 1894 when it was included in Gustave Caillebotte's (1848–1894) bequest to the French nation; along with a number of works by other impressionists, the state refused this part of the gift. Between 1896 and 1898, Cézanne reworked the composition for a lithograph to be sold by Vollard (see fig. 17). There remains some disagreement among scholars as to which of two versions of this composition was included in the 1877 Impressionist exhibition; see John Rewald, in collaboration with

Walter Feilchenfeldt and Jayne Warman, *The Paintings of Paul Cézanne: A Catalogue Raisonné*, 2 vols. (New York: Harry N. Abrams, 1996), 1:177–80, entries for cat. nos. 259, 261. I am inclined to agree with Rewald that the work illustrated here (Rewald 261) is the correct choice.

137. Edgar Degas manipulated (perhaps caricatured) this ambiguity in sketches after the central standing figure in *Bathers at Rest;* see the illustration in Françoise Cachin and Joseph J. Rishel, *Cézanne* (Philadelphia: Philadelphia Museum of Art, 1996), 540.

138. In 1888, Joris-Karl Huysmans referred to a canvas "weighed down [with paint] to the point that it bowed outward." His description would fit *Bathers at Rest*, except for the fact that he identified the figures as women (Cézanne's title explicitly signifies the male gender: *Baigneurs*). He may have confused the bathers' sex, or been thinking of a different painting, or conflated two different works, for he wrote his brief article only to lend support to Cézanne's cause, having no particular exhibition in mind (Huysmans, "Trois Peintres," *La cravache parisienne*, n.p.).

139. Bergson, *Le rire*, 68–71.

140. Morice, "Le XXIe Salon des Indépendants," 553.

141. I allude to the traditional Enlightenment association of morality with reason: "Morality is the same in all humans who make use of their reason"; Voltaire, *Dictionnaire philosophique*, ed. Julien Benda and Raymond Naves, 2 vols. (Paris: Garnier frères, 1935 [1767]), 2:162.

142. Cézanne's complicated sense of humor supports this line of questioning: "Many of the naive statements attributed to him should be understood in the sense of a subtle mockery of which the listener would have been the unwitting target. . . . With people [like Cézanne] from Provence, you never know who's joking and who's fallen for it" (Edmond Jaloux, "Souvenirs sur Paul Cézanne," *L'amour de l'art* 1 [December 1920]: 285–86; *Les saisons littéraires*, 1:104). See also Gasquet, *Cézanne*, 28. Pissarro's son Lucien recalled some early instances of "Cézanne's malicious humor": see W. S. Meadmore, *Lucien Pissarro, un coeur simple* (New York: Knopf, 1963), 26.

143. See Jacques Lacan, *The Four Fundamental Concepts of Psycho-Analysis*, ed. Jacques-Alain Miller, trans. Alan Sheridan (New York: W. W. Norton, 1978), 105–19, which briefly invokes Cézanne's separate little marks of color.

144. To confirm that the stoneware jug (*pichet de grès*) actually is part of the foreground still-life arrangement on Cézanne's studio table, it helps to compare *Pichet de grès* to *Pichet et fruits sur une table:* see cat. nos. 742 and 743 in Rewald, *Paintings of Paul Cézanne*, 2:255.

Like *Still Life with Plaster Cupid*, *Pichet et fruits sur une table* is an oil work on paper; this unusual support is an indirect indication that these works were produced at about the same time.

145. Imported into Europe from North America in the eighteenth century, the hedge apple or Osage-orange (*Maclura pomifera*) could reach six inches in diameter. It was used to repel cockroaches and other pests; hence its placement on the floor of Cézanne's studio.

146. It could be argued that Cézanne's tactile stroke displaces another kind of reciprocal touching-and-being-touched, namely, the masturbatory touching of one's own body, often linked with a voyeuristic vision that has its origin in autoeroticism (see Sigmund Freud, "Instincts and Their Vicissitudes" [1915], *Standard Edition of the Complete Psychological Works of Sigmund Freud*, ed. and trans. James Strachey, 24 vols. [London: Hogarth Press, 1953–74], 14:127–133). Theodore Reff developed the theme of masturbation in Cézanne's visual imagery, regarding the repetitive brushstroke as a device to control the visualization of fantasies, more a sublimated looking than sublimated touching (Theodore Reff, "Cézanne's Bather with Outstretched Arms," *Gazette des beaux-arts* 59 [March 1962]: 173–90). Reff's argument as applied to Cézanne's male bathers with outstretched arms (see fig. 4) is significantly complicated by the identification of a source image and subsequent analysis in Wayne Andersen, *Cézanne and the Eternal Feminine* (Cambridge: Cambridge University Press, 2004), 115–35, 237 n.8.

147. See Gauguin, letter to Camille Pissarro, July 1881, in Merlhès, *Correspondance de Paul Gauguin (1873–1888)*, 21.

148. For the identification of Ceres and similar matters of iconography to follow, see Gertrude Berthold, *Cézanne und die Alten Meister* (Stuttgart: Kohlhammer, 1958); and Theodore Reff and Innis Howe Shoemaker, *Paul Cézanne: Two Sketchbooks* (Philadelphia: Philadelphia Museum of Art, 1989).

149. For the same type of effect in a painting, see the legs and the space between of the seated figure at the left of *Group of Bathers* (fig. 28).

150. The drawing makes no apparent allusion to "Leda and the Swan." Nevertheless, a recent study of Cézanne's involvement with this theme should be consulted for additional examples of the same strange graphic conflation of subjects: see Lebensztejn, "Une source oubliée de Cézanne," *Études cézanniennes*, 46–59.

151. Morice, "Le Salon d'automne," 381.

152. Morice, "Le XXIe Salon des Indépendants," 552; "Le Salon d'automne," 390.

153. Denis, "A propos de l'exposition de Charles Guérin" (1905), *Théories*, 143–44. Elsewhere Denis argued that Cézanne's decorative form, beautiful by any standard, would express "inner life" by conveying "emotions or states of mind" induced by nature, "without the need of furnishing [its illusionistic] *copy*," that is, without specificity of subject matter ("De Gauguin et de Van Gogh au classicisme" [1909], *Théories*, 267–68, 271 [original emphasis]).

154. Denis, statement in Charles Morice, "Enquête sur les tendances actuelles des arts plastiques," *Mercure de France* 56 (1 August 1905), 356.

155. Denis, "Cézanne," *Théories*, 260.

156. Morice, "Paul Cézanne," 577.

157. Morice, "Paul Cézanne," 593.

158. See Cézanne, letter to Paule Conil, 1 September 1902, in Rewald, *Paul Cézanne, correspondance*, 290.

159. Morice, "Paul Cézanne," 593–94.

160. Morice, "Le XXIe Salon des Indépendants," 553. The prevalence of studio themes (still lifes, images of models, views from windows) in early twentieth-century painting resulted, at least in part, from isolation being regarded as a suitable response to conditions of modernity. The studio, like the bourgeois home, could be a place of withdrawal. Artists represented the nude—traditionally, much more than a studio object—"as if they were making a [mere] still life, interested only in [abstract] relations of line and color [and turning the model into] a decorative accessory" (Charles Morice, "Art moderne: Nus," *Mercure de France* 85 [1 June 1910]: 546).

161. Theorists speculated that mineral and vegetable forms (rocks, trees) merely "felt" sensation in a less acute, less intense way than animal forms: "What we call matter is not completely dead, but is merely mind hidebound with habits. It still retains the element of diversification; and in that diversification there is life"; Charles Sanders Peirce, "The Law of Mind" (1892), *Collected Papers*, ed. Charles Hartshorne, Paul Weiss, and Arthur W. Burks, 8 vols. (Cambridge, Mass.: Harvard University Press, 1958–60), 6:111. See also Ian Hacking, *The Taming of Chance* (Cambridge: Cambridge University Press, 1990), 213–14.

162. Gasquet, *Cézanne*, 150, 153.

163. Paul Souriau, *L'esthétique du mouvement* (Paris: Alcan, 1889), 211 n.1.

164. Bataille, "L'impressionnisme," 12:373–74, 376.

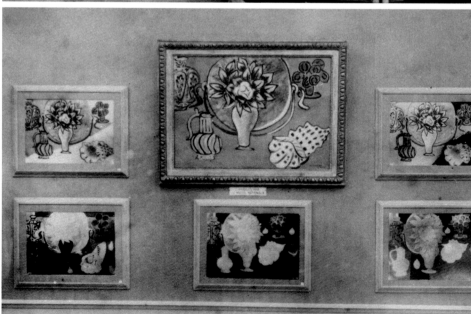

Figs. 1a–c. Installation photographs by Marc Vaux of Henri Matisse's December 1945 exhibition at the Galerie Maeght, Paris

The Matisse Grid

Jeffrey Weiss

It is a decidedly peculiar sequence of images: photographs of three walls in Henri Matisse's exhibition at the Galerie Maeght in Paris in late 1945 (figs. 1a–c). The centerpiece of each wall is a single painting by the artist: *The Dream, The Romanian Blouse,* and *Still Life with a Magnolia,* respectively (all painted in 1940–41). The rest of the wall is hung with photographs—as many as a dozen (and perhaps more beyond the camera's frame)—recording prior versions of the painting in question. The photographs are smaller than the painting they depict (but identical in size to one another); they are also identically mounted in heavy frames. The images of the Maeght exhibition (taken by the photographer Marc Vaux) have not gone unnoticed in the Matisse literature, but for all of their strangeness, they are barely remarked.

Henri Matisse (1869–1954) began using the camera in this way in 1935, but for a few earlier exceptions, recording what he referred to as states, or *états:* compositional shifts in the course of producing a single work. The evidence of this procedure was first published that year by Roger Fry in his Matisse monograph, which reproduces eight states of the recently finished *Large Reclining Nude* arranged as a single plate in two vertical columns of four images each (captioned sequentially A through H [fig. 2]). Matisse's application of the camera was much more fully revealed fifty years later by his model and studio assistant Lydia Delectorskaya in her book *L'apparente facilité . . . Henri Matisse: Peintures de 1935–1939*. There it became clear that at least several dozen paintings and possibly as many charcoal drawings had been photographed in progress. Further, the photographs appear to have taken various forms: in contrast to the Maeght gallery exhibition, Delectorskaya reproduces notebook pages onto which the images, quite small in format, are pasted down (precisely aligned in double rows, as in Fry's book) and labeled in the artist's hand (fig. 3). Looking closely, one can also detect a small slip of paper inscribed with a date in the corner of each. Several of the photographs are

174

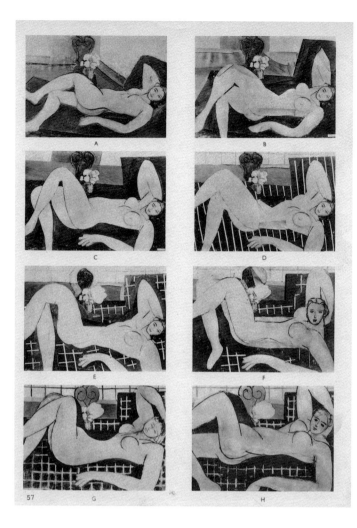

57

take, photographs in anticipation of a painting; in his easel painting he always worked from nature," which was, for him, a source of "exaltation."[1] Leaving aside questions begged by the notion of transparently "working from nature," we observe that Delectorskaya, in seeking to spare Matisse's art from negative associations with photography, makes an un-self-conscious but crucial distinction: between relying on photography in order to paint (to mediate between nature and art), which is understood to be anathema to Matisse, and the use of photography to record stages of work, which, as her book demonstrates, had become Matisse's standard practice. It remains for us to determine whether we can still describe the camera, applied in this way, not just as a recording device but also as an instrument of mediation.

In fact, it is hard not to recognize the photographs as a discrete body of work. For the conceptual nature of the images, while foreign to the language with which we usually address Matisse's painting, is acutely rhetorical, with specific reference to the photograph as a mechanical instrument of information—of inventory, of sorting, sequence, and record-keeping. More, the repetition inherent to the camera might even be said to *instrumentalize* a process of subjectivity—of labor, but also of choice and touch. And the variety of formats, from notebook scale to framed exhibition copy, further positions photography near the center of Matisse's activity. Ultimately, it is the deadpan nature of both the camera and the photograph as "instruments" that concerns us, for the camera's mechanical function encourages us to reimagine the process of the painted oeuvre after 1935. In certain respects, we have to conclude that Matisse was painting *for* the camera.

It is uncertain whether Matisse's implementation of the camera motivated, or was motivated by, the artist's shifting pictorial imperatives circa 1935, although we should probably presume the latter. Writing from

signed by Matisse. In the case of *Large Reclining Nude,* Delectorskaya shows twenty-four states—three times as many as Fry had shown—produced over the course of six months.

It is difficult to account for the relative silence regarding Matisse's camera among critics. Even Delectorskaya, in the text of her book, cautions us, claiming that the many small photographs—which she describes having received as a gift from Matisse—were no more than an "occasional amusement" (*un divertissement occasionnel*) taken, she notes, with a small Kodak camera that Matisse acquired in 1930 for his trip to Tahiti. "Unlike certain painters," she continues, "Henri Matisse never took, nor had others

Fig. 2. Eight states of Henri Matisse's *Large Reclining Nude,* 1935. Reproduced from Roger Fry, *Henri-Matisse* (Paris: Éditions des Chroniques du Jour, 1935), pl. 57

a close vantage about Matisse's late period, Clement Greenberg was well positioned to observe the shift, given the formal prejudices—his belief in the essentializing opticality of the project of modernist painting from Édouard Manet (1832–1883) through Jackson Pollock (1912–1956)—in which his criticism had been grounded for roughly a decade. In our context, Greenberg's bias is convenient. Addressing Matisse's painting *Woman in Blue* from 1937 (fig. 30), he wrote: "In 1935, Matisse, simplifying his art, abandoned shading altogether and made the figure as flat as its background, relying on line and the 'optical' properties of color—oppositions of warm and cool color—to give it relief. . . . The artist, attacking head-on the problem of flat easel painting, came dangerously near the poster in these years." In this context, Greenberg specifically references the *états:* "With sweat and concentration, he went too often where his feeling could not quite follow. Starting with a somewhat realistic statement of the subject, he would in this period carry a painting through as many as twenty-two different stages in order to arrive at the most 'permanent' definition of his 'sensation.' (The wonder is that the paint still looked fresh in the end.)" Greenberg notably misrepresents Matisse's procedure, for any close examination of the photographs show that it is rarely correct to describe the first state of a given painting as having represented a greater degree of "realism" than the final one. But he is not wrong in describing the pull of the third dimension in Matisse's late manner, his "saturations of the intensest and flattest color." For Greenberg that pull also characterizes *phases* of greater or lesser "realism" throughout Matisse's career. In this regard, he commends the artist for displaying self-awareness, a "constant questioning of his own work." Following his description of the process of *états,* he concludes, "Such studiedness made him his own art critic," although he finds that Matisse was too often satisfied "only with the most static of resolutions."

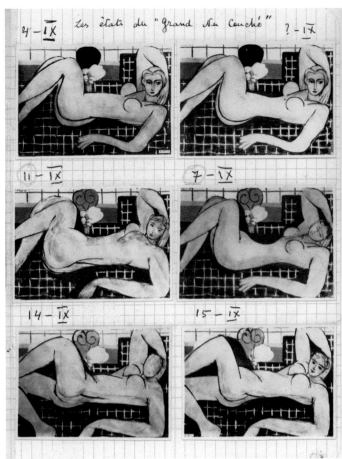

Fig. 3. Six states of Henri Matisse's *Large Reclining Nude,* 4–15 September 1935. Reproduced from Lydia Delectorskaya, *L'apparente facilité . . . Henri Matisse: Peintures de 1935–1939* (Paris: Adrien Maeght Éditeur, 1986), 63

An examination of the five photographed states of *Woman Seated in an Armchair* (figs. 4–8), allows us to itemize the kind of changes that occupied Matisse across the recorded stages of a work. These include dramatic shifts in the pattern and value (presumably the color, as well) of the floor, which occupies some 50 percent of the image and which was painted-over or scraped-out midway through the sequence, reinstated, and subjected to further revisions in the final *état* (in which changes in the pattern can be observed along the lower edge of the canvas, up around the back of the chair, and beneath the door). Further, Matisse's brushwork appears to tighten up along the way; following Greenberg's cue, we might acknowledge a stiffening of the overall design, for the first state is loosely worked and shows a good deal

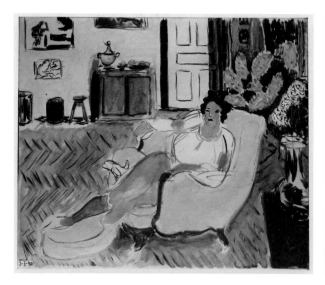

4, 5
6, 7
8

Figs. 4–8. Five states of Henri Matisse's *Woman Seated in an Armchair,* 3–17 January 1940. Courtesy Archives Matisse, Paris

Fig. 9. Henri Matisse, *Woman Seated in an Armchair,* 1940. Oil on canvas, 54 × 65.1 cm. Washington, National Gallery of Art, Given in loving memory of her husband, Taft Schreiber, by Rita Schreiber (1989.31.1)

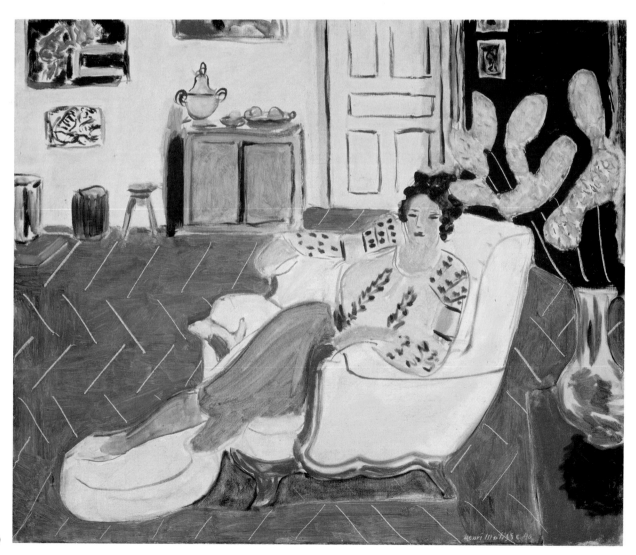

of what appears to be exposed canvas. The artist signed the penultimate version (fig. 7), which must have meant he had decided to stop there; but changes in the floor pattern eight days (fig. 8) later necessitated a new signature. In work on this painting, the position of the figure did not change, nor did the placement of furniture or other objects, although such adjustments are common in other paintings during this period.

Greenberg's characterization of Matisse's "studiedness" beginning in 1935, with the advent of the sequential development of an image through stages, establishes a clear divide in the work, but it is one defined as much by studio procedure as by the formalism of the paintings. What is the difference between "carrying a painting" through close to two-dozen stages in 1935 and the procedure of bringing a painting to completion prior to that date? Greenberg's distinction rests on the role of the camera (although he does not put it that way); photographic record-keeping implies that the "stages" or states are viable *solutions* in and of themselves, quite unlike normal stages of painting process, which implicate (pentimenti notwithstanding) gradual progress in a composition that is preestablished and that remains largely unchanged from beginning to end.

To be exact, there are a handful of examples of *états* that do reveal a somewhat conventional process of that kind—of increasing states of finish rather than shifts in design. But examples departing from such norms of progress—the *Large Reclining Nude,* among others—signal our closest attention. In those cases, which are far more common, Matisse's interest in the photographs suggests that something could be gained by examining the solutions in (and perhaps out of) sequence. Further, the fact that the photographs forfeit color surely tells us that Matisse was employing the camera partly to separate considerations of form from the overwhelming power of colorism in his work. (This is a distinction Matisse made with reference to black-and-white photographs of Pierre Bonnard's (1867–1947) paintings, which, he observed, prove that Bonnard constructs "form" through color, presumably by demonstrating how Bonnard's form dissolves when, in photographic reproduction, it is deprived of hue.)[2]

The timing of Matisse's application of the camera may correspond to the artist's changing ambition for his work beginning in 1935. But, considered as an enterprise of its own, the quasi-serial photographic record of work in progress can also be compared to a separate instance of photographic inventory from this period, one that was close at hand. Unlike Matisse, Pablo Picasso (1881–1973) had employed photography as far back as 1900, making unconventional use of the camera during his Cubist period, when he shot multiple images of paintings in the studio and even went so far as to fabricate double exposures.[3] With reference to Matisse, however, what should concern us is the compilation of a photographic record in relation to the preparation and publication of the now-celebrated catalogue raisonné on which Picasso collaborated with the historian and critic Christian Zervos.

The Zervos catalogue raisonné is a remarkable publication, for the complete catalogue of the work of a living artist (not to mention an artist who had only just passed mid-career) was virtually unprecedented in 1932, the year of the first volume's publication. Such an endeavor reflects on Picasso's work in numerous ways, not least with respect to the market. But the vastness and complexity of the oeuvre, above all, are invoked by the Zervos volumes (which number thirty-four in total, twenty-three of which were completed, with his full cooperation, during Picasso's lifetime). In this regard, we can say that the Zervos catalogue came into existence as a massive sorting device and that the procedure it represents was not only to be applied to the past, but, by implication, to work of the present and the *future*. It was, in other words, a project that could be understood to

anticipate a proliferating body of work that did not yet exist. Far from being a transparent record, then, the catalogue establishes an interpretive visual structure, one that (especially given the participation of the artist himself, whose work was still ongoing) must be understood to conceptualize the art.

To a certain but significant degree (albeit one difficult to quantify), the Zervos catalogue raisonné did not merely measure Picasso's work but—as a mechanism, even an ethos—can be said to have infiltrated it. It is, for example, no coincidence that shortly after the appearance of the catalogue's first volume Picasso began systematically to date his work—to inscribe paintings and drawings with day, month, and year. This is something he had done prior to Zervos, but only intermittently. During the early 1930s, the habit became routine. It was certainly long established by the 1960s, when Françoise Gilot remembered Picasso having said that his art was like a diary (something we should take to be at least as much about the artist's process as about his life). One must imagine the strenuous retroactive exercise of dating his own work that Picasso would have endured in helping Zervos prepare the first volume of the catalogue (keeping in mind that many of the works that appear in the catalogue still actually belonged to the artist). One can envision the new dating initiative as a form of improved bookkeeping. But it is beginning during this period, as future volumes of the Zervos catalogue show, that Picasso's work in fact took a very distinct turn in drawings and paintings that are by implication produced in far less than a single day. They can even be said to *look* that way, to have acquired a peculiar character of speed as well as, in many cases, a decided emptiness and a related, pronounced quality of sameness.

There are numerous implications for this argument relating above all to the development of Picasso's own work.[4] For the present context, my claim is that the example of Picasso—or, more properly speaking, of the

Zervos project—is central to our consideration of Matisse's *états* because of the shared implementation of the photographic image. The simple reproduction of works of art on the pages of a book is something one is apt to take for granted. But, of course, there is nothing generic or inevitable about the Zervos catalogue, at least from the vantage of 1932. The design of its pages is a specific one with obvious consequences for the way in which we apprehend Picasso's work. With the Zervos layouts, paintings are no longer distinguishable in their dimensions or palette; they are assembled instead as modules, elements embedded in a kind of counting system (fig. 10). This implicates development or advancement of some kind and further suggests that there is a functional value to establishing relational coordinates among the works in any given two-page spread. In their way, the pages of Zervos represent an interpretation of process. More, they *process* the work through the devices of mechanical reproduction.

If there is a structural principle that emerges from the Zervos project and, in turn, from the operation of the *état* in Matisse's work beginning in 1935, then it is figured by the grid. Such an image is not one we readily associate with the sinuous corporeality and dynamic asymmetry that motivate Matisse's compositional types (as far back as the pre-war period), but its very foreignness is useful. The grid in fact does occur as a representational motif, appearing in the form of checked fabrics and backdrop configurations (tiled walls, for example) throughout the period. It first emerged in Matisse's work of the 1920s, where walls and floors bear tilted or diagonal grids of this kind; but it is with the *Large Reclining Nude* in 1935 (reproduced by Fry as a sequence of *états*) that the represented grid is truly squared up such that its axes are parallel to the edges of the canvas, thereby functioning as a device that holds the surface of the painting—the canvas as plane. This

180

corresponds to the powerful flattening—remarked by Greenberg—of Matisse's figuration and his representation of pictorial space. In such a context, the grid maps the surface differently than ornamental pattern (more familiar to us from Matisse's work), although both grid and pattern constitute proliferation, repeating shapes, or linear elements distributed at regular intervals across a field.

Can this grid be said to pertain to the conceptual relation between Matisse's painting practice and his application of the camera? Simultaneously image, form, and matrix, the grid does structure Matisse's treatment of the photographic record of *états:* as small-format photographs, the images of "states" of a single composition are pasted down in precise side-by-side columns on *quadrillé* notebook pages (just as the larger versions of the photographs were shown in gridded formations on the wall of the Galerie Maeght). In both cases, chronological sequencing, which is recorded by the

Fig. 10. Pablo Picasso, *Still Lifes*, 1943–44. Reproduced from Christian Zervos, *Picasso*, vol. 13 (Paris: Éditions Cahiers d'art, 1962), 136–37

dates inscribed on each photographic state, is complemented by the cross-referencing of works through the flat space of the vertical and horizontal axes. Such comparisons are taxonomic, as the multiple states of a painting are inevitably scanned for distinctions—for features they do not share. But one also grasps the perceptual whole, the grid of paintings as a single image of modular display. In *this* regard, it is the sameness of each image that impresses us: the principle of repetition. The flatness of the grid as motif (the wall or floor tiles)—along with the flattening of Matisse's pictorial space during the period of the photographic *état*—corresponds to the compression that photographic reproduction enacts on a painting, which the photograph deprives of tactility and the visual depth of oil on canvas. These visual generalizations may have been expressly useful to the artist in his application of the camera.

In Picasso's case, the grid of images pertains to the designer's layout of the printed

page—the Zervos catalogue raisonné. There repetition occurs across multiple paintings, rather than, as with Matisse, multiple states of a single work. The difference is important: in principle, it indicates a kind of material depth in Matisse's process—painting and scraping and painting and scraping—that Picasso replaces with a form of dispersion in which each "state" is preserved. Picasso's paintings, moreover, lend themselves to the role of component parts in the Zervos catalogue, as if each were produced for the very purpose of distribution within the layout matrix. Whether deliberate or not, Picasso's precise dating of each work further suggests this impulse. That is, his painting practice represents something like an internalization of the catalogue raisonné as an index, a measuring device that succeeds in modifying or motivating the thing it sets out to measure or describe. In turn, it is not difficult to imagine that the pages of the catalogue were acutely relevant to Matisse's practice of shooting and preserving *états*.

We might instead be inclined to ascribe repetition in Matisse's work to the vague genre of theme-and-variation, a concept the artist actually enlisted for a series of drawings produced in 1943: multiple, simply executed versions of a single image, such as a face.[5] But the functionality of the grid in the language of photography and the life of the photograph in Matisse's studio suggests instead that we examine the far more complex category of the painted *état* for something other than "variation," which is no more descriptive, after all, than, say, "trial-and-error." Again, to the extent that we can identify a rupture in Matisse's practice in 1935, we can say that he came to channel his work through a staging process for the record-keeping operation of the camera's mechanical eye. Taken together, the works he produced (the *états*) appear to describe rather than reflect process; if it is too extreme to claim that they *were* created for the camera, then it is certainly fair to say

they were produced according to a regularized pattern of inventoried stages highly amenable to picture-taking. The letters Matisse used to itemize the *états* are apt: as a model, the alphabet represents a system of components, a list rather than a necessarily progressive sequence of qualitative change (which might have been implicated by a number system).

On a few recorded occasions, Matisse did expressly allude to the purpose of the photographic *état*. In an interview in 1945, he was queried on the role of spontaneity in his work, which he denied, emphasizing labor instead—six months of work, for example, to produce *The Dream* (1940) and *Still Life with a Magnolia* (1941), both paintings that had been subjected to the camera. "The photos taken in the course of the execution of the work," he explained in this context, "permit me to know if the last conception conforms more to the ideal than the preceding ones; whether I am advancing or regressing."[6] This account begs the definition or identity of an "ideal," of course, but it also suggests that the photographic record served a retroactive function for Matisse, and that it was meaningful more as a narrative than as a row of individual images. Yet it is unclear whether or not Matisse used the photograph of a given state as a means through which to assess the next step in his pursuit of the "ideal." His explanation seems to indicate only that the sequence mattered, the direction of progress from step to step—that the camera served to preserve and reveal a trajectory. This would mean that the photographic images were intended to function as single frames in a kind of film. Indeed, both Matisse and Picasso had occasion during this period to resort to the analogy of the moving picture with reference to stages of work. As we might expect, Picasso distinguishes between preserving the "metamorphosis" of the image, rather than its states or steps (*étapes*); the result, he claims, is that, in the final work, the initial *vision* remains intact.

Yet the filmstrip or cinematic model would apply better to a painting that is observed to be developing according to predictable standards of finish (beginning, middle, end), not to the kind of advance and retreat that largely characterizes Matisse's method beginning in 1935, through which, for example, the faces of the two figures in *Music* are inscribed, wiped out, and reinscribed. If anything, such a model of systematic advance applies much more plainly to Picasso's methods, as revealed by the photographs of work in progress on the painting *Guernica* in 1937, in which process is more a case of filling-in than of change (not, for that matter, unlike Matisse's work on the Barnes mural project, which Matisse photographed in process in 1932). In other words, each photograph of a Matisse *état* could, in most cases, be taken to record a "finished" work (what I have called a "solution")—hence the relevance of Zervos's Picasso, of finished paintings that resemble one another in the manner of the Matisse *états*. This distinction in the process of executing an individual work between Picasso and Matisse is heightened when we note that, in addition to the familiar case of photographed paintings, Matisse applied the procedure of successive states to drawing, as well—specifically, a number of large, heavily worked charcoal drawings that were also produced over time as a sequence of plausibly finished versions of the subject in question, such as a seated nude.[7] In the drawings, erasures and cancellations are far more obvious than in the paintings; they remain visible as pentimenti and trace, investing the image (by way of removal) with material weight, a quality that confirms the disparity in technique between Picasso and Matisse as well as in the role of the camera as a record-keeping tool.

That Matisse was fully capable of—perhaps even invested in—perpetuating common biases against the camera in relation to painting can be demonstrated by remarks from the period, such as a statement from 1933, which contains a version of much earlier observations on photography solicited by Alfred Stieglitz (1864–1946) and published in *Camera Work* in 1908, the same year Matisse wrote his celebrated "Notes of a Painter": "Photography has greatly disturbed the imagination, because one has seen things devoid of feeling. . . . Photography has very clearly determined the distinction between painting as a translation of feelings and descriptive painting. Descriptive painting has become useless." But this statement (and, by extension, Matisse's devotion to this shopworn distinction between painting and photography) contains a separate, more provocative observation: "When I wanted to get rid of all influences that prevented me from seeing nature from my own personal view, I copied photographs. We are encumbered by the sensibilities of the artists who have preceded us. Photography can rid us of previous imaginations."[8] Copying photographs of nature is, of course, different from taking photographs of one's own work, but this prescription reveals an anxiety of influence for which the camera perhaps served as a check or filter. Here the photograph's capacity for "description" as opposed to "feeling" is a source of its functional value to the painter. Something similar is suggested by Matisse, as quoted by Louis Aragon in his text "Matisse-en-France" from 1942, in which Matisse claims to copy photographs in order to produce a likeness, thereby distancing himself from artists (Raphael and Renoir are named) "who seem to have always painted from the same woman." In this way, Matisse explains, "I thus limited the field of errors."[9]

"Photography can rid us of previous imaginations." This is an extraordinary statement, one that, while based on a mistaken presumption of the objectivity of the camera, possesses a strategic edge that is not often apparent in Matisse's pronouncements from this period. If Matisse brought such a conception of the camera with him to the photographic campaign that begins in 1935, then it is reasonable

to presume it influenced the function of the *états,* which would in this respect represent not stages of pictorial progress subject to careful scrutiny toward determining a viable next move, but self-sustaining pictorial solutions that the camera was intended to seize and thereby expunge. In any case, it is clear that the photograph was, for Matisse, an objectifying and distancing device; in direct opposition to Delectorskaya's observation about photography versus the "exaltation" of nature, he claimed that it brought him closer to "nature" by distancing him from the mediating influence of other art. The technique of repetition represents a stop-action procedure for parceling process. Given the timing, the Zervos catalogue may have motivated Matisse to heighten the difference between Picasso's practice and his own; regardless, Zervos would have been a key figure in that he inadvertently demonstrated how inventory could itself be taken up as a conceptual tool. The wall of photographic *états* at the Galerie Maeght in 1945 can perhaps be accounted for by the dialectic of labor and intuition in Matisse's statements during the period. It was clearly intended to be a demonstration of some kind. Yet our impression of the Maeght images is one not just of demystified process, but of subliminal urgency—of an effort toward a defensive formulation, something like a marshalling of evidence in order to represent the practice of painting—the sustained act—as a form of endurance.

The framing aperture represents the optic of Matisse's studio. Views through a window proliferate in his work, and walls of painted interiors are frequently fenestrated and hung with framed and unframed canvases. Mirrors appear in some paintings and drawings and, perhaps more important, can be seen throughout studio photographs from the 1910s through the late years in Vence. The mirror is a traditional tool of self-portraiture and certainly served Matisse in that way; but Matisse may well have deployed the mirror in order to dis- or reorient his perception of a given painting, a role mirrors have also often served in the setting of the *atelier.* As Arnaud Maillet has discussed, Matisse recalled using both a portable frame and a "black mirror" around 1900 in the course of painting a landscape *en plein air;* the frame established a circumscribed view, while the mirror served to mute passages of bright color in the landscape (which tend to pop, compromising one's consistent impression of measurable space), thereby creating a unified tonal effect. The overall purpose of these devices, according to Matisse, was to establish "fixed elements" that would allow him to work on a single painting at the site over the course of several days without succumbing to the confusion of day-to-day shifts in "sensibility."[10] The camera, as aperture, corresponds to this function. Recalling the burden of "previous imaginations" (which is alleviated by photography), we recognize that even Matisse's own previous imagination— the sensibility that had infused his work the day before—might itself qualify as something to suppress. To photograph multiple versions of a single composition would, by conceit, be to neutralize their impulses; seeing the *états* mechanically, the artist would register their "fixed elements" in the form of an all-at-once imprint.

The language of Matisse's statements on art during the period largely concerns vague notions of "harmony" and "unity" (as well as labor), and these things—however we define them—are compatible with the reductivism of the mirror (as it was understood in the history of studio practice) and the camera, which, after all, eliminates color and literally reduces the dimensions of the canvas, creating a form of pictorial compression. The camera is, again, also an instrument of repetition—of the repeating image or frame. Its character as an iterative device is twofold: specific to the mechanical production of images in a row (or, on the proof sheet, a grid) as well as to the photographic image as a version (a record) of the thing it depicts. If

MR. MATISSE PAINTS A PICTURE: *3 Weeks' Work in 18 Views*

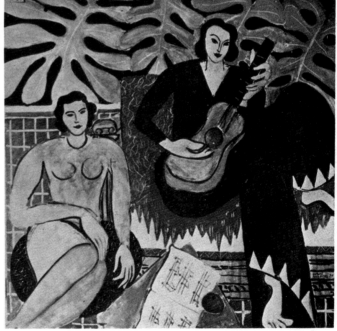

A MATISSE and how it grew can be seen at Buffalo's Albright Art Gallery where the newly acquired and comparatively recent "La Musique" (right) is exhibited together with photographs showing it in various stages (above). Revealing the first impulse, the photograph reproduced on the upper left bears the date March 17, 1939, and the more or less finished product is marked April 8, 1939. Painted at Nice, what radical changes were made in the composition in twenty days are recorded here. The figure on the left is shifted considerably, but the background was the crux of the problem. The solution to Matisse was satisfactory only when he eliminated the mural effect and extended the leaves above the head of the left hand figure. "Guernica," Picasso's large mural, was painted in almost as short a time, and day to day photographs show even more sweeping alterations. X-rays prove that the old masters changed their minds too, but not often so materially.

that "thing" is a painting, then we are speaking of reproduction—of image-making once removed. And, in the language of the camera in France, we are more precisely speaking of the *cliché*, a word that possesses a multiple meaning relating both to the image and to ordinary speech: a repetition, the source of an imprint (a photographic negative, a plate of type, a woodblock, a stencil), and a truism or tired expression. In more than one manner of speaking, then, the camera transforms the painting—the *état*—into a *cliché*, a mechanical iteration (an utterance) that does not serve to disorient, after all, but to familiarize. As a narrative of form, Matisse's photographs of compositional states describe a certain debasement of the painted image as well as an exposure of the process of producing the work, which, as a result, is surely deprived of a certain degree of auratic power.

With respect to familiarization, it is ironic that Matisse's image grid is, for its time, a startling thing. Already in 1941, it was given a fuller published treatment than Fry's in the pages of *ARTnews*, where seventeen states of *Music* were reproduced with the final painting, recently acquired by the Albright (later the Albright-Knox) Art Gallery in Buffalo, New York (fig. 11). Indeed, the photographs were shown together with the painting on the walls of the museum. Correspondence from 1940 between the gallery's director, George Washburn, and the artist's son, Pierre Matisse, in anticipation of the installation reveals that there were two sets of photographs divided between Matisse and his son; significantly, Pierre referred to them as "only snapshots."[11] In the short text accompanying the photographs in *ARTnews*, the phenomenon of photographed states was compared to the day-to-day photographic images of *Guernica*.[12] Distributed across the grid, Matisse's process looks at first glance more like a case of genetic self-replication: before examining it closely, we could mistake the photographs for a single image subjected to shifts in time of exposure or f-stop setting.

Opposite:
Fig. 11. "Mr. Matisse Paints a Picture: 3 Weeks' Work in 18 Views." Reproduced from *ARTnews*, 1–30 September 1941, 8

An analogy to the Matisse grid might be identified in the work of another artist, albeit one whose imperatives stand apart from those of Matisse. Beginning around 1920, Giorgio De Chirico (1888–1978) occupied himself with creating copies (*verifalsi*, or "authentic fakes") of his own early work and, more relevantly, producing long sequences of paintings devoted to a single subject or city view. This aspect of De Chirico's project has drawn scrutiny over the years from scholars and critics, who have often held it up to demean the work of the artist's "late" career (between 1920 and his death in 1978). As a practice, it is also related to the replication of De Chirico's paintings by other artists (including Max Ernst [1891–1976]), some apparently fakes intended to deceive.[13] Eighteen versions of De Chirico's painting *Disquieting Muses*, produced between 1945 and 1962, were reproduced together in the periodical *Critica d'Arte* in 1979 (fig. 12); that spread was, in turn, reprinted three years later by William Rubin in his catalogue essay for the De Chirico exhibition at the Museum of Modern Art in New York, where the paintings are described as "reproductions." (Rubin also observed that some canvases were backdated in De Chirico's hand.)[14] An examination of the series as they appear this way in photographic reproduction shows a pointed relationship with the images of *Music* in *ARTnews*.

Between De Chirico and Matisse we are speaking of different practices pertaining, on the one hand, to multiple "finished" replicas and, on the other, to multiple stages in the realization of a single work. Yet the Matisse resemblance is not merely coincidental: the De Chirico images show small changes from work to work, and the overall grid displays a shifting spectrum of light and dark (in the case of De Chirico, some of these shifts may indeed be due to inconsistent exposures over the years). As far as we know, De Chirico did not photograph his work in order to compose a grid, the way Matisse did; rather, as

a layout, the grid became the obvious form through which to display the working procedure of replica and repetition. But De Chirico reminds us that the Matisse *état* is an element in a matrix. With the camera, Matisse accomplished two apposite representations of process in his work. Regardless of whether or not he used them as tools over the course of producing a painting (rather than as records only), the photographs want to demonstrate that the labor of painting is slow and incremental, although not so much a matter of motor control as an exercise of rarefied intuition and choices concerning minute compositional change. Yet, in the photographic grid, intuition and manual labor themselves are made to occupy a mechanical (or technological) dimension; the narrative of the grid is less one of continuity (the continuous struggle to produce a work) than it is a series of stoppages. Given the stop-action nature of the grid as a form, Matisse's sequence of *états* recasts process as fixation: just as with the spread of De Chirico "reproductions," there is no natural terminus, no measurable index of finish per se in the sense of technique or design; there is, in other words, no obvious reason why the sequence finishes where it does. Matisse, of course, would claim that his work stops when certain values—unity or harmony—are achieved, but the mechanical depiction of the stages of labor does not evince such a thing.

If we can begin to call the grid of *états* its own species of work, then it is because Matisse's practice of recording and displaying the stages of a painting lasted some ten years and took both private and public forms: that is, in notebooks, in magazine spreads, and on gallery walls the image-grid itself was subject to repetition, the kind of persistence that enhances the purposefulness of the act, conferring intention and meaning. "Only snapshots": yet the photographs were subject to enlargement and display. They also represent a way of recasting the process of

deliberation before the easel. Finally, though, it is the very notion of the "state" that permits us to award a certain conceptual autonomy to the grid of images. The term *état* or "state" derives, after all, from the medium of printmaking, where it refers to stages in the development of a finished work; in this context, "state" pertains as much to the plate as to the image—the element that makes printmaking a reproductive medium. A printed state is a repetition in the sequential sense, a phase in a narrative of completion,[15] and printmaking in general is repetitive in that it results in the production of the same image over and over—the print as multiple. Such a twofold repetition—stages of progress toward a single finished image and replication of that image in an edition—is achieved in painting by Matisse through the agency of the camera, which, like the print, creates replication by means of an indexical trace (the trace of light on film in one case, and, in the other, the mechanical trace or impression of an inked plate).

With the Matisse grid, the activity of painting—of a kind of painting that had long been held to signify nuances of brushwork and composition—is projected through a mechanical procedure. The grid depicts intuition as a sequence of quantifiable operations, bringing us unexpectedly close to an endgame ethos we more commonly associate with abstraction and reflecting—despite the artist's claims to the contrary—some encroaching doubt regarding the viability of values pertaining to painting as an inherently subjective practice of judgment and taste. By 1935, Matisse knew that his work was the prime site of just such a practice, of intuition plus labor, although his (repetitive) statements to this effect perhaps also betray uncertainty. The Matisse grid claims intuition for the realm of inventory and in so doing, deliberately or not, it represents an anxious, acutely critical interpretation of authenticity. The apotheosis of the repeating image—of painting, photography, and

Fig. 12. Twelve versions of Giorgio De Chirico's *Disquieting Muses.* Reproduced from Carlo L. Ragghianti, "Il caso de Chirico," *Critica d'arte,* Anno XLIV, n.s., fasc. 163–65 (January–June 1979), 13–14

printmaking as the tripartite medium of a single critical project—will have to await Andy Warhol (1928–1987). By the 1960s, a crisis of means would transform painting after Abstract Expressionism; for the Warhol generation, an impoverishment of conventional esthetic values would come to be expressed through the grid as an instrument of replication, a numbing proliferation specifically pertaining to the realm of the commodified image. This is painting's second crisis of the last century. Painting's first crisis, toward the beginning of the century, was denoted by the gradual abandonment of conventions of painting as craft in favor of quasi-mechanical means (the repeated application of the brush in the work of Georges Seurat [1859–1891], for example). And it was allegorized by Marcel Duchamp's (1887–1968) invention of the readymade (with which Duchamp replaced the rejected practice of painting beginning in 1913).[16] We might say that this first crisis, as it concerns

the mechanicity of technique, caught up to the last precinct of pictorial intuition—of "harmony" and "unity" as goals of subjective judgment—when Matisse began applying the repeating image to his own work in 1935.

But to the extent that Matisse staged painting for the camera, we are permitted to say that inventory became a *form,* a structure of operations to which the artist brought specific expectations concerning the stop-action exposure (literally and figuratively) of fully formed solutions to problems of composition or design. In this respect, Matisse's claim that the photographic *états* allowed him to track his progress toward an ideal is compatible with his characterization of the camera as an instrument for the eschewal of "previous imaginations"; recorded on film, versions of a composition are transformed from expressions of sensibility into established facts (solutions subject to being discarded). Put differently, paintings and photographs are two procedural elements that constitute

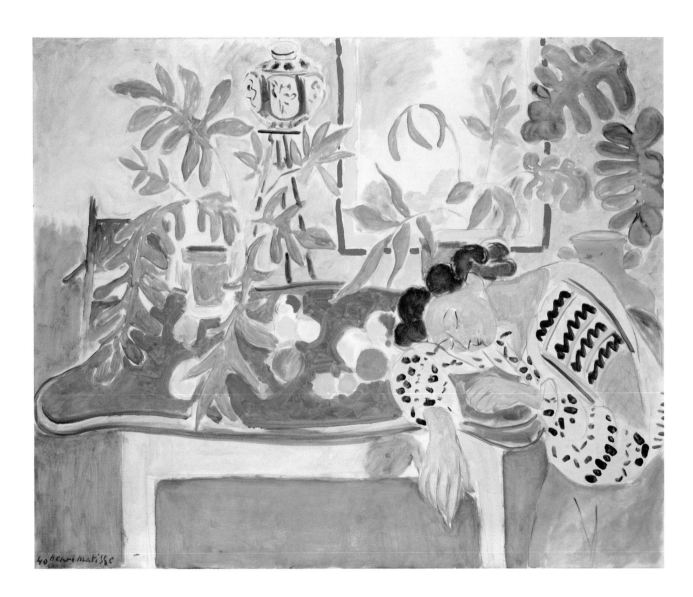

Opposite:
Figs. 13, 14. Two states of Henri Matisse's *Still Life with Sleeping Woman,* 22 December 1939, 2 January 1940. Courtesy Archives Matisse, Paris

Above:
Fig. 15. Henri Matisse, *Still Life with Sleeping Woman,* 1940. Oil on canvas, 82.5 × 100.7 cm. Washington, National Gallery of Art, Collection of Mr. and Mrs. Paul Mellon (1985.64.26)

190 a single "work," for together they indicate the search for an impersonal result—an "ideal," to use Matisse's word—arrived at by channeling personal intuition through the mechanical reflex of a recording instrument. In this context, the grid is a radical leveling device: as a figure within a painting, it is a form of pattern that articulates the shape and planarity of the canvas; as a sorting structure, it implicates not development or advance but modularity, an interchangeability of parts according to which states of a painting are autonomous; as an optical mechanism, a kind of aperture derived from layout design or the form of the proofsheet, it disperses the painted image, resulting in an all-over proliferation that is virtually abstract.

Consider the labor of Matisse's studio: draw/paint; shoot; preserve and expunge; paint; shoot; collate. And the devices of seeing: frame; window; mirror; shutter; proof (and *cliché*). Beginning in 1935, Matisse reinvented painting process as a series of operations, and thereby positioned himself at the outermost critical edge of his own work. (Painting of this kind—investigating the medium in a deeply critical mode while managing to retain and express pleasure in the materiality of it—has been inherited above all by Robert Ryman.)[17] In Matisse's late oeuvre, the act of repetition negotiates an exchange between intuition and procedure,[18] but it does so by effecting a reversal: it classes intuition as a form of certainty while demonstrating that the mechanics of procedure represent a form of second-guessing. Matisse's grid—as a figure of regularity and fixation, above all—is unexpected and, ironically, destabilizing; as such, his deployment of the repeating image posits nothing less than a renewal of the easel picture through a rigorous interrogation of painterly doubt.

Figs. 16–20. Five states of Henri Matisse's *Pink Nude,* March–April 1935. Courtesy Archives Matisse, Paris

Notes

1. Lydia Delectorskaya, *L'apparente facilité . . . Henri Matisse: Peintures de 1935–1939* (Paris: Adrien Maeght Éditeur, 1986), 24–25.

2. Letter from Matisse to his daughter Amélie, quoted in Hilary Spurling, *Matisse the Master: A Life of Henri Matisse. The Conquest of Colour, 1909–1954* (New York: Alfred A. Knopf, 2005), 440.

3. For Picasso's application of photography during his Cubist period, see Anne Baldassari, *Picasso Photographe: 1901–1916* (Paris: Réunion des musées nationaux, 1994), 93–245; and Jeffrey Weiss, *Picasso: The Cubist Portraits of Fernande Olivier* (Washington: National Gallery of Art, 2004), 30–39.

4. I first presented this thesis concerning Picasso and the Zervos catalogue raisonné as a conference paper, although it remains unpublished. The occasion was a symposium held in conjunction with the exhibition *Matisse-Picasso* at the Museum of Modern Art in New York on 12 March 2003.

5. Matisse, *Dessins: Thèmes et variations* (Paris: M. Fabiani, 1943).

6. Interview with Léon Degand in *Les lettres françaises,* translated in Jack Flam, ed., *Matisse on Art* (Berkeley and Los Angeles: University of California Press, 1995), 103.

7. Two such states are reproduced in Roger Fry, *Henri-Matisse* (Paris: Éditions des Chroniques du Jour, 1935), pl. 59. In fact, this very drawing is reproduced in Delectorskaya as a sequence of seven states, the final work dated 1936 (that is, after the publication of Fry's book); see pp. 49–51. In the case of the charcoal drawings, we have a reference by Matisse to

something like the labor of *états* in 1931, one year prior to the practice of photographic record-keeping. With regard to a heavily worked charcoal drawing, Matisse explained to Gotthard Jedlicka that "It consists, if you will, of hundreds of sketches, superimposed one on top of the other." See Jedlicka, "Begnung mit Matisse," translated in Flam, *Matisse on Art*, 103. (The interview was published in 1933 but is presumed to have been conducted in 1931.)

8. Matisse, in E. Tériade, "Emancipation de la peinture," *Minotaure* I, nos. 3–4 (1933): 10; translated in Flam, *Matisse on Art*, 106.

9. Reprinted in Louis Aragon, *Henri Matisse: Roman*, 2 vols. (Paris: Gallimard, 1971), 1:135. In 1947, Matisse would have further recourse to the camera as a metaphor for descriptive versus "inner" vision; see André Marchand, "L'Oeil," in Jacques Kober, ed., *Henri Matisse* (Paris: Maeght, 1947): 51–53; translated in Flam, *Matisse on Art*, 114–15.

10. Arnaud Maillet, *The Claude Glass: Use and Meaning of the Black Mirror in Western Art*, trans. Jeff Fort (New York: Zone Books, 2004), 125–26.

11. My thanks to Susanna Tejada at the Albright-Knox Art Gallery for providing me with this information. There are no photographs of this installation.

12. "Mr. Matisse Paints a Picture: 3 Weeks' Work in 18 Views," *ARTnews*, 1–30 September 1941, 8.

13. For a recent, revisionist consideration of this topic, see Michael R. Taylor, *Giorgio De Chirico and the Myth of Ariadne*, exh. cat., Philadelphia Museum of Art (2003), especially two essays: "The *Piazza d'Italia* Paintings" (133–44) and "Warhol and De Chirico"

(164–68). See also William Robinson, "De Chirico Forgeries," *IFAR Journal* 4, no. 1 (2001): 10–17.

14. William Rubin, "De Chirico and Modernism," in *De Chirico*, exh. cat., New York, Museum of Modern Art (1982), 72.

15. Regardless of the sometimes problematic definition of a finished or final print; see Peter Parshall et al., *The Unfinished Print*, exh. cat., Washington, National Gallery of Art (2001).

16. My summary of this historical circumstance follows a lengthy argument put forth by Thierry de Duve in various publications; see, for example, De Duve, *Kant After Duchamp* (Cambridge, Mass., and London: MIT Press), 147–90.

17. Indeed, Ryman has also made use of the camera, using images of finished paintings to examine the narrative of development and permutation in his own work. For an image of these black-and-white photographs arranged as a grid on the artist's studio wall, see Robert Storr, *Robert Ryman* (New York: Abrams, 1993), 8.

18. And, with reference to the *locus classicus* of this problematic in relation to the mechanical reproduction of the unique work of art, between aura and replication (although reproduction in Matisse's case does not imply a commodified image), see Walter Benjamin, "Art in the Age of Mechanical Reproduction," in *Illuminations*, ed. Hannah Arendt, trans. Harry Zohn (New York: Harcourt, Brace, and World, 1968), 217–51. The essay first appeared in a French translation in 1936, and was not published in German until 1955.

 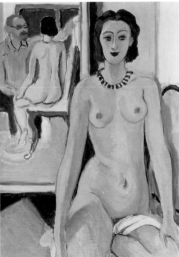 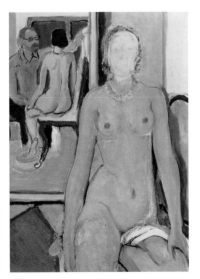

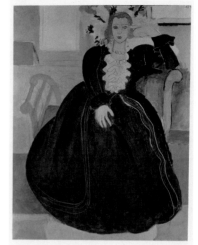

21, 22, 23

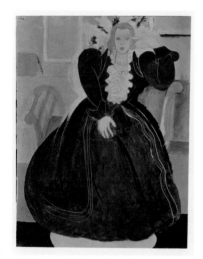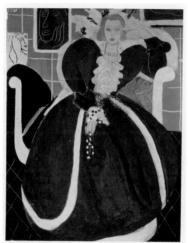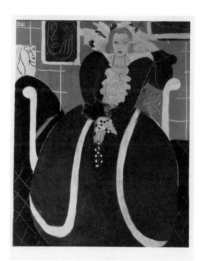

24, 25, 26

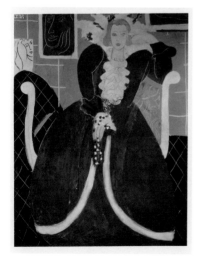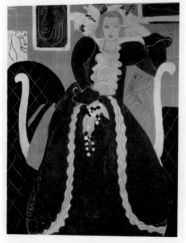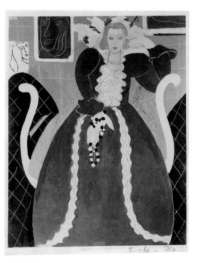

27, 28, 29

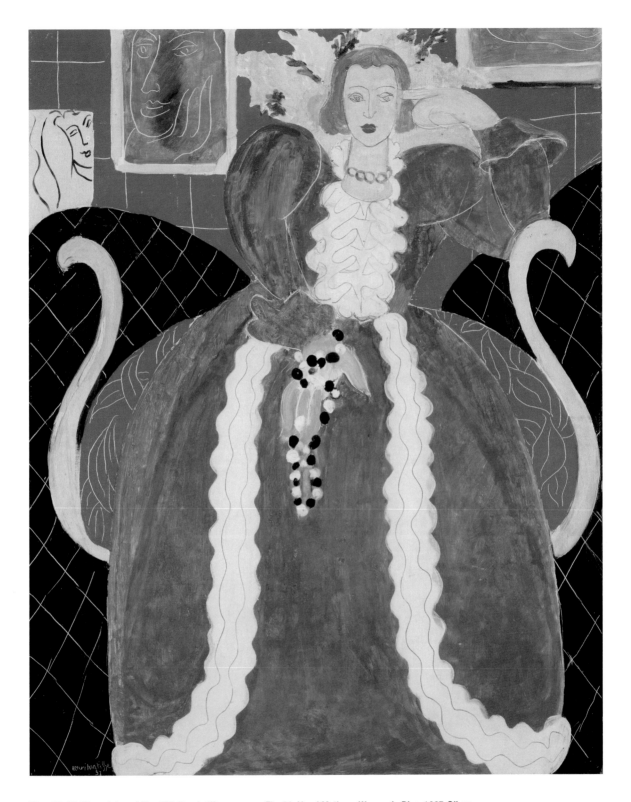

Figs. 21–29. Nine states of Henri Matisse's *Woman in Blue,* 26 February 1936–2 April 1937. Courtesy Archives Matisse, Paris

Fig. 30. Henri Matisse, *Woman in Blue,* 1937. Oil on canvas, 92.7 × 73.7 cm. Philadelphia Museum of Art: Gift of Mrs. John Wintersteen, 1956 (1956-23-1)

Checklist of the Exhibition

Data herein are those given by the lending institutions. Dates, attributions, and titles in some instances may diverge from those given by the essay authors.

1 Italian, 1550–1600, after Leonardo da Vinci, 1452–1519
Mona Lisa
Oil on canvas, 79.3 × 63.5 cm
Baltimore, The Walters Art Museum. Bequest of Henry Walters, 1931 (37.1158)
Not illustrated

2 Jacques-Louis David, 1748–1825, and Studio
La mort de Marat, ca. 1794
Oil on canvas, 111.3 × 85.6 cm
Reims, Musée des Beaux-Arts de la Ville de Reims. Don Paul David, 1879 (879.8)
Illustrated p. 23, fig. 6

3 Studio of Jacques-Louis David, 1748–1825
Marat assassiné, 1793–94
Oil on canvas, 162.5 × 130 cm
Paris, Musée du Louvre. Legs du Baron Jeanin, descendant de l'artiste, 1945 (RF 1945-2)
Illustrated p. 23, fig. 7

4 Studio of Jacques-Louis David, 1748–1825
La mort de Marat, ca. 1793
Oil on canvas, 92 × 73 cm
Dijon, Musée des Beaux-Arts de Dijon (2306)
Illustrated p. 23, fig. 4

5 Studio of Jacques-Louis David, 1748–1825
Marat assassiné, 1793
Oil on canvas, 157.5 × 136 cm
Versailles, Musée national des châteaux de Versailles et de Trianon (MV 5608)
Baltimore only
Illustrated p. 23, fig. 5

6 Jean-Auguste-Dominique Ingres, 1780–1867
Edipe explique l'énigme du sphinx, 1808
Oil on canvas, 189 × 144 cm
Paris, Musée du Louvre. Legs de la Comtesse Duchâtel, 1878 (RF 218)
Illustrated p. 48, fig. 18

7 Jean-Auguste-Dominique Ingres, 1780–1867
Oedipus and the Sphinx, ca. 1826
Oil on canvas, 17.5 × 13.7 cm
London, The National Gallery, bought 1918 (NG 3290)
Illustrated p. 48, fig. 19

8 Jean-Auguste-Dominique Ingres, 1780–1867
Oedipus and the Sphinx, 1864
Oil on canvas, 105.5 × 87 cm
Baltimore, The Walters Art Museum. Bequest of Henry Walters, 1931 (37.9)
Illustrated p. 48, fig. 20

9 Ferdinand-Victor-Eugène Delacroix, 1798–1863
Christ on the Sea of Galilee, ca. 1841
Oil on canvas, 45.7 × 54.6 cm
Kansas City, The Nelson-Atkins Museum of Art. Purchase: Nelson Trust through exchange of the gifts of the Friends of Art, Mr. and Mrs. Gerald Parker, and the Durand-Ruel Galleries; and the bequest of John K. Havemeyer (89-16)
Illustrated p. 138, fig. 8

10 Ferdinand-Victor-Eugène Delacroix, 1798–1863
Christ on the Lake of Genesareth, 1853 (?)
Oil on canvas, 45.1 × 54.9 cm
Portland, Oregon, Portland Art Museum. Gift of Mrs. William Mead Ladd and children (31.4)
Illustrated p. 138, fig. 7

11 Ferdinand-Victor-Eugène Delacroix, 1798–1863
Christ Asleep during the Tempest, 1853
Oil on canvas, 50.8 × 61 cm
New York, The Metropolitan Museum of Art. H. O. Havemeyer Collection, Bequest of Mrs. H.O. Havemeyer (29.100.131)
Baltimore only
Illustrated p. 139, fig. 9

12 Ferdinand-Victor-Eugène Delacroix, 1798–1863
Christ on the Sea of Galilee, 1853
Oil on composition board, 47.6 × 58.1 cm
Philadelphia Museum of Art: Gift of R. Sturgis and Marion B.F. Ingersoll, 1950 (1950-6-1)
Illustrated p. 139, fig. 10

13 Ferdinand-Victor-Eugène Delacroix, 1798–1863
Christ on the Sea of Galilee, 1854
Oil on canvas, 59.8 × 73.3 cm
Baltimore, The Walters Art Museum. Bequest of Henry Walters, 1931 (37.186)
Illustrated p. 139, fig. 11

14 After Ferdinand-Victor-Eugène Delacroix, 1798–1863
Christ on the Lake of Gennesaret, 1854
Oil on paper mounted on Masonite, 25.1 × 31.4 cm
Museum of Fine Arts, Boston. Bequest of Josiah Bradlee, 1903 (03.741)
Illustrated p. 139, fig. 12

15 Paul Delaroche, 1797–1856, with Charles Béranger, 1816–1853
Hémicycle des Beaux-Arts, ca. 1841; repainted and signed 1853
Oil on canvas, 41.6 × 257.3 cm
Baltimore, The Walters Art Museum. Bequest of Henry Walters, 1931 (37.83)
Illustrated p. 36, fig. 8

16 Louis Pierre Henriquel-Dupont, 1797–1892, after Paul Delaroche, 1797–1856
Hémicycle des Beaux-Arts, 1853
Engraving in three parts: Left panel of three: 53 × 112.5 cm; center panel: 53 × 65.5 cm; right panel: 53 × 112.5 cm
Baltimore, The Walters Art Museum. Gift of C. Morgan Marshall, 1944 (93.113a–c)
Illustrated p. 36, fig. 9

17 Jean-Léon Gérôme, 1824–1904
Duel after a Masked Ball (Duel après un bal masqué), 1857
Oil on canvas, 68 × 99 cm
St. Petersburg, Russia, The State Hermitage Museum (GE 3872)
Illustrated p. 44, fig. 14

18 Jean-Léon Gérôme, 1824–1904
The Duel after the Masquerade, 1857–59
Oil on canvas, 39.1 × 56.3 cm
Baltimore, The Walters Art Museum. Bequest of Henry Walters, 1931 (37.51)
Illustrated p. 45, fig. 15

19 Achille Sirouy, 1834–1904, after Jean-Léon Gérôme, 1824–1904
Un duel après le bal, 1859
Lithograph, impression on a tint-stone background, hand-colored with watercolor and gouache, with gum arabic highlights, 37.7 × 54.5 cm
Bordeaux, Musée Goupil: Direction des Établissements culturels de Bordeaux (98.l.1.5)
Illustrated p. 45, fig. 16

20 Jean-Baptiste-Camille Corot, 1796–1875
L'étoile du matin, signed 1864
Oil on canvas, 129 × 160 cm
Toulouse, Musée des Augustins (Ro 60)
Illustrated p. 62, fig. 9

21 Jean-Baptiste-Camille Corot, 1796–1875
The Evening Star (L'étoile du berger), 1864
Oil on canvas, 71 × 90 cm
Baltimore, The Walters Art Museum. Bequest of Henry Walters, 1931 (37.154)
Illustrated p. 63, fig. 10

22 Jean-Baptiste-Camille Corot, 1796–1875
The Evening Star, signed 1863 [1864?]
Oil on canvas, 112.4 × 145.4 cm
Private collection, on deposit at the Saint Louis Art Museum
Illustrated p. 63, fig. 12

23 Jean-François Millet, 1814–1875
The Sower, 1847–48
Oil on canvas, 95.2 × 61.3 cm
Cardiff, Amgueddfa Cymru–National Museum Wales (NMW A 2474)
Baltimore only
Illustrated p. 56, fig. 2

24 Jean-François Millet, 1814–1875
The Sower, 1850
Oil on canvas, 101.6 × 82.6 cm
Museum of Fine Arts, Boston. Gift of Quincy Adams Shaw through Quincy Adams Shaw, Jr. and Mrs. Marian Shaw Haughton (17.1485)
Illustrated p. 56, fig. 3

25 Jean-François Millet, 1814–1875
The Sower, 1850
Oil on canvas, 105.4 × 85.7 cm
Pittsburgh, Carnegie Museum of Art. Purchase: gift of Mr. and Mrs. Samuel B. Casey and Mr. and Mrs. George L. Craig, Jr. (63.7)
Illustrated p. 57, fig. 5

26 Jean-François Millet, 1814–1875
The Sower, 1865
Pastel and crayon or pastel on cream buff paper, 43.5 × 53.5 cm
Baltimore, The Walters Art Museum. Bequest of Henry Walters, 1931 (37.905)
Baltimore only
Illustrated: p. 68, fig. 16

27 Jean-François Millet, 1814–1875
The Sower, ca. 1865
Pastel on tan paper, 29.8 × 24.1 cm
Pittsburgh, The Frick Art & Historical Center (1984.9)
Illustrated p. 69, fig. 18

28 Jean-François Millet, 1814–1875
The Sower
Pastel on black crayon and pale brown paper, 36 × 43 cm
French & Company LLC, New York
Baltimore only
Illustrated p. 69, fig. 19

29 Jean-François Millet, 1814–1875
The Sower, n.d.
Lithograph on paper, 19.1 × 15.6 cm (plate)
Pittsburgh, Carnegie Museum of Art. Gift of Andrew Carnegie (16.18.1)
Illustrated p. 70, fig. 20

30 Eadweard Muybridge, 1830–1904
Animal Locomotion, plate 580: *Annie G, walking, saddled,* 1872–85; published 1887
Collotype, 48.5 × 61.3 cm (sheet)
Washington, The Corcoran Gallery of Art. Museum purchase (87.7.526)
Not illustrated

31 Eadweard Muybridge, 1830–1904
Animal Locomotion, plate 620: *Annie G. cantering, saddled,* 1872–85; published 1887
Collotype, 48 × 60.5 cm (sheet)
Washington, The Corcoran Gallery of Art. Museum purchase (87.7.566)
Not illustrated

32 Eadweard Muybridge, 1830–1904
Animal Locomotion, plate 621: *Annie G. cantering, saddled,* 1872–85; published 1887
Collotype, 48 × 60.4 cm (sheet)
Washington, The Corcoran Gallery of Art. Museum purchase (87.7.567)
Not illustrated

33 Eadweard Muybridge, 1830–1904
Animal Locomotion, plate 652, *Horses rearing, etc.,* 1872–85; published 1887
Collotype, 47.6 × 60.4 cm (sheet)
Washington, The Corcoran Gallery of Art. Museum purchase (87.7.598)
Not illustrated

34 Edgar Degas, 1834–1917
Horse Walking, model early 1870s; cast ca. 1920/25
Bronze, 21 × 26.6 × 9.8 cm
Washington, National Gallery of Art. Gift of Mrs. Lessing J. Rosenwald (1989.28.2)
Illustrated p. 118, fig. 49

35 Edgar Degas, 1834–1917
Rearing Horse, model 1880s; cast 1919/21
Bronze, 31 × 25.5 × 20.2 cm (with base)
Washington, National Gallery of Art. Collection of Mr. and Mrs. Paul Mellon (1999.79.38)
Illustrated p. 118, fig. 50

36 Edgar Degas, 1834–1917
Trotting Horse, the Feet Not Touching the Ground, ca. 1881
Bronze, 23.2 × 27 × 12.4 cm
Fine Arts Museums of San Francisco. Museum purchase, Gift of Jay D. McEvoy in memory of Clare C. McEvoy and Partial Gift of the Djerassi Art Trust (1989.16)
Illustrated p. 118, fig. 48

37 Edgar Degas, 1834–1917
Before the Race, ca. 1882
Oil on panel, 26.5 × 34.9 cm
Williamstown, Massachusetts, Sterling and Francine Clark Art Institute (1955.557)
Illustrated p. 115, fig. 45

38 Edgar Degas, 1834–1917
Before the Race, 1882/84
Oil on panel, 26.4 × 34.9 cm
Baltimore, The Walters Art Museum. Bequest of Henry Walters, 1931 (37.850)
Illustrated p. 115, fig. 46

39 Edgar Degas, 1834–1917
Leaving the Bath (La sortie du bain), 2nd state, 1879–80
Etching and drypoint with burnishing on laid paper, 12.8 × 12.8 cm (plate)
Fine Arts Museums of San Francisco. Museum purchase (1973.9.13)
Illustrated p. 110, fig. 33

40 Edgar Degas, 1834–1917
Leaving the Bath (La sortie du bain), 7th state, ca. 1879–80
Electric crayon, etching, drypoint, and aquatint on laid paper, 12.8 × 12.8 cm (plate)
Ottawa, National Gallery of Canada. Purchased 1976 (18662)
Illustrated p. 110, fig. 34

41 Edgar Degas, 1834–1917
Leaving the Bath (La sortie du bain), 11th state, ca. 1879-80
Electric crayon, etching, drypoint, and aquatint, 12.8 × 12.8 cm (plate)
Austin, Blanton Museum of Art, The University of Texas at Austin. Archer M. Huntington Museum Fund, 1982 (1982.705)
Illustrated p. 111, fig. 36

42 Edgar Degas, 1834–1917
Leaving the Bath (La sortie du bain), 12th state, ca. 1879–80
Drypoint and aquatint on laid paper, 12.7 × 12.7 cm (plate)
New York, The Metropolitan Museum of Art. Rogers Fund, 1921 (21.39.1)
Illustrated p. 111, fig. 37

43 Edgar Degas, 1834–1917
Leaving the Bath (La sortie du bain), 13th state, ca. 1879–80
Drypoint and aquatint, 21 × 17.5 cm (sheet)
Northhampton, Massachusetts, Smith College Museum of Art. Gift of Selma Erving, class of 1927 (SC 1972:50-19)
Illustrated p. 111, fig. 38

44 Edgar Degas, 1834–1917
Leaving the Bath (La sortie du bain), 14th state, ca. 1878–80
Etching and aquatint, 12.7 × 12.7 cm (plate)
Williamstown, Massachusetts, Sterling and Francine Clark Art Institute (1969.19)
Illustrated p. 111, fig. 39

45 Edgar Degas, 1834–1917
Leaving the Bath (La sortie du bain), 15th state, 1879–80
Drypoint and aquatint on wove paper, 12.7 × 12.8 cm (plate)
New York, The Metropolitan Museum of Art. Harris Brisbane Dick Fund, Rogers Fund, The Elisha Whittelsey Collection, The Elisha Whittelsey Fund, 1972, by exchange (1972.659)
Illustrated p. 111, fig. 40

46 Edgar Degas, 1834–1917
Leaving the Bath (La sortie du bain), 16th state, ca. 1878–80
Etching, aquatint, and drypoint on wove paper, 12.7 × 12.7 cm (plate)
Williamstown, Massachusetts, Sterling and Francine Clark Art Institute (1971.39)
Illustrated p. 111, fig. 41

47 Edgar Degas, 1834–1917
Leaving the Bath (La sortie du bain), 20th state, 1879–80
Electric crayon, etching, drypoint, and aquatint, 12.7 × 12.7 cm (plate)
Washington, National Gallery of Art. Rosenwald Collection (1950.16.48)
Illustrated p. 111, fig. 42

48 Edgar Degas, 1834–1917
Leaving the Bath (La sortie du bain), 21st state, 1879–80
Electric crayon, etching, drypoint, and aquatint, 12.7 × 12.7 cm (plate)
Washington, National Gallery of Art. Rosenwald Collection (1950.16.47)
Illustrated p. 110, fig. 35

49 Edgar Degas, 1834–1917
Leaving the Bath (La sortie du bain), impression from canceled plate, 1879–80, printed 1959
Etching, aquatint, and drypoint, 12.8 × 13 cm (plate)
The Baltimore Museum of Art: Blanche Adler Memorial Fund (BMA 1960.128)
Illustrated p. 111, fig. 43

50 Paul Cézanne, 1839–1906
Standing Bather Seen from Behind (Baigneur debout vu de dos), 1879–82
Oil on canvas, 27 × 17.1 cm
The Henry and Rose Pearlman Foundation; on long-term loan to the Princeton University Art Museum (L.1988.62.1)
Illustrated p. 164, fig. 29

51 Paul Cézanne, 1839–1906
Bathers, 1890–92
Oil on canvas, 54.3 × 66 cm
Saint Louis Art Museum. Funds given by Mrs. Mark C. Steinberg (2:1956)
Baltimore only
Illustrated p. 133, fig. 5

52 Paul Cézanne, 1839–1906
Group of Bathers, ca. 1895
Oil on canvas, 20.6 × 30.8 cm
Philadelphia Museum of Art: The Louise and Walter Arensberg Collection, 1950 (1950-134-34)
Illustrated p. 161, fig. 28

53 Paul Cézanne, 1839–1906
The Small Bathers, 1896–97
Brush and tusche and crayon color lithograph, 22.3 × 27.3 cm
The Baltimore Museum of Art: The Cone Collection, formed by Dr. Claribel Cone and Miss Etta Cone of Baltimore, Maryland (BMA 1950.12.605)
Illustrated p. 147, fig. 17

54 Paul Cézanne, 1839–1906
The Large Bathers, 1896–98
Brush and tusche transfer and crayon color lithograph, 48 × 56.5 cm
The Baltimore Museum of Art: The Cone Collection, formed by Dr. Claribel Cone and Miss Etta Cone of Baltimore, Maryland (BMA 1950.12.681.1)
Illustrated p. 147, fig. 18

55 Paul Cézanne, 1839–1906
The Bathers (Baigneurs), 1898–1900
Oil on canvas, 27 × 46 cm
The Baltimore Museum of Art: The Cone Collection, formed by Dr. Claribel Cone and Miss Etta Cone of Baltimore, Maryland (BMA 1950.195)
Illustrated p. 142, fig. 14

56 Paul Cézanne, 1839–1906
Standing Male Bather; Puget's Atlas
Page L recto from Sketchbook II, 1885–1900
Graphite pencil and graphite offset from page XLIX verso on wove paper, 12.9 × 21.6 cm
Philadelphia Museum of Art: Gift of Mr. and Mrs. Walter H. Annenberg, 1987 (1987-53-79a)
Illustrated p. 159, fig. 25a

57 Paul Cézanne, 1839–1906
Male Bathers
Page XLIX verso from Sketchbook II, 1885–1900
Graphite pencil and graphite offset from page L recto on wove paper, 12.9 × 21.6 cm
Philadelphia Museum of Art: Gift of Mr. and Mrs. Walter H. Annenberg, 1987 (1987-53-78b)
Illustrated p. 158, fig. 25b

58 Claude Monet, 1840–1926
Stacks of Wheat (Sunset, Snow Effect), 1890–91
Oil on canvas, 65.3 × 100.4 cm
The Art Institute of Chicago, Potter Palmer Collection (1922.431)
Illustrated p. 86, fig. 1

59 Claude Monet, 1840–1926
Grainstack (Snow Effect), 1891
Oil on canvas, 65.4 × 92.4 cm
Gift of Miss Aimée and Miss Rosamond Lamb in memory of Mr. and Mrs. Horatio Appleton Lamb (1970.253)
Illustrated p. 87, fig. 4

60 Claude Monet, 1840–1926
Grainstack in Winter, Misty Weather, 1891
Oil on canvas, 65 × 92 cm
Private collection, courtesy of Ivor Braka
Baltimore only
Illustrated p. 86, fig. 3

61 Claude Monet, 1840–1926
Rouen Cathedral, Façade, 1894
Oil on canvas, 100.6 × 66 cm
Museum of Fine Arts, Boston. Juliana Cheney Edwards Collection (39.671)
Illustrated p. 121, fig. 52

62 Claude Monet, 1840–1926
The Portal of Rouen Cathedral in Morning Light, 1894
Oil on canvas, 100 × 64.9 cm
Los Angeles, The J. Paul Getty Museum (2001.33)
Illustrated p. 121, fig. 53

63 Henri Matisse, 1869–1954
Woman Seated in an Armchair, 1940
Oil on canvas, 54 × 65.1 cm
Washington, National Gallery of Art. Given in loving memory of her husband, Taft Schreiber, by Rita Schreiber (1989.31.1)
Illustrated p. 177, fig. 9

64 Henri Matisse, 1869–1954
Still Life with Sleeping Woman, 1940
Oil on canvas, 82.5 × 100.7 cm
Washington, National Gallery of Art. Collection of Mr. and Mrs. Paul Mellon (1985.64.26)
Illustrated p. 189, fig. 15

65 Henri Matisse, 1869–1954
Woman in Blue, 1937
Oil on canvas, 92.7 × 73.7 cm
Philadelphia Museum of Art: Gift of Mrs. John Wintersteen, 1956 (1956-23-1)
Phoenix only
Illustrated p. 193, fig. 30

Photographic Documentation
Henri Matisse, 1869–1954
Nine states of *Woman in Blue,* 1937 (no. 65 above)
26 February 1937; 3, 12, 13, 22, 23, 24 and 25 March 1937; 2 April 1937
Courtesy Archives Matisse, Paris
Illustrated 192, figs. 21–29

Henri Matisse, 1869–1954
Five states of *Pink Nude (Nu rose crevette),* discarded and destroyed
16, 17, 20 March 1935; undated [March or April 1935], 25 April 1935
Courtesy Archives Matisse, Paris
Illustrated pp. 190–91, figs. 16–20

Henri Matisse, 1869–1954
Two states of *Still Life with Sleeping Woman,* 1940 (no. 63 above)
22 December 1939 and 2 January 1940
Courtesy Archives Matisse, Paris
Illustrated p. 188, figs. 13, 14

Henri Matisse, 1869–1954
Five states of *Woman Seated in an Armchair,* 1940 (no. 64 above)
3, 4, 8, 9, and 17 January 1940
Courtesy Archives Matisse, Paris
Illustrated p. 176, figs. 4–8

Index

Page references in italics denote illustrations. References to works not easily distinguishable are annotated with the medium and abbreviated name of the institutional owner (BMA: The Baltimore Museum of Art; PMA: Philadelphia Museum of Art; SLAM: Saint Louis Art Museum).

Photography Credits

Title page: Jean-Léon Gérôme, *The Duel after the Masquerade*, left panel: Musée Condé, Chantilly (44 fig. 13), detail; center panel: Walters Art Museum (45 fig. 15), detail; right panel: The State Hermitage Museum (44 fig. 14), detail

Page 5: Jean-Léon Gérôme, *The Duel after the Masquerade*, The State Hermitage Museum (44 fig. 14), detail

Page 10: left panel: Jacques-Louis David, *The Death of Marat*, Musée d'art ancien, Musées royaux des Beaux-Arts (22 fig. 3), detail; center panel: Studio of Jacques-Louis David, *The Death of Marat*, Musée du Louvre, Paris (23 fig. 7), detail; right panel: Jacques-Louis David and Studio, *The Death of Marat*, Musée des Beaux-Arts de la Ville de Reims (23 fig. 6), detail

Page 26: Jean-Auguste-Dominique Ingres, *Oedipus and the Sphinx*, left panel: The Walters Art Museum, Baltimore (48 fig. 20), detail; right panel: Musée du Louvre, Paris (48 fig. 18), detail

Page 52: Jean-François Millet, *The Sower*, left panel: French & Company LLC, New York (69 fig. 19), detail; right panel: The Frick Art & Historical Center (69 fig. 18), detail

Page 82: Claude Monet, *Rouen Cathedral, Façade*, left panel: Museum Folkwang, Essen (121 fig. 51), detail; center panel: Museum of Fine Arts, Boston (121 fig. 52), detail; right panel: The J. Paul Getty Museum, Los Angeles (121 fig. 53), detail

Page 126: Paul Cézanne, left panel: *Bathers*, Saint Louis Art Museum (133 fig. 5), detail; center panel: *Group of Bathers*, Philadelphia Museum of Art (161 fig. 28), detail; right panel: *The Bathers (Baigneurs)*, The Baltimore Museum of Art (142 fig. 14), detail

Front cover: Details, left to right: 1. Scala / Art Resource; 2. © Musée des Beaux-Arts de la Ville de Reims, C. Devleeschauwer; 3. © Musée des Beaux-Arts de Dijon; 4. Réunion des Musées Nationaux / Art Resource, NY
Back cover: Courtesy Archives Matisse, Paris; © 2007 Succession H. Matisse, Paris / Artists Rights Society (ARS), New York

Eik Kahng, *Repetition as Symbolic Form*
12 fig. 1: © 1962, Yale University Press, New Haven and London; 15 fig. 2: © Norton Simon Museum, Pasadena, Calif.; 22 fig. 3: Scala / Art Resource, NY; 23 fig. 4: © Musée des Beaux-Arts de Dijon; 23 figs. 5–7: © Réunion des Musées Nationaux / Art Resource, NY (Gérard Blot / C. Jean); 23 fig. 6: © Musée des Beaux-Arts de la Ville de Reims, C. Devleeschauwer

Stephen Bann, *Reassessing Repetition in Nineteenth-Century Academic Painting: Delaroche, Gérôme, Ingres*
30 fig. 1: Bildarchiv Preussischer Kulturbesitz / Art Resource, NY (photo Elke Walford); 32 fig. 2: Réunion des Musées Nationaux / Art Resource, NY (Gérard Blot); 33 fig. 4: © Sterling and Francine Clark Art Institute, Williamstown, Massachusetts; 42 fig. 12: © Mairie de Bordeaux; 44 fig. 13: Réunion des Musées Nationaux / Art Resource, NY (Gérard Blot); 44 fig. 14: © The State Hermitage Museum, Saint Petersburg, Russia; 45 fig. 15: Photograph by Susan Tobin; 45 fig. 16: © Mairie de Bordeaux, photo B. Fontanel; 48 fig. 18: Réunion des Musées Nationaux / Art Resource, NY (R. G. Ojeda); 48 fig. 20: Photograph by Susan Tobin

Simon Kelly, *Strategies of Repetition: Millet / Corot*
57 fig. 2: © Amgueddfa Cymru–National Museum Wales; 57 fig. 3: Photograph © 2007 Museum of Fine Arts, Boston; 59 fig. 8: Erich Lessing / Art Resource, NY; 62 fig. 9: Photograph by Daniel Martin; 63 fig. 18: Photograph by Susan Tobin; 64 fig. 13: Photo Jean-Louis Bellec, Courtesy Centre de recherche et de restauration des musées de France, Toulouse; 66 fig. 14: Photograph by Susan Tobin; 66 fig. 15: Erich Lessing / Art Resource, NY; 68 fig. 16: Photograph by Susan Tobin; 68 fig. 17: © Sterling and Francine Clark Art Institute, Williamstown, Massachusetts; 68 fig. 18: © The Collection of The Frick Art & Historical

Center, Pittsburgh, Pennsylvania; 70 fig. 21: © Copyright the Trustees of The British Museum; 71 fig. 22: The New York Public Library / Art Resource, NY; 71 fig. 23: The Bridgeman Art Library; 72 fig. 24: © Copyright the Trustees of The British Museum; 72 fig. 25: © Réunion des Musées Nationaux / Art Resource, NY

Charles Stuckey, *The Predications and Implications of Monet's Series*
86 fig. 1: Photography © The Art Institute of Chicago; 86 fig. 2: Photograph © 2007 Museum of Fine Arts, Boston; 87 fig. 4: Photograph © 2007 Museum of Fine Arts, Boston; 87 figs. 5, 9, and 10: Photography © The Art Institute of Chicago; 86 fig. 6: The Bridgeman Art Library; 87 fig. 7: Photograph © 1996 The Metropolitan Museum of Art; 89 figs. 14–16: © Réunion des Musées Nationaux / Art Resource, NY (Hervé Lewandowski [14], C. Jean [15], Gérard Blot [16]); 91 fig. 17: © Musée Rodin, Paris; 92 figs. 18–20: Terra Foundation for American Art, Chicago / Art Resource, NY; 98 fig. 23: © Rheinisches Bildarchiv; 110 fig. 34: Photo © National Gallery of Canada; 110 fig. 35: Image © 2007 Board of Trustees, National Gallery of Art, Washington; 111 fig. 36: Photo Rick Hall; 111 figs. 37, 40: Image © The Metropolitan Museum of Art; 111 figs. 39, 41: © Sterling and Francine Clark Art Institute, Williamstown, Massachusetts; 111 fig. 42: Image © 2007 Board of Trustees, National Gallery of Art, Washington; 114 fig. 41: Photograph by Jameson Miller; 115 fig. 42: © Sterling and Francine Clark Art Institute, Williamstown, Massachusetts; 115 fig. 43: Photograph by Susan Tobin; 118 figs. 46, 47: Image © 2006 Board of Trustees, National Gallery of Art, Washington; 121 fig. 49: © Museum Folkwang, Essen; 121 fig. 50: Photograph © 2007 Museum of Fine Arts, Boston

Richard Shiff, *Risible Cézanne*
128 fig. 1: Erich Lessing / Art Resource, NY; 131 fig. 3: Photo Katya Kallsen © President and Fellows of Harvard College; 132 fig. 4: Photograph by Dorothy Zeidman; 138 fig. 7: © Portland Art Museum, Portland, Oregon; 138 fig. 8: Photograph by Robert Newcombe; 139 fig. 9: Photograph © 1984 The Metropolitan Museum of Art; 139 fig. 10: Photograph by Graydon Wood; 139 fig. 11: Photograph by Susan Tobin; 139 fig. 12: Photograph © 2007 Museum of Fine Arts, Boston; 141 fig. 13: Scala / Art Resource, NY; 144 fig. 15: Digital Image © The Museum of Modern Art / Licensed by Scala / Art Resource, NY; 146 fig. 16: Photograph Reproduced with the Permission of The Barnes Foundation™. All Rights Reserved; 152 fig. 19: Erich Lessing / Art Resource, NY; 153 fig. 20: Image © 2007 Board of Trustees, National Gallery of Art, Washington; 154 fig. 21: Erich Lessing / Art Resource, NY; 158 fig. 24: Photograph by Graydon Wood; 160 fig. 28: Photograph by Graydon Wood; 164 fig. 29: Photo Bruce White © Trustees of Princeton University

Jeffrey Weiss, *The Matisse Grid*
172 figs. 1a–c: Bibliothèque Kandinsky—Centre de documentation et de recherche du Musée national d'art moderne / Centre de création industrielle (Centre Georges Pompidou). Paris; 174 fig. 2: © Annabel Cole; 175 fig. 3: © Adrien Maeght Éditeur, Paris; 176 figs. 4–8: © 2007 Succession H. Matisse, Paris / Artists Rights Society (ARS), New York; 177 fig. 9: © 2007 Succession H. Matisse, Paris / Artists Rights Society (ARS), New York; image © 2007 Board of Trustees, National Gallery of Art, Washington; 180 fig. 10: © Éditions Cahiers d'art, Paris / Yves Sicre de Fontbrune; photograph courtesy Special Collections, The Sheridan Libraries, Johns Hopkins University, Baltimore, Maryland; 184 fig. 11: © 1941, ARTnews LLC, September 1–30; Reprinted courtesy of the publisher; 187 fig. 12: Courtesy Università internazionale dell'arte—Firenze; 188 figs. 13, 14: © 2007 Succession H. Matisse, Paris / Artists Rights Society (ARS), New York; 189 fig. 15: © 2007 Succession H. Matisse, Paris / Artists Rights Society (ARS), New York; image © 2007 Board of Trustees, National Gallery of Art, Washington; 190–91 figs. 16–20: © 2007 Succession H. Matisse, Paris / Artists Rights Society (ARS), New York